From Fu Manchu to Kung Fu Panda

Critical Interventions
Sheldon H. Lu, general editor

CRITICAL INTERVENTIONS

From Fu Manchu to Kung Fu Panda

Images of China in American Film

Naomi Greene

University of Hawai'i Press

Honolulu

19 18 17 16 15 14 6 5 4 3 2 1

Critical Interventions
Sheldon H. Lu, general editor

Critical Interventions consists of innovative, cutting-edge works with a focus on Asia or
the presence of Asia in other continents and regions. Series titles explore a wide range of
issues and topics in the modern and contemporary periods, especially those dealing with
literature, cinema, art, theater, media, cultural theory, and intellectual history as well as
subjects that cross disciplinary boundaries. The series encourages scholarship that com-
bines solid research with an imaginative approach, theoretical sophistication, and stylis-
tic lucidity.

Library of Congress Cataloging-in-Publication Data
Greene, Naomi, author.
 From Fu Manchu to Kung fu panda : images of China in American film /
Naomi Greene.
 pages cm — (Critical interventions)
 Includes bibliographical references and index.
 ISBN 978-0-8248-3835-5 — ISBN 978-0-8248-3836-2 (alk. paper)
 1. China—In motion pictures. 2. Motion pictures—United States—History.
I. Title. II. Series: Critical interventions (Honolulu, Hawaii)
 PN1995.9.C47G74 2014
 791.43'65851—dc23

Designed by Santos Barbasa
Printed by Sheridan Books, Inc.

This book is dedicated to the memory of
Frank Kretschmer

Contents

List of Illustrations

Acknowledgments

It is safe to say that without one person in particular—my late friend Frank Kretschmer—this book would never have been written. Had Frank not insisted that I visit him in Beijing—where he taught English for many years—I would never have become interested in China much less in American perceptions of China. Before that visit, in fact, my gaze had been firmly fixed on Europe—first as a student of French literature (Frank and I met, in fact, in graduate school, where we were both studying Romance languages), then as a scholar and teacher of cinema. If I thought of China at all, it was surely through the cold war lens of my childhood. But that visit changed everything. Here was a vast and ancient civilization with a literature, an art, an approach to life about which I knew nothing. Determined to fill that impossible lacuna, I began studying Mandarin and eventually returned to China on several occasions with Chinese colleagues from my university.

But even as I visited and learned about China, certain questions became insistent. How was it that I had never been taught about this huge and important civilization? Why were cold war images so persistent? Why did our film courses seem to ignore Chinese cinema? Why did my daily newspaper—the *New York Times*—seem eager to bash China at every turn? Why—as a student of Frank's once asked me did Americans dislike the Chinese? Gradually, with Frank's guidance and encouragement, I decided to explore these questions from the vantage point I knew best: by looking at the manifold ways film images interact with broad cultural, political, and historical impulses. Although Frank died well before I completed the project, I continued to hold imaginary conversations with him as I wrote the later chapters. What did he think of the almost inconceivable changes taking place in China? How did he feel about the resonance of a film like *Kung Fu Panda*?

As I approached the end of this project, much needed help came from other quarters. In California, Thong Win unraveled for me some of the mysteries of

technology involved in gathering images; in New York, Dollie Banner showed unfailing good cheer and patience in locating wonderful stills. My partner, Paul Slater, provided invaluable help in preparing the manuscript and bibliography. Finally, I had the great good fortune of encountering the most supportive of editors in Pamela Kelley.

The Pendulum Swings . . .
and Swings Again

Past and Present

This book is about the representations of China found in American films, Or, more precisely, about the images and myths regarding China found in such films. It is based on two underlying premises. First, that film both reflects and fuels widespread, and often deeply rooted, perceptions and attitudes. In a book about the interactions of film and history, French historian Marc Ferro argues that cinema is both a "source" and an "agent" of history. A film is a "source" in that it reveals not only the physical and social realities of the past but also the attitudes and beliefs of the period in which it was made. It acts as an "agent" in a two-fold way. That is, it shapes visions of the past—think, for example, of how *Gone with the Wind* has influenced memories and perceptions of the Civil War[1]—that almost invariably have an impact on future behavior and decisions. "Attitudes and policies are formed," writes Jerome Ch'en in a book about China and the West, "approaches and procedures are chosen, on the basis of things as they are perceived, not as they really are."[2] Ch'en may not have been thinking principally of how film shaped perceptions of China—he was concerned, rather, with the role played by "missionaries and converts, scholars and students, traders and emigrants"—but no one would deny that, once film turned to China, it created powerful perceptions that became part of a landscape of shifting sympathies and strident fears.

This brings us to the second general premise: that is, in the case of American perceptions of China, screen images bear on a relationship between two countries—that is, China and America—that is as deeply problematic as it is critically important. No country has figured more prominently in recent American history: since the onset of the cold war the presence of China has loomed large in domestic American politics as well as foreign policy. Fears of China arguably prompted the United States to fight in Korea and, later, in Vietnam. Speaking of the Korean War, historian David Halberstam makes the point that the war "was never just

about Korea. It was always joined to something infinitely larger—China, a country inspiring the most bitter kind of domestic political debate."[3] And if China was a critical player in the nation's recent past, it has become abundantly clear that no country promises to play a more important role in America's future. Even as early as 1970, China's growing importance was sensed by historian Henry Steele Commager. "What was said of America in Tocqueville's day," wrote Commager, "can be said of China in ours, that no student can be indifferent to its existence, no economist omit it from his calculations, no statesman ignore its immense potentialities, and no philosopher or moralist refuse to accommodate his speculations to its presence."[4]

In the years since Commager wrote those words, China's "immense potentialities" have loomed larger with every passing day. "The most important thing happening in the world today," declared a succinct Nicholas Kristof in the pages of the *New York Times* on December 10, 2003, "is the rise of China." Barely a week goes by that we do not read about how China appears to be catching up to, if not surpassing and challenging, the United States. Headlines tell us that "China is drawing high-tech research from the U.S." even as it races to replace the United States "as economic power in Asia." Its construction of a "vast network of fast trains" means that the United States "falls further behind."[5] Almost as if there were no other important countries or national groups in the world—as if the European Union, and the nations of Latin America barely existed—Americans tend to view the contest for global hegemony in terms of America and China. Every realm of experience—the Olympic medals won by athletes, the achievements of schoolchildren—is measured in terms of this contest. The coming century, suggests one commentator after another, will belong not to America but to the Chinese. "If the 20th was the American century," writes William Grimes flatly, "then the 21st belongs to China. It's that simple."[6]

In recent years, perceptions of this contest have given rise to insistent comparisons between China's "rise"—as it is inevitably called—and America's "fall." Books about China's rise and what it portends for this century—such as Ted C. Fishman's *China, Inc: How the Rise of the Next Superpower Challenges America and the World* (2005), Wendy Dobson's *Gravity Shift: How Asia's New Economic Powerhouses Will Shape the 21st Century* (2010), Martin Jacques' *When China Rules the World: The End of the Western World and the Birth of a New Global Order* (2009), Clyde Prestowitz' *Three Billion New Capitalists: The Great Shift of Wealth and Power to the East* (2005), Stefan Halper's *The Beijing Consensus: How China's Authoritarian Model Will Dominate the Twenty-First Century* (2010), Aaron L. Friedberg's *A Contest for Supremacy: China, America, and the Struggle for Mastery in Asia* (2012)—are matched only by those devoted to America's imperial decline. A sampling includes Cullen Murphy's *Are We Rome? The*

Fall of an Empire and the Fate of America (2007), Amy Chua's *Day of Empire: How Hyperpowers Rise to Global Dominance—and Why They Fall* (2008), and Robert Kagan's *The Return of History and the End of Dreams* (2008).

Yet despite the important role China has played in the past, and will clearly play in the future, no country—as the films under consideration make clear—has been more enveloped in American ignorance or bathed in changing illusions and myths. In part, of course, such myths are symptomatic of a broader ethnocentric bias: Americans are not known for their interest in, or knowledge of, other places in the world. Long before the contemporary era, as historian Tony Judt once observed, "foreign visitors were criticizing [America's] brash self-assurance, the narcissistic confidence of Americans in the superiority of American values and practices, and their rootless inattentiveness to history and tradition—their own and other people's."[7] Still, even within this general context of "inattentiveness," Americans' ignorance of China *is* striking. It may not be as acute as it was in the postwar era, when virtually all contacts between America and China—educational, cultural, and economic—were severed. Nonetheless, it is telling that an observation made in 1974 by the dean of American Sinologists, John K. Fairbank, still rings largely true. "At any given time," said Fairbank wryly, "the 'truth' of China is in our heads, a notoriously unsafe repository for so valuable a commodity."[8] And well before Fairbank wrote those words, Harold Isaacs—author of what is widely considered a pathbreaking study of American attitudes toward China, *Scratches on Our Minds: American Images of China and India*—declared that China "occupies a special place in a great many American minds. It is remote, strange, dim, little known."[9]

Throughout the years, the "strange" and "remote" place that China occupies in the American mind has been accompanied by a curious phenomenon. It is one that, as we will see, comes vividly to life in the films explored in these pages. That is, under the force of changing historical circumstances, Americans tend to swing from intensely positive images of China to those that are relentlessly negative. On the positive side, China is regarded as an ancient and wise civilization—a land blessed with citizens who are intelligent and industrious, peaceful and stoic, devoted to the values of family and the moral teachings of Confucius. But there is another—fearsome—China. This is the land of Oriental despots, of Genghis Khan and his marauding hordes, of strange practices and barbaric tortures. Noting that "the inhuman powers of endurance attributed to the Chinese are loosely related to the idea that they are also inhumanly cruel," Harold Isaacs observes that "the term 'Chinese torture' has a place in our language signifying devilishly ingenious methods of inflicting pain and death."[10] A land of "devilish" methods of torture, this latter China is peopled, continues Isaacs, by "a faceless, impenetrable, overwhelming mass, irresistible if once loosed. Along this way we

discover the devious and difficult heathen, the killers of girl infants, the binders of women's feet, the torturers of a thousand cuts, the headsmen, the Boxer Rebellion and the Yellow Peril."[11]

Isaacs wrote those words more than a half century ago. But in the eyes of many Sinologists, historians, and political scientists, the schizophrenic view of China he describes is still alive and well. Reflecting on the dueling visions of China that seem to inhabit the American imagination, in the wake of a 1979 visit to China, David Chan underscored Americans' "inability to be objective" about China even as he suggested that China either "seduces" or "repels."[12] Approaching this from a slightly different perspective, in a study published in the year 2000, Jasper Becker made much the same point. Noting that China is seen either as an "oriental utopia" or a "Communist hell," he pointed out that then recent books portrayed China along characteristically dualistic lines, that is, "as the next superpower, the new evil empire or as descending into chaos and civil war."[13]

In today's media-saturated world, where images and perceptions change with astonishing speed, the swings of the pendulum and dueling images of China described by these commentators have, if anything, become more visible than before. To see this phenomenon at work, one has only to consider two important dates—1972 and 1989—when the pendulum governing perceptions of China took a violent swing. The first date represents the year that President Richard Nixon and Secretary of State Henry Kissinger met with Chairman Mao Zedong in the course of a historic visit to Beijing. In the period that followed that visit, the "repulsion" that Americans had felt for China throughout the era of the cold war gave way to a moment of "seduction"—one marked by an infatuation with China so strong that Harry Harding likened it to a kind of "China fever."[14] The second date, of course, marks the year that viewers around the world witnessed soldiers of the People's Liberation Army fire on unarmed student protestors in Beijing's Tiananmen Square. Putting an end to what Richard Madsen calls the "liberal China myth" that had guided Americans' relationship to China for a quarter century,[15] the massacre at Tiananmen Square suddenly reawakened quasi-dormant fears of Chinese malevolence and brutality. This watershed event was, moreover, soon followed by a number of confrontations between America and China so tense that, as historian Warren Cohen writes, for a while it seemed as if a new cold war loomed on the horizon.[16]

As political tensions escalated and "seduction" gave way to "repulsion," negative images of China—absent from view since 1972—came back to life with a vengeance. Nowhere was this phenomenon clearer, perhaps, than in America's newspaper of record, the *New York Times*.[17] Revealing the weight of ancient stereotypes, articles insistently brought to mind age-old images of Chinese torture and inhumanity, of weird practices and strange superstitions. For example, a June 29,

2001, report about the alleged harvesting of organs from executed Chinese pris-oners was replete with grisly details that evoked the specter of Chinese torture.[18] In other articles, China's faceless bureaucratic leaders were described in ways that brought to mind visions of cruel and barbaric Oriental despots. Going so far as to use the term "satrap," a report on May 29, 2001, sententiously declared that in China "might makes right, whether wielded by traditional clan chiefs, by cabals of corrupt police, Communist Party satraps and gangsters or . . . by all of the above." And once the SARS crisis erupted, images of "devilish" methods of Chinese torture and of Oriental despotism were joined by those bearing on dirt and disease, on the perceived weirdness and degeneracy of Chinese habits and tastes. While some articles faulted China's leaders for their response to the outbreak of illness, others lingered on what were, to American eyes, the strange foods, super-stitions, and medicines used by the Chinese to battle the plague. A front-page article published on May 10, 2003, bore the deliberately shocking headline "Herbs? Bull Thymus? Beijing Leaps at Anti-SARS Potions."[19] Earlier images of a strange and barbaric people given to wearing pigtails and eating weird crea-tures assumed a contemporary cast even as rats—the symbol of Chinese dirt and deceit—surfaced everywhere in American media coverage of China. One article described an expensive Guangdong restaurant that featured on its menu small mammals like civet cats that, it said, "may have caused the original outbreak"; still another focused on a Chinese slaughterhouse where trucks arrive daily "with animals jammed into cages—cats, dogs, pigeons, goats, ostriches, even rats."[20]

As in the past, the rise of such stereotypes was directly linked to the percep-tion of threats or danger. In recent decades, of course, fears have borne principally on China's growing economic might. Portrayed as both a "Communist hell" and a country of cutthroat capitalism, China is seen as a menacing behemoth eager to devour U.S. markets, alienate U.S. friends and allies in Africa and Europe, exac-erbate the U.S. trade imbalance, attract U.S. graduates with jobs, draw high-tech research from the United States, and challenge the U.S. military by stealing its secrets. Not surprisingly, reporters have been all too happy to chronicle the dark side of China's stunning economic success. Sensationalistic headlines in the *New York Times* announce Dickensian portraits of the ravages wrought by unbridled capitalism: for example, "China's Workers Risk Limbs in Export Drive" (July 4, 2003), "Making Trinkets in China, and a Deadly Dust" (June 18, 2003), "China Crushes Peasant Protest" (October 13, 2004), "When China's 'Haves' Are Abusive, 'Have Nots' Respond with Violence" (December 31, 2004), "Rivers Run Black, and Chinese Die of Cancer" (September 12, 2004), "China's Super Elite Learn to Flaunt It While the New Landless Weep" (December 25, 2004), "A Village Grows Rich Off Its Main Export: Its Daughters" (January 3, 2005), and "Rules Ignored: Toxic Sludge Sinks Chinese Village" (September 4, 2006).

As one might have expected, the drumbeat of negative articles intensified during the 2008 Summer Olympics in Beijing. Even as China dazzled the world with its flair for spectacle and its growing athletic prowess, readers learned about ordinary Chinese people whose homes were gutted in the name of "development," about elderly women forced into "re-education" for complaining when their houses were seized, about protests (in Xinjiang and Tibet) carefully hidden and brutally suppressed.[21] Every aspect, and detail, of the Olympics became symbolic of a country whose rulers would stop at nothing in their quest to impress viewers around the world. Even the fact that the young girl who sang at the opening ceremony lip-synched was taken, for example, as a sign of Chinese "deceit."[22] At least when Pavarotti lip-synched at the 2006 Olympics, waxed the indignant reporter for the *New York Times,* he did so to his own voice!

All this, of course, is not to defend the policies of the Chinese government. Nor is it to suggest that the reports are necessarily untrue or to ignore the extent of the problems the nation faces: no one could deny that China's record on human rights is deplorable or that the country faces pressing social, economic, and environmental issues as it makes the difficult transition to a consumer capitalist culture. Still, without denying the truth of many journalistic reports—or the fact that they bear upon important problems—their tenor *is* nonetheless striking. Replete with the lingering presence of ancient stereotypes, they are often marked by a patronizing tone and an ethnographic bias that, ignoring Chinese history and values, applies American criteria to China.[23] Their obvious determination to cast Chinese realities in the worst possible light frequently seems to defy common sense. Can we really believe, as *New York Times* reporter Mark Landler implies in a front-page feature, "Chinese Savings Helped Inflate American Bubble," published on December 26, 2008, that China deliberately fueled American profligacy by lending the United States money at low rates? Why, too, with so many terrible and repressive regimes around the world (some of which are U.S. allies)—to say nothing of the United States' own lamentable record on human rights in recent years—does the newspaper feel called upon, at every possible moment, to remind us of the authoritarian and repressive nature of China's rulers past and present? Indeed, why are the problems of other emerging nations—the example of India immediately comes to mind—treated in a far more benign way that those confronting China?[24] In short, why is China seen not as a country like any other—one with its own failings, virtues, and problems—but as a "paradise" or (as is far more often the case) a "hell"? In short, why, as Gore Vidal once wrote, is "the yellow peril [such] a permanent part of the American psyche?"[25]

Clearly, the specter of the yellow peril has waxed and waned in relation to American fears of China. Such fears of China may be particularly intense at the present time, but, as Robert McClellan reminds us, even in the nineteenth

century, the Chinese—as non-Christians—were perceived as a "different kind of people whose very nature was threatening to Western civilization." Moreover, as he points out, the obvious greatness of Chinese civilization seemed to challenge the belief in "American uniqueness"—a belief that justified America's expansion westward and across the Pacific. Americans, he writes, "seemed unable to face the possibility of China's being a great civilization and a possible power in the Far East, because it would require a reevaluation of basic values."[26] And the challenge China posed to American "superiority" in the nineteenth century paled, of course, alongside that which occurred a century later: that is, China's embrace of Communism in 1949 seemed to threaten the universality of U.S. values as well as America's exceptional role as a nation. In this sense, China's choice of Communism seemed, to borrow a phrase from historian Henry Steele Commager, nothing short of "treasonous." Noting that Americans "must be first in everything," Commager goes on to say that "their system must not only be the best in the world, but must be acknowledged to be the best; preference for another system is regarded as a kind of treason. . . . It is American standards that must be accepted as the norm everywhere."[27]

The fury evoked by China's "treason" had still another dimension—one rooted in the nineteenth century rather than in the politics of the cold war. That is, Mao's victory was not merely a rejection of America's deeply rooted belief in its own "system." It was also the last act, the convulsive end, of a towering historical phenomenon that had done more to shape American perceptions of China than any other single factor. I am referring, of course, to the missionary enterprise. Again and again, commentators have underscored the role played by nineteenth-century Protestant missionaries—usually from America's heartland—in creating the United States' first, crucial, images of China. The letters and reports missionaries sent back from the field, as well as the accounts of China they gave to church audiences while on furlough, writes Paul A. Varg, "did more to give form to the American image of China than all the other factors combined."[28] Similarly emphasizing the tremendous legacy of the missionary enterprise, in a vivid passage Harold Isaacs writes that the men and women who went to China as missionaries "placed a permanent and decisive impress on the emotional underpinning of American thinking about China. The scratches they left on American minds over the generations, through the nineteenth-century and into our own time, are often the most powerfully influential of all. More than any other single thing, the American missionary effort in China is responsible for the unique place China occupies in the American cosmos, for the special claim it has on the American conscience."[29]

The "scratches" etched by missionaries were fundamental in two critical, deeply interrelated ways. First, they created an image of radical Chinese

"otherness"—an image based principally on the fact that the Chinese were re-
garded as "heathens." (Indeed, it was precisely because of its huge population
of heathens that China was regarded not only as the "the key to world-wide
salvation" but also as "Satan's chief fortress."[30]) Perceived as an inferior people
who "lacked the light of God,"[31] the Chinese were considered, as nineteenth-
century writer Bret Harte wrote in a famous couplet of "Plain Language from
Truthful James," pitiful and deceitful. "For ways that are dark / And for tricks
that are vain," wrote Harte, "The Heathen Chinee is peculiar."[32] In utter con-
trast to the "the heathen Chinee," the missionaries—as still another well-
known poem had it—were "heavenly troops" assigned a divine mission. The men
and women who went to China were nothing less, enthused poet Vachel Lind-
say, than

> An endless line of splendor,
> These troops with heaven for home . . .
> These, in the name of Jesus,
> Against the dark gods stand,
> They gird the earth with valor,
> They heed their King's command.[33]

The martial tone of Lindsay's poem opens upon still another critical dimen-
sion of the missionary enterprise. For if the missionaries went to China in search
of souls, they also played an important and multifaceted role in the imperial proj-
ect itself—that is, America's march westward and then across the Pacific and into
China. For one thing, the presence of American missionaries in China justified
the use of military force; that is, they had to be protected by American gunboats.
For another, their mission both fueled and embodied the sense of "benevolence"
and "mission" that served to legitimize the imperial project itself. As Lian Xi
writes, "America's incorporation of all adjacent lands was virtually the inevitable
fulfillment of a moral mission delegated to the nation by Providence itself."[34]
Lastly, their involvement in the imperial project meant that their charge—
or what William Hutchison deems their "errand"—was double: both "Christian
soldiers" and "couriers" for the nation, America's missionaries were to spread the
Gospel even as they helped create a new society modeled on the values and the
religion of the country they had left behind.[35] As one missionary declared, "Wher-
ever on pagan shores the voice of the American missionary and teacher is heard,
there is fulfilled the manifest destiny of the Christian Republic."[36] This sentiment
was echoed, by one president after another, from the bully pulpit of the White
House. "Christianity," declared President William Howard Taft, "and the spread of
Christianity are the only basis for the hope of modern civilization."[37]

It is against this background—amid what James Thomson calls the "tides of missionary and manifest destiny"[38]—that one sees the full impact and lasting resonance of the missionary advance into nineteenth-century China. It is not only that missionaries created the crucial first images of China and its people. It is also that the missionary enterprise interacted with Americans' history and self-image in a profound way. For, as Harold Isaacs writes in a particularly dramatic and important passage, the missionaries' dream of saving "400 million souls from damnation" inspired a larger national dream—that is, it inspired "the role of benevolent guardian in which the American saw himself in relation to the Chinese and which is so heavily stamped on the American view of all this history."[39] For more than a century this role enhanced the American ego—"we felt ourselves," writes Fairbank, "on the giving end and enjoyed the feeling"[40]—even as it heightened the conviction that, in China, America had been chosen to play a special role. That is, America had been assigned nothing less than what Lian Xi describes as "a disproportionately large role in God's saving plan for humankind."[41]

Given the psychological dimension of this "disproportionately large role," it is hardly surprisingly that when it came to an end, in 1949, the results were dramatic. As the recipient of American benevolence for as long as people could remember, China had enhanced Americans' self-image and offered proof of America's exceptional nature and special destiny. Now, in rejecting a long tradition of evangelical effort and paternalistic benevolence, China not only dealt what Fairbank calls a "grievous blow" to Americans' self-confidence[42] but also challenged the American belief in the superiority and universality of American values. Noting that the repercussions of this "blow" would reach far into the future, Shirley Stone Garrett does not exaggerate when she writes that

> with the Communist takeover hope gave way to frustration, friendship to bitterness, and the collapse of the missionary era left a deep sense of betrayal. . . . China's repudiation of the missionary gift worked like a disease in the consciousness of many Americans, infecting the relationship between the two countries more than has yet been assessed. The connection is too subtle to be traced precisely, but is nevertheless worth close attention, for it may indicate why the American passion for China turned to rage, and why for twenty years America blotted the Chinese state from its map of the world.[43]

As Garrett suggests, once this "disease" took hold, China morphed from its role as the principal theater of U.S. benevolence into that of America's worst enemy. As it did so, ancient images roared back in ways that, as I hope to show, continue to reverberate into the present day.

Dueling Images

Nowhere do the impulses I have just described—the centrality of the missionary enterprise, the perceived otherness of the Chinese, the ebb and flow of fears—come to life more vividly, more nakedly, than in cinema. In some sense, of course, films echo information that can be gleaned from more orthodox historical documents. Like historical documents, films mirror the dramatic shifts of the pendulum, the opposing constellations of images, that have marked the United States' relationship to China. But films also allow us to glimpse beliefs and emotions—often welling up from a kind of collective unconscious—that may resist clear articulation. At the same time, by giving concrete form to relatively abstract ideas or concepts, films suggest not only the presence but also the intensity of certain desires and fears. For example, it is one thing to speak about America's belief in its benevolence. It is another to glimpse the almost desperate quality of that belief in one cold war film after another. Even the improbabilities and erasures, the contradictions and tensions, of films are telling. It is significant, surely, that films as otherwise diverse as *Broken Blossoms* (D. W. Griffith, 1919) and *The Sand Pebbles* (Robert Wise, 1966) bear witness to similar tension—that is, although both consciously espouse the values of tolerance and humanism, they are permeated by currents of deep, undoubtedly unconscious, racism.

Paying close attention to telling inconsistencies and tensions such as these, this study follows the arc of history as it traces how films both reflected and fueled the swings taken by the pendulum governing images of China for nearly a century. On rare occasions, these swings take place within a single film: in *Mr. Wu* (William Nigh, 1927), the Chinese protagonist morphs from a cultivated mandarin into an obsessed murderer before our eyes. More often, though, we are at one end of the pendulum or the other. When the pendulum is at its most positive, we see images of self-sacrificing Buddhist scholars (*Broken Blossoms*), hardworking laundrymen (*Shadows*; Tom Forman, 1922), noble peasants (*The Good Earth*; Sidney Franklin, 1937), and courageous allies (*Thirty Seconds over Tokyo*; Mervyn LeRoy, 1944). When, instead, the pendulum swings to its negative pole, these images are replaced by those of devious torturers like Fu Manchu, evil warlords and perverse half-castes (*Shanghai Express*; Josef von Sternberg, 1932), scheming Chinese dragon ladies (*The Shanghai Gesture*; Josef von Sternberg, 1941), and treacherous "allies" (*The Mountain Road*; Daniel Mann, 1960). But whether films depict the Chinese as good or evil, they rarely acknowledge the complex dimension of otherness—that is, the ways the Chinese are, in fact, both like and unlike ourselves. Instead, almost invariably, difference is either fear—or erased.

It is true that, over the course of time, certain images—and the attitudes they embody—have faded or receded into the past so deeply that they leave few traces behind. Religion and sexuality—issues at the center of early films such as *Broken Blossoms* and *The Bitter Tea of General Yen* (Frank Capra, 1933)—are no longer used as markers of Chinese otherness. If the use of yellowface has disappeared, so, too, has the swirl of fascination and fear that surrounded the Chinese other in, say, *Shanghai Express* and *The Shanghai Gesture*. While *Kundun* (Martin Scorsese, 1997) resembles cold war films in that its portrayal of China harks back to images of Genghis Khan and his marauding hordes, it contains no Chinese villains like Fu Manchu or his later incarnation, the ruthless brainwashing expert at the center of *The Manchurian Candidate* (John Frankenheimer, 1962). In recent decades, as I suggest in Chapter 6, changes have been even more dramatic. Faced with competing images coming both from Chinese films and from Chinese American films, as well as the demands of a globalized film industry, films deliberately avoid the stereotypes of an earlier era even as they suggest the stilling of the pendulum.

And yet, despite these changes, one fundamental impulse—at the root, perhaps, of all the others—has remained constant. That is, from first to last, cinematic portrayals of China and the Chinese inevitably raise the division between the self and the other. In this sense, they confirm Gary Y. Okihiro's argument that we still live in a world permeated by rigid dichotomies, or what he calls binaries." Suggesting that the "attributions of 'West' and 'East'" constitute the "principal geographical binary in American history," Okihiro underscores the long-lived nature of these binaries. Comparing them to often detested but indomitable insects like cockroaches, he observes that binaries "survive, may thrive, in environments old and new, diminutive and prodigious, noxious and wholesome. They scurry about, those binaries, despite ice ages, urban pollution, and exterminators. . . . They seem to persist, over decades, over centuries."[44]

There is no question but that these "binaries" haunt films about China: every aspect of these works—characters, emotions, actions, visual style—feeds into and reflects the fundamental divide between East and West, between the (American) self and the (Chinese) other. When, for example, the pendulum is at its positive end, the Chinese characters seen on-screen bear a distinct resemblance to the self—at least to our better self. The virtuous scholar of *Broken Blossoms* and the stoic laundryman of *Shadows* could hardly be more Christian; the noble peasants of *The Good Earth* would not be out of place on a midwestern farm; the courageous Chinese soldiers in *Thirty Seconds over Tokyo* are, we are told, just "like our boys." When, instead, negative images dominate, a towering chasm separates the self from the other: there is absolutely no resemblance between the bloodthirsty Boxers of *55 Days at Peking* (Nicholas Ray, 1963) and their Western opponents; no

understanding or dialogue is possible between the American businessman of *Red Corner* (Jon Avnet, 1997) and the Chinese officials who frame him for a murder he did not commit.

At times, this fundamental divide, or binary division, seems to recede or even disappear. This is especially true in the case of films that paint a rosy picture of China. Take, for example, a 1934 film directed by Sam Taylor with comedian Harold Lloyd—*The Cat's-Paw*. Not only does this film mock Chinese stereotypes but also it seems to bridge the gap between the self and the other by creating a protagonist who, though American, was inculcated with Chinese virtues during his missionary upbringing in China. But the disappearance of this divide is ultimately more apparent than real; that is, as I make clear in Chapter 2, the film actually erases the other by turning China into a nostalgic version of an earlier America. This erasure becomes even more sweeping in the animated features discussed in Chapter 6, *Mulan* (Tony Bancroft and Barry Cook, 1998) and *Kung Fu Panda* (John Wayne Stevenson and Mark Osborne, 2008). Both films create a mythic, one-dimensional China in which everyone thinks and behaves like Americans. Far from destroying binary divisions, then, all these works create a world in which the self has engulfed the other.

In the end, of course, the divide between the self and the other reflects and fuels, at the individual level, the distinction between two countries, the United States and China. Speaking of still another divide—that between East and West—in his now classic book, *Orientalism*, Edward W. Said makes the following observation: "The Orient," he writes, "is not only adjacent to Europe; it is also ... its cultural contestant, and one of its deepest and most recurring images of the Other. In addition, the Orient has helped to define Europe (or the West) as its contrasting image, idea, personality, experience."[45] It seems to me that, framed somewhat differently, a similar observation can be made about China and America. That is, just as "the Orient has helped to define Europe," I would argue that, more than any other country, China has helped define America. China has served not only as America's absolute "Other" but also as America's "contrasting image, idea, personality, experience." Films about China illustrate this phenomenon in a particularly dramatic way. In other words, as I argue throughout these pages, films about China are, inevitably, films about America itself. Informed both by the crucial dialectic between the self and the other, and by unacknowledged or even unconscious desires and fears, they are often revealing mirrors—what one critic has called Rorschach tests—of our deepest selves.

One of the most obvious examples of this phenomenon stems from the ways early films in particular portray Chinese sexuality. For, like all binary divisions, those bearing on sexual difference bring us back to the self. Perceptions of the sexual other speak of our own sexual longings and fears. Thus the taboo forbid-

ding miscegenation, or "love between the races"—a taboo at the heart of many early melodramas—reveals not only the heavy weight of Puritanism but also the suffocating legacy of America's own unhappy racial history. That is, behind the anxiety produced by the possible Chinese lover—or would-be lover—lurked sexual fears bearing on relations between black men and white women. Foregrounding this taboo, the films explored in Chapters 2 and 3 approach it in ways that say much about American views of sexuality. In *Broken Blossoms,* for example, this taboo merges with a Victorian perception of the dangers inherent in all sexuality; in *Shanghai Express* and *The Shanghai Gesture,* instead, the taboo fuels an obsession with the darkest, most death-infused corners of desire. Only *The Bitter Tea of General Yen* dares to challenge this taboo—to probe how racial prejudice seeps into and corrupts love itself.

If sexuality is the most striking aspect of the mirror that films such as these hold up to America, it is by no means the only one. In fact, works as otherwise diverse as *Broken Blossoms, Shadows, The Bitter Tea of General Yen,* and *The Cat's-Paw* all draw a comparison—implicit or explicit—between China and America. Indeed, they create an idealized vision of China—as a spiritual civilization given to nonviolence and harmony—from which to cast a jaundiced eye on the failings of the West. So, too, is *The Good Earth* marked by an idealized China, but here, explicit comparisons are replaced by a tendency to project American realities and mythologies onto a Chinese landscape. Not surprisingly, comparisons such as these—whether implicit or explicit—vanished after 1949. At that time, it became impossible to compare two civilizations that were so radically, unalterably opposed to each other.

But even as such comparisons disappeared, as I suggest in Chapter 4, films about China continued to say a great deal about America. In fact, in many ways, the often murky reflection of America seen in films made after 1949 is more intriguing than the more transparent gaze of earlier works. They offer a kind of distorting mirror marked by omissions and denials, by repetitions as revealing as they are strident. Darkened by the paranoia of the era, some films expressed the anguish of the present—the doubts and anxieties that began to assail the nation as we went from the war in Korea to the war in Vietnam. Thus, for example, behind the fears surrounding China in both *The Manchurian Candidate* and *The Sand Pebbles,* one senses still deeper fears—those bearing on the collapse of American political institutions (*The Manchurian Candidate*) and on the failure of its imperial mission (*The Sand Pebbles*).

While these films expressed contemporary anxieties, still other cold war films seemed to take refuge in an idealized past. But they, too, said much about the mood of the country. It is telling, for example, that at the very moment when China's "betrayal" challenged Americans' self-image and sense of mission, one

film after another took care to remind viewers of the good faith, the benevolence, that had marked American conduct there in the past. The memory of a time when benevolence was generously given and gratefully received was so important that it permeated even action films and melodramas. It was not only self-sacrificing missionaries—like Ingrid Bergman in *The Inn of the Sixth Happiness* (Mark Robson, 1958)—who stood ready to come to the aid of the Chinese people but also, and far more improbably, rough-and-tumble heroes like John Wayne in *Blood Alley* (William Wellman, 1955) and Charlton Heston in *55 Days at Peking*. In these films—and even more dramatically in *Kundun*—binaries have expanded to the point where they suffuse, and divide, the entire world.

Even when films about China turned their back on history—and, indeed, on the real world itself—they continued to reflect telling images of America. At least this is the case, I think, of the two animated features—*Mulan* and *Kung Fu Panda*—discussed in Chapter 6. Set in a mythical China, both films pull us into a postmodernist world of pastiche and parody marked by many of the strategies seen in children's cartoons. Here, distinctions—between the real and the unreal, history and myth, animals and humans—dissolve amid frenzied swirls of slapstick and farce. But if the fantasy realm they create is deliberately unreal, it also testifies to impulses that could hardly be more real: that is, they reflect the ultimate triumph of the self as well as the centrifugal force of American popular culture that pulls everything into its orbit. In *Mulan,* a legendary Chinese heroine is transformed into an American teenager; in *Kung Fu Panda,* the age-old Chinese tradition of the martial arts is emptied of weight and meaning. In both films, China itself is reduced to a heap of motifs in which the Forbidden Palace and the Great Wall have no more meaning—and probably less—than egg rolls and chopsticks. Projecting American values onto a Chinese landscape, not only do these films absorb the other but also, as if they had a magic wand, they make the real China vanish before our eyes.

To a large extent, the focus of this study—the changing perceptions of China and what they say about America—has determined the choice of films explored. That is, insofar as possible, I have chosen images that bear on China and its people rather than on Chinese immigrants to America's shores or on Chinese Americans. True, it is often very difficult to make this distinction: not only do the two sets of images tend to blur into one another but also they have had a profound impact on one another. As Harold Isaacs notes, "The experience with Chinese in the United States is second only to the missionary experience as a source of some of the principal images and emotions about the Chinese to be found in contemporary American minds."[46] The corollary to this is also true; that is, America's changing relationship to China has deeply affected perceptions of both Chinese immigrants and Chinese Americans. It is telling that during periods of great

anti-Chinese sentiment, Chinese Americans have become targets of persecution. For example, as Lynn Pan observes, after 1949 "federal agents swooped the Chinatowns repeatedly, to sniff out 'un-American' activities."[47] Similar instances of persecution were also visible during the tense decade of the 1990s: the most notorious of these occurred when, in charges later proved baseless, Chinese American scientist Wen Ho Lee was accused of spying for the Chinese.[48]

It is no surprise, then, that films, like Americans at large, have frequently blurred similar distinctions. Take, for example, the case of two of the most enduring Chinese stereotypes: the sinister Fu Manchu and immensely sympathetic San Francisco detective Charlie Chan. The two figures clearly represent a study in opposites: in fact, Richard Bernstein reminds us that in creating the figure of Charlie Chan, novelist Earl Derr Biggers "wanted to counter the demeaning portrayals of Asians that were standard at the time, particularly the evil Fu Manchu, the most recognizable Chinese character in Western books and movies before Chan came along."[49] Lynn Pan tells us that the producers of the original Charlie Chan films at Fox Studios nourished a similar hope: they wanted their portrait of an amiable, Confucius-spouting detective to "counter the characterizations of Chinese as Fu Manchus."[50]

Times change. And one of the ironies of changing mores is that today, Charlie Chan—with his inexhaustible fund of Chinese proverbs and his inscrutable "Eastern" wisdom—is often perceived as no less a detestable racist stereotype than Fu Manchu. In fact, as historian Jill Lepore observes, Charlie Chan is "one of the most hated characters in American popular culture—a kind of yellow Uncle Tom."[51] As for Fu Manchu, while he has hardly become more sympathetic, he, too, has changed. That is, the resurgence of fears of a powerful China has meant that he has taken on new interest. In fact, when Yungte Huang, the author of *Charlie Chan: The Untold Story of the Honorable Detective and His Rendezvous with American History,* suggested the possibility of translating his book into Mandarin, he was told politely by one Chinese publisher, "Right now, we're actually more interested in Fu Manchu."[52] Whatever the changing resonance of these two archetypal figures, the fact remains that when they first came to prominence, the geographical and national divide separating them was lost on viewers and critics alike. Although Fu Manchu plotted revenge on America from the plains of Central Asia while Charlie Chan won sympathizers and fans on the streets of San Francisco, viewers saw both men in exactly the same way, that is, as "Chinese."[53]

For many years, scholars and critics alike seemed more interested in Charlie Chan—and what he represented in terms of Chinese American stereotypes— than in Fu Manchu. This may be because many Chinese American critics, as well as filmmakers, were touched by such stereotypes in a deep, existential way. In any case, while recent decades have seen the publication of numerous books and

articles devoted to the representation of Chinese Americans in the media,[54] the situation is quite different when it comes to books dealing with screen representations of China. In fact, for many years, the only work principally devoted to this topic was one written more than a half century ago: Dorothy B. Jones' *The Portrayal of China and India on the American Screen, 1896–1955* (1955). This began to change in the 1990s as scholars began to look at screen representations of China from a variety of perspectives. For example, both Gina Marchetti's *Romance and the "Yellow Peril": Race, Sex, and Discursive Strategies in Hollywood Fiction* (1993) and Mari Yoshihara's *Embracing the East: White Women and American Orientalism* (2003) view such representations through the prism of romance and sex, while Homay King's *Lost in Translation: Orientalism, Cinema, and the Enigmatic Signifier* (2010) brings a psychoanalytic lens to the visual tropes that signify Orientalism. Still other critical works have begun to examine how China is represented not only in American films but also in those coming from mainland China as well as from various communities of the Chinese diaspora. I am thinking here of studies such as *Transnational Chinese Cinemas: Identity, Nationhood, Gender* (a 1997 collection of essays edited by Sheldon H. Lu), Gary G. Xu's *Sinascape: Contemporary Chinese Cinema* (2007), and Kenneth Chan's *Remade in Hollywood: The Global Chinese Presence in Transnational Cinemas* (2009).

Although many of these works touch on issues and films explored in these pages, none explores the historical arc of American film representations of China from the point of view of the tensions between the self and the other or, broader still, those between America and China. The films I have chosen to explore in terms of these tensions clearly constitute but a limited sample of those that portray China and its people in one way or another. But arguably, they are among the most revealing and compelling. Marked by ambiguities, they suggest some of the complex and often conflicting emotions and perceptions that characterize American beliefs about China. I am not sure that we can ever give an adequate answer to the rhetorical question posed by Fairbank decades ago: "How," he asked in 1974, "could the Chinese be such 'bad guys' in the America of the 1950's and 1960's and such 'good guys' today?"[55] But films remind us of how easy it was to move from perceptions of the Chinese as "our kind of people" to a worldview in which China was seen as the embodiment of betrayal and deceit. Films may not tell the whole story, but they make it easier to understand how the "good guys" of yesterday became the villains of today. If, as it is said, the past is another country, then as seen in these films, this "country" speaks all too eloquently about the present.

East Meets West

Cultural Collisions and Marks of Difference

Looking back at early films, it is difficult to say which particular mark of difference was most important in defining Chinese otherness. Was it religion (as the missionary outlook had it) or sexuality (as Hollywood melodramas seem to suggest)? In any case, for many years it was the rare film that did not remind viewers of the absolute contrast between Christians and heathens or envelope Chinese sexuality in a miasma of taboos and unease. Indeed, it is precisely the complicated amalgam of these two critical marks of difference—and the taboos and ambiguities that swirl around them—that I will explore in the films discussed in this chapter: *Broken Blossoms, Shadows, The Bitter Tea of General Yen,* and *The Cat's-Paw.*

In one way, these films were not representative of their era—at least of their cinematic era. As film historian Kevin Brownlow reminds us, most early films about China were melodramas that represented the Chinese simplistically as a "mystery" or a "threat."[1] In the films *Broken Blossoms, Shadows,* and *The Cat's-Paw,* China is instead portrayed as a spiritual and wise civilization that, in every way, offers a stark contrast to a hypocritical and violence-prone West. In another way, these works *did* reflect their era: the values they ascribe to China—tolerance, compassion, spirituality, and humanism—were very much part of the larger sentimental and ideological landscape that marked America before and after the cataclysm of the First World War.

In respect to this landscape, one should remember that, unlike the devastated nations of Europe, America emerged from the maelstrom of war with a renewed sense of national confidence, vigor, and idealism. China, too, had undergone important changes—ones that encouraged America's hopes for President Woodrow Wilson's dream of international cooperation and goodwill. The fall of the last imperial dynasty in 1911, and the birth of the Chinese Republic—led initially by Sun Yat-sen, a man baptized as a Christian—appeared to signal the birth of a new, modern nation able to cast off the double yoke of feudalism and imperialism. These changes encouraged the fervently held American desire that China

might well become a fellow republic—one that was at once Christian, demo-cratic, and resolutely pro-American. "Americans," as Paul Varg writes, "generally looked forward with confidence to China becoming a democratic nation guided by Christian ideals and closely allied with the United States."[2] If we were the oldest republic, might not the new China become the youngest?

Inspired by the idealistic climate of the era, and encouraged by the hope of a new China, American missionaries flocked to China in renewed numbers. "The founding of the Republic of China," writes Lian Xi, "modeled on Western consti-tutionalism, further boosted missionary confidence about Chinese receptivity to Christianity and led to a large expansion of America's evangelical enterprise in China."[3] Unlike preceding generations of missionaries, many of those who went to China at this time—especially those who were young, liberal, or both—began to question the role they had played in the imperial advance of the preceding century. Eager to distance themselves from the shadow of imperialism and the gunboat diplomacy of the past, they began to cast off the stern admonitions and sermons, as well the sense of moral and cultural superiority, that had character-ized their forerunners. Christians, they felt, had to do more than preach: they also had to promote the economic and social welfare of others. Hence, like social reformers in the United States, American missionaries worked to alleviate the lot of ordinary Chinese people. To this end, they established hospitals and medical clinics, schools, and rural agricultural stations designed to help Chinese peas-ants laid low by the depredations of famine, flood, and internal warfare.

The humanitarian and moral goals embraced by many missionaries of the era, as well as their spirit of cultural relativism—that is, the sense that true Chris-tianity had to be seen in broad ethical terms rather than narrow religious ones—are felt in virtually all the films explored in this chapter. Indeed, in both *Broken Blossoms* and *Shadows,* it is not Westerners but rather Chinese characters who are the most "Christian"—that is, the most ethical and self-sacrificing. Of course, things are not quite that simple or straightforward. As suggested earlier, what makes these films particularly interesting is that even their sympathetic view of China and the Chinese does not banish the swirl of contradictions and ambigui-ties, the bewildering confusions, that have repeatedly propelled the pendulum governing images of China to swing dramatically from one end point to the other. Despite a conscious, often explicit, embrace of tolerance and cultural relativism—despite, too, their idealized portrait of China—these works cannot quite banish the taboos and fears, the enduring stereotypes, that have long shadowed Ameri-can perceptions of China. Nor can they hide the intensity of their desire to erase marks of difference and assimilate the other. Significantly, it is only when the Chinese characters of these works shed their otherness—when, for example, they display virtues perceived as Christian—that they achieve their full nobility.

In this respect, it is noteworthy that even the noblest Chinese characters in these films are not free of racist stereotypes. On the contrary: idealized and stripped of human foibles, they often correspond to racial stereotypes as much as, say, an evil villain like Fu Manchu. Indeed, these positive stereotypes may be all the more striking since they are so clearly unconscious. Although, for example, Griffith clearly wants to make his protagonist as admirable as possible, he can no more resist labeling him "the yellow man"—a term that defines him solely by his race—than he can refrain from endowing him with a taste for opium or what he calls the "purple poppy." Similarly, while the Chinese protagonist of *Shadows* possesses every moral virtue, he speaks—as the subtitles suggest—in a pidgin English that immediately lessens his stature in the viewer's eye. If this aspect of these films causes us to wince today, it also suggests how deeply marks of difference were etched upon the American imagination.

Imbued with the leaden weight of long-standing images and stereotypes, the films explored here also illustrate the taboos that for decades surrounded the representation of Chinese characters, in particular the taboo against miscegenation. (An indication of the strength of this taboo is that the U.S. Supreme Court did not strike down state laws requiring separation of the races in marriage until 1967.) The presence of this taboo meant that binary categories were very much in force in portrayals of Chinese sexuality. While good Chinese men were usually seen as unsullied or pure (as in *Broken Blossoms* and *Shadows*), evil ones were sexually obsessed characters often given to perverse urges and driven by lust for white women. The portrayal of Chinese women, too, generally followed one of two opposing sexual paths. Either they were vengeful and deadly dragon ladies or they followed in the steps of Puccini's tragic heroine, Madama Butterfly, who commits suicide after her Western lover abandons her. Indeed, an early film, *The Toll of the Sea* (Chester M. Franklin, 1922), features America's leading Chinese American actress, Anna May Wong, as a kind of Chinese version of Puccini's Japanese heroine. Speaking of the unhappy fate that awaited her not only in this film—where her character throws herself into the sea at the end—but in many others, Wong once complained that "no film lovers can ever marry me. If they got an American actress to slant her eyes and eyebrows and wear a stiff black wig and dress in Chinese costume, it would be all right. But me? I am really Chinese. So I must always die in the movies, so that the white girl with the yellow hair may get the man."[4]

A cri de coeur for a career thwarted by race, Wong's lament opens upon still another taboo that for many years, governed the representation of Chinese characters—at least those in leading roles. That is, featured characters had to be played by Caucasian performers who, using layers of makeup and affecting highly conventional and artificial "Chinese" mannerisms and gestures, appeared

in yellowface. (Indeed, referring to the elaborate makeup needed to transform a Caucasian into an "Oriental," cameraman James Wong Howe apparently called whites playing Chinese roles "adhesive tape actors."[5]) Curiously, as if to hint at shades of difference, such roles were often given to foreigners—for example, to the German Austrian Louise Rainer (*The Good Earth*), the Armenian Georgian Akim Tamiroff (*The General Died at Dawn*), and the Swede Nils Asther (*The Bitter Tea of General Yen*). But the actors playing Chinese roles could not be too different—in other words, they could not be actual Chinese or Chinese American performers.

The nature of this taboo was such that while, for example, Anna May Wong played a secondary character in *Shanghai Express* and was even given an important supporting role in a low-cost Fu Manchu film, *The Daughter of the Dragon* (Franklin Lloyd Corrigan, 1931), in a decision that still rankles in the Chinese American acting community, she was denied the leading role in the prestigious production of *The Good Earth*. Judging by still another fateful casting decision, this particular taboo remained in force even decades after *The Good Earth*: for the leading role in *Kung Fu*—a 1972 pilot for a television series by that name—the producers chose not the real-life Chinese kung fu superstar Bruce Lee but the Caucasian performer David Carradine. "I guess," said a disappointed and ironic Bruce Lee, "they weren't ready for a Hopalong Wong."[6] Twenty years after that there was still another indication of this lack of readiness: in 1990 playwright David Henry Hwang—who would explicitly address this issue in his 2007 play *Yellow Face*—spearheaded the opposition to casting Caucasian performer Jonathan Pryce in the starring role of a Eurasian in the Broadway production of *Miss Saigon*.

Yellow Gentlemen: Broken Blossoms, Shadows

CHRISTIAN HEATHENS AND FORBIDDEN PASSIONS: *BROKEN BLOSSOMS*

The presence of yellowface and the fears of Chinese otherness that swirl around it are at the core of D. W. Griffith's 1919 masterpiece, *Broken Blossoms*. Based on a short story, "The Chink and the Child," by English writer Thomas Burke, *Broken Blossoms* differs from the other films explored here in that it takes place in England rather than America. Still, not only is its sentimental, moral, and philosophical landscape distinctly American, but it also announces the maelstrom of often contradictory images of China that would mark a long tradition of American films. For *Broken Blossoms* is at once a hymn to racial tolerance and a work shot through with racial stereotypes; a film that exalts a Buddhist message of love and compassion yet gives this message an unmistakable Christian cast; a

work that praises universal brotherhood yet endows its Chinese character with unalterable marks of difference. Shadowed by the taboo against miscegenation, the film features a Chinese protagonist—played in yellowface by Richard Barthelmess—who is bathed in the mixture of fear and fascination that so often swirls around the racial, and hence forbidden, other.

The question of difference is implicitly raised in the film's opening titles. In the flowery language beloved by Griffith, they announce that the film we are about to see revolves about the two poles of experience—that is, religion and sexuality—imbued with critical marks of difference. The film, we are told, recounts "a tale of temple bells, sounding at sunset before the image of Buddha; it is a tale of love and lovers, it is a tale of tears." Once the film begins, we find ourselves in China—and in the realm of religion or, as Griffith has it, "temple bells." In a peaceful and idyllic Chinese city, the film's male protagonist—referred to simply in the titles as the Yellow Man—is praying in the temple of Buddha. His most cherished dream, the titles tell us, is to take the Buddha's "glorious message of peace to the barbarous Anglo-Saxons, sons of turmoil and strife." In the next scene, the turmoil and strife of the barbarous Anglo-Saxons come vividly to life: rowdy American sailors appear in the Chinese city and begin to fight. Their violence causes the sensitive Yellow Man to shrink even as he admonishes them, saying: "Do not give blows for blows—what thou dost not want others to do to thee, do thee not to others." But the crude sailors ignore him. Convinced that the West needs to hear the words of the "gentle Buddha," the Yellow Man leaves China for the West. Soon he is settled in the fog-shrouded streets of London. There, his dreams of spreading Buddha's message among Westerners are shattered by the sordid realities of life: impoverished and despised, he is regarded as nothing more than a "chink storekeeper."

At this point, we meet a brutal Englishman who virtually incarnates the turmoil and strife of the West. He is Battling Burrows (Donald Crisp), a savage, gorilla-like prizefighter who is a coarse womanizer and a ferocious drunk. Worst of all, he is an abusive father who, in his drunken rages, beats and terrorizes his fifteen-year-old daughter, Lucy (Lillian Gish). Her "bruised little body," the titles tell us, becomes a "punching bag" for his anger and frustration. Like the Yellow Man, Lucy and her father inhabit the Limehouse district. Clearly, the gentle Yellow Man and the terrified Lucy—these two sensitive souls—are destined to meet. And indeed, one day, an exhausted Lucy faints in the Yellow Man's shop.

The fatal meeting of these two gentle creatures signals the start of what might be seen as the second part of the film—the tale of lovers and tears. An idyll of tenderness and love begins as the gentle Yellow Man, who is clearly in love with the abused young girl he has glimpsed on the streets of his neighborhood, shows Lucy a tenderness and solicitude she has never known. Enthroning her in his bed

like a princess, he showers her with gifts, flowers, and clothes. But these moments of tenderness are not long-lived. When Battling Burrows discovers Lucy's whereabouts, he rushes to drag her home even as he vents his rage on her Chinese savior: "You're with a dirty Chink," he screams. Now Lucy, fearful of her enraged father, locks herself in a closet: in a celebrated sequence, close-ups of her terrified face convey her mounting hysteria as Battling Burrows hammers at the closet door. Finally, the door yields; in the next scene, Lucy's near lifeless body is seen lying on the bed. The Yellow Man races to the side of his beloved, but he arrives too late—Lucy is already dead. In a final confrontation between the Yellow Man and Battling Burrows, the prizefighter reaches for an ax, only to be shot by the Chinese man. Now the Yellow Man tenderly carries Lucy's lifeless body to his home, where, once again, he places her in his bed; after a final prayer to Buddha, he stabs himself just as the police arrive at his door.

As the flowery titles promised at the outset, *Broken Blossoms* is indeed a tale of temple bells as well as a tale of love and lovers. And both tales, as we were also promised at the beginning, end in tears. Torn from each other, the lovers die; the gentle Yellow Man, who wanted only to spread a message of peace, is pushed to commit a terrible act of violence. But, of course, the film is much more than a combination of these two tales. Both are embedded in a far-reaching contrast between the gentleness and peace of an idealized vision of China and the violence and savagery of the West. And beneath this contrast can be glimpsed still another tale. Implicit rather than explicit, imbued with the disquieting ambiguities that haunt the murky zones of sexual difference, this second tale—unlike the film's overall message—speaks not of tolerance and cultural relativism but of a profound ethnocentrism.

The tale of love comes directly from Burke's tragic short story. Speaking of Burke, critic Alfred Kazin roots the author firmly in what he describes as the "late Victorian country of the forbidden"—a country in which, he says, "sex and retribution, sex and fear, go hand in hand"[7] No less than Burke, Griffith, too, was an inhabitant of this "Victorian country": as virtually all his films suggest, he, too, saw sex as a source of fear and retribution. But if Griffith was temperamentally attracted to what Kazin calls the "sexual landscape" of Burke's tale, he also wanted to endow this tale with a social message. In other words, in *Broken Blossoms,* he wanted to use the romantic tragedy of the English waif and the Chinese immigrant as a springboard from which to create a broad philosophical and humanitarian canvas involving the juxtaposition of two vastly different civilizations. Moreover, perhaps stung by criticism that he had proved too sympathetic to racist aspects of the Old South in *The Birth of a Nation* (1915), he was clearly determined that this canvas encompass a plea for racial tolerance and compassion.

To create this broad canvas, Griffith transformed Burke's story in important ways. He began by adding the prologue, in which the Yellow Man is seen praying in a Chinese temple. Setting the stage for the contrast between East and West that runs throughout the film, the prologue also announces two aspects of the Yellow Man's character that were totally lacking in Burke's short story: his deep spirituality and his sense of mission. In "The Chink and the Child" the Yellow Man is neither religious nor noble: he leaves China not to carry the message of Buddha to the West but for the vaguest and most fortuitous of reasons. "He had come to London," writes Burke of his protagonist, "by devious ways. He had loafed on the Bund at Shanghai. The fateful intervention of a crimp had landed him on a boat." And if he remains in London, it is for similarly vague reasons that also do nothing to add to his nobility. He stayed, says Burke, because "it cost him nothing to live there, and because he was too lazy to find a boat to take him back to Shanghai."[8]

The lazy Yellow Man of Burke's story—the Chinese drifter who loafs on the Bund in Shanghai—becomes, of course, a totally different figure in *Broken Blossoms*. Moreover, not only does Griffith ennoble the Yellow Man but he also places him at the center of the stark, all-important contrast between East and West at the heart of the film. "The refinement of the Yellow Man," writes Richard Schickel, "makes the contrast with the stupid, violent and deeply prejudiced Burrows the more vivid. He is intended as an example of Eastern virtue, and by extension, implicitly, as a living criticism of Western values."[9] What Schickel calls the "stupidity" and "violence" of Burrows is echoed—with the all-important exception of Lucy—by everything in his life. The savagery and cruelty he displays in the boxing ring are all too clearly shared by the bloodthirsty crowds that egg him on. Even the home he shares with Lucy becomes part of the contrast between what might be seen as Eastern virtue and Western vice. While the barren and ugly rooms of the fighter's home mirror the moral squalor of his life, the home of the Yellow Man—where a shrine to Buddha nestles among flowers and beloved objcts d'art—reflects a love for religion, beauty, and poetry.

In adapting Burke's story to the screen, then, Griffith turned it into a determined celebration of Chinese civilization. But the fierceness of this celebration makes it all the more telling that the film is shot through not only with racial stereotypes—witness the Yellow Man with his taste for the purple poppy—but also with many of the ambivalences and fears, the taboos and anxieties, that have long shrouded China in the America imagination. It is here, of course, that we come to the maelstrom of conflicting impulses that constitute what I have called the film's hidden tale or, to borrow a phrase from filmmaker and poet Pier Paolo Pasolini, the "film which runs beneath the film." Leading us into the deepest unconscious layers of *Broken Blossoms*, this "second" film, as it were,

testifies to a profound ethnocentrism: that is, an inability, despite the best intentions, to acknowledge the true dimensions of otherness. For in the course of this second tale, not only does the Yellow Man assume a Christian cast but he also is surrounded by the currents of fear and fascination that swirl around the racial other.

The limits and contradictions imposed by Griffith's American bias and his personal lens are not hard to see when it comes to the issue of religion. For although the Yellow Man worships at the shrine of the Buddha, he is marked by attitudes and impulses that could hardly be more Christian. Indeed, critic Seymour W. Stern describes him as "a living symbol of non-existent Christian character" who serves as "a touchstone of the tragic failure of the Western world."[10] Even the admonishing words that he utters to the rowdy sailors at the beginning of the film—"what thou dost not want others to do to thee, do thee not to others"—ring with biblical echoes. Above and beyond what he says, he is literally conceived of—and indeed sees himself—as a kind of missionary or what might be called a missionary in reverse. That is, he goes to the West for the same reasons that midwestern Methodists went to China: to convert those who had yet to see the light. If his evangelical zeal enhances his noble cast, it also testifies, of course, to a cultural bias that flies in the face of historical fact. Not only do Buddhists not, in general, share the evangelical impulse central to certain Christian sects, but it is almost inconceivable that a patrician Chinese man—imbued with a sense of tradition and family—would abandon home and loved ones in this manner. In other words, even as the film extols the virtues of an imagined Buddhism, it bears witness to the persistent memory of the lessons taught in America's Sunday schools.

But if the religion of the Yellow Man points to Griffith's American lens, so, too, does the doomed love that he feels for Lucy. It is here, in the realm of love and passion, that the strategies of displacement and denial that turned the Yellow Man into a kind of Christian become even more complex and insistent. Again, the film operates on several levels. On the surface, of course, its depiction of a tragic love between two young and sensitive souls takes us squarely into the realm of Kazin's "late Victorian country of the forbidden." Their love is forbidden for several reasons. On the one hand, as in the case of so many of Griffith's heroines, Lucy's tender age and virginal status mean that she has not yet reached the age of passion. "Once again," as Richard Schickel writes, "an innocent child-woman lives in dire fear of an animalistic older man."[11] The noble Yellow Man, of course, is not "animalistic"; that role falls to Battling Burrows. But he *is* an adult man and thus one whose sexuality is perforce seen, through a Victorian lens, as a dark and destructive force. Worse still, of course, he is a *Chinese* man. This means that their love is rendered impossible, forbidden by the

overarching taboo against miscegenation. Pointing to the strength of this taboo, Griffith banished from his film the sexual overtones that, as Gary Y. Okihiro makes clear, pervade "The Chink and the Child."[12] For example, whereas in "The Chink and the Child" Lucy collapses in an opium den—that is, in a place redolent with the whiff of sensuality and sin—in *Broken Blossoms* she faints in the Yellow Man's shop. And while Burke tells us that the Yellow Man looked at Lucy "passionately" as well as "reverently," and that "his heart was on fire," Griffith censors any overt indication of passion on the part of his Chinese hero. On the contrary, the film's titles insistently remind us that the love of the Yellow Man is "a pure and holy thing" (see fig. 2.1).

The film's overt and explicit insistence on purity seems to have convinced certain critics. For example, Richard Schickel describes the love of the Yellow Man as little more than a "genteel longing for a love he knows to be forbidden."[13] But it seems to me that Julia Lesage comes much closer to the truth when she argues that the sensual visuals of the film constantly belie or deny the overt declarations of purity voiced in the titles.[14] Indeed, I would even take this one step further: I would argue that Griffith's insistence on purity actually heightens

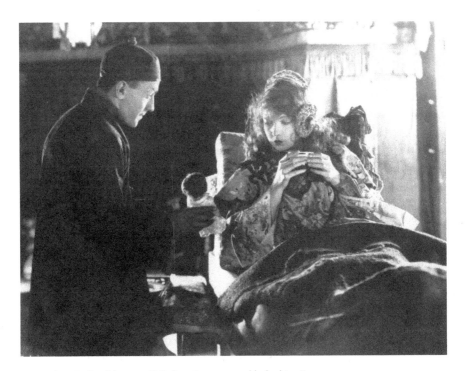

Figure 2.1. Broken Blossoms: "His love is a pure and holy thing"

the erotic charge that runs, like a film beneath a film, below the surface of *Broken Blossoms*. The titles that constantly tell us of the hero's purity inevitably remind us of what Griffith sees as its opposite: that is, a forbidden sexual passion. Both prohibited and denied, this passion makes itself felt as soon as Lucy is installed in the Yellow Man's home. Everything he does suggests that his attitude toward the young girl is less that of a tender and pure friend than that of a would-be lover. Why else would he place her in his bed and shower her with fine clothes, gifts, and his most precious treasures? When subtitles tell us that the blue-and-yellow silk robe he offers her "caresses her white skin," it does not take too much imagination to see that *he* is the one who dreams of such caresses. One scene in particular makes the true nature of his passion even clearer: here, he leans over the young girl as if to kiss her—indeed, she appears fearful for an instant—before drawing back as if in horror or dismay at his own urges. Robert G. Lee is not wrong, I think, when he writes that "the melodramatic power of *Broken Blossoms* rests on its play between three powerful taboos: pedophilia, miscegenation, and incest."[15]

Darkened by the presence of these taboos, the love of the Yellow Man underscores, of course, Griffith's Victorian fascination with the force of forbidden sexuality. But it has still another important dimension—one that takes us squarely into the realm of what critic Sander Gilman describes as the sexual "categories" that we have erected to define the racial other. Noting that we search for signs of difference (for instance, skin color, sexual structures) to distinguish the other from the "idealized self," Gilman argues that it is but a short step from these differences to what he calls "pathology." In terms of sexuality, he writes, "sexual anatomy is so important a part of self-image that the 'sexually different' is tantamount to 'pathological'—the Other is 'impaired,' 'sick,' 'diseased.'" Gilman makes the further, crucial point that this "pathology" *may be positive as well as negative*. "The 'pathological,'" he declares, "may appear as the pure, the unsullied; the sexually different as the apotheosis of beauty, the asexual or the androgynous; the racially different as highly attractive."[16]

Seen from this perspective, the nature of the Yellow Man's love for Lucy clearly constitutes a striking demonstration of one of the sexual "pathologies"—that of "unsullied purity"—used to define and categorize the racial other. Nor does this exhaust the pathological dimension of the Yellow Man's sexuality. In him, purity is accompanied by still another sexual impulse that heightens the sense of unease and otherness that surrounds him. For I would argue that the love of the Yellow Man—a love that is forbidden, constantly held in check, marked by advances and retreats—bears a distinctly masochistic dimension. Indeed, in this respect, as in so many others, Battling Burrows and the Yellow Man are a study in polar opposites: while Battling Burrows's abuse of Lucy reveals a sadism that turns

murderous, the Yellow Man's behavior is worthy of the protagonist of the tale often taken as a paradigm of masochist desire: Leopold Sacher-Masoch's novel *Venus in Furs*.

It is true, of course, that the erotic drama that unfolds in *Broken Blossoms* lacks some of the conventional accoutrements of masochism found in *Venus in Furs*. There are no furs and whips, no instruments of torture, no straps of bondage. The pure and vulnerable Lucy bears no resemblance to the cold and haughty aristocrat who, in *Venus in Furs,* dominates her lover and turns him into a groveling slave. Still, if Lucy is not an aristocrat or princess, she *is* treated like one. As if she were a queen, the Yellow Man showers her with gifts and marks of devotion. Even more important, Lucy is as *unattainable* as Sacher-Masoch's icy princess. Both her tender age and the purity of the Yellow Man dictate that the passion he feels for her remain unconsummated. As for the Yellow Man, his postures, his gifts, his humble demeanor—all these call to mind the love-struck supplicant of *Venus in Furs,* who willingly abases himself time after time at the feet of his beloved. Racked with the intensity of a love he must suppress, the Yellow Man crouches at Lucy's bedside, follows her beseechingly with his eyes, and barely dares to stand erect when he is with her.

The masochist dimension of *Broken Blossoms* may go deeper still. For it seems to me that the film exhibits some of the visual tropes and fundamental psychic impulses that French philosopher Gilles Deleuze locates at the heart of the masochist sensibility. In a well-known study of *Venus in Furs* entitled "Coldness and Cruelty," Deleuze makes the case that the best-known aspects of masochist dramas—whips and furs—are but the most obvious indications of a complex erotic matrix that includes, for example, an insistence on fetishism, theatricality, and what he calls "suspended gesture." In Deleuze's view, as Gaylyn Studlar writes, "masochism tells its story through very precisely delimited means: fantasy, disavowal, fetishism, and suspense are its formal and psychoanalytic foundations."[17]

One could hardly ask for a work that better displays these "delimited means"— and the impulses they embody—than *Broken Blossoms*. For example, the "magic robe" that the Yellow Man offers Lucy suggests the taste for fetishism that Deleuze deems fundamental to masochist desire: "there can be no masochism," he declares, "without fetishism in the primary sense."[18] Similarly, the Yellow Man's room, with its bizarre assortment of objects and its little altar to Buddha, is marked by the sense of claustrophobia and theatricality that Deleuze deems a vital aspect of the rooms imagined by Sacher-Masoch. "The settings in Masoch," observes the philosopher, "with their heavy tapestries, their cluttered intimacy, their boudoirs and closets, create a chiaroscuro where the only things that emerge are suspended gestures and suspended suffering."[19] Most important, *Broken*

Blossoms as a whole is shot through with Deleuze's heightened sense of theatricality, which is marked by the presence of "suspended gestures" and "suspended suffering."

If Deleuze ascribes a vital role to suspended gestures and suspended suffering, it is because the masochist lover (or would-be lover) can only wait, endlessly, for a sensual moment that will be forever deferred. "In masochism " writes Studlar, "the excesses of Sadian debauchery and insatiability are replaced by the heightened emotionality of suspended vignettes of suffering."[20] And if Deleuze deems theatricality essential, it is because the masochist lover denies reality even as he (re-)creates a world of his own. Such a lover, says Deleuze, "questions the validity of existing reality in order to create a pure ideal reality." These impulses, in turn, open upon the paradox at the very heart of masochist desire: that is, pleasure comes precisely from the suspension of pleasure, from a period of endless waiting characterized by the denial of reality and the deferral of pleasure. "The masochistic process of disavowal," writes Deleuze, "is so extensive that it affects sexual pleasure itself; pleasure is postponed for as long as possible and is thus disavowed. The masochist is therefore able to deny the reality of pleasure at the very point of experiencing it, in order to identify with the 'new sexless man.'"[21]

Both the disavowal of reality and the intense pleasure that comes from the endless deferral of pleasure are at the core, I think, of the Yellow Man's purity and, by extension, his sexual difference. In fact, in this last passage Deleuze might almost be describing one of the most compelling and intensely romantic scenes in *Broken Blossoms*. Marked, quite literally, by suspended gestures and by an intense theatricality, it consists of a striking pantomime. Here, as if to offer the world, and the moon, to his inamorata, the Yellow Man performs an elaborate pantomime in which he captures a moonbeam glimpsed through the window and carefully places it over the head of the sleeping, much beloved Lucy. The gesture could hardly be more poetic or romantic: with his melancholy and sensitive face, the Yellow Man seems the incarnation of every love-struck Harlequin ever seen in paintings or on stage. But, of course, the action he performs could not be more unreal. It invites us into a highly theatrical and imaginary world—the "ideal" realm of poets, of children, of those unmarked by sexuality and its discontents—far removed from the sordid real world of Battling Burrows and others of his kind. It is, in Deleuze's words, a "pure ideal reality"—a realm in which reality is denied even as sexuality is both experienced and disavowed.

This intensely poetic scene points to the sexual ambiguities and denials that run through the film and surround its protagonist. Here, reality itself disappears even as marks of difference are both denied and affirmed. Both the fascination and the threat of sexual difference are unmistakable. The Yellow Man is at once someone who burns with sexual passion and the most chaste of lovers. Just as his

Christianity is both challenged and affirmed—he is at once a heathen and a man whose words and deeds vibrate with Christian ardor—so too is his sexuality. Here, pleasure comes from the denial and disavowal of pleasure. As the Yellow Man becomes the embodiment of what Deleuze calls the "new sexless man"— the kind of ideal creature that haunts the dreams of young girls—the threat of sexual difference dissolves in an imaginary realm of "unsullied purity." As it does so, the Yellow Man loses the complex contours not only of his sexuality but also of his very being.

CHRISTIAN AMBIGUITIES: *SHADOWS*

Like *Broken Blossoms*, *Shadows*, a 1922 film directed by Tom Forman, is also based on a work of popular fiction: in this case, a short story entitled "Ching, Ching, Chinaman," by Wilbur Daniel Steele. Although it contains no hint of the sexual dramas that play out in *Broken Blossoms*, the film *does* revolve around the other mark of difference that defines Griffith's Yellow Man: religion. Clearly influenced by *Broken Blossoms* in this respect, *Shadows* also features a Chinese heathen who gives a lesson in true Christianity to intolerant and cruel Westerners. No less than Griffith's film, *Shadows* is at once a plea for tolerance, a celebration of Chinese culture and virtue, and—despite all the evidence it offers to the contrary—an affirmation of the superiority of Christianity. But here the ambiguities and unresolved tensions that hovered over *Broken Blossoms* assume a starker, more unmistakable hue. For while Griffith's Yellow Man behaves like a Christian, the Chinese protagonist of *Shadows* is actually made to become one.

In *Shadows*, the role of the Chinese heathen falls to one of the great stars of the silent screen: Lon Chaney. Indeed, if the film is remembered at all today, it is largely for Chaney's outsize presence. Known as "the man of a thousand faces," Chaney—who transformed himself into a myriad of guises through the use of carefully crafted makeup—is probably best known for the roles in which he gave life to bizarre, freakish, or afflicted characters: he played, for example, the title role in *The Hunchback of Notre Dame* (Wallace Worsley, 1923) and in *The Phantom of the Opera* (Robert Julian, 1925). On several occasions, though, he used his makeup skills to play Chinese characters: in addition to his appearance in *Shadows*, he played a small role as a Chinese gangster in *Outside the Law* (Tod Browning, 1921) as well as the leading role in a later film, *Mr. Wu*. Indeed, it is difficult to know if his appearance in yellowface was merely one more indication of his avowed taste for disguise or if it meant that the Chinese were considered as freakish as, say, the hunchback of Notre Dame or the phantom of the Paris opera. In any case, in *Shadows,* he played a creature almost as strange as the afflicted beings of other films: he was cast as Yen Sin, a Chinese man who, in the wake of a storm, is washed up on the shores of the small New England town of Urkey.

As the film opens, the townsfolk of Urkey discover the stranded Chinese man on the beach. They have gathered there to pray for those lost at sea—including a fellow villager named Daniel Gibbs. When they see Yen Sin, their reaction is one of intolerance and cruelty. Declaring that "we want no heathen in Urkey," the villagers give him a stark choice: either he must join with them in Christian prayer or he must leave. Despite this terrible welcome, Yen Sin remains in Urkey. Making his home in a houseboat, he earns his livelihood as the village's hard-working laundryman. Compassionate and kind, he is also stoic and patient in the face of schoolchildren's taunts and insults. Eventually he makes a few friends. One is the town's new minister, John Malden (Harrison Ford), who, frustrated by his failure to become a missionary in China, wants nothing more than to convert Yen Sin. Along with the minister, Yen Sin also becomes friends with the minister's new wife, the widow of the man lost at sea, and with a schoolboy who initially mocked him.

Before long, the kindhearted minister is confronted with terrible problems of his own. His friend Nate Snow (John St. Polis) brings him fearsome news: his wife's former husband, Daniel Gibbs, is still alive and—worse still—is intent on blackmailing him. Fearful of losing his wife and of sullying the life of his young baby—who would become a bastard if his marriage were not valid—the minister pays the sum requested. But his life becomes a living hell: wracked by a sense of sin because he is not legally married, he cannot go near the wife he loves and eventually has a breakdown in the pulpit. At this point, Yen Sin becomes gravely ill. When the minister begs him to confess as a Christian before dying, Yen Sin agrees on one condition: the minister—as well as his friend Nate—must also confess. Acceding to this request, the minister finally acknowledges the "sinful" life he has been forced to live. But his confession is met with a revelation on the part of Yen Sin. Through his friendship with another Chinese laundryman, Yen Sin has discovered that Gibbs is indeed dead. It was the minister's supposed friend, Nate, who—prompted by greed and desire for the minister's wife—concocted the entire plot. Upon seeing that his terrible fears were nothing but "shadows," the minister—full of fury for all that Nate has made him suffer—attempts to strangle his former friend. Only Yen Sin's intervention saves him from this terrible act.

But the drama is not quite over, for now, Yen Sin, in contrast to the distraught minister, displays true Christian forgiveness. Begging the minister to forgive the evil Nate, he solemnly promises his friend, "If you forgive, then Yen Sin believe." When the minister complies with Yen Sin's entreaty, the saintly Chinese man gives his best friend a final gift: he converts and is "saved." In an echo of the opening scenes when the townspeople gathered on the beach, the villagers assemble to watch as the dying Yen Sin sets out to sea in his houseboat. Prominent among those gathered together is the young family—the minister, his wife,

and their baby—that Yen Sin has saved from ruin. As they watch their benefactor leave their midst, the titles announce, "Yen Sin go back China way." It is the sea that will swallow him up just it was the sea that delivered him to the small town where he gave a lesson in Christianity to so-called Christians.

Although the complicated plot of *Shadows* lacks the emotional directness and narrative coherence of *Broken Blossoms,* its message is clearly the same. Once again, the virtues of an idealized Chinese man give rise to a sharp moral contrast between East and West. The lines of virtue and vice are starkly drawn. On one side of a deep moral divide we find the so-called Christian inhabitants of Urkey: mean and intolerant, they show no mercy or pity toward the shipwrecked refugee who has landed in their midst. Even the good-hearted minister exhibits moral failures: faced with blackmail, he falls into a life of deception and despair. On the other side is Yen Sin: although regarded by those around him as a heathen, he exhibits every Christian virtue: he is at once chaste and tolerant, forgiving and selfless. Without wife, family, or female companion, Yen Sin lives the solitary existence of a hermit or saint—the embodiment of absolute purity. As Alice Maurice writes, the film turns "the 'heathen' into a Christ-like savior who sacrifices himself to save the community."[22] Yen Sin is so idealized, in fact, that—in an ironic twist—major theatrical chains apparently refused to show the film. "In the 1920s," writes Michael Blake, "Orientals were nearly always played as cold-hearted villains and exhibitors felt the film-going public would not accept them in heroic roles. As a result, no major theater chain would touch [*Shadows*]. . . . It was finally distributed to smaller independent theatre houses without advance payment for a share of the profits."[23]

Focused on its chaste and virtuous protagonist, as noted earlier, *Shadows* gives no hint of the uneasy currents surrounding sexuality in *Broken Blossoms.* But when it comes to the other defining mark of difference—religion—*Shadows* is even more deeply ambiguous than *Broken Blossoms.* I say this because Yen Sin's conversion can be read in two very different—if not contradictory—ways. On the one hand—and one senses that this is the interpretation desired by the filmmaker—Yen Sin's embrace of Christianity can be seen as the logical end of someone who has always displayed true Christian virtues. On the other hand, this "salvation" can be interpreted in a very different way—one that raises fundamental questions about the missionary's ardent desire to effect his friend's conversion. After all, throughout the film, it is the heathen Yen Sin who—in total contrast to the narrow-minded and prejudiced townspeople of Urkey—has behaved with true goodness and spirituality. In light of his moral superiority, why does he need to convert to a faith that, at least in Urkey, does not appear to inspire either goodness or mercy? Seen from this perspective, isn't the minister's ferocious zeal to convert his friend simply one more example of the narrow-minded

mentality of the townsfolk? And if the minister's zeal is misplaced, what does this say about the evangelical impulse that motivates not only the minister but also all his brethren who nourished similar dreams of converting the "heathen" in China? Taking this one step further, what does it imply about Christianity itself?

To a certain extent, it is true, the ambiguities surrounding Yen Sin's conversion can be attributed to unresolved and telling differences between the film and the short story upon which it is based. This is particularly true when it comes to the all-important character of the minister. Not only does the short story take the minister (rather than Yen Sin) as its leading character, but it gives a scathing portrait of the town's spiritual leader. In the film, the minister seems weak and slightly unbalanced: quick to despair, he is also slow to forgive. But these failings are slight compared with the traits that characterize him in Steele's story. Repeatedly mocking both the man and his calling, Steele describes the minister's thwarted desire to become a China missionary thus: "Minister Malden had seen 'the field' in a day of his surging youth—seen it, and no more. He had seen it from the deck of the steamer by which he had come out.... He perceived the teeming harbor ... the fantastic, colored shorelines, the vast, dull drone of heathendom stirring in his ears, the temple gongs calling blindly to the blind."[24] Steele's irony becomes even sharper when it comes to the minister's fierce desire to redeem his friend Yen Sin. "There is more joy in heaven over one sinner," writes Steele, "was [the minister's] inspiration, his justification, and, I suspect, his blessed opiate."[25] In light of Steele's mocking tone, it is hardly surprising that the conclusion of the story is very different from that of the film. While *Shadows* concludes with an affirmation of the minister's calling—the conversion of Yen Sin—"Ching, Ching, Chinaman" closes with a scene in which the minister simply prays "for the soul of the heathen."

To some degree, then, the unresolved tensions of the film arguably reflect the uneasy amalgam of these two very different visions—that of Forman the director and of that of Steele the author. Writing for a relatively limited public, Steele was able, perhaps, to express a cynical, disabused view of the minister and of his evangelical zeal that might well have been inadmissible on-screen. But I think that the film is more than a fairly clumsy adaptation of Steele's story. That is, the tensions and ambiguities that surround the main characters and that condition our interpretation of Yen Sin's conversion bear witness to a far more general impulse. In other words, they suggest that, like *Broken Blossoms*, *Shadows* is torn between a conscious embrace of tolerance and what is certainly a much less conscious desire to assimilate the other.

As in the case of *Broken Blossoms*, this fundamental tension leads, once again, to a film that operates on two levels. On the surface, of course, *Shadows* is a plea

for tolerance: condemning the intolerance of the townspeople, it demands that Yen Sin's difference—a difference marked by his sexual purity, his pidgin English, and, above all, his rejection of Christianity—be respected. At a deeper level, it is unable to transform its plea for tolerance into a true acceptance of difference. It is this conflict that creates all the ambiguities that swirl around Yen Sin's conversion. That is, he *has* to convert not only because of the cultural arrogance that proclaims the superiority of Christianity but also because only in this way can the stigma of otherness be removed. If the Yellow Man is made to die for his difference—for his transgression in loving someone not of his race—than Yen Sin is made to become a Christian. In this respect, the ambiguities of the film echo the conflicted message embraced by many reformist missionaries: despite a new-found respect for Chinese religion and culture, missionaries continued to regard the Chinese people as potential converts to Christianity. Heathens were fine, but Christians—whatever their failings—were even better. In short, the missionary message, like that of the film, would seem to be this: we can accept heathens as long as they act like Christians and, in the end, are prepared to accept the truth of Christianity.

The Strange Cases of Frank Capra and Harold Lloyd

THE MAIDEN AND THE GENERAL: *THE BITTER TEA OF GENERAL YEN*

The uneasy tensions and suppressed emotions that run through all the films discussed thus far come out into the open in two works made little more than a decade later: Frank Capra's 1933 melodrama, *The Bitter Tea of General Yen,* and *The Cat's-Paw,* a 1934 comedy starring Harold Lloyd. (It is usually thought of as a film by Harold Lloyd although Sam Taylor received credit as director.) In some ways, the two films are very different from each other. *The Bitter Tea of General Yen* is a tragic tale of "love between the races," while *The Cat's-Paw* is a comedy in which racial prejudices and taboos are swept aside as if with a magic wand. But no less than *Broken Blossoms* and *Shadows,* both *The Bitter Tea of General Yen* and *The Cat's-Paw* involve revealing cultural collisions between East and West. Interestingly, both were initially considered "strange" or "curious"—oddities or even mishaps in the context of the larger oeuvres of Capra and Lloyd. In fact, this perceived strangeness is one of the issues that I will explore here. Did it really stem from the intrinsic qualities of both films? Or, as I think, did it reflect the fact that both portrayed China and America in a new and unaccustomed light?

In terms of film representations of China, *The Bitter Tea of General Yen* in particular is nothing less than one of the most interesting—and daring—films of its era. Based on the eponymous novel by Grace Zaring Stone, it concerns the

passionate attraction between a beautiful American missionary, Megan Davis (Barbara Stanwyck), and a Chinese warlord, General Yen (played by the charismatic star of silent Swedish cinema, Nils Asther). While it does not break the taboo prohibiting interracial sex, it does something almost as unconventional. Explicitly confronting this taboo, it explores—and, implicitly, denounces—the visceral prejudices and fears that nourish it. Underscoring the fascination exerted by the forbidden other, the film makes clear the long reach—at once psychological and social, cultural and sexual—of racial prejudice. What might be seen as the film's radical dimension goes further still. Pushing aside all the ambiguities that surrounded the missionary enterprise in a film like *Shadows*, *The Bitter Tea of General Yen* challenges the mind-set and motives of those bent on bringing the light of Christianity to the heathens of China. In so doing, it throws into question not only the missionary enterprise but also the values of the civilization from which it sprang. Far from grafting American values onto another culture, Capra's film is one of the rare works to suggest the ways in which civilizations are, in fact, truly different.

Capra's association with a deep strain of Americana has frequently prompted critics to view both *The Bitter Tea of General Yen* and *Lost Horizon*—a 1937 film that deals with the mythical utopia of Shangri-La—as anomalies in the director's oeuvre. For example, underscoring the apparent contrast between *The Bitter Tea of General Yen* and a political-realist drama like *Meet John Doe* (1941), critic Anthony Lane asks the following question: "How do you get from here [*The Bitter Tea of General Yen*] to *Meet John Doe* . . . made only eight years later? Who made the switch from opium pipe to apple pie?"[26] While various factors have been suggested to explain this switch—for example, the regulations imposed in 1934 by the implementation of the Hays Code governing the representation of sexuality on screen; the harsh realities of the Depression—I tend to agree with critic Ray Carney when he suggests that the dichotomy between what he calls Capra's "exotic" films and works like *Meet John Doe* is more apparent than real.[27] *The Bitter Tea of General Yen*, in particular, bears a striking resemblance to some of Capra's most "American" films in at least two critical respects. First, no less than, say, Capra's romantic comedy *It Happened One Night* (1934), the film depicts a man and a woman who realize only gradually how deeply they are drawn to each other. Second—and more important in the context of this study—like political dramas such as *Mr. Deeds Goes to Town* (1936) and *Mr. Smith Goes to Washington* (1939)—*The Bitter Tea of General Yen* depicts what might be deemed the education of an innocent. The lesson learned by the protagonist (the character played by Barbara Stanwyck) in the course of this education differs, of course, from that taught to the male protagonists of other films. Bearing not on politics but on matters of the heart, it raises an issue far less familiar than the corruption

of politicians—and far less certain to elicit popular support and sympathy. That is, the encounter between the young American woman and the Chinese general raises the thorny issue of American racism and its convoluted roots.

As the film opens, Megan (Barbara Stanwyck) has just arrived in Shanghai to join her fiancé, a young man who has been doing missionary work in China. Although the city is wracked by violence, a group of missionaries have assembled to welcome her to China and to celebrate her imminent wedding. (The film appears to conflate two distinct moments of historical violence: the 1931 Japanese attack on the Chinese district of Shanghai and the bitter struggles of China's ongoing civil war.) As the missionaries exchange gossip and pleasantries, they unwittingly reveal the deep sense of racial superiority and cultural arrogance that shapes their attitudes toward China. "The Chinese," declares one, "are all tricky, treacherous and immoral. I can't tell one from the other." Several recount chilling tales of Chinese barbarism: one missionary, for example, tells of merchants who were robbed and crucified by Mongolian bandits. Another appears ·to express despair about their mission: "Perhaps," he muses sadly, "we are just persistent ants trying to move a mountain."

Before the bride-to-be can digest this unsettling introduction both to China and to the missionary mind-set, her imminent marriage is disrupted by violence in the streets. Fearing that the children in a missionary orphanage are in danger, the prospective groom rushes to save them. His fiancée follows, only to be separated from him in the crowd. Amid the chaos, the young woman is rescued—spirited away?—by a handsome Chinese military man who, having glimpsed the young woman earlier, is clearly attracted to her. Her rescuer—who turns out to be none other than a powerful warlord named General Yen (Nils Asther)—takes her to his sumptuous summer palace. There, they engage in a series of revealing conversations. Forced to acknowledge her deep-seated prejudice—at one point she labels him "you yellow swine"—the young woman is also made to realize the enormity of the cultural gap that separates her from the general. When, for example, she expresses horror at the sight of prisoners being executed in the courtyard, his response could hardly be more matter-of-fact: "I have no rice to feed my prisoners," he says. "Isn't it better to shoot them quickly than to let them starve to death slowly?" While the young woman cannot understand the general's casual attitude toward his beautiful Chinese concubine, Mah-Li (Toshia Mori), the general cannot comprehend the fact that her fiancé left her on their wedding night for a group of orphans. Why, he asks, would he leave such a beautiful woman for children with "no ancestors"? (See fig. 2.2.)

Still, despite the chasm between them, the young woman is clearly fascinated by the general. Nor is this surprising: the contrast between the worldly general and her narrow-minded fiancé could hardly be more striking. While her

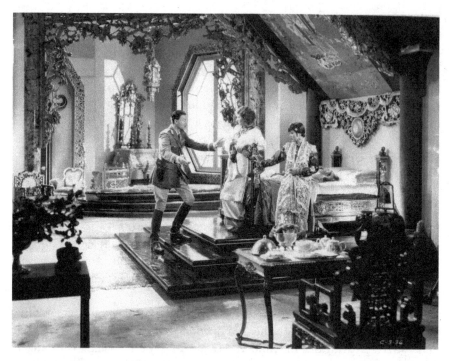

Figure 2.2. The Bitter Tea of General Yen: Megan (Barbara Stanwyck), the general (Nils Asther), and Mah-Li (Toshia Mori) in the light of day

fiancé seemed indifferent to her charms, General Yen is a man who loves women and life to the fullest. The general is not only sensual and intelligent but also endowed with a striking literary and artistic sensibility. "Have you read our poetry," he asks the young woman, "listened to our music? Seen our paintings? There has never been a people more purely artist and therefore more purely lover than the Chinese." Finally, one beautiful and moonstruck night, the young American has a dream that forces her to confront the swirl of conflicting emotions the general elicits in her. Both racially charged and vividly sensual, the dream leaves little doubt that sexuality becomes all the more insistent when it is forbidden and repressed (see fig. 2.3).

As the dream begins, General Yen appears as a sinister Oriental devil or villain who threatens to rape her. Endowed with exaggerated teeth and long fingernails, he becomes, as Joseph McBride notes, a "rapacious monster," a figure who "demonstrates the absurdity of her racist fears at the same time that he gives them visual expression."[28] Just as this loathsome figure is about to ravish her, she is saved by a masked man in European clothes—a man, writes Gina Marchetti,

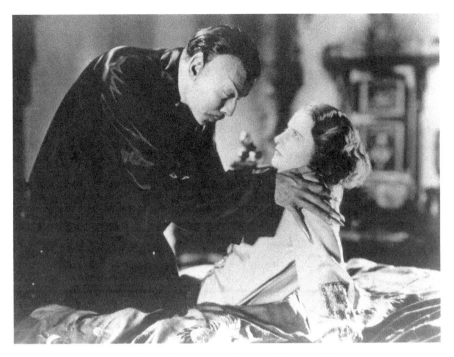

Figure 2.3. The Bitter Tea of General Yen: Megan dreams of the general

whose "dark blazer, light pants and collegiate hat make him appear ready to go off to the country club with the leading lady."[29] Salvation seems at hand: they kiss and he removes his mask. But as he does so, she discovers that—lo and behold!—he, too, is none other than General Yen. Her savior and her tormentor are one and the same person. The conclusion is inevitable: she is attracted to the general as a man but repelled by his race. If danger and evil come in the form of the Chinese would be rapist, then salvation takes the form of the lover who initially seems white. Embodied in these diametrically opposed dream figures, the currents of fear and fascination evoked by the racial other could hardly be clearer. Musing on the mix of attraction and revulsion her character experiences, actress Barbara Stanwyck observed that "any revulsion would be within herself, at least that's how I felt—'How could I be attracted? How *could* I?'"[30]

After this critical night, the young woman's behavior toward the general softens. As their lives become more intertwined, she meets the general's "financial adviser"—an unsavory and crass American adventurer played by Walter Connolly—and becomes friendly with the general's mission-educated Chinese concubine, Mah-Li. But the friendship between the two women leads to catastrophe. Megan

helps Mah-Li communicate with the latter's secret lover—a man who is working with the general's opponents. With the information Mah-Li supplies, the general's adversaries rob and destroy him. Faced with the terrible consequences of her actions, Megan—as the general predicted—is finally "converted": she realizes she has been naive and racist, provincial and foolish. The lesson has been learned all too well. Deeply chagrined and chastened, she dons Mah-Li's sexy clothes and offers herself to the general. But the general—convinced that she has not really vanquished the racial aversion she feels for him—refuses her offer. "Could General Yen accept anything," he asks, "that the heart did not fully give?" Finally, bereft, the general poisons himself with a cup of "bitter tea." As the young missionary heads back to rejoin her fiancé, she has an abstracted, dreamy, far-off look on her face.

Deeply enigmatic, the conclusion of *The Bitter Tea of General Yen* is both highly conventional and deeply unconventional. On the surface, of course, it suggests the most conventional of happy endings: that is, the young woman has emerged from her ordeal unscathed and can finally return to her fiancé. But on a deeper level, it raises a series of questions that take us into zones that are anything but conventional. To begin with, does Megan's abstracted expression and half smile mean that she is dreaming of what might have been? Or is she finally at peace now that the threat of forbidden passion has vanished? Above and beyond her emotions of the moment, we are left to wonder if she will really return to her conventional fiancé. Won't he seem even more naive and limited after her encounter with the sensual and passionate general? And if she does decide to marry him, can she possibly be happy? Will she be able to accept the self-righteous and racist mind-set of missionaries like him?

In its blend of the conventional and the unconventional, the conclusion of *The Bitter Tea of General Yen* embodies impulses vital to the film as a whole. Again and again, the film draws upon certain conventions only to transform and subvert them. It makes use, for example, of what Gina Marchetti calls "captivity" narratives. Noting that such narratives have been popular since the "first Chinese arrived in number to mine gold in California," Marchetti defines them thus: "A young, naïve woman finds herself held against her will in an alien society by a sinister, despotic Asian man. After several tests of her virtue, she is returned to her own society, and her captor dies."[31] If the odyssey of the female protagonist of *The Bitter Tea of General Yen* follows the path laid out by a captivity narrative, the presence of the general roots the film firmly in a genre that took hold in the late 1920s and 1930s: the so-called warlord genre. Indeed, in addition to *The Bitter Tea of General Yen,* at least three other films of the era—*Shanghai Express, The General Died at Dawn* (Louis Milestone, 1936), and *West of Shanghai* (John Farrow, 1937)—graft a captivity narrative onto a warlord genre. In

other words, they all feature warlords who, like General Yen, take a Western woman hostage.

In large measure, the warlord genre was triggered by historical circumstances: it reflected the rise of powerful generals, known as warlords, who headed feuding factions during China's long civil war. But it is also true that the genre struck a particular chord in the American imagination because the warlord resembled the iconic Hollywood figures of Westerns and gangster films.[32] For example, *The General Died at Dawn*—a well-known warlord film that offers an interesting point of comparison with *The Bitter Tea of General Yen*—follows the schema of many Westerns. Here, the hero—played by Gary Cooper, an actor who himself would become an iconic Western hero—incarnates a kind of exotic version of the righteous "outsider" who, in so many Westerns, comes to the aid of a suffering town or an endangered family living on the frontier. In *The General Died at Dawn*, of course, the character played by Cooper is not in the old West but in China. And the villain of the piece is not an outlaw or Indian but, rather, a brutal warlord who, played by the burly Akim Tamiroff, thinks nothing of stamping out entire villages in his quest for power. Still, the results are the same: just as Cooper conquers the outlaws terrorizing an entire town in the classic Western *High Noon* (Fred Zinneman, 1952), in *The General Died at Dawn* he triumphs over the ruthless and sadistic general. "There is no better work for an American," he proudly declares at the end of the film, "than a healthy fight for democracy" (see fig. 2.4).

If *The General Died at Dawn* illustrates how easily Hollywood genres could absorb, or be grafted onto, different cultures, it also provides a revealing contrast to *The Bitter Tea of General Yen*. Unlike *The General Died at Dawn*, *The Bitter Tea of General Yen* does not simply transpose American values onto another country; nor does it merely transfer familiar genres and tropes onto an exotic context. On the contrary, it questions American values even as it subtly subverts familiar filmic conventions. Its heroine may well be a captive. Her changed demeanor toward the general may even hint at the masochism that, in Marchetti's view, was often displayed by such characters.[33] But the crucial point is this: what makes her interesting is not the resemblance she bears to the heroines of other captivity narratives but her difference from them. In other words, she is interesting and unconventional precisely because her experience leads her to question the unthinking assumptions upon which she—and how many of her compatriots?—has built her life. Similarly, while one can scarcely argue with Marchetti's characterization of General Yen as a despot, his character, too, is very different from the brutal and sadistic warlords of other films. By describing him as just one more despotic figure, Marchetti not only flattens Capra's highly nuanced portrayal of General Yen but also gives a false impression of this tragic and charismatic figure.

Figure 2.4. The General Died at Dawn: A brave American (Gary Cooper) confronts a sadistic Chinese warlord (Akim Tamiroff)

It is true that General Yen displays certain characteristics—a world-weary fatalism, a callousness toward the value of human life, an attraction to white women—sometimes perceived or regarded as "Chinese." But he gives no hint of the taste for torture and cruelty that virtually defines the brutal warlords in films as diverse as *Shanghai Express* and *The General Died at Dawn*. Unlike them, General Yen is a man of great delicacy and erudition. He may show little regard for the feelings of his concubine, but as the film progresses, it becomes increasingly clear that he has good reason to distrust her. Above all, of course, his feelings for the young missionary could hardly be more romantic. While the warlord (played by Boris Karloff) of *West of Shanghai* cannot be bothered to pronounce the name of the white woman he desires, and the warlord of *Shanghai Express* commits a brutal rape, General Yen refuses to sleep with the woman he desires even when she offers herself to him. In true romantic fashion, it is not only her body he wants to win but also her heart and mind. Joseph McBride is, I think, absolutely correct when he describes the general as a kind of "poetic dreamer": "Despite his moments of casual savagery," writes McBride, "and despite his protective façade of cynicism . . . Capra's General Yen is overwhelm-

ingly a romantic, a sensitive and poetic dreamer, a lover of the most exquisite refinement."[34]

Nor is it only the "poetic" figure of the general that distinguishes *The Bitter Tea of General Yen* so sharply from other films of the warlord genre. It is also the moral landscape of the film. In Capra's film, the stark moral contrasts of other works—a contrast that pits a good American against an evil warlord in a film like *The General Died at Dawn*—give way to a world in which moral absolutes are consistently called into question. Here, no one is totally good or totally evil; instead, everyone—as a character in Jean Renoir's *Rules of the Game* puts it—"has his reasons." (Interestingly, the only truly despicable character in the film is the callous and cynical American who serves as the general's financial adviser.) Even the treacherous concubine—who betrays the American woman who befriends her—has *her* reasons. After all, not only does she resent her treatment at the hands of the general, but she is also very much in love with his opponent. Instead of the struggle between good and evil, then, *The Bitter Tea of General Yen* depicts a tragic confrontation between two civilizations, two perspectives on life and love.

But, significantly, in sweeping away Manichean moral divisions, *The Bitter Tea of General Yen* does not absolve America of its faults. On the contrary: precisely because the film is so subtle and nuanced, the disquieting mirror it offers of America is all the more compelling and disturbing. No one could deny that the young missionary—the very embodiment of American beliefs and values—is idealistic and well-meaning. But she is also narrow-minded and hypocritical, self-righteous and racist. The general's charge that all her virtuous sentiments are nothing but words is not misplaced. In her, Christian pieties and hollow generalities betray a lack of introspection and self-knowledge. Parochial and culture-bound, she is unable to understand the values and mores of other people and, indeed, of civilizations other than her own. Her desire to protect and trust the young concubine may be prompted by the best of motives, but in the end, her belief that the young woman must be good because she went to a mission school is not only naive but also fatal. Only when the general is destroyed does she realize the depths of her ignorance and her parochialism. Elliott Stein is right on the mark when he comments that "the theme of *Bitter Tea* is really an exotic variation on that of James' *The Ambassadors*: the education of a puritan, or the would-be converter converted."[35]

Judging by the reception of *The Bitter Tea of General Yen*, this "conversion"— and what it implied not only about the heroine but also about the moral landscape she embodies—was simply too difficult for audiences to accept. Although initial expectations for the film obviously ran high—indeed, it received a prestigious opening at the spanking-new Radio City Music Hall—it did not fare well either with critics or at the box office. Its evident virtues—striking performances,

luminous cinematography, a well-crafted story—were apparently not enough to overcome what an influential critic described as its "queer story."[36] Reflecting on the failure of the film, Barbara Stanwyck herself suggested, in an oft-cited remark, that the film's portrayal of an interracial romance was simply too shocking for the mores of the time. "The women's clubs came out very strongly against it, because the white woman was in love with the yellow man and kissed his hand."[37]

Neither the actress nor the critic was wrong. As I have suggested, *The Bitter Tea of General Yen* was both "queer" and "shocking"—although not solely for the reasons put forward by contemporary critics or by Barbara Stanwyck. Avoiding the usual black-and-white moral universe of melodrama, the film consistently thwarted both cultural and filmic expectations. Here, after all, audiences were confronted with a heroine who was not quite a heroine and a hero who was not quite a hero. Above and beyond its portrayal of complex and flawed individuals and its deeply ambiguous ending, the film also challenged broader cultural and political assumptions and conventions. On the surface, it respected the taboo against miscegenation: the heroine merely kissed the general's hand. On another level, it implicitly challenged that taboo by underscoring the depths of her passion and the extent of the racial prejudices behind that taboo. At the same time, by probing beneath the young woman's veneer of purity and idealism—by revealing the hollowness in her avowed message of universal love—the film opened upon a still wider horizon. That is, it put into question the motives and behavior of the missionaries—the "Christian soldiers"—who flocked to China in the service of God and country. And beyond the missionaries themselves lurked the specter of the self-serving idealism that has all too often darkened America's relations with other nations. In the end, it may well have been this aspect of the film—even more than the "queerness" of its story or the "shocking" nature of the love it portrayed—that rendered *The Bitter Tea of General Yen* one of Capra's very few failures.

TABOOS BEGONE! HAROLD LLOYD AND *THE CAT'S-PAW*

The Bitter Tea of General Yen was not the only film of its era to question American attitudes and prejudices in regard to the Chinese. So, too, did one of the rare comic films on a Chinese theme: *The Cat's-Paw*, a 1934 film that was produced by, and starred, one of the great comedians of the silent era, Harold Lloyd. Significantly, as suggested earlier, no less than *The Bitter Tea of General Yen*, *The Cat's-Paw* has also been deemed "queer" or "strange." Indeed, it is still regarded as little more than a curiosity or anomaly in terms of Lloyd's cinema. While Jeffrey Vance and Suzanne Lloyd consider *The Cat's-Paw* one of Lloyd's "strangest films and least typical of Lloyd or any other comedian of the early 1930s," Adam Reilly seems reluctant to even classify it as a Lloyd film. *The Cat's-Paw*, he declares,

"holds up today not so much as a Lloyd film, but as an extremely interesting amalgam of various Hollywood trends in the mid-thirties."[38]

Although, as I will show, the film is by no means as strange or as atypical of Lloyd as these remarks suggest, it does differ from Lloyd's great silent comedies of the 1920s in crucial respects. For one thing, the advent of sound meant that by 1934 Lloyd had abandoned the celebrated daredevil stunts he had performed in the famous "thrill" sequences of his silent comedies in favor of the verbal wise-cracks, cross talk, and repartee of 1930s screwball comedies. Along with this change went still another: in *The Cat's-Paw* Lloyd also abandons the role or persona that had endeared him to audiences of the preceding decade, that of the all-American boy dreaming of success. Instead, he plays a strange young man named Ezekiel Cobb who, brought up in a missionary family in China, knows nothing about his native America. The irony is—and this is the point that I will explore here—that it is precisely by playing Ezekiel Cobb, an American who could hardly be more "Chinese," that Lloyd manages to (re)affirm the very American values and ideals that prevailed in his earlier films.

As *The Cat's-Paw* opens, a small boy, Ezekiel, together with his missionary parents, is seen arriving in a little Chinese village. The film jumps ahead: Ezekiel, now grown—and played by Lloyd—is about to leave China for his parents' California hometown of Stockport. There, it is hoped, he will find a wife and return to China to perpetuate his father's mission. But things do not go as planned. Once in Stockport, the naive Ezekiel makes the unhappy discovery that his sheltered and scholarly Chinese upbringing and education—he has read the Chinese classics and is graced with exquisite manners—have ill prepared him for life in rough-and-tumble America. Amid a series of misadventures and misunderstandings, he makes two important acquaintances: one is a sassy and cynical young woman, Petunia Pratt (Una Merkel), with whom he falls in love; the other is a corrupt Irish political boss, Jake Mayo (George Barbier), who decides that the naive young man from China would make a perfect dupe (or cat's-paw) to run for mayor as a reform candidate. Mayo is sure that this odd unknown will lose to the existing mayor—a man supported by Mayo and his corrupt cronies. But fate decrees otherwise. In the course of a momentous visit to a nightclub with Miss Pratt, Ezekiel inadvertently cavorts with scantily dressed dancers and righteously stands up to the town's bullying mayor. When the people of Stockport learn of Ezekiel's adventures, they are delighted and quickly elect him their new mayor. Although Ezekiel does not want this job, he virtuously accepts his mandate: after all, as his cultivated Chinese friend, Tien Wang, tells him, he is man who knows "right from wrong."

Now, to the consternation of the corrupt Irish politicians who have long been running the town, Ezekiel begins to reform the city government in earnest. He

fires the corrupt police chief, demands legitimate bids and contracts, and abolishes sweetheart deals. To rid themselves of this zealous reformer, the old-time racketeers persuade a stripper to plant incriminating documents in Ezekiel's safe-deposit box. When the documents are discovered, Ezekiel hatches a daring plan. Citing his favorite Chinese poet, Ling Po, he solemnly declares, "If your enemy forces you over the cliff, death is sweeter if you leave with his body in your arms." Taking the law into his own hands, he has the city gangsters and racketeers rounded up and imprisoned in Tien Wang's antique shop. Surrounded by fearsome Chinese guards, the prisoners are given an ultimatum: unless they confess their crimes, they will be beheaded. When they remain stubbornly silent, one of their number is led into a back room: before long, his body is wheeled out on a gurney with his head atop his chest. The terrible deed has been done! But when the next prisoner is led into the execution chamber, we see that the supposed beheading was a magician's trick. Still, the ploy succeeds: the sight of still another headless "corpse" so frightens the prisoners that they fall over one another in their haste to confess. Ezekiel is cleared; the radio announces that he has "purged the city and smashed the corrupt regime" of the former mayor. As for Miss Pratt, she is so struck by Ezekiel's daring and his goodness that at long last she agrees to marry him. In the last scene, the newlyweds discuss their plans. Ezekiel's new wife is more than willing to go to China, but Ezekiel decides otherwise. "Stockport," he insists, "needs a missionary far more than China." As the film comes to a close, Ezekiel creates an epigram of his own: "Should the lark feed worms to the seagull," he asks, "when the baby larks are starving in their own nest?"

Like *Broken Blossoms* and *Shadows,* then, *The Cat's-Paw* is informed by a fundamental contrast between East and West—one in which an idealized image of Chinese society is a vantage point from which to criticize the West. Faced with the corruption and materialism of small-town America, Ezekiel assumes the role played by Griffith's Yellow Man: that is, he, too, becomes a kind of missionary in reverse—albeit one who is inspired less by the teachings of Buddha than by the proverbs of his favorite poet/sage, Ling Po. Of course, *The Cat's-Paw* also differs from these films in at least two critical respects. For one thing—and I will return to this issue later in this chapter—although Ezekiel may embody virtues seen as "Chinese," he is not really a Chinese man. For another, the contrast between East and West that runs throughout the film is marked, for once, not by tragedy but by comedy.

In fact, almost all of the humor of *The Cat's-Paw* comes from the cultural collisions and misunderstandings that in other films are a source of dramatic conflict or tragedy. Once he arrives in Stockport, Ezekiel becomes a kind of latter-day Candide—an innocent from China who bumbles into a highly mysterious,

and very American, world of gangsters and con men. Misreading motives and misinterpreting people, Ezekiel can barely communicate with the Americans he meets: while he is stumped by American slang, Americans look at him as if he came from another planet when he quotes from his beloved Ling Po. Cultural misunderstandings reach frantic heights in the nightclub sequence: convinced that the stripper, who first appears in a maidenly Victorian outfit, is dropping her clothes by accident, the gentlemanly Ezekiel repeatedly runs after her to pick them up until, finally, he is swept along in a line of chorus girls.

Throughout much of the film, then, the comedy springs from Ezekiel's perceptions or, rather, misperceptions of American life and mores. But toward the end, the tables are turned. Once the gangsters are imprisoned, suspense and comedy stem not from the way Ezekiel (mis)perceives America but from American perceptions and fears of the Chinese. It is here that Lloyd launches his most sustained attack—albeit a comic one—on American prejudices and stereotypes of China. After all, Ezekiel's staged threats and beheadings are so successful because they play off two constellations of closely related images. On the one hand, they hark back to ancient fears of Chinese torture and barbarism. On the other, they recall earlier film portrayals of stereotypical Chinatowns seen as exotic places of mystery and danger—of winding and narrow streets full of opium dens and tong wars, of murder and mayhem. Indeed, in a film made five years earlier, *Welcome Danger* (Clyde Bruckman, 1929), Lloyd himself had portrayed Chinatown as just such a place. Even in this earlier film, though, Lloyd gave a hint of how he would mock similar stereotypes in *The Cat's-Paw*. For before *Welcome Danger* comes to an end, we learn that, far from being Chinese, the archvillain who terrorized the inhabitants of Chinatown was, in truth, a traitorous American policeman who loved nothing better than to disguise himself as a Chinese "dragon" and drug lord.

In *The Cat's-Paw*, the comic assault on ancient fears and stereotypes adumbrated in *Welcome Danger* moves to center stage. Playing on fears of Chinese barbarism, the supremely mild-mannered and virtuous Ezekiel assumes a role calculated to strike terror into the hearts of local gangsters. Barking orders in Chinese to ferocious half-naked guards, he makes a show of sharpening the huge Chinese sword to be used in the beheadings. But clearly, even as he evokes these iconic images, he also mocks and subverts them. In the end, everything is revealed as an illusion, a magician's trick. Created with splashes of ketchup and artfully draped sheets, Chinese torture—one of the most enduring of Chinese stereotypes—is revealed as the creature of fear and prejudice. As John Belton writes, Lloyd "exploits the stereotype of the 'inscrutable' Oriental, using Chinatown as a setting for his phony executions, recounting exotic legends, using elaborate Far Eastern ceremony, speaking Chinese in order to make his bluffs more effective."[39] (See fig. 2.5.)

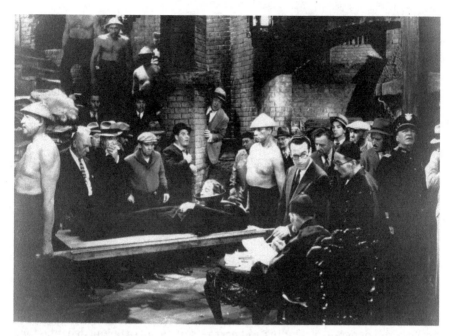

Figure 2.5. The Cat's-Paw: Ezekiel Cobb (Harold Lloyd) stages an execution in Chinatown

Even as *The Cat's-Paw* mocks Chinese stereotypes, it also plays off still another set of earlier images. That is, the film inevitably evokes earlier films by Lloyd. For although, as suggested earlier, many regard *The Cat's-Paw* as an atypical film by Lloyd, the character of Ezekiel Cobb—despite the oddness of his Chinese upbringing—bears a striking resemblance to Lloyd's earlier incarnations. Not only does Ezekiel wear Lloyd's trademark horn-rimmed glasses and tight suits, but he also displays the comedian's characteristic awkwardness and what Richard Schickel calls his "disastrous entanglements with the contraptions of modernism."[40] Most important, though—as the scene with the imprisoned gangsters makes very clear—like all of Lloyd's characters, Ezekiel, as William K. Everson puts it, is a "dreamer" until he springs into action in the last reel or so and becomes a "doer."[41] Ezekiel may not dream of success in the same way as earlier Lloyd characters, but in the end, he *is* wildly successful. He gets the girl, humiliates and conquers the villains, and rescues the town of Stockport. Indeed, his success is more sweeping than that of the all-American boys of earlier films. After all, like a hero in one of Capra's populist fables of the late 1930s, Ezekiel liberates an entire town from the forces of corruption and greed.[42] In this last respect, in particular, Ezekiel deserves the label of "national hero" that French critic Roland Lacourbe bestows on Lloyd. "Harold," writes Lacourbe, "is always

prompted by a single motive: his unchanging desire to 'succeed' in life and in the society where he evolves. This very American ideal allows the comedian to incarnate a national hero."[43]

At the same time, though, Ezekiel differs from Capra's populist heroes, and from Lloyd's earlier incarnations, in a crucial respect: he comes not from America's heartland but from the remote regions of rural China. Inevitably, this raises the following question even as it points to the true strangeness of the film. For in the end, why does Lloyd choose to transform a young man brought up in China—a man who, by education and training, is not American—into someone who becomes a very American "national hero"? Why does it fall to a Chinese gentleman to liberate the men and women of Stockport? Lastly, what does this transformation mean or suggest in terms of images of China and of America?

In large measure, the answer or possible answers to these questions bear on the sweeping historical and social changes that separate *The Cat's-Paw* from Lloyd's great comedies of the previous decade. By the time Lloyd made this film, the social landscape of his earlier films—the world of the all-American boy who realizes his dreams of success—had changed dramatically. The nightclubs and flappers of the 1920s had given way to the soup kitchens and breadlines of the Depression. Indeed, a number of critics attribute the relative weakness of Lloyd's sound films to the fact that the character he had played earlier—the average, optimistic American able to succeed by virtue of his practicality and likeableness—was not suited to bleakness of the Depression. Suggesting that the harsh realities of the era put an end to the implicit message of Lloyd's earlier films—that success was both all-important and attainable in a world of limitless possibilities—William K. Everson writes, "Audiences who were more concerned with *existing* than *succeeding* found it difficult to sympathize with a man [i.e., Lloyd] who, in the context of the times, seemed only thoughtless and selfish in pursuing personal gain."[44]

If the miseries of the Depression made Lloyd's earlier incarnations appear "thoughtless and selfish," they also affected another important aspect of his earlier films. While Lloyd's films of the 1920s were imbued with the urban breeziness of the Jazz Age, they were also shadowed by the memory of an older America—the rural America of the nineteenth century—in which dreams of easy success had not yet replaced the virtues of moral earnestness and hard work. Pointing out that Lloyd himself had come of age in this older America, Richard Schickel suggests that, whether consciously or unconsciously, his films played on the contrast between the America of his childhood and the changed world of the Jazz Age. They left no doubt, he writes, that the "the decade or so between the end of World War I and the stock market crash in 1929 was a period of contrast between the older, essentially rural America—the nineteenth-century America that had, in fact, continued to flourish at least as a repository of values for the

first two decades of this century—and the new urban America that was develop-
ing."[45] The contrast Schickel describes comes vividly to life in the film *Safety Last*
(Fred C. Newmeyer and Sam Taylor, 1923): here, Lloyd plays a young man from a
small town (the emblem of a rural, older America) who goes to a big city (the
symbol of the new, urban America) to succeed. And succeed he does—by scaling
a city skyscraper the way his forbears might have climbed a mountain in the
countryside!

A decade later, of course, both the old and the new America evoked in a film
like *Safety Last* had receded into the past. While the new and enticing urban
America of the Jazz Age had taken on the dark hue of poverty and alienation, the
vision of an idyllic, rural heartland—that is, the old America of Lloyd's childhood—
had been replaced by images of the dust bowl and the tribulations of struggling
farmers. It is precisely this shifting social landscape that does much to explain
what is the real strangeness of *The Cat's-Paw*—the fact that Lloyd chose an Amer-
ican inculcated with Chinese values as his protagonist. If by this time Lloyd could
no longer return to the vision of America evoked in *Safety Last, The Cat's-Paw*
offered him a way to retain the contrast between the old and the new America, as
well as the persona, that had served him so well in earlier years. Although by this
point the image of an older America had faded, he could, in a sense, re-create it
anew—that is, in China. Indeed, in the film, China, embodied in the upright Eze-
kiel, becomes the repository of all the values lacking in contemporary America.
In contrast with the modern Californian town of Stockport, with its brassy strip-
pers and corrupt political bosses, China represents a country where people, like
Ezekiel, continue to cherish traditional virtues.

If China, in a sense, becomes the surrogate of an older America, Ezekiel Cobb
becomes a hero able to reconcile the contrast between the old and the new seen in
a film like *Safety Last*. On the one hand, Ezekiel embodies the virtues of an older
America: raised on the teachings of Confucius and imbued with a strong sense of
right and wrong, he bears little resemblance to the all-American boys whose
dreams of success had, by the 1930s, begun to seem "thoughtless and selfish." On
the other hand, of course, he *is* wildly successful. No less than Lloyd's earlier he-
roes, he is the resourceful innocent who triumphs over the pitfalls and seductions
of the modern world. After all, as suggested earlier, what is the story of Ezekiel
Cobb if not an exotic variation on the theme of the young innocent from the
countryside who makes good in the big city. There is one last crucial point to be
made about Ezekiel's success—one that further underscores his distinctly Ameri-
can cast. When he succeeds, it is, ironically perhaps, not because of his Chinese
education and his sense of virtue. Rather, it is because, in true American fashion,
he takes the law into his own hands by rounding up the gangsters who have been
preying on the town.

But if China becomes a repository of American values, and if the virtues of a Chinese gentleman are grafted onto the average American, what happens to the real China? Or the real other? It is here that the film reveals the real meaning of its strangeness even as it adds a new dimension to the issues discussed throughout this chapter. Despite its humorous critique of Chinese stereotypes, in the end, *The Cat's-Paw* affirms American values even as it denies the very existence of otherness. On the one hand, it replaces the real China with an imaginary land that serves as the symbol of an older, rural, and virtuous America; on the other, it features a very American Chinese gentleman who succeeds in life by acting like a hero of the old West. In so doing, the film adds a grace note to the process of assimilation, discussed earlier in terms of *Broken Blossoms* and *Shadows,* of other values and races into an American landscape. In both those films, as we have seen, the Chinese protagonist loses the stigma of otherness either by acting like or, indeed, by becoming a Christian. In the most unassuming manner possible, Harold Lloyd takes this one step further: with the utmost elegance and grace, he turns China into an emblem of America even as he erases the Chinese other.

Questions of Otherness

From Opium Pipes to Apple Pie

The shift of the pendulum governing images of China has often come with astonishing speed. Still, nowhere does it take place more rapidly than in a late silent film, *Mr. Wu* (1927), directed by William Nigh. Like *Shadows*, *Mr. Wu* stars Lon Chaney: once again, the "man of a thousand faces" appears in yellowface. This time, Chaney assumes two roles: he plays both the ancient patriarch of the House of Wu as well as the patriarch's grandson. In a kind of prologue, he first appears as the ancient patriarch. Compassionate and cultured, he is the very symbol of China seen as an ancient and wise civilization. Before long, the film jumps ahead: now Chaney appears as the patriarch's grown-up grandson, Mr. Wu. At first, he, like his grandfather, symbolizes a superior civilization. A highly cultivated scholar, he is a man given to beauty and the arts, in particular, poetry and music. But by the end of the film, he has taken us from one end point of the pendulum swing to the other, from one archetype to its dramatic opposite. Before the film has come to a close, this cultivated mandarin has been transformed into a diabolical torturer (see fig. 3.1).

The transformation that takes place in Mr. Wu is sparked by the tragic fate that befalls his only offspring—a much beloved daughter. Like Madama Butterfly, the naive young woman is seduced by a handsome young Westerner who falsely promises fidelity and marriage. Once Mr. Wu learns of his daughter's disgrace, he believes that custom and honor demand that he murder his daughter for having dishonored the House of Wu. Accordingly, he performs this terrible deed. Once he does so, he is consumed by the desire to take vengeance on his daughter's faithless lover and the lover's family. To this end, he captures his daughter's seducer together with the young man's sister and mother. After placing brother and sister in separate rooms—each equipped with a peephole that allows their mother to watch—he gives their mother a terrible choice. Does she prefer that one of Mr. Wu's servants murder her son or, instead, defile her daughter? In the face of this impossible choice, the mother—distraught and hysterical—manages to stab Mr. Wu. Although dying, Mr. Wu commands his servants to

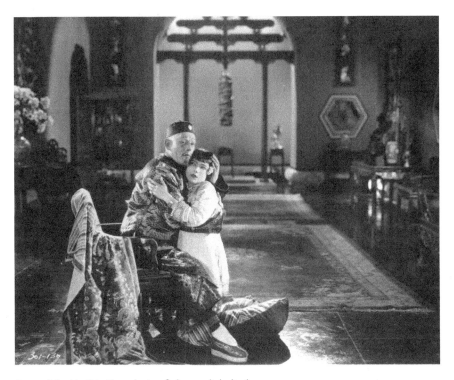

Figure 3.1. Mr. Wu: From loving father to diabolical torturer

proceed with his plan. He desists only when the ghost of his daughter appears and pleads with him to show mercy. Touched by her words, Mr. Wu has a change of heart and his captives are untouched. As he dies, his spirit leaves his body and goes off with that of his daughter.

The single character of Mr. Wu clearly bears witness to diametrically opposed archetypes of the Chinese that have long inhabited the Western imagination. Initially the most aristocratic and cosmopolitan of Chinese gentlemen, he ultimately embodies one of the most long-lived of Chinese stereotypes: that is, he reveals a taste and talent for torture that might rival that displayed by Fu Manchu. Indeed, it is perhaps no coincidence that *Mr. Wu* was made just around the time when Fu Manchu began what would be a long career in films. True, Mr. Wu is not as guilty as the evil doctor; nor is he the only guilty character in the film. After all, it is the hedonistic behavior of the young Westerner that sparks the film's tragic events. In fact, both the 1914 play that inspired the film (*Mr. Wu* by Harry M. Vernon and Harold Owen) and a 1918 novel on the same theme (*Mr. Wu* by Louise Jordan Miln) clearly blame the Westerners for the tragedy

that befalls the House of Wu. Turning Mr. Wu into the victim of the piece, they also leave no doubt that the Chinese civilization embodied in Mr. Wu is far superior to the English world of the young seducer's family.[1] But this is hardly true of the film, where moral categories are far more schematic and absolute. After witnessing Mr. Wu behead his daughter, it is the rare viewer who doubts that Mr. Wu is fundamentally, irretrievably, guilty.

The contrast between the two faces of Mr. Wu is at the heart of the present chapter. The films explored here embody the opposing archetypes that haunt the character of the mandarin-turned-torturer. The specter of the evil Mr. Wu, as well as the taboo against miscegenation evoked by his daughter's seduction, hover over two highly influential films that director Josef von Sternberg set in China, *Shanghai Express* and *The Shanghai Gesture*. In both works familiar stereotypes of Chinese dragon ladies, warlords, and half-castes engage in elaborate sexual duels amid the currents of fear and unease, of sexual ambiguity and transgression, that bathe—albeit in far cruder form—the figure of Fu Manchu. The good Mr. Wu, instead, comes to the fore in one of the most influential films ever made about China: *The Good Earth*. Based on author Pearl Buck's eponymous novel, *The Good Earth* did much to create a new set of stereotypes about China that would persist in the American imagination for decades.

Although dramatically different from each other in certain respects, these two sets of film are, as we will see, similar in others. Informed by a portrait of China that bears little resemblance to the real China of the era, they are virtually unmarked by the shattering events—the struggle for modernity, the bitter conflict between Nationalists and Communists, the ravages of Japanese aggression—that were changing the face of China at this time. Ignoring the real China of the 1930s, these films project American realities and beliefs onto a Chinese landscape. Preoccupations differ: von Sternberg's films bear witness to American sexual taboos; *The Good Earth* testifies to a missionary or Christian-inflected preoccupation with the "good life." But both define the other in terms of the self. Abandoning the cultural collisions of earlier works, these films do not use China as a yardstick by which to measure and explore American civilization. Instead, it is sameness rather than difference that holds sway. If the Chinese peasants of *The Good Earth* are noble and admirable, it is not because they are different from Americans in the manner of Griffith's Yellow Man or the stoic laundryman of *Shadows*. It is because they embody virtues seen as quintessentially American. Conversely, the most villainous characters in *Shanghai Express* and *The Shanghai Gesture* are precisely those who, transgressing the rules bearing on love between the races, are most unalterably marked as other. Either way, the characters bear witness to a fundamental inability to acknowledge, or to come to terms with, the fact of otherness. They may be at opposite ends of the pendulum, but

they all inhabit an imaginary China infused with American taboos and beliefs, mores and values.

The parabola traced by these films—one that takes us from otherness to sameness—clearly corresponds to the swing of the pendulum governing images of China that took place in the 1930s. As always, this shift was propelled by historical change. Well before the 1930s, as suggested earlier, Americans had been deeply sympathetic to China's struggle to become a modern nation—one that, it was hoped, would follow in America's footsteps. In the course of the 1930s, this sympathy only intensified as China entered a disastrous decade. The country was faced with both internal strife—Nationalist leader Chiang Kai-shek (Jiang Jieshi) battled both Communists and powerful regional warlords in his attempt to consolidate power and to unify the nation—and, beginning in 1931, Japanese aggression.

Interestingly, American support and sympathy for China came from both ends of the political spectrum, albeit for different reasons. Important left-wing intellectuals and journalists such as filmmaker Joris Ivens and journalist Agnes Smedley saw China's resistance to the Japanese as part of the antifascist struggle that was taking place around the world. On the other side of the ideological divide, those in the so-called China Lobby—a powerful lobbying group that included many in the missionary camp as well as influential conservative and journalistic figures—did everything they could to support China and, especially, its beleaguered leader, Chiang Kai-shek. Once America entered the war in the Pacific as China's ally, American friendship and support for China knew few bounds. Indeed, looking back at this period, Harold Isaacs declared that it constituted nothing less than an "Age of Admiration" for China. The "brief interlude" that stretched from 1937 to 1944, he wrote, was the only time in which "wholly sympathetic images of the Chinese dominated the entire area of American-Chinese relations."[2]

What Isaacs calls the Age of Admiration for China was both reflected in and fueled by cinema. Indeed, as we will see, the feelings of friendship and respect for China that defined this age were virtually announced by and embodied in the film *The Good Earth*. But although *The Good Earth* towered over other China-related films of the era, it was also part of a virtual explosion of films concerning China that burst upon the scene in the 1930s. Viewers could see adventure tales featuring Chinese warlords (*The General Died at Dawn*), exotic melodramas (*Shanghai Express*), stories of the villainous Fu Manchu (*Daughter of the Dragon*; *The Mask of Fu Manchu*, Charles Brabin, 1932), and sagas about the harsh existence of Chinese peasants (*Oil for the Lamps of China*, Mervyn LeRoy, 1935; *The Good Earth*). Moreover, along with feature films came travelogues, factual short subjects, and documentaries. In fact, Dorothy Jones notes that "there is a record of at least sixteen short subjects or documentaries about China made

during the 1930s—four times as many as those known to have been made during the 1920s."[3]

These films testified both to the newfound interest in China that marked the 1930s as well as to the dramatic perceptual shift of the era. The decade began with some of the most negative film images of China ever seen: that is, with a series of films featuring the Chinese villain par excellence, Fu Manchu. Created in a an era that was still marked by the anti-Chinese sentiment sparked by the Boxer Rebellion, Fu Manchu was dubbed by his creator, novelist Sax Rohmer, as nothing less than the "Yellow Peril incarnate in one man." In *The Insidious Dr. Fu-Manchu,* first published in 1913, Sax Rohmer asked his readers to imagine "all the cruel cunning of an entire Eastern race, accumulated in one giant intellect, with all the resources of science past and present. . . . Imagine that awful being, and you have a mental picture of Dr. Fu Manchu, the Yellow Peril incarnate in one man."[4] For more than four decades, from 1913 to 1959, readers all over the world eagerly consumed Rohmer's tales of the evil doctor. Noting that Rohmer's stories and novels were translated into many languages—French, German, Spanish, Italian, Dutch, Portuguese, Greek, Polish, Hungarian, Czech, Japanese, and even Arabic—Lynn Pan underscores their global impact. "The novels of Sax Rohmer," she writes, "turned Fu Manchu into a household name and distributed the stereotypes of Chinese torture, mercilessness, craftiness, and villainy across half the world."[5] (See fig. 3.2.)

In addition to novels, Fu Manchu was eventually featured in comic books, on the radio and television, and, of course, on-screen.[6] First seen on film in the 1923 British serial *The Mystery of Dr. Fu Manchu,* in 1929 he began what would be a long career in feature films with *The Mysterious Dr. Fu Manchu* (Rowland V. Lee, 1929). As on the written page, on-screen he continued to embody every negative trait—fiendish ingenuity, a taste and talent for torture, an overwhelming hatred of the West, a desire for power and conquest, an effeminate and yet sadistic sexual cast—ever associated with China.[7] Perhaps even more than the novels, the films made people feel the disturbing impulses surrounding what Robert G. Lee calls Fu Manchu's "ambiguous sexuality." Deeming the evil doctor the "archetype of the sado-masochistic Asian male character in American popular culture narratives of the twentieth century," Lee suggests that Fu Manchu's "power to incite the fevered imagination lies in his ambiguous sexuality, which combines a masochistic vulnerability marked as feminine and a sadistic aggressiveness marked as masculine."[8]

Over the years, Fu Manchu was played by a variety of actors. The first to lend his features to Fu Manchu was Warner Oland: he appeared as the sinister doctor in *The Mysterious Dr. Fu Manchu, The Return of Dr. Fu Manchu* (Rowland V. Lee, 1930), and *The Daughter of the Dragon.* But the most famous incarnation of Fu Manchu was probably that of Boris Karloff in *The Mask of Fu Manchu.* In addi-

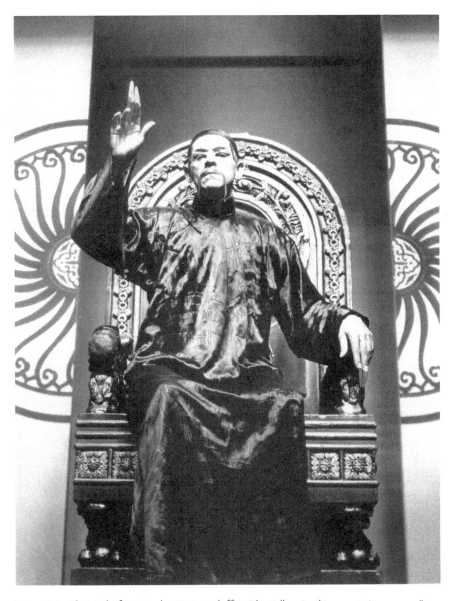

Figure 3.2. The Mask of Fu Manchu: Boris Karloff as "the Yellow Peril incarnate in one man"

tion to Karloff's performance—one that perfectly captures what Lee calls Fu
Manchu's "ambiguous sexuality"—*The Mask of Fu Manchu* is of special interest
for another reason. It draws a clear line of continuity between two powerful and
long-lasting images of the yellow peril: Fu Manchu and Genghis Khan. The plot
revolves around Fu Manchu's search for the mask and the sword of the legendary
conqueror: with them, he believes, he will be "Genghis Khan come to life"—a
mighty warrior able to lead the East to victory over the West. In the course of his
search for these artifacts, Fu Manchu finds time to create his devilish brews and
to devise ever more fiendish methods of torture: "They have ways in the East," he
tells his victims, "of shattering the strongest courage." What are probably the
strongest scenes in the film are those devoted to the horrors that take place in Fu
Manchu's so-called Garden of Torture. Here, the evil doctor clearly derives a kind
of sexual satisfaction from subjecting his hapless victims to a variety of devices
designed to inflict the "exquisite" pain and suffering associated with Chinese
methods of torture. To "shatter" their courage, Fu Manchu has them hung over
pits full of venomous snakes, placed into machines that tear them apart limb
by limb, and forced to listen to bells whose booming sounds destroy human
eardrums (see fig. 3.3).

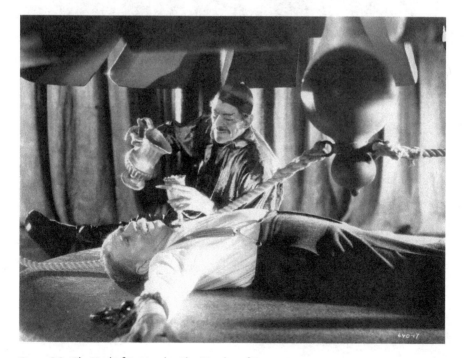

Figure 3.3. The Mask of Fu Manchu: The "Garden of Torture"

But if the 1930s began with a series of films about the "Yellow Peril incarnate," by the end of the decade, images of Fu Manchu had virtually vanished from the screen. Neither Fu Manchu with his elaborate torture chambers nor images of Genghis Khan would reappear until the dark days of the cold war. It was the rare film that, like Josef von Sternberg's 1941 *The Shanghai Gesture*, would feature the negative stereotypes that prevailed earlier in the decade. By the late 1930s, China was no longer a land of sinister villains like Fu Manchu but a country of ordinary, believable, and immensely sympathetic people like those seen in *The Good Earth*. And once America became China's ally in the Pacific, the pendulum governing images of China reached a positive point not seen before or since. Both documentaries (*China Fights Back,* 1941; *The Battle of China,* Frank Capra, 1942; *Ravaged Earth,* 1943) and feature films (*Thirty Seconds over Tokyo*; *Dragon Seed,* Jack Conway, 1944; *Objective Burma,* Raoul Walsh, 1945) celebrated China's valiant resistance to the Japanese invader even as they underscored the ties of friendship and respect linking America and China. As Dorothy Jones points out, at this time, films sympathetic to China were second in number only to films about Great Britain.[9] In this context, it is noteworthy that one film in particular—*Dragon Seed,* based on a novel by Pearl Buck and directed by Jack Conway and Harold S. Bucquet in 1944—has often been perceived as the Chinese counterpart of the pro-British family saga *Mrs. Miniver* (William Wyler, 1942). Just as *Mrs. Miniver* focused on the courage of a British family during the dark days of World War II, *Dragon Seed* portrayed the stoic endurance—and ultimately the heroic resistance—of a Chinese family confronted with the terrors and atrocities of the Japanese invasion.

As I have suggested, war films were even more unstinting in their admiration for China than those made in the late 1930s. In the film *Thirty Seconds over Tokyo*, for instance, China is no longer the eternal, unchanging land seen in *The Good Earth* but a modern country in which heroic soldiers are battling a brutal enemy. Its fighting men are not only Americans' allies but every bit Americans' equals. While the Chinese people who rise against the sadistic warlord in *The General Died at Dawn* could not prevail without the aid of the rugged and idealistic American played by Gary Cooper, in *Thirty Seconds over Tokyo* the tables are turned. Here, it is a Chinese patrol that heroically saves the lives of wounded American airmen stranded on the Chinese coast after a bombing raid over Japan. Underscoring the message of Sino-American solidarity at the heart of the film, a young Chinese doctor who cares for the wounded declares that "all up and down the China coast the people of my country are seeking those of yours . . . we'll bring them through." Not to be outdone, the pilot of the downed American plane (Van Johnson) responds in kind. Absolving the Chinese of any taint of otherness, he promises them that the Americans will

be back to fight alongside them one day because, he says, "you're our kind of people."

Perhaps an even more fervent declaration of Sino-American friendship is voiced in a documentary, *The Battle of China*, which was directed by Frank Capra and produced by the War Department as part of a propaganda series, *Why We Fight* (1942–1945). The film is built around two sets of comparisons: between China and Japan and between China and America. Not surprisingly, in the case of Japan—now seen as the embodiment of the yellow peril—the difference between the two countries is stark: while China is described as a peace-loving country that has "never waged an aggressive war," Japan is portrayed as a militaristic nation ruled by fanatic warlords intent on spreading terror and mass murder. In contrast, when it comes to America, it is not otherness and difference that hold sway but rather sameness. The commentary lists the many ways China resembles America. Asserting that China has always "believed in using the best of Western civilization," it even compares its leader, General Chiang Kai-shek, to George Washington. Never before—and certainly never after—had China seemed so American.

The Decadence of Old Shanghai: Josef von Sternberg

In light of later events it is striking to think that a film produced by the American government celebrated China in this manner. It is even more striking in light of what took place afterward—with the onset of the cold war—and what took place before. This brings us back to the negative images of China that prevailed at the beginning of the 1930s. After all, at this time, B movies like those featuring Fu Manchu were not the only ones that reveled in displaying every disturbing stereotype about China and the Chinese. So, too, albeit in a more muted but ultimately more resonant way, did a film classic by one of the acknowledged masters of American cinema: that is, director Josef von Sternberg's *Shanghai Express*. Together with *The Shanghai Gesture*, a later film that von Sternberg also set in China, *Shanghai Express* did much to fix a certain image of China—and especially of the city that Westerners referred to as "old Shanghai"—in the minds of more than one generation of viewers.

It is noteworthy, I think, that these highly influential works about China reflected the imagination of a director known for his embrace of illusion and artifice. Underscoring this aspect of his films, von Sternberg himself proudly acknowledged his disdain not only for what he called "authenticity" but for reality itself. Speaking of a late silent he directed, *Underworld* (1927), as well as *Shanghai Express*, he told film historian Kevin Brownlow: "When I made *Underworld*, I was not a gangster, nor did I know anything about gangsters. I knew nothing

about China when I made *Shanghai Express*. These are not authentic. I do not value the fetish for authenticity. . . . On the contrary, the illusion of reality is what I look for, not reality itself. There is nothing authentic about my pictures. Nothing at all."[10] Taking this one step further, he noted that he was grateful that he actually went to China—and was a passenger on the real Shanghai Express— only *after* making the film. That way, he said, reality could not impinge upon his vision of China. "I was more than pleased," he observed, "that I had delineated a China before being confronted with its vast and variegated reality. There is quite a difference between fact and fancy."[11]

As von Sternberg suggests, in both *Shanghai Express* and *The Shanghai Gesture,* the director's delight in "fancy" leads him to create a vision of China solely in accord with the dictates of his imagination. For example, to make what he called the papier-mâché China of *Shanghai Express*—"for this film," he said, "a China was built of papier-mâché and into it we placed slant-eyed men, women, and children, who seemed to relish being part of it"[12]—the director closed off a spur of the Santa Fe railroad and constructed "Chinese" towns along the tracks and converted stations near Los Angeles to "Chinese" terminals. Moreover, while the plot of Shanghai Express was apparently inspired by a "real" incident that occurred in 1923 when bandits attacked a train on its way from Shanghai to Beijing, in the film this incident is deliberately rendered "unreal": that is, it speaks less of the dangers of contemporary China than of similar episodes in, say, Hollywood Westerns.

If the dreamlike China of *Shanghai Express* and *The Shanghai Gesture* reflects von Sternberg's broad, all-encompassing disdain for "authenticity," both films are also permeated by still another intensely personal current that runs throughout the director's oeuvre. "Every cineaste," writes a pithy Herbert Weinberg, "is haunted by an obsession. Sternberg's is desire."[13] The contours of this obsession, which was shadowed by a fascination with the darkest, most unruly, and often death-haunted aspects of sexuality, were announced in *The Blue Angel* (*Der blaue Engel,* 1930), the film that first brought von Sternberg to international attention. Here, Marlene Dietrich—in the role that would launch her toward world-wide stardom—assumed the persona of the glamorous femme fatale that she would re-create in one von Sternberg film after another. As Lola-Lola, a chanteuse in a Berlin café, she first charms, and then destroys, an upright teacher (Emil Jannings) who becomes obsessed with her. It is not her fault, she sings in a famous sequence of the film, if men fall victim to her charms. "Men flutter around me," she sings, "like moths around a flame / And if they get burned then, well, I am not to blame."

Assuming a variety of guises, what has been called *la danse macabre* of *The Blue Angel* recurs in one von Sternberg film after another. This includes, certainly, both *Shanghai Express* and *The Shanghai Gesture*. But the presence in these

two films of Chinese characters and stereotypes—deadly dragon ladies, brutal warlords, and lascivious half-castes—gives the deadly dance they bring to life a special cast. Not only are the Chinese characters bathed in the ambiguous sexuality that surrounded Fu Manchu, but also they take us to the darkest zones of von Sternberg's obsession with desire—zones marked by the same impulses seen in a film like *The Mask of Fu Manchu.* That is, they are shot through with currents of sadomasochism, with the unease created by shifting gender identities, and with the fear and fascination surrounding the taboo forbidding miscegenation. In other words, although the director constantly insisted—implicitly or explicitly—that the China he re-created in Hollywood sprang from his own imagination, much of the suggestive power of both films comes from the fact that, in many ways, the director's own vision both reflected and was heightened by long-standing images and stereotypes concerning China. Characterized by a kind of luxurious *orientalisme,* the China he created is not only dreamlike and unreal; it is also permeated by images of China and the Chinese that compose a kind of collective memory bank that was firmly rooted in the popular imagination well before the director made *Shanghai Express.*

The most obvious indication of the lingering weight of earlier images lies in the realm of esthetics, that is, in the look of both *Shanghai Express* and *The Shanghai Gesture.* Like all of von Sternberg's films, both works exhibit what Susan Sontag, in an essay on camp, called von Sternberg's "outrageous aestheticism," his extravagant plastic imagination, his taste for baroque images, for dazzling décor, stylized theatricality, and carefully crafted pictorial composition. But here, that aestheticism is nourished by a kind of baroque chinoiserie: sumptuous clothing, intricate calligraphy, statues, and paintings create what Claude Ollier calls "an extremely oneiric concentrate of Asiatic exoticism."[14] Stylized motifs like gongs and Chinese characters become markers for the very notion of "Chineseness," even as China becomes, to borrow a phrase from Homay King, "a labyrinthine world teeming with inscrutable objects, concealing secrets that are irretrievably lost in translation."[15] As John Baxter observes of *Shanghai Express,* what is normally seen as background décor becomes as important as characters, plot, or action. "The opening credits with a huge gong struck," writes Baxter, "smoke wreathing over lilies and dragons, a steady hand brushing delicate calligraphy on a page, indicate that *décor* is a central factor in the film, not mere decoration but an integral part, veering vitally on the action and characters."[16]

While *Shanghai Express* is set under the sign of the sinuous curves of Chinese calligraphy, *The Shanghai Gesture* is marked by the frontal and immobile stances, the masks and disguises, of Chinese opera or even Kabuki theater. While in China, the director had been struck by a theatrical performance in which, he declared using characteristic hyperbole, the Chinese actors spoke "in a falsetto

that could only have been acquired by previous training as eunuchs" and the actors painted "their faces to resemble lifeless masks, and their efforts [went] not to achieve mobility but immobility."[17] The use of "falsetto"—if not the specter of impotence or homosexuality that it suggests—may be missing in *The Shanghai Gesture*, but there is no doubt that the measured and hieratical quality of the film owed a debt to what von Sternberg perceived as the "immobility" of Eastern theater. In the carefully choreographed world of *The Shanghai Gesture*, inanimate objects—statues, paintings, puppets—often seem to have as much life as living people. The film, to cite an eloquent John Baxter once again, "has the hieratic super-reality of Kabuki theatre. Its characters, tense, mask-faced, dressed in exotic mixtures of eastern and western styles, move like mechanical dolls across Sternberg's white-walled stage, as stiff and open to manipulation as . . . wax dolls."[18]

In addition to the look of each film, there is another overarching indication of the way the director drew upon a memory bank of shared images: that is, the very presence of Shanghai. Although neither film is set in the city—most of *Shanghai Express* takes place aboard a train, while a huge gambling casino sets the stage for *The Shanghai Gesture*—in both, the presence of Shanghai is unmistakable and fundamental. If the rich visual imagery associated with China fed the director's extravagant plastic imagination, the legendary sexual openness of "old Shanghai"—that is, Shanghai between the two world wars—nourished his fascination with the more forbidden zones of desire. The city known as the "whore of Asia" provided the perfect background for a director fascinated by the more unruly zones of gender and sexuality. Shanghai, of course, was not the only exotic locale that von Sternberg "re-created" in Hollywood. On the contrary, as Andrew Sarris writes, "as if in a dream" the director wandered through studio sets that represented one exotic locale after another: imperial Russia, China, North Africa, Spain, Austria, France, and Germany.[19] Nor was he the only director to exploit the lure and the legend of what was one of the world's most glamorous cities. The seductive image of the city was such that even films that had little or nothing to do with Shanghai for example, *The Ship from Shanghai* (Charles Brabin, 1930) and *West of Shanghai* (John Farrow, 1937)—alluded to the city in their titles. The most famous of such films is doubtlessly Orson Welles's legendary film noir thriller, *Lady from Shanghai* (1948). Although set in San Francisco, the film is careful to tell us (and thereby justify its title) that its protagonist—a deadly temptress (Rita Hayworth) who speaks Chinese and who resembles an Americanized version of a Chinese dragon lady—learned everything she knows about love in Shanghai. Even relatively recent features such as *The Painted Veil* (John Curran, 2006) and *The White Countess* (James Ivory, 2005), as well as Chinese films such as Zhang Yimou's *Shanghai Triad* (1995) suggest the continuing fascination exerted by old Shanghai.

Of all the many films dealing with old Shanghai, though, probably none did as much to fix a certain image of the city as firmly in the American imagination as *Shanghai Express* and *The Shanghai Gesture*. It was an image, of course, that reflected Western views of the city. After all, it is important to remember that Westerners and the Chinese perceived the city very differently. For the Chinese, Shanghai was not only, as Lynn Pan writes, a "unique" city[20]—a modern metropolis endowed with what writer Mao Dun famously called "light, heat and power"—but also the so-called crucible of modern China. It was there the Communist Party was born; there, too, that in 1927 Chiang Kai-shek turned on and massacred many of his former Communist comrades. For Westerners, Shanghai was less a place of history and memory than the embodiment of every fevered dream of the Orient. It is true that some Westerners—White Russians, German Jews—fled to Shanghai for political reasons while others were propelled there by ambition or the desire to flee an unsavory past. But, above all, Westerners were entranced by the city known as the "Paris of the East" because of what they perceived as the city's exoticism and decadence: its easy and seductive women, its flamboyant nightclubs and dance halls, its racetracks and opium dens.

Even today, one commentator after another resorts to overheated adjectives in describing old Shanghai. "In Shanghai's prime," announces Stella Dong at the beginning of *Shanghai: The Rise and Fall of a Decadent City,* "no city in the Orient, or the world for that matter, could compare with it."[21] Deeming the city "the strange fruit of a forced union between East and West," Dong calls it not only the world's most "depraved" city but also the "most pleasure-mad," the most "rapacious," and the most "licentious." Harriet Sergeant, author of still another study of old Shanghai, reminds us that in the years between the wars the city's reputation was such that "no world cruise was complete without a stop in the city. Its name evoked mystery, enthralled passengers with stories of the 'Whore of the Orient.' They described Chinese gangsters, nightclubs that never closed and hotels which supplied heroin on room service. . . . Long before landing, wives dreamed of the fabulous shops: husbands of half an hour in the exquisite grip of a Eurasian girl."[22]

The Shanghai described by writers like Dong and Sergeant is precisely the Shanghai that fascinated von Sternberg. The city that was perceived as licentious and depraved, the "strange fruit" of a union between East and West, provided the perfect setting for him to pursue his obsession with the more forbidden zones of desire. So, too, did old Shanghai provide the perfect background for the glamorous allure and often perverse eroticism of Marlene Dietrich. Indeed, in *Shanghai Express,* her name is inextricably linked to that of the city, for she plays Shanghai Lily, a beautiful courtesan, or "coaster," who has seduced men up and down the China coast. Sometimes called the "notorious white flower of China," she is at

once sexually available and fiercely independent. "It took more than one man," she defiantly declares, "to change my name to Shanghai Lily." Dressed in diaphanous black garments that quiver lightly as she moves, black plumes against her white face, she is as beautiful as she is dangerous. Bathed in an aura of sexual unease and ambiguity—one in which sexual roles and identities are constantly called into question—she is the very image of what Henri Agel describes as a "perverse and insensitive goddess" who rules in "insolent splendor."[23]

In *Shanghai Express,* Shanghai Lily is one of the passengers aboard a train known as the Shanghai Express, which is bound from Beijing to Shanghai. In addition to the beautiful courtesan, other important characters—all of whom are touched eventually by her "flame"—include Doc Harvey (Clive Brook) an upright British officer who was a former lover of Shanghai Lily; Henry Chang (Warner Oland), a mysterious Eurasian; and Hui Fei (Anna May Wong), a beautiful young Chinese woman who hopes to exchange her past life as a prostitute for that of a respectable wife. Not long after the trip begins, the train is stopped by rebel soldiers who, we soon learn, are commanded by none other than the soft-spoken Eurasian, Henry Chang. But this melodramatic development merely sets the stage for the erotic dramas of obsession and desire that swirl around Shanghai Lily. It turns out that two men—her former lover, Doc Harvey, and the rebel commander, Henry Chang—desire her. But for her, the choice is clear: rekindling her old romance with the British officer, Doc Harvey, she rebuffs the rebel commander. In a rage fueled by sexual frustration and wounded pride, Chang vents his anger by raping the beautiful and defenseless Chinese prostitute, Hui Fei. Nor does the drama end there. Humiliated and enraged, her future shattered, Hui Fei takes *her* revenge by stabbing and killing Chang. As the young prostitute is led off to meet her fate at the hands of justice, the two former lovers—Doc Harvey and Shanghai Lily—are left to ponder their future. Although Doc Harvey fears that Shanghai Lily betrayed him with Chang, in the end they are reconciled. As the film ends, Doc Harvey begs forgiveness from Shanghai Lily for his lack of faith in her.

In the dance of desire and death that spins us from one character to another, Marlene Dietrich's Shanghai Lily is clearly the bright star around whom the others revolve. She is so bright, in fact, that critics have tended to ignore the other characters. For example, speaking of Shanghai Lily and Doc Harvey, John Baxter suggests that despite its seemingly happy end, the film presents us with a "stock Sternberg confrontation between destroyer and victim, the two bound together by an interlocking and unexpressed desire for immolation."[24] Although this is obviously correct as far it goes, I would argue that it simplifies the complicated shapes desire assumes in this film. To begin with, what Baxter calls the "confrontation" between Shanghai Lily and Doc Harvey is decidedly not the only one in

the film. A confrontation also takes place between Shanghai Lily and Chang as well as between Chang and Hui Fei. Further, even as confrontations multiply, the roles assigned the various characters become increasingly complex. Chang is at once the victim of Shanghai Lily and the destroyer of Hui Fei. The double nature of Hui Fei's role is even clearer: the beautiful Chinese prostitute is at once Chang's victim and his destroyer.

The characters of Chang and Hui Fei do more, however, than add layers of complexity to the stock confrontation of *The Blue Angel.* They also take us to the darkest and most racially charged zones of the film, where desire is shadowed by sadomasochism, transgression, and death. It is true that the shifting and uneasy relationship between Shanghai Lily and Doc Harvey—one in which roles are slyly reversed—hints at these darker recesses: assuming a quasi-masculine persona, Shanghai Lily not only takes the sexual initiative in regard to Doc Harvey but takes his hat—and his whip!—from him. When it comes to Chang and Hui Fei, the playful role reversals and hints of sadomasochism Shanghai Lily and Doc Harvey enact take a deadly turn. While Shanghai Lily only plays with her lover's whip, Chang engages—as we will see—in acts of torture; by killing Chang, Hui Fei assumes, in the darkest possible key, the role of femme fatale played by Marlene Dietrich. In the case of Hui Fei and Chang, moreover, desire leads not to a joyful reconciliation but to rape and murder. One can debate whether Doc Harvey will eventually be destroyed by his passion for Shanghai Lily[25]; no such debate is possible when it comes to Chang and Hui Fei. Both are destroyed and immolated, to use Baxter's term, before our eyes.

Nor, of course, does the role of Chang and Hui Fei end there. Not only do these two Chinese characters (in the case of Chang, half-Chinese) take us to the darkest zones of eroticism in *Shanghai Express,* but they also suggest the ways von Sternberg gives new life to racial stereotypes by fusing them with his own erotic obsessions. This process of fusion is made very clear in the character of the young Chinese prostitute, Hui Fei. In her, the director combines two archetypal figures: Hui Fei is at once a femme fatale—albeit a faint echo of Marlene Dietrich— and one of the most enduring of Chinese stereotypes: a Chinese dragon lady. As if to underscore this merging, or fusion, the director establishes a series of intriguing parallelisms and correspondences between Shanghai Lily and Hui Fei. To begin with, as courtesans, both are shrouded in an aura of illicit sexuality and shunned by the "respectable" passengers aboard the train. Amplifying this sense of forbidden sex still further, the two women forge a friendship that has clear lesbian overtones. Most important, though, both women are seen as objects of desire by Chang. Indeed, it is because of his thwarted desire for Shanghai Lily that Chang rapes Hui Fei. And even that brutal act does not put an end to the implicit ties between the two women. By killing Chang, Hui Fei implicitly

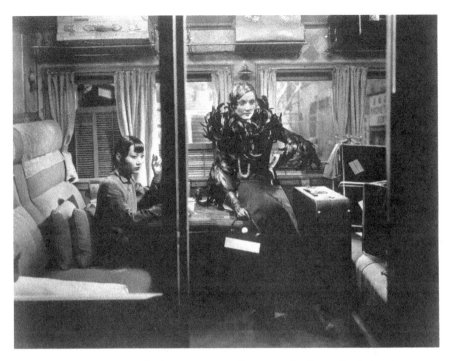

Figure 3.4. *Shanghai Express*: Archetypes meet and merge as the femme fatale (Marlene Dietrich) befriends the future dragon lady (Anna May Wong)

sacrifices herself for Shanghai Lily, the white woman who has befriended and protected her (see fig. 3.4).

For most of the film, it is true, Hui Fei remains in the shadow cast by Shanghai Lily. But once she kills Chang, she comes into her own even as she takes her place among the many Chinese dragon ladies who haunt Hollywood films. Unlike the dowager empress seen in *55 Days at Peking*—an imperious ruler who may well have given rise to this particular archetype—Hui Fei is not arrogant and power hungry. ("It is because of the empress, Tzu Hsi [Cixi]," writes Sheridan Prasso, "that we think 'Dragon Lady' in association with Asian women who wield power."[26]) Nor is she as sinister as the black-clad concubine of *The Letter* (William Wyler, 1940), who plants a dagger in her rival's heart. And, certainly, she does not display the sadism exhibited by Fu Manchu's daughter, who, in *Daughter of the Dragon,* is filled with delight at the sight of an attractive British officer being whipped. But Hui Fei resembles them all in one crucial respect. Once she is hurt and humiliated, she is consumed by a passion that the beautiful Shanghai Lily will never know, by an all-consuming desire for revenge. It is here that the

archetype of the femme fatale and that of the dragon lady, so close in many other respects, part company. While the femme fatale usually lures men to her flame with a certain insouciance—think, for example, not only of Dietrich's Lola-Lola but of the femme fatale par excellence, Carmen—dragon ladies are driven by a desire for revenge. They ask for nothing more, as Hui Fei makes clear, than to wield the assassin's knife themselves.

If Hui Fei corresponds to an important Chinese archetype or stereotype, so, too, does Henry Chang, the mysterious Eurasian turned rebel commander. Indeed, it is Chang who takes us to the heart of the erotic and racial obsessions—marked by gender instability, taboo and transgression, and currents of sadomasochism—that play themselves out in the film. In him, von Sternberg's fascination with the power struggles inherent in all sexuality merges with and is heightened by the uneasy sexuality that surrounds the Chinese other. His very being—the half-caste status that is inscribed on his body like a kind of sexual wound—points to the taboo surrounding love between the races. Stamped as irretrievably different by virtue of his "mixed race," Chang also has a strangely effeminate manner that, as in the case of Fu Manchu, seems to spring from the same soil as his cruel impulses and sadistic urges. Indeed, in a comparison between Fu Manchu and his longtime British adversary, Nayland Smith, Robert G. Lee might almost be speaking of the difference between Chang and *his* British rival, Doc Harvey. Suggesting that Fu Manchu's power "to incite the fevered imagination lies in his ambiguous sexuality," he compares the two men thus: "Fu Manchu, cruel of lip and long of fingernail, the agent of the ultimate female domination, is invariably described physically in feline and androgynous terms; Nayland Smith . . . is the imaginary archetype of the Anglo-Saxon hero: gaunt, tanned, weathered."[27]

If Chang evokes the memory of Fu Manchu, he also exhibits virtually all the traits that characterize Chinese villains. At first his soft-spoken and self-effacing manner seems to distinguish him from the brutal warlords seen in films like *West of Shanghai* or *The General Died at Dawn.* But it soon becomes clear that he shares their calm disregard for the value of human life—"you're in China," he tells his fellow passengers, "where time and life have no value"—and their lust for white women. Underscoring the ubiquitous presence of this last trait, Gary Hoppenstand gives it an added dimension when he observes that narratives about the yellow peril were always dominated by "the threat of rape, the rape of white society."[28] Above all, Chang displays a sadistic streak worthy of Fu Manchu. For example, when he learns that a Western hostage who insulted his half-caste status is an opium dealer, he calmly punishes the man by having him branded with a red-hot iron. The link between, on the one hand, Chang's twisted sexual nature and his deadly pride and, on the other, his cruel and sadistic urges

becomes even clearer when in a fit of jealous rage, Chang threatens to blind his successful rival, Doc Harvey. One has to wonder: does he really want to blind his rival? Isn't it rather that he wants to castrate him? To render Doc Harvey as impotent as he feels—or fears—himself to be? And what is his rape of Hui Fei if not a further indication of sexual humiliation and unease? (See fig. 3.5.)

Shadowed by sexual unease and transgression, Chang is, fittingly, at the center of what is arguably the most important dramatic confrontation of the film, which takes place between him and Shanghai Lily. Although the relationship between Shanghai Lily and Doc Harvey is usually considered the most important in the film, it seems to me that the affair between Shanghai Lily and the unknowing and hapless British officer pales beside her deadly encounter with the brutal and twisted Chang. Only Chang can provide a dramatic counterfoil to the charming coaster; only he can match her in cunning and intelligence. Seen from this perspective, it makes perfect sense that not only is Chang ultimately destroyed (albeit indirectly) by the passion he feels for Shanghai Lily, but he is killed by a woman who in some ways acts as a reflecting double for the beautiful cour-

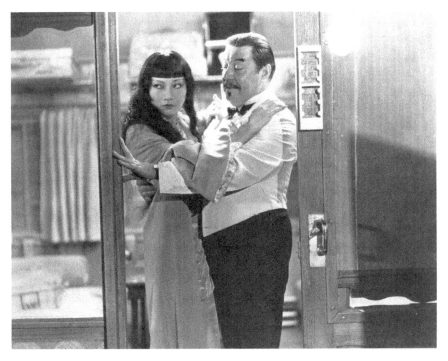

Figure 3.5. Shanghai Express: The warped warlord Henry Chang (Warner Oland) prepares to vent his rage on Hui Fei (Anna May Wong)

tesan. No less than the pitiful teacher of *The Blue Angel,* Chang is immolated by the flame of von Sternberg's most famous femme fatale. But unlike that earlier victim, Chang is destroyed, at least in large part, because of his racial—and hence sexual—difference.

By the time von Sternberg made his second film set in China, *The Shanghai Gesture,* the world had changed radically. Japanese bombs had destroyed old Shanghai; the Chinese had become America's cherished allies in the Pacific. But none of this seemed to matter to von Sternberg. Never before had his indifference to "authenticity" and "timely" topics been so marked. In *The Shanghai Gesture,* not only did he amplify the web of uneasy sexual and racial impulses seen in *Shanghai Express,* but he also moved the Chinese archetypes of that earlier film to center stage. In large measure, it was a move made possible by the absence of Marlene Dietrich, whose collaboration with the director had come to an end a few years earlier. Instead of being dominated by a single femme fatale, *The Shanghai Gesture* features a kind of quartet: a British officer, two half-caste figures (male and female), and an imperious Chinese dragon lady. If each character underscores the dangers of love between the races, he or she adds still another layer to the swirl of sexual ambiguities seen in *Shanghai Express.* At the same time, all serve as a reminder that the presence of the racial archetypes embodied in Hui Fei and Henry Chang was as intrinsic to the director's imaginary China as the image of eunuchs that came to him when he attended a theatrical performance in Shanghai.

Even as von Sternberg moved his Chinese characters to the foreground of *The Shanghai Gesture,* so, too, did he amplify the trove of images associated with old Shanghai. The aura of decadence surrounding the legendary city is in fact announced in the opening titles. "Years ago," they tell us, "a speck was torn away from the mystery of China and became Shanghai. A distorted mirror of problems that beset the world today, it grew into a refuge for people who wished to live between the lines of laws and customs—a modern Tower of Babel. . . . Its destiny, at present, is in the lap of the Gods." The principal set of the film—a huge gambling casino—places the decadent pleasures of old Shanghai constantly before our eyes. Patronized by rootless people from every corner of the globe, the casino—deemed a "maelstrom of iniquity" by Herbert Weinberg[29]—embodies the frenzied search for pleasure and wealth associated with the city known as the "whore of the Orient." Frequently shot from above, its cavernous pit suggests one of Dante's infernal circles. Indeed, its hellish nature is made clear in one of the earliest scenes in the film: here, a desperate gambler attempts to kill himself by jumping from the higher reaches of the casino into the gaming pit below.

The hallucinatory set of *The Shanghai Gesture* may well stem from von Sternberg's memory of a so-called pleasure palace he visited in Shanghai and de-

scribed at length in his autobiography.[30] The film's narrative, instead, was based largely on an eponymous 1926 play—revived on Broadway in 2009—by John Colton. (Colton is probably best known for his stage adaptation of *Rain,* W. Somerset Maugham's steamy tale of a lust-obsessed missionary and a beautiful prostitute in the South Pacific.) Well before von Sternberg began work on his film, several proposed film adaptations of Colton's sensational play, which was set in a brothel rather than a gambling casino, had been rejected by the monitors of the Hays Office. By toning down the racier aspects of the play, von Sternberg created a script that passed muster with the censors. Thus, in the film, Colton's brothel becomes a gambling casino; the name of the madam is changed from Mother God Damn to Mother Gin Sling. (One scene of the film does hint at the original brothel setting: seemingly naked girls are seen swinging high in the air in the furthest reaches of the gambling hall.) But as we will see, these changes are far less important than those that stem not from fear of the censors but from the recesses of von Sternberg's erotic imagination. Weaving his own obsessions into Colton's tale of love and revenge, the director created new characters and altered others in ways that amplified some of the darkest and most racially charged sexual zones seen earlier in *Shanghai Express.*

At the center of the film stands one of the fiercest dragon ladies in screen history: the owner of the gambling casino, Mother Gin Sling (Ona Munson). Icy and forbidding, with trailing robes and elaborate hair ornaments, she rules over a thriving empire. In the words of one habitué of the casino, she is the "most cold hearted dragon you'll ever meet . . . [who] will devour you like the cat the mouse." As if she were a real monarch, her every entrance is announced by the sound of ominous gongs. Her power extends even to the omnipotent Westerners who govern Shanghai: that is, she carefully ferrets out their most shameful secrets so that she can wield the threat of blackmail over them. As the film progresses, though, we learn that Mother Gin Sling has not always enjoyed the position of wealth and power she occupies today. Although born a "Manchu princess," in her youth she met the same unhappy fate as Madama Butterfly: she, too, fell in love with a treacherous Westerner who abandoned her when she became pregnant. Worse still, her lover took her fortune, ferreted away the child she bore him, and sold her into a life of prostitution. Turned into a virtual slave, she was forced to cater to sailors up and down the Chinese coast. Although that life has been behind her for many years, Mother Gin Sling has never ceased to nourish hope of revenge.

Before long, she learns that this long-held hope might soon be realized. Her faithless Western lover—now a British official named Sir Guy Charteris (Walter Huston)—has returned to Shanghai. Plotting her revenge, she invites him and other Western notables to a dinner celebrating the Chinese New Year—a time, she says, when Chinese "people pay their debts." Indeed, in the course of the dinner,

she shames Charteris by revealing his unsavory past to one and all. Charteris, in turn, has a terrible surprise for her. He tells her Poppy (Gene Tierney)—a hysterical young woman who has been haunting the casino and having a dissolute affair with a mysterious Eurasian named Dr. Omar (Victor Mature)—is the daughter they had together so many years ago. Deeply disturbed by Poppy's wanton behavior, Mother Gin Sling confronts the young woman; when Poppy learns that she is a half-caste, she unleashes a racist diatribe at the Chinese mother she cannot abide: "You'd be the last mother I'd pick," she screams. "I have no more connection with you than with a toad in the street." As Poppy utters these terrible words, Mother Gin Sling takes out a gun and shoots her. In the last sequence of the film, Charteris, bowed down by grief at the death of his beloved daughter, is seen leaving the gambling hall. As he steps into the streets, in a final touch of irony, a New Year's merrymaker asks him, "Likeee Chinese New Year?"

Like *Shanghai Express*, *The Shanghai Gesture* tells a melodramatic tale of desire and death. But the *danse macabre* it portrays is even more complex than that which unfolds in *Shanghai Express*. Weaving between past and present, *The Shanghai Gesture* presents us with two deadly confrontations. One—between Mother Gin Sling and Sir Guy Charteris—is rooted in the past; the second—between Poppy and the mysterious Dr. Omar—unfolds before our eyes. Both underscore von Sternberg's fascination with the unstable zones of sexuality and gender. While the first deadly dance is dominated by a dragon lady with a powerful masculine cast, the second features a man—Dr. Omar—with traits usually perceived as feminine. At the same time, both reveal the ways in which racial stereotypes and taboos work to heighten the unease provoked by gender instabilities. As we will see, the two most unsavory characters featured in these confrontations—Dr. Omar and Poppy—are half-caste products of East and West. Bathed in the taboo surrounding love between the races, in their moral and sexual corruption they are reminders of the consequences and dangers of miscegenation.

In these confrontations, no figure is more important than the character von Sternberg invented for the film: Poppy's lover, the half-caste Levantine named Dr. Omar. One of the most complex and interesting characters in von Sternberg's cinema, in certain ways Dr. Omar evokes the figure of Henry Chang, the rebel commander of *Shanghai Express*. True, Dr. Omar gives off a whiff of Arab sensuality that speaks more of the North African world of von Sternberg's *Morocco* (1930) than it does of the war-torn China of *Shanghai Express*. Dressed in a cape and fez, given to spouting verses by the Persian poet Omar Khayyám, he evokes images of harems and eunuchs, of sexual delights unknown in the West. But in more fundamental ways he resembles Chang. For example, he exhibits Chang's cruelty and cunning—in his own words, he is a man who "cheats at everything

except cards." Most important, he, too, is a half-caste figure—his mother, he says, was half-French, and the other half was lost in the sands of times—in whom "tainted blood" seems to have nourished a twisted form of sexuality. Strangely effeminate and subtly sadistic, he lures Poppy into an affair that is both excessive and yet immune to feeling, voluptuous and cold. And just as Poppy exploits the love and solicitude her father feels for her, Dr. Omar exploits the sexual dependency he arouses in her.

But if Dr. Omar exhibits the sadistic streak associated with Chang, he also displays Shanghai Lily's irresistible sexual magnetism. He is as "fatal" as any femme fatale. As sexually irresistible as Dietrich, he shares her taste for extravagant costumes, her amorality, and, finally, her androgynous cast. "The 'femme fatale' who clothed her bewitching carnality in all climates," writes Henri Agel, "has become in *The Shanghai Gesture* a fatal man, and androgynous as well."[31] No less than Lola-Lola or even Shanghai Lily, Dr. Omar is more desired than desiring, indifferent to the sufferings of those, like Poppy, singed by his flame. Once Poppy falls under his spell, she is doomed to follow the same path taken by the upright teacher of *The Blue Angel*—a path that leads to humiliation, degradation, and death. Indeed, the resemblance between the "fatal woman" and the "fatal man" is so strong that Ado Kyrou calls *The Shanghai Gesture* "a Marlene [Dietrich] film. One feels her presence . . . she is Gene Tierney, a woman down to the tip of her disheveled locks, and she is also Victor Mature, the man Sternberg himself. This doctor Omar . . . has Marlene's lascivious poses, her great cruelty, her voluptuousness."[32]

What Kyrou calls Omar/Dietrich's "lascivious poses" and "great cruelty" are on display in what is probably one of the most striking—and most disturbing—scenes of the film. Here, like the poor middle-aged schoolteacher in *The Blue Angel*, Poppy degrades and humiliates herself before her lover. The scene begins when Poppy—frantic with jealousy and passion—tracks Dr. Omar to his home and furiously beats on the door until he is obliged to let her in. Once he opens the door, it is clear that he is as bored by her hysteria as he is untouched by her passion and her beauty. In the midst of her outbursts, he lies back sensually on the cushions of his couch as if to display the very charms that have destroyed the young woman. Stretched out like one of Goya's *majas*, he impassively observes the agony of his latest victim. It is he who might be la femme fatale and Poppy the sex-starved and desperate lover burned by his/her flame (see fig. 3.6).

Of course, if Dr. Omar resembles Dietrich in his sensuality and his cruelty, in at least one crucial respect, the fatal woman and the fatal man—at least, *this* particular fatal man—are very different from each other. Although generally overlooked by critics, this difference—which bears on both gender and race—is arguably a crucial one. For however ambiguous and deadly, Marlene's sexuality—bathed

Figure 3.6. The Shanghai Gesture: Two half-castes—Poppy (Gene Tierney) and Dr. Omar (Victor Mature)—engage in a *danse macabre*

in a playful and self-knowing irony—is fascinating and exciting. One can well understand why men fall victim to her flame. When it comes to Dr. Omar, however, it is hard to fathom why Poppy is obsessed with her indifferent lover. In total contrast to Dietrich's presence, that of Dr. Omar, as Henri Agel points out in an eloquent passage, repulses far more than it fascinates. Observing that the an-

drogynous figure of Dr. Omar bears the "oily and animal face of Victor Mature," Agel compares what he calls the "rotten grandeur" of Dr. Omar and his surroundings to that which emanates from Baudelaire's *Flowers of Evil*. "The sumptuous decomposition," writes Agel, "of a décor infused with Byzantium, asphyxiating us with all the sweat and enervating scenes that accompany it, is perfectly suited to ... this species of human fauna."[33]

But it is not only Dr. Omar who is rotten. So, too, is Poppy, the woman who loves him. Indeed, if one needed further confirmation of the link between "mixed blood" and uneasy sexuality, one has only to look at the young woman who is so obsessed with the so-called poet of Gomorrah. In her moral and sexual obsessions, Poppy provides still another illustration of the racial stereotypes that inhabit the film. Despite her luminous beauty and vulnerability—traits that would normally awaken the viewer's sympathy—Poppy is barely less repulsive than Dr. Omar. Rarely has a Hollywood film cast a beautiful woman in such a disturbing light. It is true that, unlike the Poppy of Colton's play, in the film she is neither an opium addict—although her name hints at this particular addiction—nor an overt nymphomaniac. But she *is* addicted to alcohol, gambling, and, of course, sex. Moreover, she abuses these stimulants with a ferocious, self-destructive intensity that pulls her ever deeper into a masochistic maelstrom of jealousy and self-degradation. When, in her final frenzied outburst, she turns on the father who has cared for her with tenderness and love, there can be no doubt that her very blood—the blood of a half-caste—is tainted. Mother Gin Sling does not exaggerate when she tells Sir Guy, "Your daughter is no good for anything. Her soul is hollow, her blood is no good, and her emotions are cheap. She has no honor" (see fig. 3.7).

There is, finally, one last indication of the racial bias and stereotypes that permeate the film. This time, it comes from an unlikely source: von Sternberg's portrayal of Sir Guy Charteris. Unlike the other characters, Charteris is neither Chinese nor of "mixed blood": on the contrary, as the British official determined to clean up Shanghai, he is the very embodiment not only of the Anglo-Saxon race but also of the imperial powers that have subjugated China. Significantly, in the play—but not, as we will see, in the film—the political resonance of Charteris's role does not prevent Colton from portraying the archetypal Englishman as the blackest of villains. Indeed, in the play Charteris may be more rotten than anyone else. To underscore his villainy, Colton gives Mother Gin Sling a long speech in which she recounts the sufferings she endured because of her faithless lover. Not only did Charteris sell her into slavery and prostitution—where she was at the mercy of the cruelest of "masters"[34]—but also, she tells us, he stole both her daughter and her fortune from her. By the time she finishes her litany of horrors, the audience sympathizes full well with her hatred for the faithless Englishman and with her burning desire for revenge.

Figure 3.7. The Shanghai Gesture: "Her blood is no good," says Mother Gin Sling (Ona Munson) of her daughter, Poppy

It is precisely Colton's unsparing portrait of Sir Guy Charteris that is changed dramatically in the film. For one thing, in the film, his character—the very picture of arrogance in the play—is played by an immensely sympathetic and fatherly Walter Huston. For another, on-screen, he counters Madame Gin Sling's version of the past with *his* narrative of the life-altering events that occurred years earlier. And, significantly, it is a narrative that is as psychologically improbable as it is ideologically revealing. For he tells us that he knew nothing of the terrible fate that awaited his lover when she left his life. Far from robbing her of her fortune and selling her into slavery, he insists, he placed her money in a special account so that she could retrieve it upon her return. As if these far-fetched explanations were not enough to win our sympathy for his character, Charteris is also portrayed as the most loving of fathers. Indeed, while the play concludes with scenes of a distraught Mother God Damn keening over her daughter's dead body, the end of the film is dominated by Sir Guy's heartfelt grief. By the

end of the film, Colton's imperial scoundrel—the man who embodies the Western rape of China—has become a man who evokes not our censure but our deepest compassion.

In the end, the grief that overwhelms Sir Guy as the film draws to a close gives him one last measure of redemption for the "sin" he committed in breaking the taboo against love between the races. But no similar redemption is possible for Madame Gin Sling, the Chinese woman he loved so many years ago. As a Chinese dragon lady consumed by the desire for revenge, Mother Gin Sling stands outside the charmed circle—marked by morality, humanity, and redemption—that surrounds the bereft Englishman. No less than her half-caste daughter and the detestable Dr. Omar, she, too—as she says of Poppy—is "without honor." In underscoring the chasm that divides Poppy's unhappy parents from each other, von Sternberg gives us a last reminder of the unbridgeable racial divide that structures and informs the film. For Madame Gin Sling, this most arrogant of Chinese others, there is no possible redemption—no way to lose the stigma conferred by difference.

Our Neighbors, Ourselves: The Good Earth

Even in light of von Sternberg's avowed blindness to history and politics, the 1941 release of *The Shanghai Gesture* was striking. It is not only that the film says nothing about the war that was raging in the Pacific. It is also that by this time, a dramatic swing of the pendulum governing images of China had turned visions of vengeful dragon ladies and corrupt warlords into anachronistic relics of a past that seemed increasingly remote with every passing day. The yellow peril was still alive and well, but now, in the aftermath of Pearl Harbor and the outbreak of war, it was the Japanese who embodied all Americans' fears about the Asian other. As for the Chinese, they had become our friends, our neighbors, our relatives. America had entered what Harold Isaacs deems the Age of Admiration with a vengeance.

It is no coincidence that Isaacs cites 1937 as the year that marked the beginning of this "brief interlude"—one in which the Chinese were viewed not only as good guys but as some of the best guys in the world. For that year saw the appearance of the film *The Good Earth,* which did much to create the intensely positive image of China that would prevail for much of the next decade. Indeed, it is difficult to overstate the important role both the novel and the film version of *The Good Earth* played in fueling the Age of Admiration toward China and in reshaping American attitudes toward that country. Both novel and film were enormously successful. Published in 1931, the novel was one of the most famous best

sellers in the history of American fiction: translated into more than thirty languages, it sold more than two million copies. (The fact that it was chosen for Oprah's book club in 2004 suggests that it has not lost its appeal.) Critical success, too, was not lacking. *The Good Earth* won a Pulitzer Prize in 1932 and, along with Buck's biographies of her missionary parents (*The Exile* and *The Fighting Angel*), contributed to the Nobel Prize that she was accorded six years later for, as the Nobel citation read, "rich and genuine epic portrayals of Chinese peasant life and for masterpieces of biography."

The novel's success was matched by that of the film. Seen by an estimated audience of twenty-three million people in America and by forty-two million viewers around the world, it also received an enthusiastic critical welcome. "MGM," enthused the critic for the *New York Times*, "once again . . . enriched the screen with a superb translation of a literary classic"; *Time* magazine deemed *The Good Earth* a "real cinema epic"—a film destined to "rank as one of the great pictures of all time."[35] Nominated in five categories for an Oscar, the film won for Best Actress (Luise Rainer) and Best Cinematography (Karl Freund). Its vast audience meant that the film had an even greater impact on American perceptions of China than the novel did. "It is probably safe to say," declares Dorothy Jones, "that this motion picture, more than any other single book or document or film, has been responsible for shaping the ideas and images held about China, not only in our own country but throughout the world."[36]

Turning Pearl Buck into America's leading "China expert," book and film together created images of China that still linger in the American imagination. Rarely, in fact, has a single work so influenced the way the people of one country viewed those of another. "It is safe to say," declares historian James C. Thomson Jr. of Buck, that "no non-Chinese writer in history since Marco Polo (in the thirteenth century) had such an influence on so many millions of people on the subject of China."[37] More than twenty years after the release of the film, when Harold Isaacs interviewed Americans concerning their views of China, he noted that, in the minds of many, China *was* the land they had read about in *The Good Earth* or seen in the film—a vast land of brave and courageous peasants, of "wonderfully attractive people," of "solid, simple, courageous folk staunchly coping with the blows of fate and adverse circumstance."[38] "It can almost be said," he concluded, "that for a whole generation of Americans [Buck] 'created' the Chinese, in the same sense that Dickens 'created' for so many of us the people who lived in the slums of Victorian England."[39]

Although, as we will see, the film transforms the novel in several crucial respects, both novel and film trace the life of a central figure: a stoic, resourceful, hardworking Chinese peasant farmer named Wang Lung. As *The Good Earth* begins, Wang Lung is about to marry a young woman, O-lan, who has been work-

ing as a domestic slave in the powerful House of Hwang. At first, all goes well for the young couple. O-lan turns out to be the best of wives: she caters to Wang Lung's querulous father, works alongside her husband in the fields, cooks excellent food, and bears him three male children. The farm—the good earth—responds to their industry and hard work with abundant harvests. But then Wang Lung and his family face a series of near biblical trials and tribulations: famine forces them to leave the farm and take refuge in the city; a terrifying plague of locusts threatens the farm; jealous frictions threaten to tear the family apart when Wang Lung takes a concubine or second wife, Lotus. But through it all, their devotion to the land never ceases. Ultimately, their devotion is rewarded: they make a prosperous life for themselves and their progeny.

Even this brief summary suggests one of the reasons behind the enormous success and resonance of *The Good Earth*—its timing. For if von Sternberg's portrait of old Shanghai in *The Shanghai Gesture* was as "untimely" as one could imagine, *The Good Earth* could hardly have been more in tune with the tenor of the era—both at home and abroad. On the domestic front, the harsh realities of the Depression had rendered Americans particularly receptive to a tale of suffering, endurance, and eventual triumph. From an international perspective, news of Japanese aggression in China had heightened American sympathies for Buck's beleaguered and stoic peasants. By the time the film, in particular, was released, it was not hard to make the connection between Wang Lung and O-lan's fight for survival and the struggles of ordinary Chinese people as they confronted civil war and foreign invasion. The fictional characters seen on-screen became the emblem, the embodiment, of millions of suffering Chinese. Fueling America's growing admiration for the stoicism and heroism of the Chinese people, the film interacted with history in a profound way. While contemporary events added to the sense of realism and authenticity the film conveyed, the screen images of *The Good Earth,* in turn, gave a name and a face to contemporary victims of Japanese aggression. "Millions of Americans," writes Thomson, "knew whom the Japanese tanks and planes were slaughtering—it was Wang Lung, O-lan, and all the rest."[40]

There is no doubt, then, that the timing of *The Good Earth* was crucial. But timing alone does not explain its enormous success. Striking a distinctly new note in respect to films about China, *The Good Earth* left the world of noble Buddhist scholars and poetic and world-weary generals behind for one of ordinary, believable people who were, in their very familiarity and humanity, immensely appealing. Their trials and tribulations, concerns and preoccupations, were rooted in the everyday world of home and family: they worried about their livelihood, about the future of their children, and about the burden of difficult relatives. To heighten this sense of realism, long sequences focused on the fabric of ordinary

life: harvesting crops, worshipping ancestors, celebrating births and marriages. Even practices that might have appeared exotic to a foreign eye were embedded in a familiar context. For example, when Wang Lung takes a second wife, his actions speak less of seductive concubines than of a familiar male midlife crisis. "I can recall no novel," declared the reviewer for the *New Statesman and Nation,* "that frees the ordinary, flesh-and-blood everyday Chinaman so satisfyingly from those screens and veils and mirrors of artistic and poetic convention which nearly always make him . . . a flat and unsubstantial figure of a pale-coloured ballet."[41]

In addition to Buck's portrait of flesh-and-blood Chinese people, many critics hailed the novel for what they felt was its universal cast. *The Good Earth,* declared the critic for the *New York Times Book Review,* was "less a comment upon life in China than upon the meaning and tragedy of life as it is lived in any age in any quarter of the globe. Notwithstanding the essential differences in manners and traditions, one tends to forget, after the first few pages, that the persons of the story are Chinese and hence foreign."[42] If the reviewer for the *New York Times Book Review* forgot the characters were Chinese, critic Helen MacAfee, writing in the *Yale Review,* suggested that they resembled one's relatives and friends. Despite their ignorance and poverty, said MacAfee, Wang Lung and his family "behave very much like our first cousins—struggling, enduring, puzzling over the meaning of things, seizing what they can of the common prizes of existence."[43] In an oft-cited remark, noted critic Carl Van Doren went even further: "*The Good Earth,*" he declared, "for the first time made the Chinese seem as familiar as neighbors. Pearl Buck has added to American fiction one of its larger provinces."[44]

Still, amid the chorus of praise that greeted the novel, there *were* some dissenting voices. Significantly, these voices were those of Chinese (and in one case Korean) critics. Admittedly, they did not represent a majority of critical opinion in China: on the contrary, as Michael Hunt points out in an article entitled "Pearl Buck: Popular Expert on China," most Chinese critics felt that "the work was all the more impressive because it came from the pen of a foreigner and all the more welcome because it projected abroad a new and more attractive image of their country."[45] But the dissenting voices were those of highly respected men and women. Most important, the passage of time has rendered the issues they raised all the more compelling. For at the heart of their remarks lay the sense that Buck's characters were, indeed, too "familiar"—that is, too American. While American critics like Carl Van Doren praised Buck for making the Chinese seem like "neighbors," these critics complained that the writer—despite the fact that she had grown up in China as the daughter of American missionaries—approached China as an outsider or, as Sophia Chen Zen put it, a "foreigner."

These remarks were made in an important 1931 review of *The Good Earth*. Here, the Chinese critic took Buck to task for the ways the novelist reduced the complicated realities of "organic social life" to what she called a simplistic "moral pattern." Arguing that Buck "always keeps herself apart from the nation of which she writes, and never becomes a part of it," she declared that "the result of this aloofness is that nearly all her characters . . . are types and not individuals."[46] So, too, did Younghill Kang (an expatriate Korean writer) underscore Buck's "foreignness." In his view, Buck's "misunderstanding" of Confucian realities made her resemble "someone trying to write a story of the European Middle Ages without understanding the rudiments of chivalric standards and the institution of Christianity. None of her major descriptions is correct except in minor details."[47] But perhaps the most wounding criticism of this nature came from a man for whom Buck felt deep admiration: Lu Xun, one of the giants of modern Chinese literature. "It is always better," the writer declared, "for Chinese to write about Chinese subject matters, as that is the only way to get close to the truth. It is no exception with someone like Mrs. Buck . . . who regards China as her own motherland. Her books, after all, reveal no more than the position of an American woman missionary who happens to have grown up in China."[48]

To some degree, these harsh opinions—which remained controversial for many years[49]—doubtlessly reflected political considerations and loyalties. Those on the left of the political spectrum were dismayed by Buck's refusal to acknowledge the importance of politics and ideology—in particular, the realities of class struggle and of the ravages of imperialism. Those on the right were upset by her focus on common peasants and on what were seen as the "darker" aspects of Chinese life—that is, her unsparing portrait not only of famine and poverty but also of practices such as infanticide and the presence of concubines. Still, above and beyond political concerns, hindsight has made it clear that at least some of Buck's detractors were circling around an issue of great contemporary concern—one that runs throughout the pages of this book. At the heart of their remarks lay the sense that Buck erased not only the concrete realities of Chinese life but also the essential otherness of her Chinese protagonists. Even Harold Isaacs, who clearly welcomed Buck's glowing portrait of her Chinese protagonists, wondered whether *The Good Earth* destroyed one set of stereotypes (those bearing on Genghis Khan and his faceless hordes of heathens) only to create another: that of "the Noble Chinese Peasant, solid, wonderful, virtuous, admirable."[50]

Isaacs wrote those words more than a half century ago. But his remarks—like those of the dissenting voices of the 1930s—foreshadow the seismic critical shift that has taken place in regard to *The Good Earth*. If, in the 1930s, the perceived "universality" of *The Good Earth* was deemed praiseworthy, it is that very same quality that, to the contemporary eye, hints not only at American paternalism

but also at a refusal to acknowledge the other. Our era is one that agrees with Zhang Longxi when he writes that "it is time that the Other was recognized as truly Other, that is, the Other in its own Otherness."[51] It is precisely Buck's refusal to let the other be "truly Other" that in the eyes of contemporary critics constitutes a major failing of *The Good Earth*. For example, one of the most eloquent of such critics, Michael Hunt, argues that *The Good Earth* rendered China easily accessible to a large popular audience only by "ignoring the broad cultural context which distinguished Wang Lung's life from that of the Nebraska farmer." By neglecting "what made China complex and the Chinese different from Americans," he declared, Buck's work erased vital differences even as it "helped sustain an unfortunate ethnocentrism."[52]

In many ways, I would not argue with Hunt. Buck *does* ignore what he calls the "broad cultural context" surrounding her characters as well as the factors that "made the Chinese different from Americans." Yet I wonder if the pendulum of critical reactions has not swung too far. If Buck tends to view Chinese realities through an American lens, it is nonetheless difficult to think that someone who was truly a "foreigner"—who had neither Buck's intimate knowledge of Chinese mores and customs nor her love of China and the Chinese—could have written *The Good Earth*. She may not have been, as she once famously remarked, half Chinese. "By birth and ancestry I am American," she declared, "by choice and belief I am a Christian; but, by the years of my life, by sympathy and feeling, I am Chinese."[53] Still, throughout her life, her love of and devotion to China never faltered. After graduating from college in America, together with her first husband, John Lossing Buck, she went back to China as a missionary. Like many progressive missionaries in the decades following World War I, they devoted themselves to humanitarian efforts: she worked as a teacher while her husband served as an agricultural expert helping peasants in rural areas. While she cut her ties to the missionary establishment around the time she published *The Good Earth*,[54] she never ceased to campaign in support of the Chinese people even as she worked to build bridges between America and China. A fierce opponent of the notorious exclusion laws, during World War II she worked for China War Relief and later helped established two adoption agencies involving Amerasian children. Referring to Buck's many activities, Lian Xi writes that her "great cause" was not the evangelization of the world but rather, the "development of understanding between East and West so that peoples of different races could live in peace and mutual respect."[55]

In terms of this "great cause," of course, nothing else Buck did was as influential or resonant as *The Good Earth*; no other book "taught" Americans as much about China as did her epic of Wang Lung and his family. Yet as her Chinese critics sensed at the time—and as American scholars have made clear in recent

years—the lessons of *The Good Earth* were deeply ambiguous. Informed by a pull between Buck's two selves, in some ways *The Good Earth* testifies to a sensibility at war with itself. Some of the tensions felt in the book clearly stemmed from Buck's missionary background. For example, on the one hand, the novel revealed her scorn for what she saw as the "pure intolerance" and "blind certainty," as well as the cultural arrogance and bigotry that characterized traditional missionaries like her stern and forbidding father.[56] This scorn is underscored in a brief—but striking—scene in *The Good Earth*. It begins when the protagonist of the novel, Wang Lung, is accosted by a tall, strange, blue-eyed foreigner who hands him a picture that, to the uncomprehending peasant, offers the curious sight of a lifeless man hung upon a crosspiece of wood. Baffled by the strange image, Wang Lung hands it to his wife, O-lan. She, too, finds it baffling but in good wifely fashion puts it to good use: she uses it to reinforce the sole of a shoe. Thus, even as the picture of the crucified Christ is sewn into the sole of a peasant's shoe, Buck evokes the futile zeal and cultural blindness of missionaries like her father—men and women unable to fathom the chasm that separated them from those they wished to convert.

And, yet, if a scene such as this leaves no doubt about Buck's attitude toward missionary zeal, the novel *is* undeniably permeated by a deeply religious sensibility. For one thing, as Paul Doyle observes, its very language rings with biblical echoes. For another, it is structured around the kind of parable—informed by a struggle between vice and virtue—beloved in America's Sunday schools.[57] (In the novel, the war between these moral absolutes is traced through the juxtaposed fortunes of two families: that of the virtuous Wang Lung and O-lan and that of the vice-ridden and powerful House of Hwang.) Moreover, the presence of this parable opens upon still another tension or paradox. That is, despite the fact that Buck wanted to teach Americans about the real China that she knew and loved, the use of parable—or what critic Sophia Zen Chen deemed a "moral pattern"—meant that the story did not engage with the dramatic historical and political events (the invasion of the Japanese, the presence of the Western powers, the struggle between Communists and Nationalists) of the era. In other words, in order to make everything fit into this moral "pattern," or parable, not only did the novel flatten psychology by turning people into moral "types" but, also, as Mari Yoshihara notes, it avoided the mention of anything that would locate the action in a specific time or place.[58] In this sense, rather than giving Americans a picture of contemporary China, *The Good Earth* came perilously close to embracing a stereotype of that country that has long haunted the Western imagination: that of an eternal and unchanging China, or what Zhang Longxi describes as a "site of space stubbornly inaccessible to the revolution of time."[59] Describing Western images of this eternal China, philosopher Michel Foucault might almost

be speaking of *The Good Earth*. "In our traditional imagery," he writes, "the Chinese culture is the most meticulous, the most rigidly ordered, the one most deaf to temporal events, most attached to the pure delineation of space; we think of it as a civilization of dikes and dams beneath the eternal face of the sky; we see it, spread and frozen, over the entire surface of a continent surrounded by walls."[60]

Yet even this is a simplification. For if *The Good Earth* seemed to embrace this "frozen" China in its refusal to engage with the tangled web of modern Chinese history, in at least one important respect, it raised an issue crucial to its era: the emancipation of Chinese women. Its portrait of the ceaseless sufferings endured by Wang Lung's wife, O-lan, is nothing less than an implicit indictment of the age-old oppression suffered by Chinese women under an unforgiving patriarchal system. Not only did this indictment take the novel out of the world of parable and into that of history, but it also could hardly have been more in tune with the tenor of the times. Chinese reformers struggling to create a modern country believed that female emancipation was vital if China were to escape from the shadow of its feudal past. Indeed, this was a central theme of contemporary political and social film melodramas. Again and again, Chinese films of the era reflected the terrible plight, the impossible choices, faced by women of all social classes. Buck's peasant protagonist may be very different from the "modern" women seen in film classics such *The Goddess* (*Shennu*; Wu Yonggang, 1934) and *New Woman* (*Xin nuxing*; Cai Chusheng, 1934).[61] Still, her plight is no less touching—and no less indicative of a fundamentally unjust social order.

To a contemporary eye, Buck's deeply felt indictment of female oppression constitutes one of the most interesting aspects of the novel. Not only does it raise issues that are (alas) still pressing in many parts of the world but, also, it gives the novel a personal dimension. After all, Buck was no stranger to patriarchal rigidity and injustice: she had witnessed both firsthand at home and in her encounters with the missionary—and, perhaps, the literary—establishment. (One wonders how she felt about Lu Xun's condescending remark that she was not only a "missionary who had grown up in China" but, worse still, a "*woman* missionary"!) (Emphasis added.) Indeed, a later work, *Dragon Seed*—a 1942 novel made into a 1944 film—leaves no doubt about the importance this issue held for her. While the problem of female emancipation is pushed into the melancholy background of *The Good Earth*, it is at the very center of this later saga of a Chinese family confronted with the brutalities and deprivations of life during the Japanese occupation. For the protagonist of *Dragon Seed* is a young woman who, in sharp contrast to O-lan, eventually frees herself from the age-old social constraints inherent in her role as wife and mother.

Above and beyond its personal dimension and historical resonance, moreover, Buck's compelling portrait of female oppression is of interest in this study

for another reason. That is, despite its important role in the novel, it is virtually absent from the film version of *The Good Earth*. And if, in its historical and personal dimension, the plight of O-lan constitutes one of the most striking aspects of the novel, its absence in the film is equally striking—although, of course, for very different reasons. It points to the issue I would like to consider in the remaining pages of this chapter: the stark differences between the novel and the film. For although the filmmakers insisted on their fidelity to Buck's work—in fact, the trailer for the film showed potential viewers a page from *The Good Earth* even as it promised them "just as you read it . . . so will you see it"—in truth, the two were very different. The erasure of Buck's portrait of female oppression is but one of the most telling indications of a far broader landscape of change. Erasing Buck's harsh indictment of female oppression, the film gives little hint of the swirl of competing images—a belief in virtue versus a dark view of human nature, a scorn for missionary zeal versus a deeply Christian worldview, an ardent love of China versus a refusal to acknowledge that country's struggle for modernity—that constitutes one of the most interesting aspects of the novel. Not only does the film erase the religious dimensions of the novel, but it replaces the worlds of both history and parable with the kind of sentimental realm featured in countless Hollywood films. Wiping away any trace of Buck's Chinese "self," the film amplifies, instead, the constellation of American beliefs and values that were implicit—although in a far less pronounced way—in the novel. In so doing, it does nothing less than turn China into one of America's "larger provinces," even as it completes the transformation of Buck's farmers into "Nebraska farmers."

Well before the film entered production, in fact, two well-known and revealing remarks by Irving Thalberg, the legendary MGM producer responsible for *The Good Earth,* hinted at how this transformation would be effected. One remark was made in the course of an exchange between Thalberg and Louis B. Mayer, the powerful head of MGM. It seems that when Thalberg first broached the idea of the film to Mayer, the studio head objected to the project on the grounds that the American public was not interested in farmers, still less in Chinese farmers. In response to this objection, the producer explained that the film would not really be about farmers. Rather, he said, it would be a romance of the sort that audiences loved. "It's the story," he insisted, "of how a man marries a woman he has never seen before and how they live a life of intense loyalty."[62] His second remark—made to the film's director, Sidney Franklin—was equally revealing.[63] Thalberg spoke of the qualities that he deemed essential for a so-called prestige production like *The Good Earth*. In addition to the presence of stars and superior production values (cinematography, art direction, costumes), Thalberg felt that such a film had also to contain one visually spectacular sequence. "Every film of

major importance," declared the producer, "must have one great sequence from the standpoint of the camera, in acting and story, in light and shadow, in sound and fury."[64]

If *The Good Earth* had to conform to the values Thalberg deemed intrinsic to a prestige production, the nature of the film—the fact that it was based on an acclaimed novel and would clearly have an impact on perceptions of China—meant that he and Mayer were not the only ones who felt they had a stake in the finished film. Author Pearl Buck, as well as the Chinese government, also weighed in with *their* concerns. The involvement of the Chinese government dated back to 1933, when the original director of the film, George Hill, led a small crew to China to locate props and shoot background footage. At that time, MGM signed a highly unusual formal agreement with the Chinese government outlining several very general guidelines for the film. It was agreed, for example, that the film would present a "truthful and pleasant picture of China and her people"; that MGM would accept the suggestions of a Chinese supervisor whenever possible; and that a Chinese censor would examine all footage taken by MGM in China. Chinese officials also made their views known concerning an issue as important as it was controversial: they expressed the hope that—defying long-standing casting taboos—the film would cast Chinese actors in leading roles.[65]

Like the Chinese government, author Pearl Buck was also concerned about the shape the film would assume. She and the Chinese government disagreed on an important issue: while the government urged the directors to present "a pleasant picture of China and her people"—one that would avoid indications of Chinese poverty and backwardness—Buck urged as much authenticity as possible. She went so far as to write a letter to an MGM executive in August of 1932 urging that the film crew visit China in the spring or autumn so that they could film an authentic—that is, an actual—harvest in process.[66] "Pearl," observed a friend of the novelist, "wants the shots to be absolutely authentic, as she knows them. The Chinese officials, who give out the permits, will lose much face here and abroad unless everyone, down to the last extra, is in new clothes and the buildings are freshly painted."[67] But if Buck wanted a far "truer" portrait of China than was palatable to Chinese officials, she agreed wholeheartedly with them on one crucial point: she too wanted Chinese performers to play the leading roles in the film. Indeed, as she notes in her autobiography, the sight of American actors in an earlier stage production of *The Good Earth* had firmly convinced her "that it was impossible for Americans to portray the parts of Chinese with any reality."[68]

Thalberg, clearly, could not satisfy all these different—and in some ways conflicting—constituencies. He did give the Chinese government an immensely sympathetic (if not always pleasant) portrait of their country. And to a limited extent—and one not unusual in "prestige" productions—he satisfied Buck's de-

mand for "authenticity." That is, the producer went to great lengths to find "authentic" costumes and props: his biographer, Roland Flamini, tells us that Thalberg imported "tons of artifacts from China: everything from teak furniture to bone needles and opium pipes."[69] (It seems that Chinese peasants apparently dubbed the film's property man "crazy" because, to their amazement, he eagerly took their oldest and most worn household goods in exchange for new ones.[70]) The film's lavish budget also meant that Thalberg could have a "real" Chinese landscape re-created in America. Thus, the set representing the Wang family farm, which was built in the San Fernando Valley north of Los Angeles, included not only an imported well, rice paddies, and a real water buffalo, but also a section of the Great Wall hovering in the distance.[71]

But what of the hope, nourished by both Buck and the Chinese government, that the film's "authenticity" extend to the presence of actual Chinese faces on-screen? Thalberg, of course, could not satisfy this request. To do so would have meant breaking the rule that such roles be played by Caucasian performers—a rule that was particularly stringent in the case of an expensive production like *The Good Earth*. "I was told," wrote a disappointed Buck in her autobiography, "that our American audiences demand American stars."[72] This "demand," as Buck puts it, still rankles among Asian American performers. In *Hollywood Chinese,* a 2008 documentary by Arthur Dong, one interviewee after another laments the fact that the leading role of O-lan fell not to Anna May Wong—America's leading performer of Chinese descent—but to a Caucasian foreigner: that is, German Austrian actress Luise Rainer.

Much has been said and written about the casting of Luise Rainer and Paul Muni in the leading roles of O-lan and Wang Lung. Critical opinion is dramatically divided. Although Buck felt that Paul Muni was "simply wrong" in the part of Wang Lung, she had nothing but praise for Luise Rainer. "None of the white actors are really good," she wrote, "except Rainer and the old rascally uncle." In her view, Rainer gave such a "perfect performance that it is incredible she isn't Chinese."[73] At the other end of the critical spectrum, in recent years Robert Gottlieb has declared flatly that "Rainer is ludicrous as O-lan. Indeed, the whole movie is ridiculous."[74] Not everyone, I think, would find Rainer "ridiculous." Still, it is hard to think that anyone—much less Buck herself—could be convinced that Rainer is, indeed, Chinese. No amount of makeup or "Chinese" mannerisms can disguise the fact that we are watching a Caucasian performer in yellowface. Indeed, to my mind, Rainer's "Chinese" mannerisms bring her performance to the brink of stereotype.

Even in the novel, as Chinese critics sensed so long ago, the characters had a stereotypical cast. Rigidly ensconced in a world of "moral patterns," they are seen less as individuals—marked by flaws and redeeming qualities, by quirks as

well as contradictions—than as moral beings easily defined by a few traits: thus, Wang Lung is courageous and indomitable; O-lan, patient and faithful. Still, reading the novel, it is easy to imagine individual Chinese characters—each with his or her own appearance and bearing, speech patterns and mannerisms. No similar transforming effect of the imagination is possible when the eye is greeted by the sight of Western performers on-screen. Played by the irrepressible Paul Muni, Wang Lung takes on the actor's unmistakable voice and inflections, as well as his energy and enthusiasm. Indeed, even the critic of the *New York Times,* who was generally rapturous about the film, felt that Muni fell "out of his Chinese character . . . talking, walking, reacting more as Muni than as Wang Lung."[75] Similarly, a number of secondary characters—for example, Wang Lung's cranky father (Charles Grapewin) and his jealous and greedy uncle (Walter Connolly)— are played by Hollywood character actors more suited to other kinds of films (such as, say, the Westerns of John Ford) than to a saga about Chinese farmers.

In the end, though, the sight of Western performers heavily made up to resemble Chinese peasants is but the most obvious indication of the American lens, or what Michael Hunt calls the "ethnographic bias," that pervades the film. For beginning with the "good earth" itself—that is, the land—the film is infused with American beliefs and values. To say that the land holds a special place in American minds and hearts is not to deny that Chinese peasants like Wang Lung treasured their corner of the good earth. (Indeed, progressive missionaries like Buck and her first husband were convinced that issues related to the land held the key to winning the sympathies of China's desperately poor peasants.) However, it is to say that the land enjoys a profound resonance in the American imagination. The image of indomitable settlers settling the frontier or working the land is certainly central to one of the nation's founding myths. During the Depression of the 1930s, this myth assumed a renewed urgency: at a time of widespread poverty and homelessness, a time when banks failed and jobs disappeared, when the devastation of the dust bowl turned hardworking farmers into migrant Okies, "it was not certain," as Carl Van Doren puts it, "that anything but the land remained."[76]

As the harsh realities of the Depression gave new meaning to the land, the trials and tribulations of farmers began to constitute what Peter Conn calls a "special subject of fiction."[77] *The Good Earth* may have been the only fictional work that featured Chinese farmers. But the sufferings Wang Lung endured are not very different from those confronting American farmers in novels such as *Tobacco Road* and *The Grapes of Wrath*. Along with works such as these, as Karen Janis Leong points out, the era witnessed the resurgence of a fictional genre, in vogue at the turn of the century, that also dealt with farmers and the land—what she calls the "frontier novel."[78] This "special subject" made itself felt not only in

novels but also in the world of photography—in *Let Us Now Praise Famous Men,* writer James Agee and photographer Walker Evans worked together to create a "photographic and verbal record of the daily living and environment of an average white family of tenant farmers"—as well as that of cinema. In addition to *The Good Earth, Our Daily Bread* (King Vidor, 1934), *Gone with the Wind* (Victor Fleming, 1939), and *The Grapes of Wrath* (John Ford, 1940) all stressed what Conn describes as the "suffering and endurance" of those who worked the soil.

But in no work of the era, perhaps, does the land have a deeper resonance, a more complex moral and mythological aura, than in *The Good Earth.* Here, the land is far more than a source of livelihood, a treasured asset to be defended through stoic struggle and toil. It is also part of a long-lived American mythology that pits the virtues of a simple life—that is, a life lived close to the land—against the perceived dangers and decadence of the city. There is no doubt that this mythology, as Michael Hunt observes, had a deep existential appeal for Buck. The novelist, he writes, "had seen the effects of industrialization and rapid urbanization in both the United States and China and concluded that rural life was good, city life bad."[79] Embedding this mythology in *The Good Earth,* Buck built the central parable of the novel around what she saw as the contrast between the goodness of rural life and the evils of the city. Again and again, the decadent and empty existence of hedonistic city dwellers—embodied in the vice-ridden family members of the powerful House of Hwang—stands starkly opposed to the virtuous and simple life, marked by hard work and thrift, that Wang Lung and O-lan lead on the farm. Significantly, when famine temporarily forces them to leave the land and take refuge in a city, it is not long before their children— contaminated by corrupt city mores—begin to beg and steal (see fig. 3.8).

Unlike Buck's novel, the film can—and does—consistently heighten the resonance of the land through visual means. Marked by beauty and harmony throughout the film, the land is at the heart of the "spectacular" visual sequence that Thalberg deemed essential to a "prestige production" such as *The Good Earth.* Building upon a relatively short scene in the novel, the filmmakers devised a striking sequence—full of hundreds of extras and marked by special effects—in which the family struggles to save their harvest from a plague of locusts. As the family desperately erects firestorms to halt the locusts' advance, carefully calculated editing rhythms take us from sweeping shots of the terrifying swarms to close-ups of menacing insects feeding on the crops. To create screen images of marauding insect hordes, wind machines were used to direct the flight of grasshoppers, which were trucked in for the scene and used as stand-ins for locusts. (Dubbing this scene "cinema's first investigation of the War against the Insect," an irreverent *Time* magazine made sure to let its readers know that some close-ups of the "locusts" were shot during a grasshopper plague in Utah.[80]) In the end,

Figure 3.8. Paul Muni as Wang Lung in The Good Earth: A life lived close to the land

of course, the family's heroic struggle is successful: the locusts are diverted and the farm is saved.

Visually dazzling even today, this sequence amply fulfills Thalberg's demand that *The Good Earth* "have one great sequence from the standpoint of the camera, in acting and story, in light and shadow, in sound and fury." In addition to its visual impact, the sequence also played a significant dramatic role. Underscoring both the centrality of the land and the heroic endeavors of those who till the soil, it also set the stage for an important change in the narrative made by the filmmakers in adapting the novel to the screen. That is, they decided to use the locust sequence to restore a sense of family unity that was lost when Wang Lung made the terrible discovery that his son had slept with his concubine, Lotus. Indeed, in the eyes of associate producer Albert Lewin, the "primary dramatic problem" of the locust sequence was not the struggle against the invading insect hordes—which he deemed "incidental"—but the "reconciliation" of father and son.[81] Thus, in the course of the locust sequence, Wang Lung's estranged son proves his loyalty to the family and demonstrates his love for the farm and his ability to protect it with the help of the new agricultural techniques—in this case, the firestorms that

ultimately halt the locusts' advance—he has learned. In the best of Hollywood traditions, then, the fight against outside danger brings people—in this case, father and son—together. While bitter fault lines and rivalries continue to divide father and son in the novel, in the film—by virtue of this sequence—the family once again becomes, in Lewin's words, a "wholesome, affectionate, sympathetic unit, bound together by profound ties."[82]

Although this change represented a dramatic departure from the novel, it was probably not quite as dramatic—or at any rate as sweeping—as still another change effected by the film. For the filmmakers were not content simply to mend family ties that in the novel remained shattered. They wanted something more—something that was even more foreign to Buck's novel: romance. If Thalberg had to promise Mayer that the film would contain elements of romance—*The Good Earth,* he declared, would be the "story of how a man marries a woman he has never seen before and how they live a life of intense loyalty"—it was precisely because those elements were nowhere to be seen in Buck's novel. While the novel did contain many sexual scenes, it gave little or no hint of love or romance—much less Hollywood romance. On the contrary, as suggested earlier, Buck's portrayal of the sufferings endured by O-lan, in particular, constitutes an implicit denunciation of a world of patriarchal privilege. The novel never lets us forget that in this world, women are little more than property to be bought and sold: their role is to provide heirs (O-lan) or pleasure (Wang Lung's concubine, Lotus). Far from living a life of "intense loyalty" with her husband, in the novel O-lan receives neither love nor loyalty—nor even affection—from Wang Lung. Indifferent to his wife's feelings, Wang Lung treats her as little more than a servant. Not only does he take a concubine into his home once his wife ceases to arouse him, but he lavishes money and jewels—including some pearls cherished by O-lan—upon the grasping courtesan. "It is not my fault," he says speaking of his wife, "if I have not loved her as one loves a concubine, since men do not."[83] Even when his wife is on her deathbed, Wang Lung feels nothing but a mixture of pity and deep physical repugnance for the woman who has devoted her life to him and their children. All Wang Lung can see, writes Buck, is "how wide and ghastly her purpled lips drew back from the teeth." When he takes her dying hand into his own, he realizes "he did not love it, and even his pity was spoiled with repulsion."[84]

In the end, it would be difficult to imagine a less romantic marriage than that portrayed by Buck. And, indeed, to endow the workaday marriage between Wang Lung and his wife with an aura of romance, the filmmakers had to make a series of important changes—some of which eroded Buck's finely tuned observations of Chinese life. Take, for example, the contrasting ways film and novel portray Wang Lung's erotic interests. In the novel, not only is Wang Lung filled with lust for the beautiful concubine, Lotus, but also, when he is quite old, he

takes a young servant girl, Pearblossom, into his bed. Both relationships clearly shed light on the complicated sentimental/erotic/domestic arrangements of a traditional Chinese household. But just as clearly, both had to be changed for the film. Pearblossom, of course, disappears from the film: after all, how could one show audiences the stoic and admirable Wang Lung with a twelve-year-old adolescent girl? While Lotus does remain in the film, her character and role are greatly altered. She is no longer a woman who, albeit in a different way, is just as oppressed as O-lan. Rather, she is seen as a cunning seductress—a Chinese version of the "other" women dear to Hollywood melodramas—who lures a reluctant Wang Lung away from the wife he loves. As the trailer told potential viewers: "the love of Wang and O-lan endures until hunger for the lips of Lotus makes Wang forget the heart of O-lan."

Above all, as one might have expected, the character of O-lan undergoes a total metamorphosis. In the film, the oppressed woman of the novel—one whose plight served as a constant reminder of the evils of a feudal world—becomes an idealized creature beloved by Hollywood films: that is, a loving, and much beloved, wife. The transformation begins with her appearance. The semi-brutish and silent peasant woman described by Buck—one whose death provokes nothing but "repulsion" in her husband—becomes, on-screen, an immensely appealing creature. She may say, "I know I'm ugly, not to be loved," but as played by the luminous Luise Rainer, she is clearly a beautiful woman. Along with her appearance, the dramatic import of her role also blossoms. A distinctly secondary character in the novel, she becomes, in the film, a pillar of family life. No longer a kind of domestic servant, she is Wang Lung's trusted partner in life and love. Their marriage is closer to, say, the romantic partnership associated with a couple like Spencer Tracy and Katherine Hepburn than to the matter-of-fact alliance of Buck's peasant couple. From the outset, Wang Lung strikes a note of marital equality that would be virtually unheard of in a traditional Chinese marriage: he tells his new bride that the land belongs not to him but "to both of us." As their bond strengthens, Wang Lung shares all his feelings with O-lan even to the point of lamenting the sexual attraction that draws him to Lotus. "It's like a sickness," he cries as he describes his feelings for the glamorous courtesan. Ultimately, of course, in the best of romantic traditions, Wang Lung finally realizes that the great love, the only true love, of his life is indeed his wife. As they celebrate their son's wedding, Wang Lung tenderly whispers to O-lan that "now I know that you were the one . . . the best that man could have" (see fig. 3.9).

There is, finally, one last indication of the important role O-lan enjoys in the film. Just as the filmmakers invented a spectacular sequence to underscore the harmony of the family, they also introduced an important visual motif designed to emphasize the centrality of O-lan's character. Created by noted scriptwriter

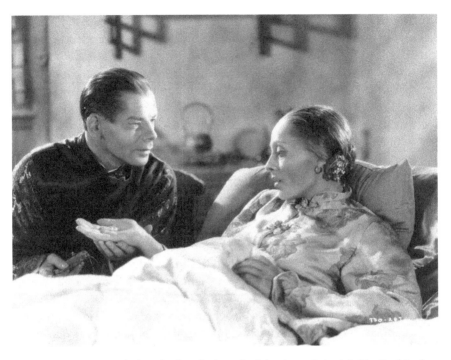

Figure 3.9. Wang Lung declares his love for his wife, O-lan (Luise Rainer), in The Good Earth: "An American romance," said author Buck of the filmed version of her novel

Frances Marion (who was not given credit for this contribution), it consists of a flowering peach tree that O-lan planted on the day of her wedding. As the years go by, O-lan cares for the tree with the same tender solicitude she displays toward her family. And just as the tree, a symbol of the good earth, becomes ever more beautiful and bounteous, so, too, does her family grow and prosper. Intimately associated with the loving O-lan, the images of the growing tree come to signify, in the words of Peter Conn, "O-lan's beauty and strength, her fertility, and her indispensable place in Wang Lung's life."[85] The association between O-lan and the peach tree—between woman and nature—is so strong that after O-lan's death, the screen fills with images of the flowering peach. As it does, Wang Lung, now a grieving widower, offers the ultimate tribute to the wife he cherished: "O-lan," he murmurs as the film comes to a close, "you are the earth."

Dominated by Wang Lung's sentimental tribute to his wife, the end of the film brings us to one last transformation effected by the filmmakers in adapting Buck's novel to the screen. This time, it bears not on characters or relationships but on the somber mood of the novel—one shadowed, as associate producer Lewin

sensed at the time, by "bitterness" and "futility."[86] If bitterness darkens the marriage of Wang Lung and O-lan, then futility dominates its melancholy conclusion. For as the novel comes to an end, it is clear that the seeds of vice that prompted the decline of the House of Hwang have already taken root in Wang Lung's family. Wang Lung's sons leave no doubt about their intention to sell the farm after their father's death. Softened by prosperity and corrupted by the seductions of city life, they want nothing more to do with the land—the good earth—that was the source of their family's prosperity. In doing so, of course, they will squander all that their parents achieved even as they embark on the downward spiral taken by the Hwangs before them. With the death of Wang Lung, a cycle of life will come to an end: the triumph of virtue—of hard work and a simple life lived close to the land—was, it seems, but a temporary turn of the wheel.

The somber end of the novel lends itself to different interpretations. Perhaps, like other aspects of the novel, it is part of the vision of an eternal, unchanging China in which time folds back upon itself in endless cycles. Or perhaps it has a dark Christian resonance, pointing to the vanity of all things and all human strivings—the *vanitas vanitatum omnia vanitas* of Ecclesiastes. However one interprets the novel's fatalistic conclusion, though, it clearly had no place in the film. Just as the filmmakers had to turn Buck's tale of struggling Chinese farmers into one of marital love and loyalty, so, too, did they have to banish the novelist's unhappy ending. How could an uplifting film that celebrates the virtues of Wang Lung and his wife, and which makes viewers identify with them and their problems, end on such a dark note of human folly and blindness? Obviously, it could not: filmic and cultural expectations virtually demanded that Buck's fatalistic ending be transformed. Indeed, as if to erase even the slightest hint of futility, several sequences were added to underscore the triumph of family harmony and generational continuity.

One such sequence—the battle to save the family farm from the plague of locusts—has already been mentioned. But another scene, which occurs at an important point toward the end of the film, further underscores this uplifting message. Here, an elderly Wang Lung and O-lan are seen celebrating their son's marriage to a beautiful woman. If the expensive marriage feast reminds us of the long and fruitful journey they have taken together, this scene also looks ahead to a prosperous future in which their son—as well as *his* sons—will carry forward his parents' devotion to work and family. Radically altering Buck's fatalistic conclusion, this scene makes it clear that Wang Lung's legacy will not be carelessly tossed aside but, rather, nourished and cherished. "Where the book," writes Peter Conn, "declined into a whisper of resignation over human frailty, the movie closes with a shout of love and loyalty."[87]

In the end, although radical, the transformation of the novel seen on-screen is hardly surprising. Speaking of Buck's role as America's best-known "China

expert," Michael Hunt makes the point that the novelist "could not question fundamental assumptions about the American relationship to Asia and at the same time retain her popularity and influence."[88] In a slightly different vein, one could make a similar point about the film: to win the hearts of viewers and critics, this MGM prestige production had to fulfill cultural as well as filmic expectations. Just as it had to offer viewers a tale of love and loyalty—to say nothing of a sequence full of sound and fury—it had to banish, as Lewin had it, the bitterness and futility of the novel. But if it is easy to understand why the film changed the novel's tenor and import, it is more difficult to see why, for so long, the radical changes it effected went virtually unnoticed. After all, for many years, viewers and critics alike followed the filmmakers' lead in reiterating the fidelity of the film to the novel.[89] Did the constellation of American beliefs and mythologies present in Buck's novel blind readers to the deeper ambiguities that distinguished it from the film? Did they wish to ignore its dark and bitter substratum? Or did the vast number of viewers who saw the film inevitably mean that the screen version of *The Good Earth* eclipsed that of the novel?

Interestingly, amid the chorus of voices that initially proclaimed the film's fidelity to the novel, there was at least one viewer who knew better: Pearl Buck. In a letter dated February 5, 1937, Buck remarked, "as to the film . . . it's too long . . . and it is so intense with noise and drama . . . that one is exhausted after it. . . . It's too *much*—too much storm, too much locusts, too much looting. . . . The end is changed from the book. O-lan gets the pearls, the second wife [Lotus] is dismissed, Wang returns to the land—the American romance in other words."[90] The novelist was not wrong: presenting viewers with one more version of an American romance, the film changed the very meaning of the novel even as it provided viewers with the most upbeat, the happiest, of Hollywood endings. It replaced Buck's dark Christian parable with a Horatio Alger tale of virtue and success. Embracing the notion of progress dear to the American imagination, it ensconced Buck's Chinese peasants in a landscape imbued with the glow of American optimism. In the end, the most important film ever made about China the work that was to teach Americans about that ancient land—offered them little more than a rosy mirror of themselves.

Coda

Little more than a decade after the release of *The Good Earth,* what Isaacs deemed the Age of Admiration for China—a moment embodied in and fueled by that film—came to a decisive and shattering end. When the Chinese Communists came to power in 1949, the haze of goodwill and friendship—the dissolution of

differences—that had prevailed during the Age of Admiration vanished as if it had never existed. China was no longer the land of Buck's stoic peasants but a place of fierce warriors out to conquer and destroy the West. People like Wang Lung and O-lan—who had won American hearts and minds throughout the 1930s—were no longer friends and neighbors. Now they had become Communist revolutionaries who were radically different from and opposed to Americans. By "going communist," writes Michael Hunt, "Wang Lung had forfeited his humanity in American eyes."[91] As America and China became implacable enemies, Pearl Buck—the woman who had spent her life trying to foster understanding and friendship between America and China—retreated into silence.

And, yet, if this transformation was stunning in its absolute and sudden nature, in some sense it was not really surprising. The Chinese could scarcely have become such villains had they not been perceived as friends. Only trusted friends could "betray" America as deeply as they had. It was almost impossible to believe that "our kind of people" had deliberately chosen a path America abhorred—that people as virtuous as Wang Lung and O-lan could have become Communist enemies. As Americans tried to absorb the nature of that "betrayal," the Chinese turned from mirror images of the self into absolute others. Never had the pendulum of American attitudes toward China swung so radically, so suddenly, and for so long a time. Indeed, as I plan to show, the repercussions of that swing have yet to run their course.

The Cold War in Three Acts

"When we saturate ourselves in old films," writes Nora Sayre in a book about films of the cold war, "we can employ them as hidden memories of a decade—directly or indirectly, they summon up the nightmares and day-dreams that drifted through segments of our society."[1] In this chapter I will explore several films—notably *The Manchurian Candidate*, *55 Days at Peking*, and *The Sand Pebbles*—that suggest the shapes taken by China in the cinematic "dreams" and, especially, the "nightmares" of this era. Marked by the heightened passions and often surreal logic of dreams, these works make it clear that no dreams were more intense—or, to borrow a phrase from director Samuel Fuller, more "confused"—than those that concerned America's recent ally. Both reflecting and fueling the paranoid climate that erupted in the late 1940s, they point to the ways ancient images of Chinese barbarism merged with and drew strength from fears surrounding the Red Scare of the 1950s. "Never before," writes A. T. Steele of this period, had Americans "felt quite like this about the Chinese. For a parallel we would have to go back to Medieval Europe and the Tartar hordes. It was the rebirth of the 'Yellow Peril' specter."[2]

Shadowed by this specter, in the course of these years, screen portraits of China and the Chinese underwent a dramatic change. Not only did the Chinese themselves become ever more unreal and phantasmagorical, but also the dialectic between the self and the other seen in earlier films blossomed into an almost mythic, absolute struggle of civilizations. Transposed into the past, this struggle is at the heart of both *55 Days at Peking* and *The Sand Pebbles*: both re-create moments of Chinese history when, as at the time of the cold war, China was once again seen as the land of conquering hordes. At the same time, marks of difference—like those of sexuality and Christianity—tended to disappear. There was no longer any need to qualify the Chinese as different since they now belonged to a world that was fundamentally, radically alien to America. But one element remained constant: as always, China—seen through what Ronald Steel describes as "the lenses of our own inflated anxieties and our

own betrayed illusions"[3]—served as a reflecting mirror of America. The image it reflected at this time was one of a nation anxious about its present and fearful of its future. If China poses such a threat in *The Manchurian Candidate*, it is because America appears to be collapsing from within. And if *55 Days at Peking* and *The Sand Pebbles* insist on American benevolence in the past, it is, I argue, because of unease surrounding its ever-expanding imperial role in the postwar era.

Impregnated with America's "anxieties" and "betrayed illusions," the films of this era mark, as suggested earlier, the most radical swing of the pendulum governing images of China seen to date. As we have seen, from the late 1930s to the end of World War II, China had been regarded as our friend, ally and, ultimately, equal. Chinese troops were "our kind of people" (*Thirty Seconds over Tokyo*) and "the best hope for the future" (*Stage Door Canteen,* Frank Borzage, 1943); China was described, as Capra's war documentary had it, as "an ancient civilization which had never waged an aggressive war." Within a few short years, the Chinese were anything but "our kind of people." Marching under the banner of international Communism, the "godless" Chinese became the latest incarnation of the nameless and faceless hordes of Genghis Khan. As the United States' former Chinese friends morphed into fiends and torturers, even Chinese Americans came under a cloud of suspicion. Although they were not interned like the Japanese during World War II, they were subject to what Iris Chang describes as "an atmosphere of hostility reminiscent of what Japanese-Americans had experienced during World War II."[4] By the 1950s, the Chinese were not only heathens and barbarians. They had become something that at the height of the cold war was even more frightening—Communists.

As always, the dramatic swing of the pendulum governing images of China was sparked by historical circumstance: first by the victory of Mao's Communist troops in 1949 and the following year by the outbreak of the Korean War. Even before Mao came to power global tensions ran high: the Soviet advance into Eastern Europe meant, in American eyes, that the world was increasingly divided into two camps: democracy and totalitarianism/Communism. "World Communism," warned the infamous Security Act of 1950, "has as its sole purpose the establishment of a totalitarian dictatorship in America, to be brought about by treachery, infiltration, sabotage and terrorism."[5] As fears of the monolithic nature of world Communism intensified, the nation began to seek out the traitors (Alger Hiss, Julius and Ethel Rosenberg) in its midst even as its earlier, and relatively benign, view of Chinese Communism—as distinct from the Soviet variety—changed dramatically.[6] In this climate of fear and tension, as David Halberstam writes, the Communist victory in China—together with the first Soviet atomic tests— signaled "a changing global security balance [that] sent psychological shock

waves through the American political system. The United States was no longer the only member of the atomic club, and at virtually the same time, China, a beloved country to millions of Americans because of the missionary outreach programs there, the country that was supposed to be our great ally in Asia, had gone Communist."[7]

As Halberstam suggests, China was not merely one more country entranced by the call of the Communist siren. Its so-called loss—a word that speaks volumes about American paternalism—was far more than a terrifying shift in the geopolitical landscape or even what Martin Walker calls a "portent of eventual defeat on a global scale."[8] For as long as people could remember, China had been considered America's friend and ally—a kind of junior republic that the United States had hoped might follow it in a path that was at once Christian and democratic. Seen from this perspective, China's embrace of Communism was not only a frightening political choice but also—perhaps above all—a betrayal of America and its values. It represented a dramatic repudiation of all that America felt it had ever done, or hoped for, in China. As "benevolent guardians" in China since the nineteenth century—as teachers, doctors, and spiritual guides—Americans had played an ego-enhancing role that bolstered their self-confidence and confirmed their belief in what Jane Hunter calls the "purity" of American motives.[9] Conversely, by embracing Communism, China challenged the "purity" of these motives—that is, the very values (the sense of exceptional destiny and national mission) that rendered America "special."

Furthermore, throughout the 1930s and 1940s, both missionary hopes for a Christian China and the image of China as a kind of junior partner to America had been kept alive with a fierce determination by the so-called China Lobby. Composed, as suggested earlier, of many in the missionary camp as well as conservative politicians, this powerful lobby was spearhead by a child of China missionaries who, like author Pearl Buck, had an enormous impact on American perceptions of China: the founder of *Time* and *Life*, media magnate Henry Luce. But while Buck ultimately questioned the cause of evangelical Christianity and national mission embodied in the missionary enterprise, Luce never ceased to promote this cause with determination and fervor. Indeed, it was largely this fervor that prompted his ardent support for Nationalist leader Chiang Kai-shek (Jiang Jieshi). "In Luce's mind," writes Theodore H. White, "the purpose of Christ and the purpose of America joined in a most simple, uncomplicated fashion, and the purpose of both embraced the Chinese people.... Luce's missionary forebears had helped plant Christianity in China. Chiang was their creation, and bore their message. Luce felt ... that he must take his stand: support Chiang or else."[10]

For nearly three decades Luce kept up a steady drumbeat of support for Chiang in his publications. Often featured on the cover of *Time*, Chiang was

portrayed as a great revolutionary hero—"a second Sun Yat-sen"—intent on modernizing China in a distinctly American way. He was seen not only as a resolute foe of godless Communism but also as a convert to Christianity, a leader who embodied Western hopes for the conversion of China's masses. "No other American," writes David Halberstam, "was as influential in creating the illusion of a China under Chiang that wanted to be like America."[11] Perhaps even more than Chiang himself, his American-educated and very devout Christian wife, Madame Chiang Kai-shek, seemed, as her *New York Times* obituary put it, "to be the very symbol of the modern, educated, pro-American China they yearned to see emerge."[12] After a triumphant 1943 visit to the United States in which she gave an electrifying speech before the joint houses of Congress appealing for American aid for Nationalist China, it was often said that she was worth "ten divisions to the Generalissimo."

Luce and others in the China Lobby could hardly have been more effective: for decades, the adulatory portrait of Chiang, and of China, they put forth was widely accepted in America. Pointing to America's infatuation with Chiang, a 1942 film about American airmen in China, *The Flying Tigers* (David Miller), begins with a stirring speech in which the Chinese leader extended his gratitude to those Americans who fought the Japanese. But this portrait was also, as historians have since made very clear, illusory—the expression of a wish rather than a reality. It belonged to what A. T. Steele describes as a period of "dreamy unreality" about China—one in which "the American public seemed prepared to accept anything and everything good and wonderful that was said about the Chinese, their Generalissimo, the Generalissimo's wife and the heroic Chinese people."[13] It was a period marked, as David Halberstam suggests, by the presence of "two" Chinas. While the real China of the 1930s and 1940s was coming apart, the "illusory" China—the China created by Luce and the China Lobby—"was a heroic ally, ruled by the brave, industrious, Christian, pro-American Chiang Kai-shek."[14]

Mao's victory, of course, put an end to this period of "dreamy unreality" about China. As is often the case when dreams are shattered, the collapse of the illusory China cherished by Americans led to shock and disbelief, to denial and outrage. Americans could not believe that the China they had dreamed about for so many years had never existed. How could the China they had read about in Luce's publications—the beloved country "inhabited by industrious, obedient, trustworthy, good Asians"[15]—have morphed into the land of Fu Manchu? How could the "second Sun Yat-sen"—the man hailed by *Life* as the "leader of Asia's restless masses"—have been rejected by his own people? For some, these bewildering events could be explained only by acts of treason or betrayal. This was the position taken—and exploited—by the man who would come to embody the

paranoid climate of the era: Senator Joseph McCarthy. McCarthy virtually launched his career by demanding that America find the "culprits" and "spies" responsible for the loss of China. In his view, they were to be found in the Far Eastern division of the State Department—a place full of individuals, he ranted, "who are loyal to the ideal and designs of Communism rather than those of the free, God-fearing half of the world."[16] Although congressional investigations into the State Department found no evidence supporting McCarthy's allegations, they did manage to destroy the careers of eminent China specialists and to strip the State Department of virtually anyone who knew anything about Chinese culture and history.

Other explanations for the loss of China were no less fanciful—or hysterical—than those put forward by the senator from Wisconsin. Perhaps Mao's government, it was suggested, was not really Chinese. Or perhaps it represented only a tiny minority of the country. Along these lines, Dean Rusk, then assistant secretary of state, declared that Red China (as the People's Republic of China was called until 1971) was a "colonial Russian government—a Slavic Manchukuo on a large scale—it is not the government of China. It does not pass the first test. It is not Chinese."[17] Making a similar charge, the *New York Times* deemed the Chinese Communist movement a "nauseous force" as well as a "compact little oligarchy dominated by Moscow's nominees."[18] Passions ran so high that even Dean Rusk suggested that they spoke less of political realignments than of the bitterness felt by a "jilted lover."[19] But remarks made decades earlier by philosopher John Dewey were even closer to the mark. As early as the 1920s, Dewey had cautioned that the United States' relation to China was fraught with all the dangers of a parental bond. Noting that "parents are rarely able to free themselves from the notion that gratitude is due them," he went on to say that the "failure to receive it passes readily into anger and dislike." As for the "children"—that is, China—he warned that, as the nation came of age, it would increasingly "resent more and more any assumption of parental tutelage even of a professedly benevolent kind." Almost as if foretelling the passions that would erupt after 1949, Dewey continued:

> There is a crisis in most families when those who have been under care and protection grow to the point of asserting their independence. It is the same in the family of nations. . . . In the next ten years we shall have . . . to alter our traditional parental attitude, colored as it has been by a temper of patronage, conscious or unconscious, into one of respect and esteem for a cultural equal. If we cannot successfully make the change, the relationship of this country with the entire Far East will take a decided turn for the worse.[20]

The turn for the worse that Dewey predicted assumed its full measure the following year. When North Korean troops attacked South Korea below the thirty-eighth parallel—the line that had been established to divide the nation in the wake of World War II—China became an enemy in fact as well as in the fevered imagination of those who had earlier decried its loss. Now, like Europe, Asia became the scene of a global clash between opposing forces. Behind the North Korean troops that had launched the attack loomed the specter of the Chinese; and behind them, the Soviets. America, declared Major General Charles Willoughby, General Douglas MacArthur's intelligence chief, had to defend itself against "Imperialist Mongoloid Pan-Slavism";[21] the Chinese, affirmed President Harry S. Truman, "are satellites of Russia and will be satellites as long as the present Peiping [Beijing] regime is in power."[22] The conviction that America was fighting a global conspiracy in Korea seemed to find confirmation in a battle that took place at the Yalu River—the border between China and North Korea—soon after the war began. Chinese troops emerged from the mountains and dealt the advancing American-led NATO troops a defeat of historic proportions.[23] Waves of disbelief and anger went through the United States: the American troops, declared one newsreel, were "being routed by Chinese Red Army Legions, treacherously forced into this war by the unscrupulous leaders of international communism. The G.I.s battle the new elements with everything they have, but the latest Communist perfidy in Korea makes the picture grim."[24] The grim defeat at the Yalu River presaged years of entrenched fighting and endless negotiations. Finally, a truce was signed in 1953. Little had changed—the thirty-eighth parallel continued to divide North and South Korea—but Americans and Chinese were both able to claim victory. The Americans maintained that they had "contained" Communism in Asia while the North Koreans declared that they had "contained" the United States by retaining a buffer zone.

Obscured in every way by the shadow of Vietnam, the Korean War may well have been, as it is often called, the most forgotten war of recent history. Still, it had a profound effect on American perceptions of the world—and especially of China. In the wake of the Korean War, attitudes toward China became, in the words of Colin Mackerras, a "litmus test of one's ideological position on international issues."[25] As the seat of a global conspiracy seemed to move from Moscow to Beijing, what Lewis Purifoy calls "frenzied McCarthyite attacks upon the government" inspired a "military-ideological crusade" against China.[26] It was a crusade that saw the United States embrace new policies that reached far into the future. Putting the country on the slippery slope toward Vietnam, Americans aided the French in Indochina; reversing the earlier U.S. policy of neutrality in China's civil war, Americans lent support to the Chinese Nationalists, who had established a government in Taiwan after their defeat on the mainland. Ameri-

ca's determination to contain Communism in Asia became, as Warren Cohen observes, "increasingly anti-Chinese, an unprecedented campaign of opposition to the development of a strong, modern China. There was no longer any question of whether the United States would interpose itself between China and her enemies, for the United States had become China's principal enemy."[27]

The conviction that China had become America's "principal enemy" also had a profound impact on the domestic front where it did much to fuel the eruption of what historian Richard Hofstadter famously called the "paranoid style" of American politics. Noting that this style was marked by "qualities of heated exaggeration, suspiciousness, and conspiratorial fantasy," Hofstadter described it in the following manner: "The distinguishing thing about the paranoid style," he wrote, "is not that its exponents see conspiracies or plots here and there in history, but that they regard a 'vast' or 'gigantic' conspiracy as *the motive force* in historical events. History *is* a conspiracy, set in motion by demonic forces of almost transcendent power, and what is felt to be needed to defeat it is not the usual methods of political give-and-take, but an all-out crusade."[28]

If, in this passage, Hofstadter articulates the defining impulses behind the cold war campaign against China, still another eminent historian, David Brion Davis, implicitly sheds light on the ways the United States' historical relationship to China may have helped fuel the crusade of the 1950s. Davis suggests that the nation's secular moral crusades—exemplified by the cold war fight against Communist China—were imbued with the sense of communal spiritual and religious fervor that originally accrued to Protestantism. "In a competitive and individualistic society," he writes, "crusades against subversion could at once become a substitute for the communal solidarity of the church and the means of defining a higher national purpose. As a secular reinforcement of religious revivals, they could help counteract the effects of materialism and moral lethargy."[29] Seen from this perspective, it is not difficult to draw a line of continuity between the nineteenth-century missionary enterprise in China and the secular crusade of the following century. Not only had missionaries accustomed Americans to view the Chinese as radically other, but their mission in China had been explicitly shadowed by the sense of "higher national purpose" that Davis deems essential to the secular crusades of the 1950s. In this sense, the ideological crusade against Mao's China could almost be seen as a kind of latter-day incarnation, a dark mirror, of that earlier Christian mission. Imbued with a quasi-religious sense of fervor and "higher national purpose," it, too, was directed against a people seen as godless—in this case, Communist.

Of course, if the two crusades were alike in these respects, in still others they were fundamentally—radically—different. For one thing, the goal of the anti-Communist campaign of the 1950s was not to convert the heathen—or to "liberate

and democratize" the world—but to combat and contain a fearsome enemy. For another, this time, the United States' cold war mission was infused not by benevolence but by fear and paranoia. This had a further consequence: while the benevolence of America's nineteenth-century mission had made Americans feel good about themselves, the paranoid "crusade" waged against Communist China—against the very country that had so decisively rejected America's benevolence—was wreathed in self-doubt, anxiety, and confusion. While some of this anxiety doubtlessly stemmed from the moral unease provoked by the nation's growing imperial role, the loss of China had nonetheless dealt a tremendous blow to America's self-esteem. It was a blow that was shadowed by a question that was as repressed as it was insistent: could the colossal failure of America's earlier mission be attributed solely to the ward—that is, to China? Or was the benefactor also to blame? Could the loss of China be attributed solely to traitors in America's midst, or was it a much broader phenomenon? The uneasy sense that somehow America itself might be at fault explains, perhaps, the intensity of the crusade itself. For America's vision, its self-identity, to remain intact, the enemy had to be the very embodiment of evil.

Nowhere does the troubled landscape of the period come to life more vividly, more dramatically, than in films of the era. Even more than more conventional historical documents, films make us feel the paranoia of the era, the intensity of America's crusade against Communist China, and the ways fears of China were entangled in a darkening national mood and a faltering sense of mission. Often permeated by contradictory impulses and logical inconsistencies, they point to an inability to fully absorb the bewildering events that had radically changed Americans' worldview within a few short years. Again and again, as if to reassure America about its mission, they return to the benevolence of the past. At the same time, consciously or unconsciously, implicitly or explicitly, they reveal the anxieties of the present. Marked by what director Samuel Fuller called the confusions of the era, they suggest a complex welter of deep-seated doubts created by the betrayal of America's former ally and by the barely acknowledged imperial role the United States began to assume in the postwar world.

To see these confusions at work one has only to look at the films of Fuller himself. Firmly rooted in the era of the cold war, they reveal the wrenching contrast between past and present and the chasm between ideals and realities, which had begun to haunt America at this time. In particular, like many war films of the era, Fuller's films offer a telling contrast to works of the preceding decade. In earlier films, there was never any doubt about the distinction between friend and foe or about the goals that inspired Americans to fight. For example, the hero of *The General Died at Dawn* explicitly tells us that he is in China because he

"enjoys a healthy fight for democracy"; the American soldiers in *Objective Burma* and *Thirty Seconds over Tokyo* never question the need to struggle against America's mortal foe. It is precisely these distinctions and certainties that vanish in Fuller's films. The world he creates is one in which goals are ill defined, men are morally ambiguous, and enemies can take any form. America is no longer the "shining city upon a hill" seen in films like *The General Died at Dawn* but rather a nation that is morally compromised in a crucial respect. Again and again Fuller returns to one of the deepest flaws running throughout the nation's life: the so-called race malady. "In [Fuller's] battle-field view of a society whose members are engaged in an endless struggle for subsistence," writes Phil Hardy, "America is literally in a position to be the saviour of the world, in short to play the role the Puritans had originally assigned to it. But Fuller is also aware that the 'city upon a hill' . . . is torn by racism . . . and by internal strife . . . of which the external fight against Communism is but an extension. From the desire that America live up to its role comes the urgency of Fuller's films."[30]

What Hardy calls the urgency of Fuller's films—one prompted by the desire that America "live up to its role"—makes itself felt in a film that deals explicitly with Chinese Communism: *China Gate* (1957). Set in Indochina in 1954, the film takes as its protagonist a Korean War veteran named Brock (Gene Barry) who now leads a squadron of French legionnaires engaged in fighting Communist revolutionaries in Indochina. Like earlier films, *China Gate* features Americans fighting alongside foreign soldiers in a far-off land. But the differences between *China Gate* and works such as *The General Died at Dawn* or *Thirty Seconds over Tokyo* point to a striking rupture between past and present. Not only has China morphed into a bitter enemy, but America has changed dramatically as well. The man who embodies America, Brock, is a morally flawed figure who bears little resemblance to the heroes of earlier films. While the idealistic hero of *The General Died at Dawn* is willing to die for people of another race, Brock is an inveterate bigot whose racism goes so deep that he abandons his young wife and infant son because the baby resembles his Chinese grandmother rather than his European forbears. Nor does Brock share the clear and noble motives that inspired the hero of *The General Died at Dawn* to fight alongside his Chinese allies. At one point, he tells us that he is there because "soldiering" is all he knows. He does not even seem to share the sentiment of a fellow soldier who declares that he wants to finish the battle that began in Korea. Even if he did, this motive raises more questions than it answers: how, we wonder, does fighting alongside colonialist troops in an imperialist war finish a struggle that began in a different land—against a different enemy?

In the end, of course, it is not only Brock's attitude toward the war that is both troubled and troubling. It is, above all, the attitude of the film itself. This

brings us back to the intensity of America's crusade against China and to the anxieties and unease surrounding our ever-expanding imperial role. If the loss of China challenged America's sense of mission, then the global role the nation began to assume in the postwar era put into question America's exceptional nature as a country devoted to freedom and national self-determination. Underscoring this fundamental issue, an ironic Martin Walker points out that, by aiding France in its struggle to retain an imperial hold on Indochina, the United States was essentially fighting *with* a colonial power against a Vietnamese resistance whose founding document "quoted the American Declaration of Independence."[31]

This vital dilemma is at the heart of the confusions that run throughout *China Gate*. That is, when it comes to the war in Indochina, the film seems pulled in two opposing directions. Even before it begins, the prologue points us clearly in one of these directions: it explicitly denounces the ravages of colonialism. Indeed, its denunciation of colonialism was so explicit that French authorities made the removal of the prologue a condition for the film to be released in France. Not only did Fuller refuse to accede to this demand, but he did so in terms that further underscored his anticolonialist stance. "France," he said, "had been colonizing countries for hundreds of years because it was good business. What I didn't like about all those colonial powers, whether they were French, British, Spanish, or Dutch . . . was the way they disguised their exploitation of their colonies by hanging a pretty veil over the whole affair . . . Bullshit! My movie's prologue was accurate and would stand."[32]

There can be no doubt, then, about Fuller's explicit opposition to colonialism. But this opposition makes it all the more telling that, despite the prologue, the film seeks, however implicitly or unconsciously, to justify *this* particular colonial war. This message is conveyed in two ways, both of which suggest the ways the anti-Communist crusade of the era both reflected and was fueled by ancient stereotypes and fears of China. First of all, harking back to images of Chinese torture and barbarism, the film portrays the Chinese Communists as inhuman fiends who deserve to die. In one scene, for example, Chinese soldiers saw off the leg of a priest and leave him to die bearing a sign that proclaims him a capitalist. Second, these fiends are seen as part of a new yellow peril that threatens Western civilization: world Communism. Underscoring this threat, the film shows posters of its supposed architects: a poster of Vietnamese leader Ho Chi Minh takes its place alongside those depicting Stalin and Mao.

In light of this overarching threat, Brock's conflation of the war in Indochina and the war in Korea makes perfect sense. In other words, as his remarks imply, Brock is engaged less in a specific war against a specific people than in an

apocalyptic battle against a global terror. Both denying and yet justifying an imperial war, the film manages to avoid the crucial moral and political issues raised by France's imperial struggle (with American aid) to retain its hold on Indochina/Vietnam. Ignoring the complex contours of nationalist struggles like that of the Vietnamese, the film reflects and endorses America's conviction that countries such as Vietnam represented little more than crucial "dominos" in the battle against a larger threat. In so doing, of course, it takes us, as Fuller seemed to acknowledge, into a morally ambiguous zone. "My take," declared the director in a revealing remark, "is full of human foible and confusion. I deliberately wanted that confusion."[33]

The confusion that permeates *China Gate* is even more visible in another war film of the era: *The Mountain Road*. Here, though, confusion stems not from America's conflicted stance toward postwar colonial struggles but rather from an inability to absorb China's "betrayal" into a coherent narrative of the past. Marked, like *China Gate*, by a wrenching contrast between past and present, *The Mountain Road* rereads not only the recent past but also films about that past. At first glance, it clearly resembles pro-Chinese films made during the war: that is, *The Mountain Road* features an American army unit—led, this time, by a major played by James Stewart—that is fighting with the Chinese in their struggle against the Japanese. But a closer look reveals a stark contrast between *The Mountain Road* and films such as *Thirty Seconds over Tokyo* and *Objective Burma*. For here, the Chinese soldiers are not heroic fighting men, much less "our kind of people." On the contrary: in the face of danger, they abandon their American allies and flee to the mountains without hesitation. And if the Chinese soldiers are treacherous cowards, the Chinese people are, as two scenes in particular make clear, little more than latter-day barbarians. In the first of these scenes, starving villagers trample and kill a brave American soldier who risks his life to bring them army rations; in the second, Chinese bandits (or, perhaps, army deserters) first murder a helpless, wounded American soldier and then strip his body and toss it into a ditch. The overt story of the film is clearly confused: why, after all, would we be fighting with allies such as these? But its implicit message could hardly be clearer. The American soldiers portrayed here are brutally betrayed by their wartime ally just as America was betrayed by China in 1949. Both the realities of history and the weight of logic count for naught before the imperatives of ideology.

The implicit contrast between past and present that hovers over both *China Gate* and *The Mountain Road* becomes totally explicit in still another film of the era: a strange love story made by Frank Borzage in 1958, *China Doll*. The film's protagonist is an American airman, played by Victor Mature, who is fighting at

the side of the Chinese against the Japanese in the dark days of World War II. In the course of his stay there, he falls in love with and marries a Chinese woman with whom he has a daughter. But their romantic idyll soon ends in tragedy: both are killed in the course of a Japanese attack. Their little girl is rescued by a kindly missionary and brought up in China. At this point, the film jumps ahead to the present even as it transforms all that we have seen about the past. Suddenly, the year is 1958 and a group of the deceased airman's military colleagues are standing at an airport waiting to welcome his grown-up daughter, who is arriving from China. Nothing is said about her experiences in China or why she has decided to come to America. But these unanswered questions and narrative gaps only underscore the ideological message of this scene—and, indeed, of the film. That is, the airman's daughter must be rescued from the very people for whom he gave his life.[34]

The recurring impulses that mark films as otherwise diverse as *China Doll, The Mountain Road,* and *China Gate*—the wrenching contrast between past and present, the presence of narrative gaps and logical inconsistencies, the insistent weight of ideology—are symptomatic, of course, of a broad cultural, political, and cinematic landscape. In the remaining pages of this chapter, I will explore this landscape in terms of the three films mentioned earlier: *The Manchurian Candidate, 55 Days at Peking,* and *The Sand Pebbles.* Marking various stages on the road that saw us go from the war in Korea to that in Vietnam, they suggest some of the internal contradictions—the zones of anxiety, ambivalence, and confusion—that characterized the paranoid style that emerged in the 1950s. The films are, admittedly, quite different from one another. While *The Manchurian Candidate* is a thriller set in McCarthyite America, both *The Sand Pebbles* and *55 Days at Peking* are historical epics that deal with critical moments of the Chinese past. Political messages also vary: while *55 Days at Peking* seeks to justify America's participation in a colonial war, *The Sand Pebbles* questions the very notion of imperial intervention. Despite these differences, though, all pivot around issues and events—the brainwashing of American POWs in Korea (*The Manchurian Candidate*), the Boxer Rebellion (*55 Days at Peking*), the attacks on missionaries that occurred in the course of the national revolution of 1925–1928 (*The Sand Pebbles*)—that served as flashpoints for American fears of China. Testifying to the long reach and the repercussions of America's crusade against Communist China, they suggest how paranoid images of the yellow peril merged with and drew strength from cold war fears of the 1950s and 1960s. Informed by fears new and old, they are vivid illustrations of historian Michael Schaller's contention that China "has long served as a kind of national Rorschach test for the United States onto which we project our hopes and fears."[35]

The Yellow Peril Meets the Red Tide: The Manchurian Candidate

What Richard Hofstadter calls the "conspiratorial fantasies" at the heart of the paranoid style emerge, full-blown, in *The Manchurian Candidate.* No document of the cold war period better reflects the "nightmare" that erupted in the late 1940s than director John Frankenheimer's 1962 thriller. Based on a 1959 best-selling novel by Richard Condon with the same title, in a certain way *The Manchurian Candidate* differs from other works examined in this chapter. Not only are there few references to China, but only one scene—which represents a power-ful "nightmare" that, quite literally, haunts the dreams of several characters—takes place in that country or, more precisely, in Manchuria. But if China itself is largely unseen, its presence is both insistent and terrifying. For one thing, the figure at the center of the dream is a latter-day version of the archetypal Chinese villain, Fu Manchu. For another, the film is imbued with memories of one of the most frightening and controversial aspects of the Korean War: the so-called brainwashing scare of the 1950s.

Set in the immediate aftermath of the Korean War, *The Manchurian Candidate* begins with a flashback: titles tell us we are in Korea in 1952. A brief se-quence, depicting American GIs in a local brothel, introduces us to one of the film's protagonists, the authoritarian and prudish army officer Lieutenant Ray-mond Shaw (Lawrence Harvey). The scene shifts rapidly: Shaw's platoon, led by a native guide, is making its way through the darkness. In an instant, their guide betrays them: captured by the enemy, they are spirited away by helicopter to a place later identified as Manchuria.

The film jumps ahead: in the next scene, which takes place two years later, Lieutenant Shaw—who has just won the Medal of Honor for bravery in battle—is being welcomed home by a cheering crowd in Washington, D.C. The lieutenant greets his mother—a domineering, icy woman played by Angela Lansbury—and stepfather, John Iselin (James Gregory), a right-wing senator obviously based on the figure of Joseph McCarthy. Although his mother wants to take political advantage of her son's fame, the lieutenant rejects her advances and curtly in-forms her that he has accepted a job in New York with a sympathetic liberal publisher, Holborn Gaines (Lloyd Corrigan).

The scene shifts to the other major protagonist of the film, Captain Bennett Marco (Frank Sinatra). Formerly a member of Shaw's platoon, the captain is plagued by a recurring nightmare that, in the film, takes the form of a powerful hallucinatory sequence. Repeated later in the film with a few variations, the dream begins in a kind of atrium where a matron is giving a lecture to a women's club. The members of the platoon, led by Lieutenant Shaw and Captain Marco, are seated on

a kind of podium where they can be observed by everyone in the room. The camera slowly leaves the speaker and pans around the room; when it returns to the speaker, we are shocked to discover that an official-looking Chinese man has taken the place of the droning matron. Other striking metamorphoses have also occurred: the atrium has turned into a lecture hall where the walls are hung with huge posters of Joseph Stalin and Mao Zedong; the matrons in the audience have been replaced by a roomful of Chinese and Russian officials. Once again, the matron speaks; now, however, her voice is that of the Chinese official glimpsed earlier. He/she explains that the American soldiers have been brainwashed into believing that they are at a New Jersey garden club. In actuality, however, they are at the Pavlov Institute in Manchuria, where they have been conditioned to believe that Lieutenant Shaw's bravery in battle saved their lives. A much worse fate has been reserved for the lieutenant: his Korean captors have turned him into a robotic killer unable to remember—much less feel remorse for—his deeds. In fact, to demonstrate how thoroughly Shaw has been brainwashed, the Chinese official commands him to kill his favorite fellow platoon member. As if in a trance, Raymond obediently rises, strangles his comrade, and calmly returns to his seat.

Back in the present, Senator Iselin is giving a televised press conference in which, like McCarthy, he calls national attention to himself by making inflammatory charges about the "traitors" and "Communists" in America's midst. Meanwhile, Lieutenant Shaw, seated at his desk in New York, receives a telephone call in which the speaker gives him a series of cues—including one that prompts him to look at a playing card bearing the image of the queen of diamonds—that put him into a trance. Told to go to a certain destination, in the next scene, he is in an East Side clinic secretly run by the Pavlov Institute. Before long, the Chinese official who lectured in the dream sequence—a man now identified as Yen Lo (Khigh Dhiegh)—enters his room. To make sure that the lieutenant remains brainwashed, Yen Lo gives Shaw still another command: he is to kill the sympathetic publisher for whom he works. Zombielike, Shaw obeys and kills a man he both likes and admires.

Now the scene shifts to Washington, where a suspicious Captain Marco is becoming increasingly convinced that something is "phony": he *knows* that Shaw is antipathetic, yet when asked about the lieutenant, he automatically responds that Raymond "is the nicest, warmest, kindest, most wonderful human being I've ever known." His suspicions are confirmed when he discovers that Shaw's manservant is the guide, Chunjin (Henry Silva), who betrayed the platoon in Korea. With the help of army intelligence, Marco finally discovers that the Chinese and Soviet officials seen in his dream correspond to real people. Then, by a fluke, he discovers the triggers that prompt Shaw's trances.

Meanwhile, Shaw's mother, who is scheming to obtain the vice presidential nomination for her husband, invites one of her husband's most determined opponents—liberal senator Thomas Jordan (John McGiver)—to a costume party at her home. Even as the upright senator resolutely rejects her advances, his daughter Jocie (Leslie Parrish)—who had fallen in love with Raymond earlier—agrees to elope with the young man. Now, in what is undoubtedly the most shocking moment of the film, Shaw's mother—who is dressed in the costume of the Red Queen—reveals that it is *she* who has been chosen by her Communist comrades as her son's American operator.

As soon as Shaw returns from a brief honeymoon with Jocie, his mother-turned-handler gives him a terrible command: he is to kill his new father-in-law because the liberal senator is staunchly opposed to Iselin's nomination as his party's vice presidential candidate. Once again, Shaw obeys. As he bends over the senator's dead body, Jocie rushes to the scene of the crime. Since Shaw has been commanded to leave no witnesses, he turns and—like a robot—shoots the wife he loves so deeply. But the horror of this act is such that it affects the brainwashing mechanism that up to this point functioned so well. Now, Raymond, too, is prey to the hallucinatory nightmare that haunts Captain Marco. Together with Captain Marco, an increasingly distraught Shaw reconstructs all the terrible crimes he committed in Korea and New York.

At this point, Shaw's mother issues a final command: at the forthcoming national convention, her son is to shoot the party's presidential nominee so that his stepfather—now the vice presidential nominee—will step into the presidential slot. Following her instructions, Raymond takes up a marksman's position at the top of Madison Square Garden. But at the vital moment his conscious will finally asserts itself: instead of shooting the designated target, he kills his stepfather and, finally, his mother. After these terrible acts, he turns the gun on himself and commits suicide. It is left to Captain Marco to pay tribute to the lieutenant. Although, he says, Shaw "was made to commit unspeakable acts by an enemy who had captured his mind and his soul," he turned out to be a true American hero who "heroically and unstintingly, gave his life to save his country." With these words of praise and absolution, the film comes to an end.

Even this schematic summary of the complicated plot of *The Manchurian Candidate* suggests how profoundly the film reflects the hysterical and paranoid climate of the early 1950s. Whirled from past to present, from dream to reality, we enter a world where no one can be trusted and nothing is what it seems. One betrayal follows another as Communist agents—posing as right-wing politicians who seek to preserve "American" values—plot to take control of America. The transformations and shifting identities that permeate the film are both announced and embodied in the critical nightmare that haunts members of Shaw's platoon.

As in this scene, in which imaginary garden club matrons turn into very real enemy agents, the film repeatedly plays on the frequently shocking gap between appearance and reality. Thus, the trusted guide seen in the opening sequence is revealed as an enemy agent; the seemingly affable Chinese handler—who looks forward to a day in New York so that he can go shopping at Macy's for his wife—is as fiendish as Fu Manchu. Lieutenant Shaw, winner of the Medal of Honor is, in truth, a robotic assassin trained to feel neither remorse nor guilt; his far-right mother, who looks like a pillar of the DAR, is a paid Communist agent who acts as her son's American operator. Even seemingly innocuous objects and places reveal a sinister dimension. A New York clinic is really a Soviet institute dedicated to brainwashing; a banal deck of playing cards contains the cues that trigger deadly trances. A mother's "love" is imbued with the deepest currents of treachery. To top it off, even the nation's anti-Communist fervor becomes, in the end, an instrument to subvert the very values the nation holds dear.

In many respects, the twists and turns of the plot of *The Manchurian Candidate* could hardly be more improbable. Is it conceivable, after all, that the lieutenant's demonic mother—a pillar of the Far Right if not an outright fascist—would be a paid Communist agent? Or that the Communists would choose no one other than her son to become a deadly assassin? And how, after all, could the Chinese official, Yen Lo, manage to turn up in New York? Along similar lines, how could the Soviets have commandeered a wing of a fancy clinic on the East Side of New York? Indeed, these improbabilities have prompted a number of critics to stress what they see as the "absurdity" of the plot. The film, declares Greil Marcus, "revels in absurdity, works off it, takes absurdity as a power principle: the power of entertainment. The movie takes absurdity as a pleasure principle."[36] Although *The Manchurian Candidate* was billed in 1962 as a "political thriller," says Susan Carruthers, it is "largely devoid of politics."[37] Bruce Crowther reaches a similar conclusion: in his eyes, *The Manchurian Candidate* is a "wildly impressionable drama . . . [that] really has very little to say about the Korean War . . . [or] about McCarthyism."[38]

No one could deny that at least in certain respects, the film was "wildly impressionable" and perhaps even "absurd." At the same time, it is astonishing to what degree this "wildly impressionable" drama reflected circumstances and impulses that, however improbable, were manifestly real. If, for example, the film's notion of a highly public political assassination seemed the stuff of fiction in 1962, by the end of the sixties—after the death not only of President John F. Kennedy but also of Robert Kennedy, Martin Luther King Jr., and Malcolm X—it had begun to seem eerily prophetic. On a very different level, one of the basic premises of Frankenheimer's film—the idea that the two ends of the political spectrum could come together in Communist agents who pose as pillars of the Right—was

also grounded in reality. As Sean Wilentz notes, the founder of the right-wing John Birch Society, Robert Welch, claimed that Republican president Dwight D. Eisenhower was in truth a Soviet agent—"a dedicated, conscious agent of the Communist conspiracy"—who had been maneuvered by his Communist handlers into the White House.[39] Even more bizarre is the fact that in the late 1940s, the CIA embarked on a program of experiments in mind control that used a combination of hypnosis, drugs, and sensory deprivation.[40] In the event, the CIA was apparently no match for Fu Manchu or for his latter-day incarnation, Yen Lo: not only were the CIA's experiments unsuccessful—no drugs were found that could "reliably induce a zombie like trance and slavish obedience"[41]—but they were also an eventual source of embarrassment to the agency. In fact, before retiring in 1971, director Richard Helms ordered the destruction of all records related to these events.[42]

These parallels between reality and fiction were, perhaps, largely inadvertent. But they were accompanied by still another that was totally conscious and deliberate: the resemblance between the film's portrait of the imaginary right-wing senator John Iselin and his real-life prototype, Joseph McCarthy. Here, parody and reality are virtually indistinguishable: McCarthy himself was hardly more believable than his fictional counterpart. It is true that, unlike McCarthy, Johnny Iselin is a dimwitted fool, the unwitting pawn of his ruthless wife. But, McCarthy, too—as Richard Rovere tells us in his biography of the senator—had an "antic," even "ridiculous," side. Most important, the lies the fictional Iselin tells are no more outrageous or improbable than those McCarthy uttered with such conviction; the ever-changing lists of "Communists" Iselin recites are no more preposterous or absurd than those with which McCarthy managed to destroy innocent lives. Gifted with McCarthy's ability to manipulate both the media and public opinion, the Iselins, too, seize on anti-Communism as a ticket to power. In fact, Rovere might well have been describing Lieutenant Shaw's mother when he writes that McCarthy was a "political speculator, a prospector who drilled up Communism and saw it come up a gusher. He liked his gusher but he would have liked any other just as well."[43]

Firmly ensconced in the broader landscape of cold war paranoia that pervades the film, the figure of Iselin—like that of McCarthy—raises an important, oft-discussed issue. It is one that takes us back to the cold war crusade against Communist China even as it opens upon one of what I have called the "confusions" of the era. In this case, the confusion takes the shape of a striking paradox. For even as the film derides McCarthy/Iselin, it suggests that the very threats McCarthy warned against—and manipulated—were intensely real. After all, in *The Manchurian Candidate*, spies *are* everywhere; the Russians and the Chinese *have* made common cause to enslave and destroy the West. The sinister world

portrayed in the film *is* one in which Communist agents—like the lieutenant's mother—are entrenched at the very heights of power.

Some critics take this essential paradox—to borrow a phrase from Richard Combs, the fact that the film produces a "McCarthyite fantasy out of a McCarthy send-up"[44]—as one more proof of the film's political incoherence or even its apolitical nature. Others (including Frankenheimer himself) suggest that this paradox is a critique of those at both ends of the political spectrum.[45] (Indeed, reactions suggested that both the Right and the Left felt targeted by the film: *The Manchurian Candidate* was denounced by both the American Legion and the Communist Party.[46]) But it seems to me that, like so many other aspects of *The Manchurian Candidate,* this essential paradox—the fact that it was both a send-up of McCarthy and a McCarthyite fantasy—was deeply rooted in reality. In this respect, it is vital to remember that even after McCarthy had been totally discredited and undone by his own excesses, the worldview that he endorsed—in particular, his view of a vast Communist conspiracy spearheaded by the Russians and the Chinese—continued to plague the American imagination. As Lewis Purifoy points out, McCarthy's vision of the world—formulated at the most hysterical and paranoid moment of the cold war—continued to shape foreign policy long after the domestic witch hunts of the era had come to an end. "The term 'McCarthyism,'" writes Purifoy, "would become a term of opprobrium only in domestic 'commie-haunting,' whereas the McCarthyite rhetoric of fear and hate . . . would soon attain full respectability in the realm of foreign affairs."[47]

To some extent, the persistence of a foreign policy animated by McCarthy's "rhetoric of hate" was driven by politics. Shut out of the White House for many years, the Republicans, in particular, embraced a foreign policy of rabid anti-Communism as a way back to power. And they were abetted by Democrats who were fearful of being seen as soft on Communism. But it is also true—and this brings us back to the convergence of the paranoid style of the 1950s and the contemporaneous crusade against China undertaken by the nation's leaders—that the persistence of McCarthy's "rhetoric of fear and hate" was fueled by a still deeper substratum of fears that bore, principally, on perceptions of China. In other words, if the virulent anti-Communism the senator embraced had such a long life in foreign affairs—indeed, some would argue that it is still alive and well—it was because the specter of global Communism merged with and took strength from long-standing fears and images of the yellow peril.

Viewed from this perspective, what might be seen as the more problematical zones of *The Manchurian Candidate*—its political incoherence or what one critic deems the presence of "outright camp"[48]—assume a very different coloration and meaning. They are part of a landscape of fear and paranoia, of hallucination and

phantasmagoria, that bears witness to the specter of the yellow peril. In this respect, it is significant, surely, that *The Manchurian Candidate* is marked by a kind of tonal dichotomy characterized by a shifting balance between the real and the unreal. On the one hand, to a great extent, the film's portrayal of America and things American is marked by the real. If its portrait of New York—from the decaying splendor of Riverside Drive apartment houses to the old Madison Square Garden—captures the flavor of a bygone era of the city's past, its depiction of American political practices and institutions—from the skillful manipulation of the media on the part of the extreme Right to the antic bedlam of a national convention—is, alas, all too accurate. But when it comes to places or events related to China, any hint of realism vanishes. From a world grounded in physical and social realities we shift to one dominated by the myths and stereotypes of popular culture. The streets of New York give way to a hallucinatory Manchuria; political practices are replaced by mythical brainwashing; the villains are no longer ruthless politicians but sinister Orientals.

Along with this tonal dichotomy, the film also points to the presence of the yellow peril specter in more concrete ways. Its very title, for example, suggests ancient stereotypes of Chinese aggression, barbarism, and cruelty. Manchuria, after all, calls to mind Manchu—the term given the northern tribes who swept down from the plains to conquer and rule China from 1644 until 1911. And images of the Manchu give rise to memories of still another tribe of conquering northerners—the ferocious hordes led by Genghis Khan. If in the past China was threatened by northern barbarians, now it is China itself—governed by the new Manchus (i.e., the Communists)—that threatens the West even as it sponsors its own candidate for the American presidency.

The menace that lurks in the very word "Manchuria" intensifies still further once the nightmarish sequence of brainwashing begins. Here, too, ancient stereotypes are felt beneath cold war fears: the specter of the yellow peril, in particular, finds its modern-day counterpart in a vast Sino-Soviet conspiracy directed against the West. Evidence of this terrifying conspiracy is everywhere: posters of both Stalin and Mao look down on the captive Americans as they listen to Yen Lo speak; while the research center, the Pavlov Institute, is named after the Russian scientist associated with the study of conditioned reflexes, the spymaster, Yen Lo, appears to be Chinese. (His presence points to American fears that the Koreans, America's actual enemy, were mere puppets of the Chinese.) These indications of a Sino-Russian conspiracy set the stage for still another drama infused with fears both ancient and modern. As we will see, Lieutenant Shaw's transformation into a robotic killer harked back to images of Fu Manchu even as it as reflected recent fears concerning the brainwashing of American POWs by their Korean captors.

The specter of brainwashing was certainly one of the most frightening and controversial issues surrounding the Korean War. If it assumed such a hold on the American imagination, it was at least in part because it seemed to explain the inexplicable: the striking degree to which American GIs—unlike the captured soldiers of other nations—collaborated with their North Korean captors. Underscoring the widespread nature of such collaboration, John D. Marks writes that "70 percent of the 7,190 U.S. prisoners held in China had either made confessions or signed petitions calling for an end to the American war effort in Asia. Fifteen percent collaborated fully with the Chinese, and only 5 percent steadfastly resisted. The American performance contrasted poorly with that of the British, Australian, Turkish, and other United Nations prisoners."[49] The hints of collaboration that leaked out during the war turned into a "flood," as Charles S. Young tells us, as soldiers began to return home with their stories.[50] The headlines screamed: "POWs Say Some G.I.s 'Swallowed' Red Line," "Bitter G.I.s Out to 'Get' Informers Among POWs."[51] Reeling from increasing evidence of widespread collaboration, America also had to deal with the defection of twenty-one Americans who elected to remain in Korea.

The distress occasioned by evidence of collaboration and defection was further heightened by an investigative report, written by journalist Eugene Kinkead, that appeared in the *New Yorker* magazine on October 26, 1957. (The report—which apparently had a great impact on Frankenheimer[52]—was later published as a book entitled *In Every War but One* [1959].) Kinkead argued that the phenomenon of widespread collaboration meant that the Korean War represented something unique in American history. No other war, he declared, witnessed "a wholesale breakdown of morale or wholesale collaboration with the captors. Moreover, whatever the rigors of the camps, in every war but one a respectable number of prisoners managed, through ingenuity, daring, and plain good luck, to escape. That one war was the Korean War."[53] Although Kinkead's damning charges did not go uncontested—it was pointed out, for example, that harsh winter conditions rendered escape impossible and that the soldiers had not been adequately trained in how to deal with captivity—it added to the shock occasioned by evidence of collaboration. "To betray the United States in this manner," writes Stephen Badsey of this phenomenon, "was both unprecedented and unthinkable, and the shock was felt at the very core of America's belief in itself."[54]

As Badsey suggests, the shock surrounding the issue of collaboration fed into a wider sense of unease that haunted America in the aftermath of the war. After all, the nation that had emerged so triumphant at the end of World War II had just fought a frustrating, perhaps futile, war with an enemy that it did not regard as a worthy match. Feelings of shock and self-doubt—what Young calls

America's "crisis of confidence"—were soon transferred to returning POWs. Not only did the soldiers seem to symbolize a larger failure of national will, but also, because of their prolonged exposure to the North Koreans, they were tainted by the tremendous aura of guilt that, in the McCarthy years, clung to every "Communist." "Their detention in communist hands," writes Callum MacDonald, "indeed their very act of surrender, made them ideologically suspect. They had been exposed to contamination by a system which many believed capable of almost superhuman feats of indoctrination and mind control."[55]

It was but a short step, of course, from a belief in "superhuman feats of indoctrination and mind control" to the specter of brainwashing. It was a specter that, as Marks writes, tapped into primal fears: "No mind-control technique," he declares, "has more captured popular imagination—and kindled fears—than hypnosis."[56] But it was also one—and this is the crucial point—that spoke more of myths and stereotypes, of the evil Dr. Fu Manchu and his mysterious brews, than of fact. For in respect to the indoctrination the captive soldiers suffered, the difference between fact and fiction was striking. The POWs had not been hypnotized or given mind-altering drugs. Instead, as noted psychiatrist Robert Lifton made clear in a 1961 work entitled *Thought Reform and the Psychology of Totalism: A Study of "Brainwashing" in China*, they had been subjected to a process of "thought reform" originally designed for the Chinese people. In the course of this process, American POWs underwent a process of intense indoctrination intended to win them over to the Communist cause: obliged to attend "political education" classes, they were subjected to psychological pressure as well as techniques of harassment and humiliation. But as the U.S. Army acknowledged, there was never any hint of the kind of brainwashing—marked by "superhuman feats of indoctrination and mind control"—that haunted the popular imagination. As Kinkead observed, "brainwashing . . . is a process producing obvious alteration of character. However the alteration is accomplished . . . the subject clearly ceases to be the person he was before. According to the repatriates' own accounts, the kind of severe measures required to effect a personality change were not employed at any time with Army prisoners."[57]

It is here, of course, in its depiction of brainwashing, that *The Manchurian Candidate* departs most dramatically from the realm of history and enters that of myth. It is here, too, that what I have called the tonal dichotomy of the film is most intense. For the film's portrayal of brainwashing clearly belongs more to the phantasmagorical world of Sax Rohmer than to the real world of recent history. If the "alteration of character" was by no means the goal of the Chinese Communists, it is at the very heart of *The Manchurian Candidate*. Lieutenant Shaw's handlers do not want to change his beliefs or values—to "remake him in the Communist image." They want something far more absolute and terrifying: to rob him

of his free will and his soul. Their goal corresponds to what Lifton describes as the very definition of brainwashing: an "all-powerful, irresistible, unfathomable and magical method of achieving total control over the human mind."[58]

Interestingly, *The Manchurian Candidate* was not alone in showing the ease with which "character" could be altered and personality "changed." Assuming various guises, the specter of brainwashing haunts still other films of the era. For example, a little known Korean War film released the same year as *The Manchurian Candidate, War Hunt* (Denis Sanders), also features a soldier who, like Shaw, becomes a kind of killing machine. In the wake of horrors seen and endured, he loses his mind and is unable to stop killing even after a cease-fire is declared. But the best-known examples of people transformed into robots are probably those that come to us from two classics of science fiction: *The Invasion of the Body Snatchers* (Don Siegel, 1956) and *The Night of the Living Dead* (George A. Romero, 1968). In both films, aliens invade and assume the bodies and minds of America's citizens. "They're taking us over cell by cell," cry the hapless human hosts of *The Invasion of the Body Snatchers*. It is precisely this invasion that has taken place within Lieutenant Shaw. Like the doomed humans in these science fiction films, he has been hollowed out from within—thrust into the world of the "living dead."

But if Shaw's terrible fate resembles that of the pitiful humans seen in *The Invasion of the Body Snatchers* and *The Night of the Living Dead*, his case differs from theirs in a crucial respect. It bears witness to the way cold war anxieties were heightened by the specter of the yellow peril. The lieutenant's soul is stolen from him not by amorphous enemy aliens like those evoked in a film like *The Night of the Living Dead* but by a very specific villain: the cunning Yen Lo. It is here that the ancient stereotypes haunting the film come into sharpest focus. For the man who brainwashes the lieutenant is nothing other than a latter-day incarnation of the villain who was, in the words of his creator, the "Yellow Peril incarnate in one man": Fu Manchu. It is no accident, certainly, that around the time *The Manchurian Candidate* was released, Fu Manchu had come back to life on-screen with a vengeance: featured in television series entitled *The Adventures of Fu Manchu* and *The Drums of Fu Manchu*, he was played by actor Christopher Lee in films that included *The Face of Fu Manchu* (Don Sharp, 1965), *The Brides of Fu Manchu* (Don Sharp, 1966), and *The Vengeance of Fu Manchu* (Jeremy Summers, 1967).

Of all the various incarnations of Fu Manchu that appeared at this time, it might be argued that no actual figure of the evil doctor was as chilling and powerful as the character of Yen Lo. Indeed, both the novel and the film of *The Manchurian Candidate* take care to remind us of Yen Lo's resemblance to Sax Rohmer's legendary villain. Novelist Richard Condon tells us that Yen Lo's "entire

expression was theatrically sardonic as though he had been advised by prepaid cable that the late Dr. Fu Manchu had been his uncle";[59] in the film, Captain Marco describes Yen Lo as a "Chinese cat smiling like Fu Manchu." But we hardly need such explicit reminders to see this resemblance. With his face masked by Fu Manchu's drooping mustache, Yen Lo exhibits the archfiend's disregard for human life, his sadistic cruelty, and—what is probably most important in terms of *The Manchurian Candidate*—his skill at and pride in controlling the minds of his victims. Indeed, in a film mentioned earlier, *The Mask of Fu Manchu*, the evil doctor gives a vivid demonstration of this last ability. Using a combination of strange elixirs and hypnosis—"You will think as I think," he commands a captive Englishman, "see as I see, and do as I command"—he transforms his hapless victim into a robotic slave, or what he calls a "projection of his will."

It is a similar ability that Yen Lo demonstrates in *The Manchurian Candidate*. Instead of mysterious poisons and elixirs, though, Yen Lo relies on more contemporary methods of mind control. Armed with the tenets of behavioral conditioning, he preys on his subjects' deepest weaknesses and subconscious impulses. Thus, he chooses Lieutenant Shaw as his victim not only because Raymond is an accomplished marksman or even because family connections allow him access to the highest levels of American politics. Above all, he is chosen because his psychological makeup—his conflicted relationship with his mother, his subservience to authority, and his emotional distance from others—renders him the perfect candidate for behavioral conditioning. As much as the lieutenant loathes his mother, he is also deeply attached to her and has never been able to defy her. It is for this reason that she is designated as his handler even as the image of the queen of diamonds is chosen as the perfect trigger for his trances. At the sight of the queen's icy and imperious figure, her son is as helpless as any of Fu Manchu's drugged and hypnotized prisoners. His brain has been not only washed but, in the words of a proud Yen Lo, "dry cleaned" (see fig. 4.1).

There is one last link between Fu Manchu and Yen Lo. As embodiments, new and old, of the yellow peril, both reflect a Manichean view of the world in which Western civilization is under siege. Just as the evil doctor dreams of conquering the West in *The Mask of Fu Manchu*, the conspirators of *The Manchurian Candidate* want nothing less than to topple the U.S. government. And at least in one important way, the threat embodied in Yen Lo may be even greater than that associated with Fu Manchu. For while the villain of *The Mask of Fu Manchu* nourishes his dreams of conquest from the steppes of Central Asia, Yen Lo has *already* made his way to the West: indeed, he seems perfectly at home in New York. And his presence in Manhattan is but the most overt indication that the "conquest" of America is well under way. For the conspiracy he helps launch hinges on domestic "traitors" who, ensconced in the highest reaches of power,

Figure 4.1. The Manchurian Candidate: A latter-day Fu Manchu demonstrates his brainwashing skills

can easily manipulate the American institutions—the press, Congress, the electoral process—needed for total control.

In the end, of course, this difference is telling. Pointing to the fear of betrayal from within, it suggests the sense of internal crisis and vulnerability that was so central to the paranoid style of the postwar era. Fueled by the loss of China and the outbreak of the Korean War, as well as fears of the atomic bomb, the anxious self-doubt that swept over the nation in the 1950s was part of what Harold Isaacs describes as a "larger loss so many Americans suffered at this time . . . most of all, perhaps, the loss of the hope and expectation that they could return to their private American world, the best of all possible worlds, and be free without fear or concern to enjoy it."[60] Similarly underscoring the feelings of loss and anxiety that marked this era, John King Fairbank declares that the "Great Fear of the early 1950s was an illness in the body politic induced by a pervasive feeling of insecurity about national defense and American values and vulnerability in liberal institutions."[61]

It is precisely this "great fear"—permeated by the sense of a "larger loss," of an "illness in the body politic"—that gives *The Manchurian Candidate* its special

cast. It is not only that the film portrays a nation threatened both by cunning foreign agents like Yen Lo and domestic traitors like the Iselins. It is also—in some sense above all—that these threats are so dangerous because of the rot, the "illness," that seems to be eroding America's institutions and beliefs from within. In the darkened America of the film, signs of weakness and corruption, of moral decay, of the withering of democratic institutions, are omnipresent. What Fairbank calls the "vulnerability" of liberal institutions could hardly be clearer or more dramatic: the two upstanding liberal figures in the film—the New York publisher who hires Shaw and the engaging senator who becomes his father-in-law—are murdered with brutal ease. And these murders are but the symptoms of a larger malaise. For the America portrayed here is one in which baseless demagogic accusations are gobbled up by the press and devoured by the public. Photo opportunities and media events have replaced real debate; the national convention—the very embodiment of the U.S. electoral process—has become a grandiose costume party, a grotesque spectacle for the antics of nonbelievers. Convictions and ideals—including distinctions between right and left—have crumbled. Even the lieutenant's mother, supposedly an arch-Communist, is motivated not by conviction but by a thirst for power together with a contempt for America and its institutions. Dreaming of a state so totalitarian that it will make "martial law seem like anarchy," she displays the kind of destructive nihilism that, suggests political journalist Richard Rovere, defined McCarthy himself. Deeming McCarthy "a species of nihilist," Rovere describes the senator as a "destructive force, a revolutionist without any revolutionary vision, a rebel without a cause."[62]

Embodied in Shaw's mother, the nihilistic wind that pervades the film sweeps up everything in its wake—the nation's signs and symbols, its past as well as its present. Toward the beginning, as if to foretell the blows that will be directed against the republic, a drummer's baton repeatedly strikes a drum bearing the symbol of the American eagle; later, in the course of the Iselins' costume party, a huge cake made in the shape of the nation's flag is greedily devoured and destroyed by impervious guests. Above all, though, it is the film's many allusions to the revered figure of Abraham Lincoln—the Iselins' home contains a portrait and a sculptured bust of Lincoln, while Iselin himself dresses as the sixteenth president for the their extravagant costume party—that suggest how far the nation has fallen. On the one hand, of course, the memory of Lincoln evokes the political assassination the Iselins are plotting.[63] On the other, it also calls to mind the difference between then and now—the chasm that separates what the nation was and what it has become. Seeing the drunken and craven Iselin dressed as the log-cabin president, we are inevitably reminded of what has happened to the republic. If Shaw has lost his soul, so, too has America. It is in this sense, I think, that

far from being devoid of politics, *The Manchurian Candidate* may well be, as Pauline Kael intuited at the time, "the most sophisticated political satire ever made in Hollywood."[64]

A virtual cry of despair about America, *The Manchurian Candidate* refuses us even the relatively positive ending set forth in Condon's thriller. In contrast to the novel, where the army and the FBI work together to thwart the carefully orchestrated murder of the presidential candidate, in the film it is Lieutenant Shaw—acting alone—who decides what must be done. In bleak and nihilistic landscape of the film, the military is as helpless in the face of the Communist threat as are the nation's political institutions. Only a lone gunman can foil the enemy plot. In fact, before he turns the gun on himself, Shaw explicitly tells us that there was no other way to stop the Iselins. The military, the FBI, the political process itself—all were impotent in the face of the threat they posed. "You couldn't have stopped them," he tells Marco, "the army couldn't have stopped them. I had to do it. . . . Oh God, Ben."

As Raymond's final despairing words make clear, the external Communist threat—embodied in domestic traitors and foreign enemies—and the sense of internal crisis and "illness" that pervade the film are ultimately inseparable. It is here, of course, that the nature of the Rorschach test that inheres to images of China becomes unmistakable. If fears of China loom so large—if Yen Lo and all he represents are so menacing—it is because America has lost confidence in itself and its place in the world. The threat from without—a threat fueled by the combined force of the yellow peril and the red tide—feeds on the perceived decay from within. The reassuring "private American world" of earlier times has vanished. Political institutions and structures, debates and elections—all have been conquered, rendered useless, by demagoguery, conspiracy, and fear. Those who would defend the republic and its values are destroyed by merciless and cunning enemies. They are stopped only by a lone gunman—a tortured soldier who has lost his soul. But the escape is a narrow one. And who, the viewer is left to wonder, will stop the next would-be dictator or enemy agent who threatens the republic? Who will be there when the next incarnation of Fu Manchu comes to town?

Imperial Ambiguities: 55 Days at Peking

In *The Manchurian Candidate,* the gaze is primarily inward. True, the threat of the yellow peril, embodied in Yen Lo, is very real. But the doctor can work his sinister magic only because America is rotting away from within. In contrast, *55 Days at Peking* looks outward—to the stage of global history. Directed, in part,

by Nicholas Ray,[65] the film is a historical epic that takes us back to one of the most fraught moments in the history of China's relationship to the West: the anti-Western Boxer Rebellion of 1899–1900. Indeed, it was at this time that the specter of the yellow peril first began to haunt the Western imagination. It is true that the term was coined even before Boxer insurgents terrified foreigners living in China; it was apparently first used by the German kaiser in the wake of a conflict—the Sino-Japanese War of 1894–1895—that prompted Western fears of a newly aggressive Asia. But it was the Boxer Rebellion that, fueling every negative stereotype bearing on China and the Chinese, brought the yellow peril vividly to life. By the time the rebellion was over, the term—which appeared in the 1901 edition of the Oxford dictionary—had officially entered the language.

Most of *55 Days at Peking* can be seen as a vivid, spectacular reenactment of that peril. Grafting cold war anxieties on the past, it provides a perfect illustration of how images of the yellow peril merged with those of the cold war. At first glance, the film seems to have little or nothing in common with the bleakness of *The Manchurian Candidate*. I say that not only because *55 Days at Peking* follows the well-worn conventions of adventure and spectacle, but also—in some sense above all—because it provides a triumphalist reading of the American past. That is, it seems to erase or repress the self-doubts and anxieties that give *The Manchurian Candidate* its special cast. Still, even here—in a fairly conventional epic that appears to celebrate America and its values—one senses some of the malaise that left such a dark imprint on Frankenheimer's thriller. For example, no less than *The Manchurian Candidate*, *55 Days at Peking* is also permeated by a telling confusion or paradox: it both denies and yet justifies U.S. complicity in nineteenth-century Western imperialism in China. Moreover, as if this denial did not suffice—as if to reassure itself still further about America's conduct in the past—the film contains a curious subplot designed to underscore the benevolent and innocent nature of the U.S. presence in China. Hinting at the shock and denial that surrounded the loss of China, these ambiguities and insistences inevitably raise an issue that has grown more pressing with every passing decade: the United States' conflicted attitude to the very idea of empire.

From the perspective of the twenty-first century, the fears of Chinese "barbarism" awakened by the Boxer Rebellion have undoubtedly been eclipsed by those that accompanied the red scare of the 1950s and 1960s. Still, there is no question that, well into the twentieth century, the Boxer Rebellion had an enormous impact on Western perceptions of China and the Chinese. "The Boxer War of 1900," writes Jerome Ch'en, "engaged more Western pens and consumed more Western ink than any other event before the communist revolution of 1949."[66] And no moment of the Boxer Rebellion was better known, or induced more fear in the West, than the episode portrayed in *55 Days at Peking*: the so-called siege

of the legations. For fifty-five days in the summer of 1900, Boxer troops besieged the Peking district that housed the foreign compounds, or legations, where Chinese converts and foreigners—drawn mainly from the diplomatic community of the imperial powers—had taken refuge.[67] (The right to establish permanent foreign legations in the Chinese capitol was wrested from the Chinese by Western imperial powers in 1860.) In fact, as John King Fairbank remarks, it was largely because of the siege that the Boxer Rebellion became so notorious. "The Boxer Rising in the long, hot summer of 1900," he writes, "was one of the best-known events of the nineteenth century because so many diplomats, missionaries, and journalists were besieged by almost incessant rifle fire for eight weeks (June 20–August 14) in the Peking legation quarter—about 475 foreign civilians, 450 troops of eight nations, and some 3,000 Chinese Christians."[68]

The rebellion that would culminate with the siege of the legations began with the formation of the so-called Boxers—a Chinese secret sect that combined a belief in magic spells and spiritual powers with techniques drawn from traditional martial arts practices and shadow boxing (hence the English name Boxers). Many of its initial members came from the desperately poor northern provinces of China. There, the vagaries of nature (the year 1898 saw a great flood followed by a plague of locusts and a terrible drought), combined with the depredations of nineteenth-century imperialism, had rendered the lives of China's poor unendurable. In the eyes of the Boxers, foreigners were to blame for many of the ills that had fallen upon them and their country. As Diana Preston points out in a history of the Boxer Rebellion, while the influx of cheap foreign goods had hurt native workers, artisans, and manufacturers, the introduction of "foreign technology"—that is, steamboats and railroads—dealt a blow to Chinese laborers who worked on barges along the canals or hauled freight using camels and mules.[69] Summing up the desperate state of the Chinese economy in these years, historian Immanuel C. Y. Hsü writes that "by the end of the 19th century, the country was beset by bankruptcy of village industries, decline of domestic commerce, rising unemployment, and general hardship of livelihood. Many attributed this sorry state of affairs to evil foreign influence and domination of the Chinese economy."[70]

Convinced of this "evil foreign influence," the Boxers directed much of their xenophobic wrath—a Boxer slogan from 1899 urged people to "support the Qing, wipe out the foreigners"—against those foreigners they knew best: Western missionaries. In the eyes of the Boxers, as Paul A. Cohen observes, the missionaries—who constituted a quarter of the foreign community in China—were "the only concrete manifestation of the foreign intrusion and, as such, the only flesh-and-blood object against which opposition to this intrusion could be directed."[71] In addition to their role as the most concrete face of Western imperialism, mission-

aries were also detested because, in their evangelical zeal, they threatened to undermine ancient Chinese customs and beliefs such as ancestor worship.[72] "Catholics and Protestants," declared Boxer placards, "have vilified our gods and sages . . . conspired with the foreigners, destroyed Buddhist images, seized our people's graveyards. This has angered Heaven."[73] Moreover, the Christian converts—who enjoyed special legal privileges by virtue of their newfound religious status—were a further source of friction and resentment. Often referred to disparagingly by other Chinese as "rice bowl" Christians—that is, people who had converted solely to fill their bellies—they were sometimes more hated than the missionaries. Doubtlessly, the Dowager Empress Cixi spoke for many when she called the Chinese Christians "the worst people in China. They rob the poor country people of their land and property, and the missionaries, of course, always protect them."[74]

The hatred and resentment that the Boxers nourished toward Westerners in general, and toward missionaries and their converts in particular, finally erupted in the summer of 1900. Preying on vulnerable or isolated Westerners, groups of Boxers killed missionaries in provincial stations as well as foreigners working on the railroad. The Boxer threat reached a dramatic climax in the course of the events depicted in *55 Days at Peking*: the siege of the foreign legations. Surrounded by Boxers, besieged foreigners and Chinese coverts erected what Jonathan Spence describes as "barricades of furniture, sandbags, timber, and mattresses."[75] Increasingly beset by fear, hunger, and illness (especially dysentery), they finally saw their plight come to an end when troops sent by the imperial powers routed the Boxers. As foreign troops marched into Peking, the dowager empress, disguised as a peasant, fled with her court to the ancient capital of Xi'an. Although the empress subsequently returned to Peking, the Boxer defeat had momentous consequences for China and its rulers. Not only did foreign powers loot the imperial palaces and the Chinese capital but they demanded huge indemnities of the Chinese even as they staked out further claims to Chinese soil. As for the Manchu court—which was profoundly humiliated by this crushing defeat—it entered the twilight phase that, eleven years later, would end with the fall of the last Chinese dynasty.

A milestone in China's long march toward modernity, as suggested earlier, the Boxer Rebellion had a profound impact on Western perceptions of China. It confirmed and exacerbated every stereotype and fear that surrounded China in the Western imagination. "In film, fiction, and folklore," writes Paul A. Cohen, the Boxers "functioned over the years as a vivid symbol of everything we most detested and feared about China—its hostility to Christianity, its resistance to modern technology, its fiendish cruelty, its xenophobia, its superstition. Arguably, by extension, the Boxers were emblematic of the range of negative associations

Westerners in the twentieth century have had concerning the non-West in general."[76] It was the rare Westerner who, like Pearl Buck, acknowledged that the Boxers had ample reason to detest not only foreigners in general but missionaries in particular. Recalling that she and her family had to flee their missionary station during the Boxer Rebellion, years later Buck would observe that "we had to take our place with our own kind, guiltless though we were, and we had to suffer for their guilt."[77] In utter contrast with Buck, however, the vast majority of her countrymen saw the Boxers as the very embodiment of Chinese backwardness and heathen cruelty. They were, as a contemporary poem had it, "pitiless" and "alien." Vividly evoking the Boxers' attack on Westerners, the poem read:

> Millions of yellow, pitiless, alien faces,
> Circle them round with hate;
> While desperate valor guards the broken places,
> Outside the torturers wait.[78]

Interestingly, both the poem and the fears it expresses reflected not only contemporary reports of the siege but also the fictional portrait of a clash of civilizations found in a widely read and highly influential potboiler that appeared in 1898, shortly before the Boxer Rebellion. Written by English novelist M. P. Shiel, and entitled, unambiguously, *The Yellow Danger,* the novel is dominated by a villain who is clearly a precursor of the greatest Chinese villain of the twentieth century: Sax Rohmer's Fu Manchu. No less than Fu Manchu, Shiel's protagonist—a man called Yen Low—harbors a taste for torture, a hatred of the West, and a thirst for global conquest. Born of a Chinese mother and a Japanese father, he combines, in his person, what Shiel called the "antagonistic races." Consumed by a "secret and bitter aversion to the white race," in his quest for power, Yen Low begins by massacring all the Westerners in China. Then, turning the Chinese population into a vast army, he leads his troops—men and women Shiel describes as a "plague of locusts" and a "human worm"—westward to Europe. Conquering all the nations in their path, they finally arrive at the city that has been designated as the "new capital" of the "yellow races": Paris. Amidst unimaginable horrors—impaled heads ringing the Place de la Concorde, "screaming Chinese" playing with "bodiless heads and arms"—the City of Lights falls to Yen Low's Asiatic hordes. Only the foresight and cunning of a sole Englishman—a man who has been tortured by Yen Low and thus knows the "Chinaman's" mind—thwarts the villain's ultimate goal: the conquest of the British isles.

Vivid and terrifying, the imaginary horrors described by Shiel seemed, in the eyes of many Westerners, to come to life with the outbreak of the Boxer Rebellion. The reports of Boxer atrocities that reached the West were haunted by

Shiel's nightmare images of an apocalyptic struggle between East and West—one marked by the presence of implacable and savage Asian hordes. Soon these images were joined by others: stories of martyred priests, of helpless Chinese converts dragged to their deaths, and of foreigners besieged by "pitiless" and "alien" yellow faces implanted themselves in the Western imagination. And for generations, as James Hevia tells us in *English Lessons: The Pedagogy of Imperialism in Nineteenth-Century China,* the Boxer Rebellion would be seen as "an assault on innocent people who had come to China to give selflessly to improve the conditions of the Chinese people."[79]

It was not until the mid-1970s that these images began to give way as revisionist historians in the West began to question the firmly entrenched and distinctly one-sided story of the Boxer Rebellion—what Paul Cohen calls the "myths" surrounding the Boxers[80]—that had held sway for nearly three-quarters of a century. The first blow came from Sir Hugh Trevor-Roper: in a work entitled *The Hermit of Peking,* he revealed that a supposedly firsthand account of the Manchu court and the rebellion that had been accepted as gospel by generations of Western historians, Sir Edmond Backhouse's *Annals and Memoirs of the Court of Peking,* owed more to the author's counterfeiting skills and his fevered (and often pornographic) imagination than to historical fact. Before long, traditional views of the siege were put into question: for example, both Sterling Seagrave and historian Immanuel Hsü argue that besieged Westerners were saved not by their own valor but by the moderation and restraint exercised by the commander of the Chinese forces, Jung-lu.[81] More broadly still, revisionist historians took care to place the Boxer Rebellion in the larger context of Western imperialism in China. Deeming the Boxer affair a "monument to Western hypocrisy" rather than Chinese "treachery," Seagrave maintains that additional Western troops were sent to Peking not to "rescue" the legations—as legend and myth have it—but to start a shooting war with China that would allow them to seize "as much territory as possible before the empire fell apart."[82] Similarly, Hevia gives ample evidence of the greed and arrogance of the imperial powers. After describing the looting and savagery the foreign powers indulged in after their victory, he recounts how they sought to humiliate and punish not only the Boxers but the entire Chinese population. "Violence," he writes, "was directed at the Chinese people themselves, who, unlike the population of 1860, were no longer considered innocent, but collectively responsible for the siege of the legations, deaths of missionaries, and destruction of Western property."[83]

If the myths surrounding the Boxer Rebellion have been largely dismantled in recent decades, to be reminded of the force they exerted for well over a half century one has only to look at *55 Days at Peking.* It is not only that the film brings these myths to life in a particularly concrete and vivid fashion. It is also

that it turns them into a kind of palimpsest through which one can discern cold war fears and anxieties. As seen here, the Boxer Rebellion harks back to the clash of civilizations evoked by writers like Shiel and Sax Rohmer even as it suggests the cold war vision of a world divided in two. What Seagrave describes as the "waves of maddened Boxers [who threatened] brave Western defenders" are not only a latter-day incarnation of the murderous hordes of Genghis Khan but also the precursors of the troops that fought U.S. forces to a standstill in Korea.[84] While China's duplicitous ruler in the film contains more than a hint of Chairman Mao, the "benevolence" displayed by the film's American protagonist seems to reflect the outraged self-righteousness the loss of China provoked. Above all—at least from the standpoint of the present day—the film's implicit justification of America's participation in an imperial war points to contemporary anxieties concerning the use of American forces in far-off lands.

Set in the tense period that preceded the siege and during the siege itself, *55 Days at Peking* resembles a kind of Oriental Western. Although it sprawls in many directions, its main focus is on a contingent of American marines that comes to the rescue of besieged foreigners in Peking in much the way an army unit in the old West might have rescued a fort or an outpost of settlers threatened by marauding Indians. And as in the case of many Westerns, in *55 Days at Peking* individuals are imbued with the weight of ideology. Thus, on the side of Western civilization we find an American and an Englishmen. Both are played by charismatic stars: Charlton Heston appears as Major Matt Lewis, the commander of the American marine contingent sent to Peking; David Niven is Sir Arthur Robertson, a wise and judicious diplomat who serves as the British ambassador to Peking. On the other side of the ideological divide are, of course, the principal Chinese characters. (All, not surprisingly, are played by Westerners.) While one of the leading Chinese characters, General Jung-Lu (Leo Glenn), is an admirable figure, he is overshadowed both by the cunning Prince Tuan (Robert Helpmann) and, above all, by the scheming and duplicitous dowager empress (Flora Robson) (see figs. 4.2 and 4.3).

If, indeed, there is a villain in the piece, it is the dowager empress. In respect to her character, history and myth stand starkly opposed. Sheridan Prasso tells us that historians writing after her death in 1908 describe the Chinese ruler as an "admirable and sympathetic" young woman who was "strikingly pretty and well-proportioned: graced with delicate hands, arched eyebrows, a high nose, full well-shaped lips, a stunning smile, and a sweet feminine voice."[85] Amplifying this positive portrait of the empress still further, Pearl Buck describes her as "a fine calligrapher" who "loved flowers [and] had a magnetic and enchanting way with birds and animals, so that she could coax wild birds to come to her at call, and cicadas to sit upon her wrist while she stroked them with her forefinger."[86] When

it comes to myth rather than history, however, the "fine calligrapher" who loved flowers and birds totally disappears. Instead, in Seagrave's words, the empress becomes a "ruthless, single-minded tyrant, an iron-willed, over-sexed Manchu concubine who usurped power in 1861 to rule China with perversion, corruption and intrigue for half a century."[87]

It is, of course, the dowager empress of myth—the "ruthless, single-minded tyrant" who ruled with "perversion" and "corruption"—that comes to life in *55 Days at Peking*. Judging by her portrait here, it is not hard to understand why she has often been seen as the prototype of the stereotypical Chinese dragon lady. Tall and serpentine, rendered even taller by a ceremonial headdress, in *55 Days at Peking,* she displays, like Fu Manchu, the viciously long fingernails of a savage beast. Surrounded by fawning courtiers and opulent splendor, she calls to mind the cruel and icy princess of Puccini's 1925 opera, *Turandot*. No less than Puccini's despotic ruler—who condemns her would-be lovers to death when they fail to decipher her mysterious riddles—the dowager empress exhibits a profound indifference to human life. To placate the Western powers, she casually, shockingly, has a group of Boxers beheaded and calmly warns her counselors that their lives, too, will be forfeited if their advice proves faulty. As duplicitous as she is

Figure 4.2. 55 Days at Peking: The Boxers savagely disrupt a diplomatic function

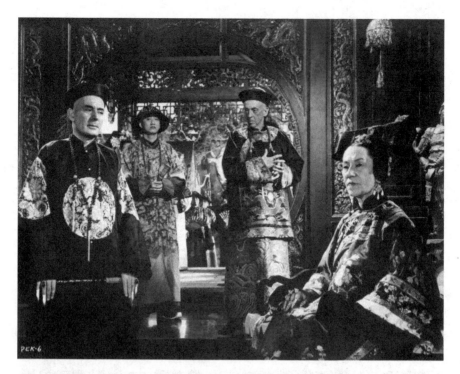

Figure 4.3. 55 Days at Peking: The dowager empress (Flora Robson), General Jung-Lu (Leo Glenn), and the duplicitous Prince Tuan in the background (Robert Helpmann)

cruel, she manipulates and deceives both her countrymen and the assembled foreign diplomats. Even as she commits imperial troops to the Boxer cause, she has Prince Tuan reassure the diplomats of her desire for peace.

The combination of cruelty and cunning that defines China's ruler extends, of course, to the Boxers. Early in the film, they display a talent for the "exquisite" methods beloved by Fu Manchu: in an important scene, the Boxers strap a missionary to a turning wheel that periodically drags him through a pool of water so that he will die by a process of slow asphyxiation. Quick to make others suffer, the Boxers are also cowards in battle, as a duel between a Boxer and Major Lewis reveals. Moreover, in contrast to the well-defined Westerners of the film, the Boxers usually appear as a faceless mass of anonymous beings. Reduced to silent phantoms—we never hear an individual Boxer speak—the Boxers resemble an invincible army of robots as, again and again, they attempt to scale the legation walls. Dressed, strikingly, in white garb and red headbands, their every

appearance accompanied by an ominous drumbeat, they cannot help but evoke frightening and long-standing images of Asiatic barbarism—that is, of the "barbarian hordes sweeping all before them by sheer numbers and rapacity."[88]

Together with the duplicity of the dowager empress, the cruelty and inhumanity of the Boxers, represent, of course, one-half of conventional Western narratives of the Boxer Rebellion. The other half, obviously, bears on the behavior of Westerners—the men and women seen as "innocent people who had come to China to give selflessly to improve the conditions of the Chinese people." In this respect, too, the film hews closely to the narratives that took shape at the time of the rebellion. Casting a sympathetic light on the besieged Westerners, it erases any hint that their behavior contributed to the violence. Take, for example, its portrayal of a notorious incident—the murder of a German diplomat—that brought fears in the foreign community to fever pitch. Although the film portrays his murder as an act of wanton violence, in truth, the diplomat had deeply provoked the Chinese: not only did he abduct and kill a young Chinese boy, but he ordered German legation guards to shoot unarmed Boxers. Nor is this the only significant erasure in *55 Days at Peking*. The film carefully omits any hint of racial prejudice and cultural arrogance on the part of Westerners. From this account of the siege, we would never know that the Chinese converts were not only carefully segregated from Westerners but also denied important rations. Without food, the men and women whose very presence was used to justify the missionary enterprise were reduced to eating leaves, twigs, and tree bark.

In almost every respect, then, *55 Days at Peking* testifies to the persistence, and the cold war resonance, of the myths surrounding the Boxer Rebellion. But this is not the only reason that the film is of interest here. It is also because even here—in a triumphalist film that celebrates Western bravery and heroism—one senses some of the uneasy justifications and confusions that run throughout so many films of the era. Not surprisingly, as in the case of *China Gate*, unease and confusion are most intense when it comes to America's complicity in the kind of imperial venture that the nation had always condemned: in this case, the suppression of the Boxer Rebellion. After all, not only was this a quintessential imperial venture—one in which foreign powers aligned themselves against a nationalist uprising—but it was also one that saw the United States allied with the very nation from whom it had won its own independence: Great Britain. Like the United States' later role in Indochina/Vietnam, the one the United States played in nineteenth-century China went to the core of America's self-image: allied with architects of empire like Britain and France, how could we continue to view ourselves as a beacon of democracy and self-determination for the rest of the world?

To some extent, in nineteenth-century China, history—or, more precisely, the dynamics of nineteenth-century imperialism in China—came to the United

States' aid. As John K. Fairbank makes very clear, the very fact that Great Britain led the imperial charge in China enabled the United States to maintain the fiction of its historical innocence. Simply put, as Fairbank observes, the United States could both pursue, and yet implicitly deny, its imperial interests precisely because Great Britain occupied a preeminent position in establishing and maintaining the unequal treaty system imposed on that country in the wake of the first Opium War. In other words, the United States could benefit from the concessions and treaties wrung from China by Great Britain and the other foreign powers without establishing concessions of its own—concessions that would have provided unalterable proof that the United States, too, was involved in the race for imperial gain.[89] Protected by British gunboats and British bankers, America had no vital decisions to make, says Fairbank, except to say "me, too" when it came to dividing the spoils of empire. And the fact that Great Britain freed the United States from what Fairbank calls the "moral burden" of aggressive action meant that Americans could embrace what he describes as "a holier-than-thou attitude, a righteous self-esteem, an undeserved moral grandeur in our own eyes that was built on self-deception and has lasted into our own day."[90]

Just as *55 Days at Peking* embraces the myths of the Boxer Rebellion, so, too, does it demonstrate the presence of this "righteous self-esteem." To cleanse America of the shadow of its imperial past, the film resorts to a variety of strategies. Two of these have already been mentioned in connection with *China Gate*. To begin with, just as Fuller's film turns the Communist revolutionaries into monsters, so, too, does *55 Days at Peking* transform the Boxers into enemies so inhuman that, forgetting the broader context of the rebellion, we cheer their defeat. Second, *55 Days at Peking* also resembles *China Gate* in that it, too, explicitly condemns, and yet implicitly justifies, the presence of the Western powers in China. This time, the explicit condemnation comes not in the prologue—as it does in Fuller's film—but from the mouth of the dowager empress. In several powerful speeches, China's ruler rails against the ways in which the foreign powers have destroyed her country. Likening China to "a prostrate cow," she declares that "the powers are no longer content to milk her. They are butchering her for her meat." But the very fact that these speeches, powerful as they are, are uttered by this cruel and calculating tyrant renders them suspect. That is, the very presence of the empress—the symbol of China's corrupt, decadent, feudal government—suggests that China is not ready to govern herself and that she *needs* the Western powers.

Nor does the presence of the scheming empress exhaust the case in favor of the Western imperial presence in China. The man who is the virtual incarnation of Western imperialism—the British diplomat, Sir Arthur—is portrayed in an immensely sympathetic light. One could hardly imagine a starker contrast than

that between the duplicitous empress and the eminently likable British diplomat. Indeed, in order to render him so sympathetic, the film had to take great liberties with the historical record. The actual British minister to Peking at the time of the Boxer Rebellion, Sir Claude MacDonald, was, writes Diana Preston, a fairly pedestrian professional soldier "whose elevation to head the legation in Peking puzzled many."[91] In contrast, the selection of the fictional Sir Arthur to this post would puzzle no one. The very model of a patient elder statesman, Sir Arthur is a deeply introspective man who wins the heart of the spectator by his moderation, his devotion to principle, and his idealism. Urging the foreign powers to "walk softly" and refrain from provoking the Chinese, he dryly reminds the American major—who is given to action rather than words—that they are not in the "Wild West": "We can't shoot the Chinese," he says, as if they were "red Indians." When this most reasonable of men maintains that the foreigners must remain in Peking to fight for a "principle," it is the rare viewer who asks the difficult, yet fundamental, question: that is, what is the principle that the admirable Sir Arthur is determined to uphold if not the less-than-noble desire for imperial gain?

As a statesman who implicitly legitimizes the British presence in Peking, Sir Arthur is clearly an important character in his own right. But as suggested earlier, he takes on additional ideological resonance by virtue of his relationship with the American major. For example, the friendship that blossoms between them when they carry out a dangerous mission together becomes a microcosm of the long-standing "special friendship" between their two countries. Tied to each other by bravery and friendship, both men—reflecting what Diana Preston calls the "cultural bias" of Anglo-Saxon narratives[92]—offer a sharp contrast with the rather effete and egotistical diplomats from the Continent. But along with these important similarities go differences that are no less important—or less telling. In fact, I would argue that it is through the differences between the two heroes that the film implicitly expresses a desired image of America.

It is true, of course, that in part the differences between the two men are personal and psychological. For example, unlike the gruff and fiercely independent major, who has no ties to home or family, the British diplomat is a deeply paternal figure—one who acts as a kind of paterfamilias to the major as well as to the larger community of foreigners in Peking. But along with individual psychological differences goes a broader spectrum of national traits. The rough-and-tumble major who shoots from the hip is as American as the cautious and careful diplomat is British. And if the marine major's obvious preference for action over words constitutes the temperamental trait of an individual, it also expresses a particularly American wariness in the face of words, diplomacy, and charm. In light of this broader perspective, it is significant that in the cultural tug-of-war embodied in the two men, it is almost always the American major whose view of

the world is proven correct. Sir Arthur's diplomatic attempts to ward off the coming crisis may be well meaning and admirable, but as Major Lewis sees from the outset, such attempts are doomed to failure. Among the assembled diplomats, only the American sees that the empress cannot control the Boxers and that the use of force will be inevitable.

Above all, though, the differences between the American major and the British diplomat—these two men who are so alike and yet not alike—bring us back to the ambivalences shrouding American attitudes toward empire. For I would argue that the semipaternal role played by Sir Arthur in respect to the American major mirrors that played by Great Britain in terms of nineteenth-century imperialism in China. As we have seen, it was this role—that is, the assumption of the mantle of empire—that allowed America to lay claim to its historical innocence and moral superiority. And, indeed, the film takes every occasion to underscore this claim. For example, while Sir Arthur and the other diplomats are reluctant to leave China because they fear for their concessions, the American major—supremely indifferent to material concerns—urges all foreigners to leave while there is still time. Moreover, his apparent indifference to imperial gain is reiterated by still another American official within the film: the American minister to Peking. Played by none other than Nicholas Ray, the minister appears only once in the film; but this brief appearance allows him to emphasize the major's sweeping disdain for the economic concerns, the preoccupation with concessions, that preoccupy all the other foreign representatives in Peking. Implicitly making the case for American exceptionality, the minister tells the assembled diplomats that the United States has no territorial concessions in China. "We never asked for one, don't want one," he declares emphatically.

The holier-than-thou attitude that characterizes both the minister and the major is reinforced, one last time, toward the end of the film. Here, we watch as American soldiers march out of Peking as soon as reinforcements arrive. The scene's implication is unmistakable: while the other foreign nations will enjoy the fruits of victory, the Americans want nothing to do with the spoils of empire. In this sense, the scene is as morally comforting as are the major's repeated assertions of indifference to imperial gain. But it is also—and this is the important point—historically inaccurate. Contrary to what we see, America did indeed participate in the gains that resulted from the Boxer affair. Ignoring this vital fact, the film erases still another fact that may be even more disturbing. That is, Americans took part in the orgy of looting and theft that occurred in the Chinese capital once the empress had fled. As a very lucid, and deeply melancholy, Pearl Buck wrote, "We are only relatively innocent . . . for in those days after 1900 when white armies punished the Old Empress so bitterly, when her palaces were looted

and incalculable treasures stolen from Peking by soldiers and officers with equal greed, Americans were among the white men."[93]

If the film's repeated assertions of American innocence often run counter to the historical evidence, they also testify, of course, to the intensity of our desire to cling to the moral high ground—to dissipate the haze of guilt surrounding America's intervention in China at the time of the Boxer Rebellion. And, judging by the film, even these assertions were not enough to cleanse us of the stain of an imperial past. For the film contains an important subplot that demonstrates a virtue no less central to America's desired self-image than its innocence: its benevolence. In fact, to make this virtue very clear, *55 Days at Peking* has the major step into a role that films usually reserve for missionaries: that is, he comes to the rescue of a Chinese orphan.

In *55 Days at Peking,* the Chinese orphan who benefits from the major's benevolence is a beautiful teenage girl, Teresa (Lynne Sue Moon). The daughter of a Chinese woman and a marine in the major's regiment, Teresa is an immensely sympathetic character: pure and innocent, she is also stoic and brave. When we first meet her in the film, she has recently lost her mother. Before long, her father dies—the victim of a Boxer attack. It falls to the major, as her father's commanding officer, to tell her of her father's death. Deeply affected by the young girl and by her sad plight, the major is further distressed at the thought that her father's solemn promise to her—that he would take her to America—will not be fulfilled. For her part, Teresa is touched by the major's concern and begins to love and care for him as she did her father. She is filled with sorrow as the major and his regiment prepare to leave Peking once the siege is over. But just as the soldiers are about to leave the city, her sadness turns to joy. Suddenly, the departing major—who has been moved by Teresa's devotion to him—swoops down from his horse, lifts the young woman up, and places her behind him. As the two ride off into the future, the viewer has no doubt that the major, now a surrogate father, will fulfill her father's promise and take her to America.

Teresa's tale is doubtlessly one of the more curious digressions in *55 Days at Peking.* It is true that the film is full of secondary characters and incidental events: for example, in addition to Teresa's tale, another subplot features Ava Gardner as a beautiful Russian countess who is love with the major. Still, Teresa's story seems particularly out of place. It is not only that the story of a poor orphan seems better suited to a film like *The Inn of the Sixth Happiness*—in which Ingrid Bergman stars as a courageous and dedicated missionary who leads a bevy of lovable Chinese orphans to safety in war-torn China—than to a Hollywood adventure epic featuring action heroes. It is also that it raises a host of unanswered, troubling questions. Most of these concern Teresa's mother: how did she die? How did she

meet the young American soldier? (After all, presumably he was not stationed in China before his regiment was sent to Peking.) Were her father and mother married? Or was her mother just the passing fancy of a young soldier or, more likely still, a prostitute?

The mysteries regarding Teresa's past are accompanied, moreover, by questions or incongruities bearing on the major's behavior. As a tough-talking, cynical military man, in essential ways, the American major represents a typical Nicholas Ray hero: like so many of Ray's characters, the major is an independent loner who lives by his own code and cares little for society's values or expectations. Unable to commit himself to the beautiful Russian countess who loves him deeply, he embodies the loners or the "nomads," to borrow a term from film critic Peter Wollen, who populate Ray's cinema. ("If Nicholas Ray's films have a thematic 'signature,'" writes Wollen, "it lies in this fascination with the impossibility of going home."[94]) All this renders him the most improbable of saviors. It is difficult to think that this archetypal masculine hero—this military nomad who has always resisted lasting ties—would assume the burdens and responsibilities of surrogate fatherhood. And not only does he return home at the end of the film but he also brings with him a young girl for whom he is now responsible.

The important point is this: if the subplot is less than convincing on a narrative or psychological level, it is instead totally coherent from an ideological viewpoint. Seen from this last perspective, for example, the background of Teresa's mother's *cannot* be mentioned. After all, the very idea of sex or marriage between whites and Asians leads to the troubled zone of miscegenation—a zone which might well tarnish Teresa's purity. More important, though, the relationship between the vulnerable and touching orphan and the soft-hearted major reminds us of the benevolence that justified the U.S. imperial presence in nineteenth-century China. The courageous and innocent Teresa is the perfect recipient for the major's benevolence: she exemplifies all her suffering compatriots who, in a film like *The Inn of the Sixth Happiness,* are rescued by American missionaries. And from an ideological (if not psychological) viewpoint, the major is also perfectly suited to his role. As an American marine, he is the very embodiment of his country. By rescuing Teresa—by literally becoming her guardian—he implicitly justifies his nation's presence among the other foreign powers in China. In other words, he gives a perfect demonstration of what Isaacs described as the "elaborate structure of guardianship, benevolent purpose, sympathetic good will, and high moral intent that . . . surrounds the American self-picture in China and the Chinese"[95] (see fig. 4.4).

In the final analysis, like *55 Days at Peking* itself—or, for that matter, like almost all America's representations of China—Teresa's tale is less about China and its tumultuous past than it is about America and what Isaacs calls its "self-

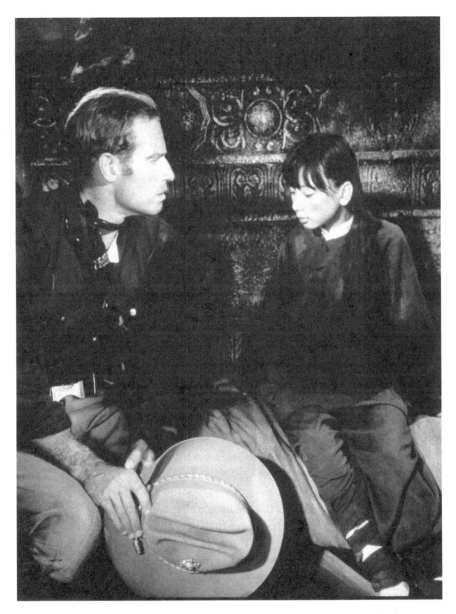

Figure 4.4. 55 Days at Peking: Benevolence on display as the American Marine (Charlton Heston) befriends a Chinese orphan, Teresa (Lynne Sue Moon)

picture." It is a self-picture that corresponded perfectly to its era. It is hardly coincidental that at a moment when America was engaged in creating one of the greatest empires in history, the film seemed determined to underscore the nation's lack of imperial designs. Reinforcing the keenly desired image of a country marked by a special destiny, *55 Days at Peking* obscures and represses historical realities even as it emphasizes American innocence and benevolence. But even at the time the film was made, this image—however ardently desired—was under siege. For the Vietnam War had begun to cast the darkest of shadows on this particular self-picture of America. It is precisely that shadow—refracted through the prism of 1920s China—that is discussed in the last film explored in this chapter, *The Sand Pebbles*.

The Fog of War: The Sand Pebbles

Like *55 Days at Peking, The Sand Pebbles*—a 1966 film directed by Robert Wise and based on a 1962 novel by Richard McKenna—is also a historical epic that filters the chaos of history through the adventures of individuals. And it too, brings to life a historical moment—in this case, the so-called Nationalist surge of the 1920s—when China witnessed a wave of xenophobic violence that reflected, and fueled, anti-imperialist sentiment. But the similarities between the two films end there. For in terms of its tenor and, ultimately, its meaning, *The Sand Pebbles* is radically different from *55 Days at Peking*. While *55 Days at Peking* is a triumphalist and rousing adventure tale dominated by conquering heroes, *The Sand Pebbles* is an introspective and tragic saga of people overpowered by the tidal wave of history. Here, in a landscape darkened by Vietnam, the anxieties about empire that lay below the surface of *55 Days at Peking* are voiced on several levels. Rereading the past in terms of the present, the film implicitly links American intervention in China's Nationalist conflicts of the 1920s to the doomed war in Southeast Asia that would take place nearly half a century later. As it does so, it casts a somber light on the very notion of American innocence. In this film, China is no longer a place that allows America to lay claim to its benevolent guidance. Rather, it has become a murky mirror that reflects nothing but the folly and tragedy of American intervention in Asia.

In a sense, *The Sand Pebbles* echoes, in the realm of foreign policy, the dark look that *The Manchurian Candidate* cast at America's domestic institutions. Like Frankenheimer's thriller, it, too, is marked by a telling paradox. As suggested earlier, in *The Manchurian Candidate* the paradox bears on the fact that the film seems to parody McCarthy even as it endorses the senator's paranoid view of the world. A similar phenomenon—one marked even more explicitly by fears of

China—is visible in *The Sand Pebbles*. On the one hand, the film—clearly permeated by the doubts and anxieties regarding American intervention abroad that arose at the time of Vietnam—decries U.S. intervention in 1920s China. On the other hand, it suggests that the threat the United States combated in China in the 1920s—one embodied in Chinese Bolsheviks or Communists—was very real. Further, this tension is accompanied by the same kind of tonal dichotomy—between a realistic America and a mythic China—seen in *The Manchurian Candidate*. For while *The Sand Pebbles* is keenly attuned to the ever-changing tremors of the American psyche, it portrays China as if it were frozen in time—the prisoner of long-standing images and stereotypes.

Set at a critical moment in the history of modern China, *The Sand Pebbles* unfolds against a background of chaos and conflict. It takes place in the era when the Guomindang (Kuomintang), or National People's Party, led by General Chiang Kai-shek after the death of Sun Yat-sen in 1925, was attempting to unify a country in which power was dispersed among various warlords and regional commanders. To consolidate power, in 1926 Chiang launched what became known as the Northern Expedition: starting from Guangzhou in the south, with the help of organizations of students and workers he took his armies north. In 1927, he purged the party of radicals and Communists; the following year, he achieved his principal goal when he reached Beijing and unified most of the country under his command.

Marked by a tremendous upsurge of Chinese nationalism, this crucial period also witnessed a renewed wave of antiforeign sentiment. As at the time of the Boxer Rebellion, many Chinese blamed imperialism for the ills that beset their country. By this time, the Chinese had lost any hope that the outcome of World War I might result in new, less onerous treaties between China and the colonial powers. Instead, the hated machinery of imperial oppression—the presence of foreign concessions, troops, and gunboats; the imposition of unequal treaties and tariffs; the invocation of the principle of extraterritoriality exempting foreigners from Chinese law—continued to undermine China's sovereignty even as it fueled a growing sense of national humiliation. As China's founder, Sun Yat-sen, put it, his country was not merely "the colony of one nation but of all, and we are not the slaves of one country but of all."[96] Similarly decrying China's exploitation at the hands of foreign powers, the 1924 Manifesto of the First Congress of the Guomindang declared that imperialism had pushed the nation into the "hell of a semi-colonial status."[97]

In 1925, simmering Chinese bitterness and resentment toward foreigners erupted dramatically in the nation's most Westernized city, Shanghai. A labor dispute in a Japanese-owned factory escalated into riots and antiforeign demonstrations. In attempting to quell the violence, the British-led police of the International

Settlement fired into a crowd of students and workers, killing twelve Chinese people and wounding seventeen others. Soon, news of these events prompted antiforeign strikes and boycotts throughout the nation. "All of China," writes Paul A. Varg, "was set aflame. Everywhere there were meetings and strikes. The antiforeign movement, sporadic and scattered until now, became general as a result of the drama in Shanghai."[98] City after city—especially those in the Yangtze Valley (which had the greatest concentration of Western traders and missionaries)— witnessed outbreaks of violence against foreigners. In early 1927, frightened British subjects had to be quickly evacuated from Wuhan (Hankow) when a mob broke into the British concession; later that year, in Nanjing (Nanking)—which would become the Nationalist capitol in 1928—the British, Japanese, and American consulates were looted and several foreigners, including one prominent American, were killed.

Despite the growing violence, the United States maintained a policy of moderation and restraint toward China. "American officials," writes Dorothy Borg in a study of Sino-American relations during this period, "took great pains to make it clear that American soldiers were expected to limit their action to insuring the safety of United States citizens primarily from the attacks of uncontrolled mobs."[99] American moderation was doubtlessly prompted by various factors: sympathy for the Nationalist cause; lack of popular support for military intervention; the belief, on the part of the administration, that aggressive action would only further endanger the lives of Americans in China. (This policy also gave President Calvin Coolidge the opportunity to distinguish American restraint from Great Britain's more bellicose stand.) But of course, it was one thing to endorse a policy of moderation; it was another to establish the parameters of intervention and to see how this policy might affect American nationals in China. Indeed, as *The Sand Pebbles* makes clear, this policy did little to help—and in some ways actually hurt—the two groups of Americans in China most affected by xenophobic violence: the military men who manned the gunboats that patrolled Chinese waterways and the men and women who served there as missionaries.

American missionaries, in particular, found themselves in a difficult and often conflicted situation. This was especially true of those who, like Pearl Buck, were younger or more liberal. On the one hand, they resisted the use of imperial force to counter antiforeign violence. Not only were they fearful that the use of such force would compromise their Christian message,[100] but by this time many also were sympathetic to the Nationalist cause. Noting that "the nationalist movement in the 1920s . . . scorched the conscience of the more liberal missionaries," Lian Xi writes that as missionaries "came to share Chinese perspectives on the missionary implication in Western imperialism, the question over missions became . . . one of legitimacy—of possible hidden wrongs and evils."[101] On the other

hand, they had to rely for protection on the very gunboats whose presence they decried. Expressing this existential dilemma in a moving passage of her autobiography, *My Several Worlds,* novelist Pearl Buck describes the swirl of conflicting emotions that assailed her when she and her family were rescued from antiforeign violence in Nanjing by American gunboats. "All my life," she confessed, "I had seen those gunboats on the river, and I had wished that they were not there. I had felt they should not be there, foreign warships in Chinese interior waters. Now such a ship was saving me and mine and taking us to a refuge. I was glad not to die, but I wished that I had not needed to justify, against my will, what still I knew to be wrong."[102]

But if missionaries were in a difficult position, so, too, were those who manned the American gunboats. In the eyes of many Chinese, such gunboats were the very symbol of Western imperialism. Their presence dated back to the mid-nineteenth century when, in the wake of its defeat in the Opium Wars, China had been forced to grant foreign gunboats the right to patrol internal waterways. Charged to guard against pirates, bandits, and warlords, the gunboats were to make the rivers safe for commercial vessels and to protect American lives and interests. But as *The Sand Pebbles* shows very vividly, as violence escalated in the 1920s, the gunboats' task became increasingly problematic. For one thing, gunboats were charged with protecting even those missionaries who, prompted by sympathy for the Nationalist cause, criticized the presence of foreign military vessels. For another, the inherent contradictions of American policies—which demanded that American seamen both respect China's sovereignty and, at the same time, uphold the edifice of nineteenth-century imperialism, which clearly undermined that very sovereignty—rendered their task virtually impossible. "The navy," writes Bernard Cole, "was faced with the task of executing the often contradictory policies of protecting American lives and property in China, while at the same time not interfering in the internal affairs of the revolutionary society which was directly threatening those lives and interests."[103]

Seen from a still broader perspective, of course, what Cole calls the "contradictory policies" that governed military action in 1920s China reflected the desire—discussed earlier in connection with both *China Gate* and *55 Days at Peking*—that America could both participate in the imperial system and yet somehow retain its historical innocence. Underscoring this impossible desire, Bernard Cole implicitly draws a line of continuity between America's contradictory policies in 1920s China and the shock occasioned by the loss of China in 1949. It was at that time, he says, that these contradictory policies—which had remained firmly in place for nearly a century—were finally, and traumatically, revealed as such. Mao's victory, he writes, revealed nothing less than "the emptiness of the so-called special relationship between China and the United States."[104] Extending this

line of continuity still further, one might well argue that if U.S. policy of the 1920s set the stage for the shock of 1949, then it was the loss of China that prepared the ground for the trauma of Vietnam.

In a sense, it is this line of continuity—one wreathed in unrealistic desires and inherent contradictions—that is at the heart of *The Sand Pebbles*. Here, the past sets the stage for the present even as earlier layers of history are imbued with contemporary anxieties. Ostensibly focused on a group of individuals affected by the maelstrom of violence that swept over China in the 1920s, the film is also a meditation on various layers of Sino-American history. As suggested earlier, the principal characters represent the two groups of Americans—the missionaries and the military—most touched by the rising tide of Chinese nationalism and the contradictory American policies it engendered. Caught in a vortex of escalating violence, the protagonists are torn between competing claims that are both political and existential. Depicting the plight of missionaries who, like Buck, both opposed and yet needed the presence of gunboats, the film also underscores the dilemma of soldiers faced with impossible, and often futile, military orders. In the dark and somber world of *The Sand Pebbles,* virtually all the protagonists—Chinese and American—are helpless before the onrush of history. They are as powerless—as the very title of the film implies—as sand pebbles tossed about in the tide.

The figure at the center of this vortex is an American sailor, a ship's engineer named Jake Holman (Steve McQueen). As the film opens, we are in Shanghai, in 1926, and Holman has just received word that he is to join the crew of the *San Pablo,* an American gunboat charged with patrolling the Yangtze. The evening before his departure, Jake wanders into a kind of restaurant/dining hall where, seated at a communal table, he meets a diverse group of people who give different opinions concerning the presence of foreign powers in China. On one side of the political divide is an American missionary, Mr. Jameson (Larry Gates), who is headed for a remote missionary station named China Light. Fierce, devoted, and liberal, he denounces the presence of gunboats even as he rails against the entire edifice of nineteenth-century imperialism. Insisting that "we can't threaten [the Chinese] into being our friends," he maintains that foreign gunboats are a "symbol of what the great powers have done to China." On the other side of the political and ideological spectrum is a man who seems to be a British merchant (Ben Wright). Observing that missionaries need gunboats to protect them from the hatred of many Chinese, he argues that China is not a sovereign nation but rather a "patchwork of bandits, mobs and warlords"—a place where justice is not only summary but often barbarous. Challenging the liberal missionary, he asks him a question that ominously foreshadows later events: what would you do, he says, if there were no gunboats to rescue you from Chinese mobs?

The day after this revealing dinner, Jake is headed upriver to join his ship. On the ship that takes him there, he meets a young American schoolteacher, Shirley Eckert (Candice Bergen), who was at the dinner the previous evening. As they speak, we have our first glimpse into Jake's character. A shy and diffident loner, he tells the young woman—to whom he is obviously attracted—that he has no use for what he calls "military crap." Once Jake is on board the *San Pablo*— which is nicknamed the *Sand Pebbles* by the marines on board—it becomes abundantly clear why he despises the military. Despite the fact that the ship is a decrepit vessel with a modest mission, its starchy captain (Richard Crenna) behaves as if he were on a real warship engaged in important military maneuvers. (The ship was apparently modeled on the *USS Villa Labos,* a Spanish ship seized during the Spanish-American War.[105]) A pompous officer given to military clichés, the captain reminds the men that their trade involves the "give-and-take of death" and that they are there to "serve the flag." His actions match his words: he makes his men perform meaningless military drills while the hardworking Chinese coolies who live aboard the ship take care of everyday tasks (see fig. 4.5).

Figure 4.5. The Sand Pebbles: Jake (Steve McQueen) about to embark on his fateful voyage

As Jake settles into life aboard his new ship, he makes two important friends: one is his assistant, a Chinese coolie, Po-han (Mako), who shares his devotion to the ship's engine; the other is a fellow marine, Frenchy (Richard Attenborough). In different ways, both point to the racism that prevails in the military. Like all the coolies, Po-han is treated with contempt by the American sailors; as for Frenchy, military rules prevent him from marrying the Chinese woman, Maily (Emmanuelle Arsan), whom he loves. Along with Maily, Po-han and Frenchy are the first victims of the ever-expanding spiral of violence that will eventually engulf all the protagonists. While Frenchy dies for reasons of love—he catches a chill when he swims ashore through frigid waters to join his beloved Maily—Po-han and Maily fall victim to political violence. They are victims of a propaganda strategy that the Bolshevik/Communist faction of the Nationalist Party has devised to create "martyrs" for their cause. As part of this strategy, when Po-han goes ashore, he is captured and tortured by an infuriated mob; it is hoped that this will provoke the marines aboard the *San Pablo* to disobey orders and fire into the crowd, thus producing some martyrs. Although the American sailors obey orders and hold their fire, Jake—who cannot bear to watch his friend suffer—ends Po-han's life. But the Bolsheviks/Communists are still determined to have their martyr. To this end, they kill the grieving Maily and attempt to frame Jake for the crime. This time, the strategy is more successful: Chinese junks soon approach the *San Pablo* and demand that Jake be delivered to Chinese justice. Although Jake's fellow marines—who are crazed with inaction and on the verge of mutiny—are willing to hand him over to the Chinese, the captain manages to defuse the incident.

By now, however, the captain himself has been pushed to the breaking point. Shamed and traumatized by the near mutiny, deeply frustrated by orders that forbid him from taking action, he momentarily contemplates suicide. But then the news that Nationalist troops have killed foreigners in Nanjing prompts him to hatch a fateful plan: he will lead the *San Pablo* upriver to rescue the endangered foreigners living at the remote missionary station upriver, China Light. He cares little that the missionary in charge, the liberal Jameson, had disregarded earlier warnings to evacuate the station. Resorting to the military vocabulary he loves, the captain declares that if the *San Pablo* has to "die," she will "die clean" by making one "last savage thrust into China."

Heading upriver to begin this "thrust," the *San Pablo* soon encounters a blockade of Chinese junks. In the course of ferocious fighting, Jake commits an act that fills him with sadness and despair: he unknowingly kills a young protégé of the American schoolteacher—an idealistic young Chinese man, Cho-jen (Paul Chinpae)—he had met during an earlier visit to the missionary station. Despair only grows when he and the others finally reach China Light, for the American

soldiers find themselves angrily repelled by the missionary, Mr. Jameson, they have come to save. True to his principles, Jameson refuses to abandon his station even as he utters a scathing critique not only of the captain's military ethos but of the entire edifice of Western imperialism. "We will not serve," he tells the captain, "to give meaning to your heroics." Declaring that he and the others at the station have officially renounced nationality and statehood, he cries, "Damn your flag, damn all flags. It is too late in the world for flags." Even as he speaks, it is indeed clear that it is already too late. For at this point, Chinese troops—who have learned of Cho-jen's death—storm the compound and kill both Jameson and the captain. Jake diverts the attention of the Chinese attackers long enough for the schoolteacher to flee. As Shirley escapes with her life, Jake asks a final, anguished, question before he, too, dies. "What the hell happened?" (See fig. 4.6.)

With Jake's death in the desolate courtyard of the mission compound, the film's dark portrait of a misguided mission comes to an end. As futile as it was tragic, the doomed mission encapsulates the film's bleak mood and somber political message. Indeed, it would be difficult to envisage a more striking contrast between the mission carried out by the English and American heroes in *55 Days at Peking* and the "savage thrust" led by the suicidal captain of the *San Pablo.*

Figure 4.6. The doomed American seamen—Frenchy, the captain, Jake—of The *Sand Pebbles:* "All forms of American intervention stand condemned"

Here, the triumphalist sweep, the heroes and heroics, of a film like *55 Days at Peking* have vanished. In their stead, we have a decrepit and paralyzed ship, a half-mad captain who dreams of military glory, and a diffident loner caught in a policy of misplaced patriotism and unleashed military ardor. It is a mission that speaks not of military glory but of suicidal illusions. Speaking of the three dead protagonists (the captain, the missionary, and Jake) lying in the mission courtyard at the end of the film, French critic Guy Gauthier underscores the film's despairing message as well as its broader political resonance. "United by a shared destiny," he writes, "there is the blind military man haunted by the values of his profession, the pacifist missionary who opposed armed intervention, and the brave soldier who was indifferent to politics but faithful to friendship and love. Condemning all forms of colonial intervention . . . [the film offers] a welcome message coming at the time of Vietnam."[106]

Gauthier is not wrong. Just as the success of the mission in *55 Days at Peking* celebrates and justifies American intervention in China at the time of the Boxer Rebellion, the failure of the mission carried out by the *San Pablo* indicts the much broader American policy in China. In the end, the blame for the *San Pablo*'s misguided mission lies less with individuals than with what Cole calls the "inherent contradictions" of U.S. policy in China. Neither the captain (who leads the "savage thrust") nor the missionary (who refuses to evacuate) is truly responsible for the bloodbath: inculcated with rigid military values, the captain remained true to the flag just as the unyielding missionary obeyed a higher calling. Fulfilling their assigned parts in an absurdist scenario, they are the victims and the agents of a deeply contradictory national policy. "Why are we fighting," asks an all-too-lucid Jake, "when China is not our enemy?"

The Sand Pebbles does more, however, than challenge U.S. policies in 1920s China or even "all forms of colonial intervention." Opening upon a still broader horizon, it also throws into question the long-standing impulses—the sense of innocence and benevolence—used to justify and rationalize the nation's imperial ventures. How, after all, can one speak of innocence when gunboats like the *San Pablo* are patrolling China's internal waterways? "How would you like it," asks Jameson succinctly, "if Chinese ships were sailing up the Mississippi?" And how can one speak of benevolence when virtually every contact between Americans and Chinese is shadowed by guilt? Take, for example, even the relatively impersonal relationship between the American marines and the Chinese coolies who live and work aboard the *San Pablo*. At first glance, although manifestly unequal, this relationship seems mutually beneficial: the Americans are freed from menial work while the coolies earn a much-needed salary. But below the surface, both groups are damaged: the Americans become racist and sybaritic while the coolies' dependency on the Americans makes them deceitful and manipulative.

When it comes to more personal relationships, the consequences are darker still. True, Americans are often prompted by the best of intentions: a generous Frenchy rescues Maily from being deflowered in a Chinese brothel; Jake takes Po-han under his wing; Shirley acts as mentor to the promising Chinese Nationalist Cho-jen. But before long, all these relationships take a fateful turn. It is, albeit indirectly, because of her involvement with Frenchy that Maily is killed by her own people. As for Jake, despite the best will in the world, the young sailor becomes the unwilling instrument of the death of both Po-han and Cho-jen. And the film's indictment of American benevolence goes further still. That is, the missionary enterprise—the very embodiment of American benevolence in China—is seen as an agent of doom: engendering Chinese hatred, it serves as a pretext for Western military action.

As suggested earlier, in its indictment of colonial intervention, as well as its dark mood, *The Sand Pebbles* seems to reflect the sense of despair and disillusion, of sorrow and anger, that overtook the nation at the time of Vietnam. When the *San Pablo* is trapped in the shallow waters of an inland lake, the ship's plight might be taken as a metaphor, of America trapped in a war that we could neither win nor end. In an important way, moreover, *The Sand Pebbles* may even say more about the dynamics and failures of the war in Vietnam than do later films explicitly devoted to that struggle. For while works such as *Apocalypse Now* (Francis Ford Coppola, 1979), *The Deer Hunter* (Michael Cimino, 1978), and *Platoon* (Oliver Stone, 1986) capture the surreal savagery and the terrible difficulties of the war—the impossibility of distinguishing friend from foe, the treacherous terrain of the jungle, the madness lurking at the edges—they do not offer the broad historical overview that flows from the very structure of *The Sand Pebbles.* That is, in exploring the inherent contradictions, as well as the often deadly consequences, of American policies in 1920s China, *The Sand Pebbles* lays bare the long-standing attitudes that set the stage for America's later intervention in Southeast Asia. Permeated by different layers of history, *The Sand Pebbles* suggests that the war in Vietnam was not, as many claimed, an aberration—a kind of metaphysical "horror" in the jungle, as we are told in a famous scene in *Apocalypse Now.* Rather, it was the almost inevitable consequence of a long-standing political policy of imperial intervention—one that, years earlier, had sent gunboats like the *San Pablo* to patrol China's waters.

Drawing a clear line of continuity between U.S. intervention in China in the 1920s and the morass of Vietnam, *The Sand Pebbles* indicts the Pax Americana even as it paints one of the darkest self-portraits of America seen in films of the era. But, of course, *The Sand Pebbles* is not only about America or American history. It is also about China and a critical moment in its history—one that saw the nation embark on its long path to power and modernity. And, significantly, when

it comes to China, the sense of historical continuity and coherence so visible in the film's portrait of America vanish. Indeed, the striking thing is that even here—in a film that challenges imperialism and racism—America and China are portrayed in very different ways. Not only does *The Sand Pebbles* obscure a crucial period in the history of modern China, but it takes us back, once again, to an unchanging world in which ancient images are felt beneath more recent fears. Once again, history gives way to myth even as confusions come to the fore. Although, as suggested earlier, the film indicts American intervention in 1920s China, it is not prepared to acknowledge that the enemy the United States fought there—the Communists or, as their virtual predecessors, the Bolsheviks—represented anything other than a force for evil. And while *The Sand Pebbles* has nothing but sympathy for victims of racism—for men and women like Po-han or for Maily and Frenchy—it comes perilously close to reinforcing long-lived racial stereotypes.

In comparison with a film like *55 Days at Peking*, of course, the racial and cultural biases that permeate *The Sand Pebbles* are relatively subtle and muted. But they come into very sharp focus when *The Sand Pebbles* is seen in relation to the novel upon which it is based. Although Wise's film is generally faithful to Richard McKenna's novel, it makes telling and important changes in respect to China and the Chinese. To begin with, the film consistently mutes, or flattens, the nuanced portrait of Chinese psychology that runs throughout the novel. A good example of this consists of the different ways novel and film portray the Chinese coolies who live and work aboard the *San Pablo*. In the novel, McKenna uses Jake's reactions to, and thoughts about, the coolies to make it clear that the Chinese workers are very different from the way they appear to Jake's fellow seamen. That is, as Jake gets to know the coolies, he begins to question the racist reactions they inspire in others—reactions he initially shared. His fellow marines, he thinks to himself, "thought they knew all about the coolies and they did not know anything." Whereas his fellow marines see the coolies collectively as a "kind of machine" that keeps the ship in order, the young engineer perceives them as individuals. "They all had their individual laughs and grins and gestures and so much play and expression in their faces that Holman wondered why he had even thought that Chinese faces were blank." As Jake enters into their mindset, he begins to appreciate their jokes and insults even as he gains a newfound respect for their careful workmanship. They are, he muses, "careful, steady workers and they [have] a grave respect for their tools and the machinery, such as few sailors [have]."[107]

Described as "careful, steady workers," as distinct individuals rather than a collective mass, the coolies of the novel offer a sharp contrast with the Chinese workers of the film. There, Jake's important reflections concerning the coolies are

eliminated, with the result that the viewer sees them through the biased eyes of Jake's fellow marines. Viewed from this perspective, the picture is not a pretty one: fawning and superstitious, the Chinese workers seem spiteful, manipulative, and deceitful. Obsessed with status and face, they also speak a strange pidgin English that gives them a distinctly childish cast. This is true even of Jake's assistant, the intelligent and resourceful Po-han. All these negative traits are underscored in an important scene that occurs early in the film. Here, a newly arrived Jake goes into the bilge to inspect the engine—a task formerly reserved for coolies. As he does so, the head coolie, fearful that Jake will make him lose his job and his status, throws a deadly switch that nearly kills the young engineer. After this demonstration of spite, jealousy, and indifference toward human life, it is difficult not to share the scorn the coolies inspire in the American marines.

If the coolies represent one dimension of Chinese life, then Cho-jen—the young revolutionary intellectual who is mentored by the American teacher, Shirley, at the mission station China Light—represents another. And if the coolies can be said to represent the stagnation of the "old" China—the China of caste divisions and rigid hierarchies, of female oppression and superstition—then Cho-jen represents the new. This makes it all the more significant, I think, that his role is changed radically in the film. In the film, Cho-jen is a distinctly secondary character, limited to two brief scenes. In the novel, in contrast, he is not only an important character but perhaps *the* most admirable character in McKenna's saga. Indeed, it is hard to disagree when, after Cho-jen's death, someone at China Light tells the captain that the young revolutionary was "worth more to humanity than you and your crew twice over." Intelligent and idealistic, Cho-jen is an ardent patriot and a born leader—a man graced, as his mentor and friend Shirley puts it, with not only "volcanic energy" but also, perhaps, "authentic genius." He is also, as the film makes clear, the bravest and most loyal of friends: despite his desire to see all foreigners leave his country, he protects and defends Mr. Jameson when other revolutionaries demand the missionary's head.

Moreover, in addition to his personal qualities and charisma, Cho-jen also sheds light on China's struggle to shake off the yoke of its feudal and imperial past. The grassroots organization he belongs to, which is composed of workers, students, and peasants, reminds us of the social and cultural goals that accompanied China's march toward independence and modernity. That is, Young Nationalists like Cho-jen embraced a vision of the revolution that would bring with it social, cultural, and educational reform. It is through him, too, that we come to fully appreciate the fervor of the nationalistic feelings that swept over China in the 1920s. Describing his faith in the Nationalist Party to Shirley, Cho-jen waxes eloquent about the need for China to rule itself. "It is the People's Party," he says of the Nationalists, "we have secret student groups everywhere in China. . . . We

will sweep away all the warlords. . . . We will send away all the foreign gunboats and soldiers. We will make the same kind of laws against Americans that America makes against Chinese."[108]

Imbued with patriotic fervor, Cho-jen's long speeches in the novel have one last important dimension. They explain some of the complicated historical and political realities of the era—especially those bearing on the ideological schisms and internecine struggles of different revolutionary factions. In one particularly important expository speech, Cho-jen clarifies why the Bolsheviks were intent on procuring martyrs for their cause. As he carefully explains, the Bolsheviks embraced this strategy because of fears—which, in fact, were soon realized—that Chiang Kai-shek would betray the revolution. They wanted martyrs in order to provoke a confrontation with the West that, they hoped, would ensure the future of the revolution. Hinting at the Nationalist leader's coming betrayal of the Left, Cho-jen describes a persistent rumor "that Chiang Kai-shek was about to lead the conservative wing of the Kuomintang in a counter-revolution against the entire worker-peasant movement . . . To do so successfully, he would have to bow to the unequal treaties in order to get treaty power support, and the revolution would be lost. But if the radical wing could force a war with one or more of the treaty powers first, they would prevent that. They would make the revolution Bolshevik instead, because then all the support would have to come from Russia."[109]

In the novel, then, Cho-jen's role resonates in many ways. An idealistic patriot who sheds light on the Byzantine political realities of the era, he is also a revolutionary deeply embedded in the most important currents of his time. In fact, it would hardly be an exaggeration to say that his presence is critical to our understanding and appreciation of the depth and complexity of the revolution. But the corollary to this is also true. That is, the greatly diminished role that he plays in the film means that this understanding and appreciation vanish. True, one can understand why the film effected this important change. Even as it stands, *The Sand Pebbles* has a tendency to be confusing: thick and sprawling, it is full of secondary characters and plotlines. (Indeed, at one point Wise remarked that the film might have benefited from the elimination of some characters and story lines.) But if Cho-jen's diminished role made dramatic sense, as I have just suggested, it exacted an important political and ideological price. For it means that we lose both the sense of revolutionary idealism and ardor he embodies as well as the light he sheds on political issues and events of the era—including those bearing on the duplicity and ruthlessness of Chiang Kai-shek. Thus, not only does *The Sand Pebbles* implicitly whitewash the figure of the Nationalist leader—a man incessantly celebrated by the China Lobby and greatly admired by many Americans—but it also reduces the revolution itself to a simplistic and familiar scenario. Stripped of its quest for social justice, the revolution is portrayed as a

nationalist movement inspired almost solely by a thirst for unification and a hatred of warlords and foreign powers.

If the scenario of the revolution is all too familiar, so, too, are the villains at its heart: the precursors of the Chinese Communists—the Bolsheviks. In the novel, as we have seen, the Bolsheviks' quest for martyrs is part of a political strategy to keep the revolution alive. But this is not the message of the film. On the contrary, as the captain of the *San Pablo* tells us in a crucial scene, the Bolsheviks are inspired by pure "hatred." The scene begins as he issues an ominous warning to his men: commanding his men to hold their fire even in the face of Chinese provocations, the captain cautions that they must not give the Russians a pretext to join the war. The Bolsheviks, he continues, "unify people by getting them to hate." Before long, the film makes it clear that the captain's fear of Bolshevik-inspired hatred is well-founded: in their quest for martyrs, the Bolsheviks kill the innocent Maily and deliver Po-han to a ferocious mob bent on torture. In the absence of the explanations provided by Cho-jen in the novel, we have little choice but to accept the captain's declaration that these actions are inspired, as he says, by sheer hatred and evil.

Like so many of the Chinese villains explored in this chapter, then, the Bolsheviks are at the intersecting point where memories of the yellow peril seem to merge with, and fuel, fears surrounding the red scare of the cold war era. But here they play an additional role insofar as they also point to the uneasy coexistence of the different layers of history that permeate *The Sand Pebbles*. One level, of course, is embodied in the Bolsheviks: harking back to the villains of earlier films, they evoke the cold war landscape of a film like *55 Days at Peking* in which moral choices seemed clear and guilt and innocence unmistakable. But in other respects, this is not the landscape of the film. Unlike *55 Days at Peking*, *The Sand Pebbles* is not about an epic clash of opposing civilizations but a highly nuanced and melancholy meditation on historical illusion and folly, on deadly dreams of empire. The murky moral climate of the film is one in which benevolence is shadowed by death and America's mission is put into question. In this world of shades of gray, only the Bolsheviks—like the relics of an earlier historical moment—are cast as the blackest of villains.

Testifying to a profound historical disjunction, the Bolsheviks—in their essentialist cast—also point to the tonal dichotomies discussed earlier in terms of *The Manchurian Candidate*. As in Frankenheimer's thriller, America and China are portrayed in very different ways. Once again, America is firmly ensconced in the world of history. Indeed, much of the melancholy of the film stems from the implicit, yet insistent, contrast between a remembered, or imagined, image of America and what that image has become. If in the past America was seen as a beacon to the world, in the film it has become an imperial power

whose mission could not be more confused or misguided. When it comes to China, however, these layers of the past—along with the complicated realities of modern Chinese history and politics—vanish. The motives and features of the enemy blur—are they Bolsheviks? Soviets? Nationalists?—as, once again, we enter an unchanging world of myth. Here, familiar figures—fawning coolies and ferocious mobs, hapless victims and evil villains—play out their assigned roles. The character who could bring us into the world of history—Cho-jen—is banished to the furthest reaches of the narrative. In this darkest of Rorschach mirrors, a defining moment in China's past becomes little more than a melancholy landscape upon which to project America's mournful present.

The World Splits in Two

From Shangri-La to Dharma-La

In terms of twentieth-century screen representations of China, films of the cold war era act as a kind of historical fulcrum. Looking back, they endow ancient stereotypes like that of Fu Manchu with a new—and sometimes not-so-new—guise. Looking forward, in their Manichean view of the world they set the stage for the spate of intensely negative cinematic images of China found in several films of the 1990s. I am thinking of works such as *Little Buddha* (Bernardo Bertolucci, 1994), *Red Corner, Seven Years in Tibet* (Jean-Jacques Annaud, 1997), and especially of the film that is explored at some length in this chapter—Martin Scorsese's *Kundun* (1997).

Like films of the cold war era, those of the 1990s came after a period of détente between America and China. In the decades following President Nixon's 1972 meeting with Chairman Mao, Americans were full of admiration for the achievements and seeming social harmony of modern China. China's "social discipline," wrote an idealistic Arthur Miller, "is unquestionably profound and in contrast to the anarchistic selfishness, corruption and crime that everyone laments in America and the West."[1] But the moment of friendship and goodwill reflected in Miller's remarks was followed by still another dramatic swing of the pendulum—this one sparked by the massacre that occurred at Tiananmen Square on June 4, 1989. Even before that watershed date, in fact, reports of the excesses and hysteria of the Cultural Revolution of 1966–1976 had begun to leak out to the West. But it was the sight of Chinese troops firing on peaceful student protestors that gave the pendulum governing images of China a violent push. Broadcast around the world, the sight of helpless protestors mowed down by Chinese soldiers evoked images of Oriental despots, of Chinese barbarism and cruelty, of an age-old indifference to human life.

If the events at Tiananmen Square brought America's "infatuation" with China to a sudden and brutal end, they also ushered in a period marked by rising

tensions between America and China. "A decade that began," writes Warren Co-hen, "with the United States breaking off high-level contacts for the brutal sup-pression of pro-democracy demonstrations ends with the Chinese canceling mili-tary and political dialogues to punish the United States for killing Chinese in Belgrade."[2] Along with tensions between the two countries went anxieties con-cerning the fate of Hong Kong once the former British colony reverted to Chinese rule. Indeed, Kenneth Chan argues that it was the fate of Hong Kong that, more than any other single factor, prompted the intensely anti-Chinese stance of the films released in the late 1990s. In his view, these films represent a "strategically timed reaction to the return of Hong Kong to the People's Republic of China. Though these films do not directly depict the handover per se, they do address its political implications through their portraiture of Chinese ideological and mili-tary aggression and its disregard for human rights, a not-too-subtle index of what the West conjures as the terrifying political fate awaiting Hong Kong."[3]

I am not sure that these films were as haunted by the fate of Hong Kong as Chan suggests. Not only do they make no mention of Hong Kong (as Chan ac-knowledges) but, also, they bear directly on a country that has become a virtual flashpoint for fears of China: Tibet. Indeed, while the memory of Tiananmen Square is fading into the past, and few Westerners remain anxious about Hong Kong, China's virtual annexation of Tibet in 1949 continues to raise passions and controversies. This issue was very much on display, for example, in the course of the 2008 Summer Olympics, hosted by China. Months before the games began, protests in favor of Free Tibet erupted in Lhasa, Tibet's capital city; later, when the Olympic torch began its so-called Journey of Harmony around the globe, it encountered demonstrations in Paris and India; and, fi-nally, the games themselves were marred by protests.[4] Since that time, scarcely a day goes by that we are not reminded of the consequences of Tibet's sad fate: we read of Chinese violations of human rights in Tibet, of protestors jailed and monks "re-educated," or, worse still, of monks who immolate themselves in pro-test against Chinese rule.

If, indeed, there is a single issue that is virtually guaranteed to evoke the worst possible images of China in the Western imagination it is the status of Tibet, or the so-called Tibet question. Commenting on a Chinese crackdown in Tibet in the spring of 2008, *New York Times* columnist Nicholas D. Kristof sug-gested that it was all too easy to fit Tibet into the conflicting narratives of history and politics embraced by China and America. "To Americans," he wrote, "Tibet fits neatly into a framework of human rights and colonialism. To Chinese, steeped in education of 150 years of 'guochi,' or national humiliation by foreigners, the current episode is one more effort by imperialistic and condescending foreigners to tear China apart or hold it back."[5] A few months later, in the face of the furor

surrounding the Olympic Games, he declared that Tibet "is one of the major shadows over the Olympics and over China's rise as a great power, sullying its international image and triggering unrest that is likely to worsen in coming years."[6] Further underscoring the resonance of this "shadow," an unequivocal Donald Lopez argues that the issue of Tibet "continues to be the most persistent of China's public relations problems. Long after the horrors of the Cultural Revolution could be ascribed to the excesses of dead leaders, the Tibet problem remains."[7]

China is not unaware of this "problem"—or of the important role Western films play in creating sympathy for Tibet and antipathy for China. In fact, Chinese authorities were so disturbed by *Kundun*—which is probably the most partisan and the most powerful of all the films reflecting what China expert Orville Schell calls the Tibet "craze" of the 1990s[8]—that they apparently made veiled threats to its producer, Disney, concerning the company's interests in China. "Disney," writes Jim Sangster in a study of Scorsese's films, "called on former Secretary of State Henry Kissinger to advise them on the best way forward but ultimately backed Scorsese completely."[9] (Scorsese tells a somewhat different story—he has suggested that Disney "buried" the film from fear of China's reactions.) At least in part to counter Western films sympathetic to Tibet, in 1997 the Chinese made a film in which they advanced *their* version of history: *Red River Valley* depicts Chinese and Tibetans fighting against turn-of-the-century British imperialists in China. But this fairly conventional propagandistic epic was hardly a match for big-budget films by some of the West's most prominent directors.[10]

The films of the Tibet craze took a variety of forms. In some, the Tibet "problem" seemed to hover around the edges. This is the case, for example, in *Little Buddha*, an English-language film made by Italian director Bernardo Bertolucci. (Years earlier, before the pendulum governing images of China took a violent swing, Bertolucci had made what was essentially a pro-Chinese epic, *The Last Emperor* [1987].) In fact, at least initially, *Little Buddha* seems to deliberately avoid the realm of politics. A dreamy celebration of Tibetan Buddhism, the film weaves between past and present as it intercuts scenes tracing the life of Lord Buddha with scenes devoted to a party of benevolent lamas who have come to Seattle in search of a young boy who is, it appears, the reincarnation of a revered Tibetan lama. But upon closer examination the partisan sympathies of the film come into sharper focus. For one thing, *Little Buddha* subtly endorses the Tibetan belief in reincarnation: that is, it suggests that the revered monk has been reborn in the American boy and—in a blatant nod to Western political correctness—a young girl.[11] For another, the very fact that the monks in the film come not from Tibet but from neighboring countries is a reminder of the fate suffered by contemporary Tibet. Formerly the epicenter of the religious tradition the monks represent, Tibet is no longer a place they can call home.

　　　Indirection takes still another turn in *Red Corner*—a political melodrama that stars Richard Gere as an American entrepreneur framed for a murder while in Beijing on business. At first glance, the film seems to be little more than an indictment—albeit a ferocious one—of human rights abuses in China. Once the protagonist is caught in China's Kafkaesque legal-judicial system, he is subjected to one abuse after another: denied the right to speak in his own defense at his trial, he is informed by a draconian judge that he should confess if he values his life. Pointing at what Kenneth Chan calls "cinematic excess," in one scene, a prison guard washes the protagonist's plate in the toilet before serving him food; in another, he is made to watch a video of Chinese soldiers being shot and bayoneted to death.[12] But the knowledge that the film's star, Richard Gere, is one of the Dalai Lama's most fervent supporters in the Hollywood community gives the horrors his character endures in the film a much broader resonance. (During the 1993 Oscar ceremonies Gere took advantage of his time at the podium to plead for the cause of Free Tibet.) That is, behind the abuse Gere's fictional businessman suffers lies the specter of Chinese cruelty directed against the people of Tibet. In their case, too, "innocence" offered no protection against a system designed to bully and oppress (see fig. 5.1).

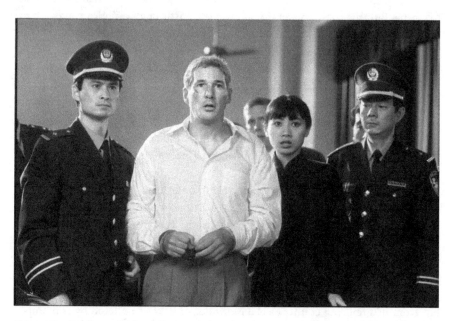

Figure 5.1. Red Corner: Richard Gere as an American businessman beaten and framed for murder in Beijing

If China's oppression of Tibet is implicit in both *Little Buddha* and *Red Corner*, it is totally explicit in *Seven Years in Tibet*. A historical epic that spans the years between World War II and the Chinese invasion of Tibet in 1949, the film combines the homage to Tibetan spirituality seen in *Little Buddha* with the ferocious indictment of China put forward by *Red Corner*. Based on a memoir by Austrian adventurer Heinrich Harrer, it is essentially, as Ian Buruma writes, a Hollywood biopic in which a "flawed European, consumed by selfishness and ambition, [is] saved by the innocence and ancient wisdom of Tibet."[13] In this case, the "flawed European," who is based on Harrer himself and played by Brad Pitt, is an egotistical adventurer and mountain climber who, after escaping from a prisoner-of-war camp in India, finds himself in Tibet. There, he is transformed by the redemptive power of Tibetan spirituality and, especially, by his friendship with the Dalai Lama. To underscore this process of redemption—or what Buruma calls the "innocence and ancient wisdom" of Tibet—*Seven Years in Tibet* alters history in dramatic ways. It is understandable, perhaps, that the film makes no reference to Harrer's Nazi past since that came to light only after the film was completed. But well before then, it was clear that Harrer's supposed "spiritual transformation" never took place. "The narcissistic loner Heinrich Harrer," writes Martin Brauen, "was still a loner after his stay in Tibet, and did not develop there into the caring father or the noble idealist who committed himself to the political future of the Tibetans."[14] Moreover, despite the film's suggestion that Harrer was an "noble idealist" ready to come to the aid of Tibetans oppressed by Chinese rule—in one scene Harrer bravely assaults a Tibetan collaborator—the truth is that Harrer left Tibet well before the Chinese invasion.[15]

But *Seven Years in Tibet* is not only a film about Tibetan spirituality or a conventional biopic about a flawed European. It is also about China, or, more precisely, about the Chinese invasion of Tibet. Here, too, the historical record is totally altered—this time, to turn the Chinese into melodramatic villains like the brutal warlords of earlier films. For example, although historians tell us that, at least initially, the Chinese tried to win the hearts and minds of the Tibetan people, *Seven Years in Tibet* depicts brutal Chinese generals stomping on fragile Tibetan sand mandalas and deliberately humiliating the Dalai Lama by defying Tibetan protocol. Even critics who acknowledged the irreparable harm that Tibet suffered at the hands of China faulted this aspect of the film. For example, Ian Buruma criticized the film for representing every "Chinese [as] an evil monster, trampling on Tibetan Buddhist images or killing innocent monks, and every Tibetan who tries to negotiate with the Chinese [as] a wicked traitor."[16]

If the starkness of the divide between Tibetans and Chinese in *Seven Years in Tibet* takes us back to the Manichean worldview implicit in cold war films, it also feeds into what Buruma describes as a sentimental myth of

"childlike innocence despoiled by absolute evil."[17] Looking at this myth from a slightly different perspective, Marc Abramson compares the film to a revisionist Western, *Dances with Wolves* (Kevin Costner, 1990), in which the idyllic life of an American Indian tribe stands in sharp contrast to the savagery and bigotry of their white conquerors. Like the Tibetans in *Kundun,* the American Indian tribe of *Dances with Wolves* knows how to live in harmony with nature and with their fellow beings. Underscoring the resemblance between the two films, Abramson observes that Annaud's Tibet appears to be "another version of the Sioux homeland in *Dances with Wolves* . . . the antidote to civilization and its discontents."[18]

This "sentimental myth," as we will see, is at the very heart of *Kundun.* But *Kundun* embraces this myth in a way that is both radically different from that seen in *Seven Years in Tibet* and ultimately far more powerful. Indeed, although the two films treat roughly the same period of history, in many ways they offer a study in contrasts. Arguably, *Kundun* is as unconventional as *Seven Years in Tibet* is conventional. To begin with, *Kundun* is that rare entity: a Hollywood film that contains no Westerners. Thus, while the protagonist of *Seven Years in Tibet* is a Western adventurer played by a superstar, *Kundun* is dominated by the figure of the Dalai Lama—a man known to family members and familiars as *kundun,* or "the presence." And while *Seven Years in Tibet* reflects the Western perspective implicit in Harrer's memoir, *Kundun* is based largely on writings by the Dalai Lama and on a series of conversations between him and scriptwriter and friend Melissa Mathison. "The essential part of the scenario of *Kundun*," observed Mathison, "was inspired by the personal revelations he [the Dalai Lama] made to me in the course of [several] meetings."[19]

The absence of Westerners is not the only indication of the film's unconventional nature. For, with the exception of a long sequence that features Chairman Mao, it also avoids portraying stereotypical Chinese villains: in contrast with *Seven Years in Tibet* as well as *Red Corner, Kundun* contains no arrogant and cruel generals, no bloodthirsty judges, and no bullying prison guards. At the same time, the absence of conventional villains does not mean that *Kundun* eschews the Manichean worldview or the cold war dichotomies—to say nothing of the "sentimental myth"—that inform *Seven Years in Tibet.* On the contrary, in the absence of such villains, China itself becomes the symbol, the embodiment, of the violence and brutality that characterized earlier villains. Both resurrecting and transforming earlier impulses, *Kundun* might almost be seen as one of the last works of the cold war era: intensifying the tonal dichotomies of earlier works, it renders the Chinese more phantasmagorical than ever before. At the same time, it places them squarely in a mythic world in which ancient images of the yellow peril merge with fears of the red tide. In the past, the Chinese often re-

ferred to Westerners as *yang guizi,* or "foreign devils/spirits/ghosts." In *Kundun,* the tables are turned: now it is the Chinese who are turned into the worst of ghosts. Both deliberately unreal and yet intensely real, the Chinese soldiers who invade Tibet are at once the latest incarnation of the murderous hordes of Genghis Khan and the brutal Communist warriors who fought U.S. troops to a standstill in Korea. Harking back to the paranoid style that erupted in the 1950s, the film depicts the historical confrontation between Tibet and China less as a political battle between nation-states than as an apocalyptic clash of civilizations. A metaphysical and spiritual struggle for the very soul of humankind, this clash is one in which a legendary Tibet is invaded and destroyed by a no less legendary China.

But if, in its Manichean cast, *Kundun* reflects a cold war vision of the world, in other respects it strikes a far more contemporary note. For one thing, its refusal to depict the Chinese as conventional villains—as, say, brutal generals or sadistic prison guards—points to an issue that I would like to explore in the following chapter: the fact that, by the time *Kundun* was released, a changing economic and cultural landscape was pushing stereotypical figures such as these into the recesses of the past. Second, by giving China and the Chinese a deliberately ghostly cast, *Kundun* explicitly acknowledges—and indeed underscores—the tonal dichotomies that in earlier films distinguished a mythic China from a realistic America. Last, by explicitly creating this dichotomy almost solely through cinematic means, the film raises an issue that runs throughout these pages: the role that images—and in particular those of cinema—play in fostering old myths and creating new ones.

Marked dramatically by the presence of the real and the unreal, *Kundun* is also permeated by intersecting strands of history and myth. To begin with history: the historical clash between China and Tibet evoked in the film had an unusually clear beginning and end. It began on January 1, 1950, when Radio Beijing announced that the People's Liberation Army of China (PLA) would engage in the "peaceful liberation" of Tibet in the course of the coming year. In October of that year, the PLA began a series of incursions into the border regions of eastern Tibet. In the face of Chinese aggression, Tibet was virtually defenseless: it had neither a modern army nor a strong leader. (The Dalai Lama, who officially became head of Tibet two years ahead of schedule, in 1950, was still young and inexperienced.) Nor did it have friends or allies in the foreign community ready to come to its aid. (Its most natural ally, India, was wary of angering its Chinese neighbor; the United States was engaged in Korea.[20]) Consequently, Tibet felt impelled to negotiate with the Chinese. Accordingly, in the spring of 1951, Tibet sent a delegation to Beijing; they—probably under duress—signed the Seventeen-Point Agreement for the Peaceful Liberation of Tibet. While the agreement guar-

anteed the continuation of Tibet's traditional politico-religious system headed by the Dalai Lama, it also contained the following, crucial, clause: "The Tibetan people shall unite and drive out imperialist forces from Tibet: the Tibetan people shall return to the big family of the Motherland—the People's Republic of China."

For a while, it seemed as if Tibet could indeed coexist with the Chinese. For one thing, not all Tibetans were opposed to Chinese rule: while the ruling monastic elite was willing to cooperate with the Chinese provided they could maintain their traditional hold on power, less privileged Tibetans saw the Chinese occupation as "a chance [to improve] their living conditions."[21] For another, Mao made determined efforts not to alienate the Tibetan people—he decreed, for example, that Chinese soldiers in Tibet behave in a friendly manner—even as he pursued a policy of cooperation with the Dalai Lama. In fact, in the course of a momentous meeting in Beijing in 1954 between the Dalai Lama and Chairman Mao—a meeting that is powerfully re-created in *Kundun*—Mao reassured the Dalai Lama that, in the latter's words, "the pace of reform [would be] dictated by the wishes of the Tibetan people themselves."[22]

But in the end, coexistence was not possible. Tribal rebellions in the outlying border districts—where the Chinese had tried to accelerate the pace of change and had shown contempt for Tibetan religious practices—were met with instances of escalating Chinese repression and violence. Reports of monasteries destroyed and monks murdered soon reached Lhasa even as refugees and rebels fled to the capital city. Amid escalating fear and violence, the beginning of the end came in March of 1959. When the Dalai Lama was invited to attend a Chinese theatrical performance, his supporters—fearful that the Chinese might kidnap him—gathered en masse to protect and support their leader. Amid rising tensions, the Dalai Lama felt he had no choice but to flee Tibet for the safety of India. Once there, he renounced the Seventeen-Point Agreement and established the Tibetan government-in-exile that persists to the present day.

But if Tibet seen as an independent geographical entity has vanished, Tibet as an idea has not. In fact, as the films of the Tibet craze make clear, this idea has become firmly ensconced in the realm of competing images and representations. Observing that the Tibet question "resonates throughout the American political landscape," historian Melvyn C. Goldstein declares that the "struggle to control territory has been matched by a struggle to control the representations of history and current events."[23] Turning history into a battleground, the Tibetan government in exile and the Chinese have offered competing narratives of past and present. (By now, these narratives—with their truths, untruths, half-truths—have generated studies of their own.[24]) The fact that the Chinese regard their advance into Tibet as a "liberation" while the Tibetans deem it an "invasion" is but the starting point for radically opposed versions of history and ideology.[25] As

historian John Powers points out, the Chinese are as passionate in their belief that Tibet is part of China—pried loose by the ravages of nineteenth-century imperialism—as are the Tibetans when they declare that their country should be independent and free.[26] While the Chinese focus on the cruelty and abuses of the old feudal system in Tibet, Tibetans denounce the cultural and human rights violations committed by China since 1950. And if China has won the geographical battle—if Tibet is increasingly populated by Han Chinese—Tibet, the country that now no longer exists except in exile, has won the battle of international public opinion in a way that could hardly be more decisive. "The history war against China waged by the Tibetan exile community," declares John Powers, "is as unequal in the Tibetans' favor as the military one that was fought in the 1950s."[27]

Many factors have contributed to the victory of the Tibetan exile community in the "history war against China." As suggested earlier, changing perceptions of China certainly played a major role: in light of the massacre at Tiananmen Square, it was all too easy to imagine similar atrocities perpetrated in Tibet. But it is also true that China's dour technocratic leaders—marked by a tin ear for how their remarks would be interpreted in the West—were hardly a match for one of the most charismatic figures of our time: the exiled Dalai Lama. Traveling widely as his country's secular and religious head, the Dalai Lama—who stepped down as head of Tibet's government-in-exile in March 2011—has won supporters to the cause of Free Tibet with every appearance, every visit, and every speech. Along with the Dalai Lama, in the wake of the Tibetan diaspora, Tibetan monks and lamas have also traveled to the West, where, attracting acolytes and followers, they have encouraged the spread of Buddhism as well as great sympathy for Tibet.[28] Moreover, beginning in the 1980s, the leaders of the Tibetan diaspora—as well as the Dalai Lama—have burnished an image of Tibet calculated to appeal to Western values. Glossing over the Dalai Lama's less appealing positions—for example, his denunciation of homosexuality[29]—they have created an image of Tibet as a country that is not only deeply spiritual but also sensitive to environmental issues and even the rights of women. Noting that the Dalai Lama has "remodeled" an ancient faith for use today, Jeffrey Paine observes that "by the late 1980s the Dalai Lama himself would sometimes stop in midsentence, and reverse a thousand years of Tibetan precedent before he reached the next period."[30]

Clearly, all these factors—the dark shadow cast by the massacre at Tiananmen Square, the successful strategy embraced by the Tibetan government-in-exile, the charisma of the Dalai Lama, the resonance of the films of the Tibet craze, the tremendous influence of the Hollywood community—have helped ensure Western sympathy and support for Tibet. At the same time, all these factors drew strength from a more overarching phenomenon, from the "myth" of Tibet—as

a lost paradise or magical role—that had taken hold in the West long before Chinese troops marched into Lhasa.[31] It is here, of course, that history cedes its place to myth. In this case, it is a myth that began in the late eighteenth century when Western adventurers first set foot on the land that, ringed by some of the highest mountains in the world, was known as the "roof of the world." Since that time, as Peter Bishop writes in a work devoted to the changing contours of this myth, Tibet's geographical remoteness has continually given "permission for many Europeans and Americans to use it as an imaginative escape. . . . Time and time again Tibet was endowed with all the qualities of a dream, a collective hallucination."[32]

In this "collective hallucination," Tibet has been perceived not only as a uniquely pure and spiritual country—one whose very mountains connected heaven and earth—but also as the antithesis, the absolute other, of a degraded, violent, and corrupted West. The site of what Bishop calls "contending fantasies," Tibet constituted one pole in what he describes as the "oppositional fantasy between East and West, between Occident and Orient." It is this "oppositional fantasy" that is heard, for example, in a letter French poet Antonin Artaud wrote to the Dalai Lama in the wake of the savagery of World War I. Drawing a dramatic contrast between the "contamination" of the West and the "perfect heights" of Tibet, Artaud implored the Tibetan leader to "share your insights with us in a language that our contaminated European minds can understand and, if necessary, change our Mind, turn us into a spirit oriented toward those perfect heights where the Spirit of Man no longer suffers."[33]

A decade after Artaud wrote those words, the "oppositional fantasy" between Tibet and the West found what is probably its most powerful embodiment in *Lost Horizon*—a 1933 novel by James Hilton that was turned into a 1937 film (with the same title) by Frank Capra.[34] Here, Hilton imagined—and Capra brought to life—the vision of a utopian community nestled high in the furthermost regions of Tibet's snowcapped mountains. Named Shangri-La, this magical community differed in every conceivable way from the West. Governed by a spirit of moderation and "benevolent kindness," the inhabitants of Shangri-La know nothing of the West's empty materialism, its meaningless demands, and, above all, its violence. Speaking of *Lost Horizon*, Bishop makes that point that "at no other time had the West created Tibet in such direct opposition to its own culture. While Tibet had always been imagined as the Other, this Otherness had never before been pictured as a simple opposite."[35] The radiance of Hilton's imagined community of Shangri-La was such that the term soon came to signify any utopia—one dictionary defines Shangri-La as any "utopia" or "remote beautiful imaginary place where life approaches perfection"—even as it merged with the real country of Tibet. Again and again, the imaginary realm of Shangri-La and the

real country of Tibet seemed one and the same. "Once we crossed into the Hima-layas," wrote Lowell Thomas Jr. describing a trip to Tibet, "we were indeed travel-ers in the land of the Lost Horizon. And it often seemed as though we were dreaming—acting the parts of characters in James Hilton's novel, on our way to Shangri-La."[36] (See fig. 5.2.)

From a contemporary perspective, one of the most interesting aspects of Hil-ton's Shangri-La is the intensely positive role it assigns to China. Reflecting the Enlightenment vision of the Middle Kingdom as what Bishop describes as a "vast land of harmony, peace, aesthetics and tranquility," Hilton's novel bears out Bish-op's contention that for many years, the perceived radiance of Tibet was actually heightened by its close relationship—both geographical and spiritual—to its vast neighbor.[37] If, for example, the novel's protagonist, a British diplomat named Conway, immediately falls in love with life in Shangri-La, it is largely because so much of what he sees and experiences reminds him of treasured years spent in China. In his eyes, the enchanted and peaceful valley of Shangri-La—its people,

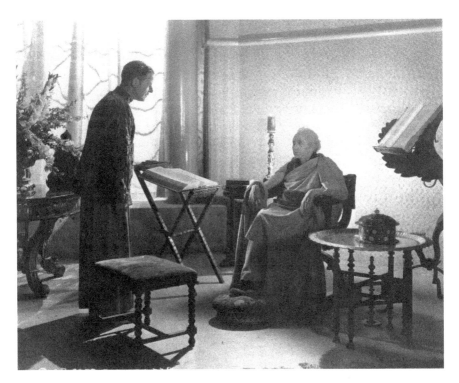

Figure 5.2. Shangri-La/Tibet as a utopian paradise in Lost Horizon: Robert Conway (Ronald Colman) at an audience with the High Lama (Sam Jaffe)

its houses, its very atmosphere—shimmers with the soft radiance of Chinese civilization. Above all, the spiritual heart of Shangri-La, the so-called lamasery, speaks of the Enlightenment view of China as the very "apogee of civilization." As Conway wanders its vast halls, he is entranced by the sight of priceless Chinese treasures: exquisite Sung ceramics, age-old paintings in tinted inks, and intricate lacquers. All these make him feel that he is witnessing "a world of incomparable refinements [that] still lingered tremulously in porcelain and varnish, yielding an instant of emotion before its dissolution into purest thought."[38] Nor are such "incomparable refinements" limited to the realm of esthetics. For Conway is also drawn to a beautiful Manchu pianist who seems to embody all the qualities that he loves in Chinese art. She, too, is "gentle, precise, and miniature"—a "symbol of all that was delicate and fragile."[39]

Scarcely fifteen years after Hilton wrote those lines, the China that Conway (and Hilton) loved came to an end as sudden as it was brutal. When Communist troops marched into Tibet, the "delicate and fragile" echoes of Chinese civilization that had lent Shangri-La much of its radiance disappeared as if they had never existed. Suddenly transformed into a sinister neighbor, China threatened both the country of Tibet and the "dream" that swirled around it. The threat to the country was, of course, political: as the world divided into two camps, Tibet—like other formerly remote places in the world—became still another "domino" threatened by the inexorable red tide. "Tibet," warned commentator Lowell Thomas Jr., "is all that stands between the Red armies of China and India. . . . The Land of the Lamas may be the next small country on the Communists' list for extinction."[40] But the role that Tibet had long played in the Western imagination meant that the "dream" it embodied—its function as what Bishop calls a "vessel for the projection of Western global fears and hopes"[41]—was also at risk. No longer could people cling to the hope, voiced explicitly in *Lost Horizon,* that Tibet might preserve the best of civilization in the case of a coming apocalypse. ("The Dark Ages that are to come," says the High Lama of Hilton's novel, "will cover the whole world in a single pall; there will be neither escape nor sanctuary, save such as are too secret to be found or too humble to be noticed. And Shangri-La may hope to be both of these."[42]) And it was the collapse of this hope, the threatened extinction of *this* Tibet, that turned a "political crisis," as Bishop puts it, into a "mythological event."[43] The conquest of Tibet, anguished Amaury de Riencourt, was "a ghastly loss . . . for every human being, the death of the most spiritual and inspiring country on this globe."[44]

Moreover, there was, of course, another dimension to this "ghastly loss," For it was part of a new—and terrifying—"oppositional fantasy." While Tibet symbolized the highest hopes for humankind's spirituality, Chinese Communism was—at least in American eyes—the very embodiment of soulless materialism.

"Communism," writes Bishop, "was already mythologized, already the Antichrist, the bearer of the West's unadulterated shadow."[45] Thus, with the advance of Communist troops into Tibet, it was not only two countries but two mythic constellations—Communist China (seen as the Antichrist) and Tibet (considered the "most spiritual country on this globe")—that were pitted against each other. When Mao's troops marched into Tibet, they were not merely annexing an independent country (as the Tibetans had it) or recovering lost territory (as the Chinese believed). Resurrecting fears of the murderous hordes of Genghis Khan, they were the destroyers of the cherished dream of Shangri-La. "Are the forces of evil," wrote Riencourt, "going to blow out the faint light which shines on the Roof of the World, perhaps the only light which can guide mankind out of the dark ages of our modern world?"[46] Chinese troops did, of course, destroy the independent country known as the roof of the world. But, significantly, they did not "blow out" the light; that is, they did not annihilate the "idea" of Tibet—the Tibet that a poetic Colin Thubron describes as "less a country than a region in the mind."[47] On the contrary, as *Kundun* makes very clear, the Chinese invasion and occupation of Tibet had profound, unforeseen consequences: as Bishop puts it, it "inadvertently seeded Western fantasy-making with what could prove a whole new series of transformations in its imaginings about Tibet."[48]

Expulsion from Eden: Kundun

These "transformations" take us to the heart of *Kundun,* The film leaves no doubt that, as Bishop suggests, in the case of Tibet the end of one myth has been accompanied by the emergence of another. And if *Lost Horizon* is both the embodiment and epitome of the myth of Shangri-La, then *Kundun* is arguably the most powerful embodiment of the changed myth of Tibet that has taken shape in the years since 1959. Discussing this newest of myths in light of what he calls the "strange fictions" that have long surrounded Tibet, critic Martin Brauen qualifies it as that of Dharma-La—a term that appears to combine the notion of Shangri-La and the Dharma, or Buddhist law or philosophy of existence. "Today," writes Brauen, "we find ourselves in 'Dharma-La': sacred Tibet has shifted from the Roof of the World to India and into the West, the Tibetan lamas—and with them, naturally, the Dalai Lama—have become leading protagonists in the Western dreams of Tibet and have left Tibet. At the same time the Buddhist Teaching, the Dharma, is degenerating more and more into a commodity: sacred Tibet is coming to be for sale."[49]

Clearly, Brauen is principally concerned with how the long tradition of Tibetan spirituality as been and is being affected—and perhaps destroyed—by its

transmission to a consumerist West in which everything is one more commodity to be eagerly used and casually discarded. But if this change is overarching, it is not the only one. The moment of Dharma-La signals other important changes in respect of earlier "fictions." One bears on the role of the Dalai Lama: in the absence of a real country, he has become the embodiment of all the myths and beliefs that surrounded Tibet itself. He is not only the dominant figure of the moment of Dharma-La but in some sense the only important one. Underscoring this change, Peter Bishop argues that by a process of "imaginative concentration," the isolated figure of the Dalai Lama has become "one of the last remaining vessels of ancient wisdom and occult power in an otherwise disenchanted world."[50]

Along with this change goes still another—one that bears on the role China plays in the "oppositional fantasies" surrounding Tibet. For now, the polar opposite of Tibet—or of the idea of Tibet—is not the West in general but the country that destroyed Shangri-La: Communist China. This means that, for the first time in the history of the "fictions" that have surrounded Tibet, we have a recognizable and specific villain: the Chinese rulers (especially Chairman Mao) who invaded Tibet in 1949 and who continue to rule that country. Formerly perceived as a kindred civilization to Tibet, the Celestial Empire has become a two-headed monster: evoking fears old and new, it is both the incarnation of godless Communism and the epitome of Western materialism, wantonness, and brutality. To our long-standing fascination with Tibet, writes Orville Schell, "has now been added a new story line, that of Tibet's occupation, oppression, and destruction by the Chinese Communist Party. Now the imagery of Tibet as a beloved spiritual refuge and geographical escape hatch runs up against that of Tibet as a defenseless underdog, a spiritual society that was minding its own business only to get crushed under the jackboot of an aggressive, materialist overlord."[51]

Of course, what Schell calls the addition of a "new story line" means that the "opposing fantasies" that formerly swirled around Tibet have taken on the proportions of an apocalyptic battle between dramatically opposed civilizations. If China has become "an aggressive, materialist overlord," Tibet has become what Colin Thubron calls a "place of violated innocence" and a "land of pained wish-fulfillment."[52] As at the time of the cold war, the battle between these two so different civilizations is one in which, as Donald Lopez writes, absolute good is pitted against absolute evil. Describing this aspect of the moment of Dharma-La, Lopez writes that the new dream of Shangri-La is one that perceives the Chinese invasion and occupation of Tibet "not as a conquest of one despotic state by another, but as yet another case of opposites, the powers of darkness against the powers of light. . . . Tibet embodies the spiritual and the ancient, China the material and the modern. Tibetans are superhuman, Chinese are subhuman. Accord-

ing to this logic of opposites China must be debased for Tibet to be exalted . . . the angelic requires the demonic."[53]

Nowhere do all these impulses—the centrality of the Dalai Lama, the modern barbarism of China versus the ancient spirituality of Tibet, the presence of a Manichean struggle between good and evil, the clash of two opposing myths—come to life more vividly or more powerfully than in *Kundun.* Speaking of the factors that prompted him to make this film, Scorsese left little doubt that he considered the presence of this clash absolutely fundamental. What interested him in *Kundun,* he said, was the "story of a man, or a boy, who lives in a society which is totally based on the spirit, and finally . . . they find themselves face to face in a society which is the most anti-spiritual ever formed, the Marxist government of the Chinese Communists."[54] Moreover, not only does Scorsese place this clash at the heart of *Kundun,* but he gives it a deliberately mythic cast—one that befits an apocalyptic struggle between a society "totally based on the spirit" and one that is the most "anti-spiritual" ever seen.

To a great degree, the mythic struggle that informs *Kundun* echoes and intensifies the tonal dichotomies that in earlier works served to distinguish a realistic America from mythic China. (In *Kundun,* of course, Tibet has stepped into the role formerly played by America.) Thus, with the exception of Chairman Mao, the clash between Tibet and China is embodied not in the realistic villains and melodramatic confrontations like those seen in, say, *Seven Years in Tibet.* However brutal or evil, characters like the draconian judge of *Red Corner* or the ruthless Chinese generals of *Seven Years in Tibet* belong to a familiar human realm—one populated by heroes and villains, by good guys and bad. Deliberately avoiding this naturalistic world, *Kundun* embeds the clash between Tibet and China in the deepest layers of the film—in color and lights, camera angles and rhythms. Touched by these formal elements in a visceral or subliminal way, we abandon the familiar world of *Seven Years in Tibet* for the mythic realm of Dharma-La. Here, Tibet and China are not merely two political entities; the Tibetans are not simply benevolent and spiritual creatures mowed down by evil Chinese monsters as in, say, *Seven Years in Tibet.* Rather, filmed in radically different ways and placed in contrasting filmic universes, they represent, as it were, different orders of being. As the powers of light engage in a fateful struggle with those of darkness, ancient images of Chinese barbarism assume a powerful new cast. In *Kundun,* perhaps for the first time, the "dream" of Tibet takes on the logic of dreams and the power of nightmares.

In light of the dichotomies that permeate the film—the real and the unreal, history and myth, Tibet and China—it is interesting that Scorsese's interest in Tibet was first sparked by a cold war film that, like *Kundun* itself, seemed to oper-

ate on several registers. On the one hand, the film, *Storm over Tibet* (Andrew Marton, 1952), was a fictional anti-Communist adventure thriller. On the other, it contained documentary footage of Tibet that had been shot by Andrew Marton in 1930. Explaining the genesis of this strange hybrid—half-factual, half-fictional propaganda—Scorsese remarked that, in the 1950s, "Columbia made a number of B films on the Communist threat in Tibet. It was at the height of the Cold War. And, seeing that Marton's images were available, the people at Columbia simply added them in the editing—for *Storm over Tibet* and *Mask of the Himalayas*."[55] Whatever the origin of the film, it—or, more precisely, Marton's documentary images—had a profound effect on the young Scorsese. Calling Marton's images "sublime," years later he remarked that they had "something that was so authentic. . . . I adored the sherpas, the Tibetan rituals, the masks, [the use] of black and white."[56]

Nearly fifty years later, the double-register, or hybrid, nature of *Storm over Tibet* would be echoed—in a complex and sophisticated way—in *Kundun*. Here, too, fiction and documentary, the real and the unreal, are deeply intertwined. Its portrait of Tibet alone marries two very different cinematic traditions: it combines aspects of documentary with currents of poetic expressionism. In terms of documentary, the film clearly seeks to capture the "authenticity" that Scorsese had loved in Marton's "sublime" images. Determined not to give audiences yet another version of Capra's idealized and obviously unreal Shangri-La, Scorsese avoids not only the conventional realism of Capra's film but its distinctly Western cast. As recent critics have repeatedly pointed out, the Shangri-La of *Lost Horizon* speaks far more of the West than of the East. Declaring that Capra's visionary community "has hardly anything Tibetan about it," Martin Brauen observes that even the lamas are "whites and not Tibetans."[57] And Orville Schell is even more scathing, arguing that the "virtual" Tibet of *Lost Horizon* offers "Occidentals the perfect fantasy blend of East and West." He writes that the spiritual heart of Capra's Shangri-La—that is, the lamasery—resembles something "Frank Lloyd Wright might have designed on a bad day for a Mormon golf club. Massive and white . . . Hollywood's Shangri-La was a curious and implausible pastiche of modernism, Orientalia, and generic fantasy that had precious little to do with the Potala—or anything else Tibetan, for that matter."[58]

Schell may be overstating the case. Still, there is no question but that Capra presents us with a quintessentially Hollywood version of Shangri-La—one that is "generic," Western, and unreal. And there is also no question but that it is precisely this well-known version of Shangri-La that Scorsese seemed determined to challenge in *Kundun*. To this end, the director broke with conventional notions of casting: instead of using Western performers—or, for that matter, professional actors—he peopled his film with men and women whom he called "real" Tibet-

ans (i.e., largely nonprofessional performers drawn from members of the Tibetan community). And their surroundings are as "real" as their faces. Although he was unable to shoot in Tibet itself, with the help of art director Dante Ferretti, Scorsese went to great lengths to re-create a vanished Tibet in the deserts of North Africa. Instead of a striking modernist fantasy, *Kundun* offers viewers a real world of sunbaked buildings and shimmering courtyards, of desert expanses ringed by snowcapped mountains. The almost phenomenological weight of faces and surroundings is accompanied, moreover, by a meticulous attention to how Tibetans wove spirituality into their daily lives. Ritual sequences break the narrative even as the camera lingers on images of statues of the Buddha, or on the Buddhist gods of Tibetan scrolled *thangkas*, and, especially, on sand mandalas with their intricate cosmological designs (see figs. 5.3 and 5.4).

But if in some sense Scorsese creates a virtual documentary about Tibetan life, he also gives this documentary the flowing contours of a dream. Just as the documentary images of Tibet he saw as a young boy were fitted into a melodramatic fictional framework, the "authentic" portrait of Tibet seen in *Kundun* is nestled into a poetic or dreamlike fabric. In this respect, too, the film was clearly influenced by still another director for whom Scorsese had a particular admiration: Michael Powell. (Probably best known for the expressionist classics *Black*

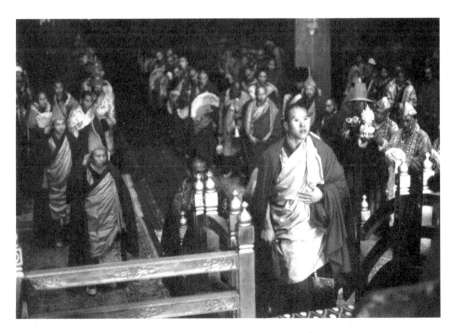

Figure 5.3. Kundun: The young Dalai Lama becomes the leader of his country

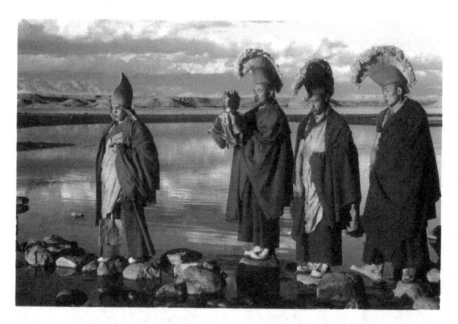

Figure 5.4. Kundun: Tibetan spirituality and peace on the eve of the Chinese invasion

Narcissus [1947] and *The Red Shoes* [1948], in collaboration with Emeric Press-burger, Powell made a series of other films that blend fantasy and reality.) Indeed, Scorsese's long-term editor, Thelma Schoonmaker—who was married to Powell at the time of his death—observed that *Kundun* owed a special debt to one of Powell's most lyrical and phantasmagorical films, his adaptation of Jacques Offenbach's oneiric opera, *The Tales of Hoffmann*. Like Powell's film, she said, *Kundun* was not conceived as a conventional narrative but as a dream or poem with its own logic and emotion. "In general," she said, Scorsese's films are "pro-pelled by characters and dialogue. *Kundun* demanded another, more delicate, dy-namic. The emotion comes from the counterpoint of image and music. Entire passages are built around the music. . . . And the film became a poem."[59]

As Schoonmaker suggests, much of the poetry of *Kundun* comes from the counterpoint of sound and image. Written by noted composer Philip Glass, the music carries us forward on a wave of feeling even as it blends the sounds of Tibet—the chants of monks, the plaintive cries of instruments—with Glass's in-cessant rhythms and harmonic variations. But other aspects of the film also con-tribute to its dreamlike or trance-like intensity. Whirling us, without transition, from past to present, from the real to the imaginary, *Kundun* seems to follow the logic of a dream in which temporal boundaries and firm chronologies dissolve and disappear. "With the inversion of sequences," writes critic Sandra Marti,

"Scorsese transforms the real character of certain sequences. Memories, premonitions, everything becomes blurred."[60] Sweeping camera movements and insistent dissolves further intensify this process of blurring, or what Scorsese called the "softness" that surrounds Tibet. Suggesting that this blurring was a way of capturing the sense of impermanence at the heart of Buddhist thought, the director declared that he tried to find a visual equivalent for the way of thinking that says "right now is not real, you're with me but the past has already happened, as I'm speaking it's the past already. . . . So there are the camera moves that kind of caress the body. . . . And once again we used a lot of dissolves, which increase the idea of the dream for me, they make it softer."[61]

The "softness" that surrounds Tibet resonates in many directions. Feeding, as we will see, into the nexus of oppositions that distinguish Tibet from China, it also turns Tibet into a kind of *paradis perdu* that is disappearing before our eyes. From the start we know that we are watching a world that is about to vanish—that by the end of the film, Tibet will be no more. But if this "softness" is an implicit reminder of the catastrophe that looms, it also serves to erase the more uncomfortable aspects of history. Thus, the darker aspects of Tibetan history—the continuation of feudal and barbaric practices until well into the twentieth century, the internecine squabbles and political intrigues of the monastic elite, and the policy of isolationism that played an important role in the nation's downfall[62]—vanish in a blur of visions and premonitions, of erasures and even hallucinations. Ignoring, for example, the political maneuvers that led to the selection of the Dalai Lama, the film deliberately reinforces the divine nature of his election or reincarnation: it contains a long and important scene in which the young Dalai Lama unerringly claims certain possessions of his predecessor as his own.[63] Most important, perhaps, *Kundun* refuses to make the fundamental admission that, as Colin Thubron writes, Tibet has seen its share of violence. While Thubron, for one, tells us that for centuries Tibet "waged aggressive war against itself and others,"[64] the film begins, instead, with titles that reiterate what is perhaps the most crucial refrain of the Tibetan narrative. "In a war torn Asia," they tell us, "Tibetans have practiced non violence for over a thousand years. The Dalai Lama is their ruler. He is the human manifestation of the Buddha of Compassion."

Of course, it is not only what the film says—or does not say—about Tibet that makes it such a powerful statement in favor of the Tibetan narrative of history. It is also what it says, and does not say, about China. Above all, perhaps, it is *how* it says it. In fact, if I have lingered so long on the contours of Scorsese's portrait of Tibet, it is because in every way—at every level of the film—this portrait is so radically opposed to that of China. Here, a play of formal oppositions incarnates the chasm between the "angelic" and the "demonic" that separates Tibet

from China. Take, for example, one of the most striking aspects of the film: its expressionist palette. While Tibet is bathed in vibrant colors and dazzling sunlight that shimmer with life, the Chinese are portrayed in monochrome shades— beige, blue, and drab white—that speak of repression and lifelessness, of coldness and death. The only spark of color in Beijing is, in fact, a menacing one: the red of Communist banners and flags, posters and scarves.

Like the contrasting palette of the film, the performers, too, are chosen and filmed in ways that enhance the play of oppositions that inhabit the film. As noted earlier, for the role of Tibetans, Scorsese insisted on casting "real" people in his film—each with a solid sense of individuality and "authenticity." The Chinese, instead, are portrayed as interchangeable, anonymous phantoms. The rows of regimented schoolchildren who greet the Dalai Lama when he visits the Chinese capital are scarcely less robotic than the marching Chinese troops who invade Tibet. The only being who escapes the anonymity that envelops his countrymen is the archvillain of the film: Chairman Mao. Significantly, when it comes to Mao and his country, there are no caressing movements of the camera, no dreamlike dissolves, no phenomenological sense of "authenticity" or any hint of "softness." There are only sharp staccato movements, unreal beings, eruptions or threatened eruptions of violence.

Moreover, it is not only that the Chinese are rendered lifeless and unreal, anonymous and ghostly. It is also that these ghosts are imbued with images— ancient and modern—of Chinese barbarism. While, for example, the film erases any evidence of cruel and corrupt practices found in Tibet, it does quite the opposite where China is concerned. That is, it creates imaginary scenes—scenes not found in the Dalai Lama's writings or, for that matter, in the historical record—to further emphasize Chinese cruelty. Along somewhat similar lines, while Scorsese is meticulous to the point of obsession when it comes to Tibetan rites and rituals, he freely invents symbolic, often deliberately anachronistic, details to heighten the violence that surrounds the Chinese. Taking us out of the world of history, these imaginary details and scenes become part of a mental landscape haunted by the memory of Genghis Khan and of cold war warriors. It is a landscape that, once again, is infused with cinematic echoes. But here, the "authenticity" of Marton's images and the oneiric universe case associated with Michael Powell give way to the lurid scenes taken from melodramas and crime thrillers. If Tibet is endowed with the allure of a vanished dream, then China is transformed into the place of nightmares.

Above all, though, Scorsese's portrayal of the Chinese is marked by violence. Indeed, if Tibet is defined by its spirituality, then it is violence that defines China. Some of Scorsese's best known films—from gritty urban dramas like *Taxi Driver* (1976) to films about gangs and the mafia such as *Mean Streets* (1973), *Goodfellas*

(1990), and *Casino* (1995)—make it very clear that the director was no stranger to violence. But, significantly, the violence of *Kundun* is very different from that seen in earlier Scorsese works such as those, or in a more conventional film like *Seven Years in Tibet*. While the violence that punctuates a film like *Goodfellas* is explicit and often graphic, that which characterizes the Chinese in *Kundun* is largely suggested rather than shown, imaginary rather than real. As Scorsese put it: "Chinese atrocities are never represented but [rather] suggested."[65] In this respect, he observed, it reflected an important, twofold lesson he had learned from the films of director Samuel Fuller. First, "emotional violence" must not be confused with "physical violence"; and, second, "emotional violence must be created with the camera, not only with the actor."[66]

It is precisely Scorsese's embrace of this double lesson that gives the violence of *Kundun* its special cast—one that befits a mythic struggle rather than a confrontation or battle between individuals or nations. For it means that, in *Kundun*, violence—or, more precisely, the threat or suggestion of violence—transcends the familiar or known realm of individuals. Created purely through cinematic means—through close-ups, chromatic explosions, editing techniques, and slow motion—it affects us viscerally and emotionally in ways that make us feel the full horror of the Chinese invasion. Imagined rather than represented, divorced from individuals, violence becomes a kind of malevolent force that, as the film progresses, intensifies until it seems to suffuse an entire world. As it does so, ancient images of Chinese barbarism assume both a powerful new dimension and a distinctly contemporary stamp.

The power of what the director called emotional violence is made strikingly clear in an important scene that takes place even before the Chinese invade Tibet. It is devoted to a so-called sky burial—a Tibetan ritual whereby a corpse is placed on a mountaintop and dismembered so that it can be disposed of by vultures. While the ritual depicted corresponds to Tibetan practice, the scene itself is historically inaccurate. For although the man to be "buried" is supposedly the Dalai Lama's father, in truth the Dalai Lama's father was not given a sky burial but cremated.[67] As we watch the scene, though, it quickly becomes clear why Scorsese decided to alter the historical record. Not only is the sequence visually striking but also, through the juxtaposition of sound and image, it creates an insistent parallel infused with emotional violence. That is, even as the corpse is hacked to bloody pieces, the Dalai Lama receives ominous news: an aide tells him of Mao's victory and of China's demand that Tibet cede its independence. The political or ideological message of this frightening scene could hardly be clearer—or more cinematic: the sky burial becomes a virtual metaphor, a chilling harbinger, of the way Tibet will soon be "dismembered," and devoured, by China.

The twin impulses at work in this scene—that is, the combination of cine-
matic effectiveness and a disregard for the historical record—are even more pro-
nounced in the next sequence of emotional violence. It concerns a crucial moment
in Sino-Tibetan relations: the Chinese invasion of Tibet. Here, the film changes
history in a particularly dramatic way: it advances the timing of the Chinese in-
vasion so that so it occurs much sooner in the film than it did in reality. This
means that the invasion is seen not as the culmination of a political decision or
clash—the sad result of a long period of frustrating political negotiations be-
tween Tibet and China—but as a burst of violence, an almost inexplicable act of
brutal aggression. The sequence begins as we hear the words "the Chinese have
invaded." Then a huge image of Mao's face, as if on a propaganda poster, appears
superimposed against the sky. Now, as if from nowhere, endless ranks of soldiers—
wearing dark sunglasses and accompanied by red flags blowing in the wind—
suddenly appear and begin to march across the Tibetan plateau. Their marching
feet kick up a storm of dust that, like a biblical plague, destroys the pristine
landscape of the high desert and eclipses the sun. As the soldiers continue their
relentless advance, indications of Communist propaganda intensify. Canted
angles evoke Soviet realist posters; the soundtrack swells with propagandistic
Chinese songs and speeches. Alluding to and mocking one of the central tenets
of the Chinese narrative of events, voices—seemingly coming from a radio or
loudspeaker—announce that the soldiers have come to "liberate the peasants."

Speaking of this scene, Scorsese suggested that his decision to alter the chro-
nology of events—that is, to advance the timing of the invasion—was done with
an eye to cinematic effectiveness. The change, he remarked, gave "a much greater
force to subsequent sequences. Scenes that were supposed to be real became dreams
and were moved around."[68] Announcing the role that dreams would play in
Kundun, the sequence itself displays the vivid and surreal quality of a hallucina-
tory nightmare. All the elements of the invasion—the huge image of Mao spread
out against the sky, the songs that come from nowhere, the canted angles, the dis-
embodied voices—distance us from the world of history and politics even as they
take us into a mental landscape haunted by fears new and old. The rows of march-
ing soldiers call to mind less the PLA than the vast army that marched on Europe
in Shiel's *The Yellow Danger.* Rather than a historical event, their forward march
is a mythic advance that takes place outside of chronological time. "The concrete
advance of the Chinese invasion," writes Hubert Niogret, becomes "a phantom-
like vision: silhouettes grey with dust, filmed in a frame broken diagonally . . .
while the percussive beats of Glass' music punctuate now and again their for-
ward movement."[69]

One of the most frightening details of this phantasmagoric scene is, signifi-
cantly, also one of the most deliberately unreal: the anachronistic dark glasses

that hide the faces of the advancing soldiers. As Scorsese observed, the scene did not need "planes, chases, or explosions everywhere" precisely because the sunglasses alone rendered the soldiers so terrifying.[70] Imbued with a powerful current of emotional violence, the sunglasses resonate in several ways. For one thing, by masking the faces of the marching soldiers, they heighten the phantomlike nature of the troops. Deprived of individuality, the soldiers are transformed into the sinister and anonymous members of an army of robots. For another, the sunglasses are imbued with cinematic echoes that intensify the sense of menace that surrounds the soldiers. That is, they call to mind the dark glasses worn by countless other "bad guys"—from corrupt law enforcement officers to sadistic mobsters—in Hollywood dramas. Associating Mao's troops with the screen villains of other films, the sunglasses are, perhaps, the first unmistakable indication of the cinematic echoes that henceforth will surround—and define—the Chinese. Pulling the invaders firmly into the realm of the simulacrum, these echoes underscore not only their barbarism but also their ghostly and unreal nature.

Shadowed by cinematic echoes and propaganda images, the Chinese advance is poised somewhere between history and hallucination, between the real and the deliberately unreal. But after this critical scene, the realm of history is abandoned altogether in favor of a psychic landscape haunted by the specter of Chinese cruelty. In large measure, this mental landscape was inspired by visions and premonitions the Dalai Lama experienced and later recounted in his autobiographies or told to *Kundun*'s scriptwriter. One can only imagine how the Tibetan leader described these visions—or what Niogret calls "mental voyages"—to Mathison. But the difference between his written descriptions of these visions and their embodiment in the film *is* striking. Memories that are relatively flat on the written page become shockingly, vividly alive on-screen. Charged with hallucinatory violence as well as explicit cinematic echoes, more than any other aspect of the film, they illustrate what Niogret describes as Scorsese's ability to amplify the "symbolic visualization of very realistic things" in order to create "images whose emotional impact is stupefying."[71]

In a sense, the impact of the first visionary sequence is the strongest—probably because it is the most unexpected. Right before this sequence, the Dalai Lama is seen in the beautiful gardens of the Tibetan Summer Palace. In his autobiography, the Dalai Lama describes this place as one he particularly loved: it was, he remembers, a verdant oasis graced with peacocks and deer, with fruit trees as well as a beautiful fishpond. The fish were so trusting, he recalls, that they would rise to the surface upon hearing his approaching footsteps. The love he so obviously feels for his fish prompts him to anxiously speculate about their fate once the Chinese invade. He wonders whether his fish would be "so

unwise as to rise to the surface when they first heard the boots of Chinese sol-
diers in the Norbulingka. If they did, they have probably been eaten."[72] It is his
anxious—but matter-of-fact—speculation about the fate of his fish that gives
rise, I think, to the first of the mental voyages seen on-screen. Bursting onto
the screen without warning, it transports us from the real world of the Summer
Palace described in his autobiography into a mental landscape of hallucination
and nightmare.

Immediately before this eruption of violence, the Dalai Lama, seated in his
beloved gardens, has received terrible news about Chinese atrocities perpetrated
against Tibetans. In the Eastern provinces, he is told, the invaders have forced
nuns and monks to fornicate and have made children kill their parents. Upon
hearing these reports, the Dalai Lama begins to weep for his people. As he does
so, violence suddenly shatters the peace and tranquility of the idyllic Summer
Palace. It takes the form of a burst of red—the color of blood and death—that
explodes in the fishpond and slowly spreads throughout the water. As startling as
it is brief, the puff of red in the water carries the same unmistakable message as
the sky burial: like the Dalai Lama's trusting and innocent fish, his beloved
people will be overcome by Chinese violence. As the pond's water assumes the
color of death, the emotional violence of the Chinese invasion becomes at once
abstract and overpowering. Without specific villains or concrete events, it repre-
sents the very essence of violence.

Bathed in fears both real and imagined, this first vision also contains what
I think is the first explicit cinematic allusion in the film. For although virtually
all of *Kundun* testifies to the weight of cinematic traditions, it is only when we
come to the Dalai Lama's mental voyages that it refers to specific—and invariably
highly melodramatic—scenes from earlier films. In the case of the first such voy-
age, *Kundun* evokes a scene in a fairly gruesome thriller about a sex-obsessed
murderer: Mario Bava's relatively little-known *Blood and Black Lace* (1964). De-
scribing this scene, Scorsese notes that it depicts a "woman in the bathtub and
she's dead and she's got black hair, a white face, and bright red lips, and it's
a white bathtub and this blood pumps up."[73] While this particular allusion might
well be lost on viewers who do not share Scorsese's vast cinematic erudition, few
would miss the cinematic echo in the next visionary sequence, for it bears on
a well-known scene in one of the most famous of all American films: the 1939
classic about the Civil War, *Gone with the Wind*. Designed to underscore the vast
number of those killed and wounded in the war, the sequence is marked by a
progressive, tripartite structure. It begins with shots of a few soldiers lying among
the dead. Soon, the camera draws back and, as our field of vision widens, their
numbers increase; finally, the entire screen is filled with dead soldiers as far as
the eye can see.

To evoke the memory of this famous sequence, in *Kundun* Scorsese uses a similar tripartite structure. Once again, it is a structure that emphasizes the number of dead. This time, of course, the dead are not Confederate or Union soldiers; rather, they are Tibetan monks who have been murdered by the Chinese. The sequence begins with a shot of the Dalai Lama standing amid a group of dead monks who, dressed in the brownish-red robes of their calling, are lying on the ground at his feet. Before long, the camera pulls back to reveal that the Dalai Lama is standing in a sea of victims; in the last shot of the sequence, the bodies of individual monks have melted into a vast, almost abstract, tableau of red and brown. As this tableau takes shape, memories of the carnage of the Civil War—and of *Gone with the Wind* itself—seem to merge with and give force to the bloodshed wrought by the invading Chinese in Tibet.

One of the most powerful aspects of this sequence—and indeed of all the visionary sequences—is the expressionist use of color. Just as different colors are used to define Tibet and China, a consistent palette also marks the Dalai Lama's mental voyages. Thus, the reds and browns of the monks' robes in the second vision hark back to the explosion of red in the fishpond. It is these colors—by now virtual signifiers of death and destruction—that reappear, once again, in the last mental voyage taken by the Dalai Lama. In this scene, the Tibetan leader, on the verge of entering India to begin a life in exile, begins to take leave of his countrymen who have accompanied him on his perilous journey to the Tibetan-Indian border. As he looks back, the desolate reality of the present turns into a horrifying vision of the future: dead Tibetans are lying on the ground, their horses splashed with blood. The most cryptic and surreal of the Tibetan leader's visions, this scene adds a final layer to the emotional violence that builds as the film progresses. "When [the Dalai Lama] looks back," observed Scorsese, "he sees the men who helped him reach the border. . . . He blesses them, then looks again and sees them dead. He knows that they are going back towards their death. In fact, he has the vision of a frightful future. When he sees these dead men, lying on the earth in their blood, he sees the destruction of a culture and a civilization."[74]

As this last sequence demonstrates so clearly, much of the power of the visionary sequences lies in their ability to pull us into an imaginary realm in which music, colors, and rhythms both flow from and create feelings and fears that are buried beneath rational analysis. Reduced to striking visual motifs and metaphors—to vultures circling in the sky or a puff of red in a fishpond—the Chinese invasion of Tibet loses its complex historical dimension. By the end, all it takes is a splash of red on the flanks of a horse to evoke the looming menace of the Chinese invasion. Swept into this imaginary realm, we tend not to notice—much less question—the film's distortions of history or the stereotypes that lurk beneath its bursts of chromatic violence.

Significantly, the visionary sequences are not the only ones designed to underscore Chinese barbarism. *Kundun* also devotes an extended sequence to the man who virtually embodies Chinese violence: the architect of the Chinese invasion, Chairman Mao. And when it comes to Mao, the distortions and simplifications that flow from the film's partisan lens—distortions that are obscured by the sheer imaginative force of the visionary sequences——come into very sharp focus. For, as seen in *Kundun,* Mao is a strange hybrid who belongs neither to the world of the imagination nor to that of history. If his historical role pulls us out of the hallucinations portrayed in the visionary sequences, he is too flat, too stereotypical, to function as a convincing historical figure. Turned into the absolute other of the Dalai Lama, he is as unreal, in a sense, as the Dalai Lama is real and authentic. In short, in his case, the cinematic echoes that give such force to the visionary sequences serve only to create an all-too-familiar villain. In the end, we are left to wonder how this cartoonish and one-dimensional creature can possibly be responsible for the powerful wave of emotional violence that gives the film much of its force.

As in the case of the visionary sequences, the film's portrait of Mao seems to have been inspired largely by the Dalai Lama's reminiscences: in his autobiographies the Tibetan leader describes at some length his historic meeting with Mao when he visited the Chinese capital in 1954–1955. Once again, the differences between the memories expressed on the written page and those re-created in the film are striking. But this time they point not to the film's strength but to what might be seen as an essential weakness: its inability or unwillingness to deal either with a historical figure or with the nuances and complications of history. It would certainly come as a surprise to the viewer of the film to learn that in his writings, the Dalai Lama portrays Mao—as well as his stay in Beijing—in terms that are not only nuanced but surprisingly positive. Not only, recalls the Dalai Lama, did he meet some "extremely nice" Communists—men and women who were, he felt, "totally selfless in their service to others"—but he even found himself attracted to the goals of equality and social justice implicit in Marxist thought. "I felt sure," he wrote, "as I still do, that it would be possible to work out a synthesis of Buddhist and pure Marxist doctrines that really would prove to be an effective way of conducting politics."[75] Most important, though, the Dalai Lama was impressed by Chairman Mao. Struck by Mao's "friendly and spontaneous" demeanor, he felt that the Chinese leader had "a very emphatic air of authority and sincerity. His mere presence commanded respect. I felt, too, that he was completely genuine as well as very decisive."[76] Toward the end of his stay, it is true, the Tibetan leader was apparently greatly disturbed when Mao expressed a negative view of religion: "religion," said Mao, "is poison. Firstly it reduces the population, because monks and nuns must stay celibate, and secondly it neglects material

progress." But even this disturbing remark did not really change the Dalai La-
ma's positive impression of Mao. He continued to believe that Mao "was a great
leader and above all a sincere person. He was not deceitful."[77] And this impres-
sion remained with him even after he left Tibet. Patrick French recounts that, in
an interview with the Dalai Lama, the Tibetan leader gave him the sense that he
continued to regard Mao with "admiration and respect, admiration for him as a
great leader. He [Mao] interacted simply, with no air of pretence. He was just
showing himself to be an old Chinese peasant."[78]

The "old Chinese peasant" that so impressed the Dalai Lama is, of course,
nowhere to be seen in *Kundun*. So, too, do the Dalai Lama's favorable impres-
sions of Beijing vanish. In the black-and-white moral universe of *Kundun*, the
friendly and selfless Communists the Dalai Lama encountered in the course
of his visit have been replaced by silent robots who haunt the gloomy corri-
dors of power. Above all, though, the sincere and friendly figure of Mao the
Dalai Lama described has morphed into an iconic villain in whom illness and
decay are both physical and moral. The Dalai Lama's observations that Mao
had some "difficulty breathing" and that his skin had a "shiny" and "curious"
sheen give rise, on-screen, to a character endowed with a strange, persistent
cough and a peculiar oily skin that seems to ooze deception and treachery
from every pore. An egomaniac in love with the sound of his own voice, Mao
moves and talks so slowly that, in the words of Sandra Marti, he suggests a
man "constantly under the influence of drugs and morphine."[79] His confiden-
tial aside about religion to the Dalai Lama becomes, in *Kundun*, a didactic
diatribe—one that betrays, in the eyes of Italian critic Serafino Murri, "a sim-
plification worthy of a children's book"[80]—on the part of a determined enemy
of religion. "You need to learn this," he sternly admonishes the Dalai Lama,
"religion is poison. Poison. Like a poison it weakens the race. . . . Like a drug,
it retards the mind. Tibet has been poisoned by religion and your people have
been poisoned."

But it is not only Mao's simplistic words or actions—or even his repellent
physical appearance—that turn him into a familiar villain. It is also, of course,
the way he is filmed. Shot in insistent and long-held close-ups, he is fragmented
and dehumanized: instead of seeing him as a whole person, we are forced to fo-
cus on his shiny face, his trouser legs, and especially his highly polished shoes.
(Interestingly, Scorsese uses similar shots in *Goodfellas* to portray an important
mobster.) The sense of fragmentation and "malaise" (to use Scorsese's term) that
clings to Mao's body is further intensified by the repeated camera flashes of re-
porters intent on capturing Mao's historic meeting with the Dalai Lama. Liken-
ing these flashes to "gun shots" and "aggressions," Scorsese observed that they
are there "to create a sense of malaise and to suggest what will come later."[81]

Imbued with malaise, dehumanized and drugged, in the end, Scorsese's Mao is perhaps even more unreal and grotesque than the figure of Mao found in a late cold war spy thriller made almost thirty years earlier: *The Chairman* (J. Lee Thompson, 1969). Permeated by elements of science fiction, *The Chairman* portrays an American scientist (Gregory Peck) who is sent to China in the tumultuous years of the Cultural Revolution. Against a background of collective hysteria— one in which robotic and possessed young people frenetically engage in acts of destruction and humiliation—the American hero must carry out an essential and dangerous mission. He must foil Chinese plans to develop an enzyme that, by reversing the effects of climate, would allow the Chinese to dominate the world's food supply. With the help of the Russians—who have become America's ally against the Chinese—he accomplishes his mission and manages to escape from the frenzied world around him. But in the course of his stay, in what must be the most bizarre scene of what is certainly a very strange movie, he engages in a game of Ping-Pong with none other than the "chairman" of the title—that is, Mao. As the two men play out their match at the Ping-Pong table, the viewer has no doubt that their so-called game is a symbol of the life-and-death struggle between their two nations.

Happily, Scorsese spares us any reference to Ping-Pong. Still, the one-dimensional Mao of *Kundun* is hardly more convincing than the cold war villain seen in *The Chairman*. In fact, Scorsese's Mao bears less of a resemblance to the leader described by the Dalai Lama than he does to the gangsters, psychopaths, and mob bosses that Scorsese himself created in films like *Goodfellas* and *Casino*. Unlike them, of course, Mao does not commit acts of violence before our eyes. But it is clear that he shares their capacity for violence as well as their defining traits. He, too, is a larger-than-life megalomaniac driven by an obsessive desire for power and an indifference to human life. When one interviewer made the revealing suggestion that Scorsese's Mao might be seen as a Hollywood mogul, Scorsese made an even more telling response. He observed that he saw Mao as an "incredible gangster." And, as if we needed to be told, he added: "I always had a morbid fascination with gangsters."[82]

There is no doubt that what Scorsese describes as his "morbid fascination with gangsters" has inspired some of his most memorable characters: the mafia bosses of *Mean Streets* and *Goodfellas,* the towering gang leader of *Gangs of New York* (2002). But transposed into *Kundun*, this "fascination" leads to a portrait of Mao that is as grotesque as it simplistic. Mao may well have been, as the director suggests, a "gangster"—or what Patrick French calls a "capo"—of sorts. But, as French goes on to observe, Mao was also "a key historical figure of the twentieth century, a politician who controlled a quarter of the world's population."[83] Politicians and statesmen as shrewd and cynical as Nixon and Kissinger, as Pankaj

Mishra notes, were "awed by Mao's raw power and historical mystique."[84] Fervently loved by millions of Chinese, Mao led one of the greatest and most far-reaching revolutions of the twentieth century.[85] But *Kundun,* of course, gives no hint of these crucial historical factors. Just as the film ignores the qualities in Mao that won the admiration of the Dalai Lama, so, too, does it virtually sweep away the enormous historical resonance of the Chinese leader. Here, Mao is little more than still another gangster—a kind of flattened caricature or pale reflection of the towering villains of Scorsese's other films.

In the end, then, the figure of Mao as seen in *Kundun* underscores both the cinematic echoes that infuse the film as well as Scorsese's disregard for the constraints, the shades of gray, of history. It is hard to argue with Serafino Murri when he writes that the film is characterized by a "superficial" approach to "controversial material" that calls for a "profound maturity and historical awareness [rather than] feelings of New Age adoration for the charismatic man-God."[86] So, too, is Marc Abramson convincing when he suggests that *Kundun* should be seen less as a historical work than as a "cinematic meditation on memory and transcendence."[87] Yet, at the same time, like all the films discussed in these pages, *Kundun does* bear witness to history and ideology. In a sense, the very absence of history is eloquent: it speaks of the erasures of memory, the weight of ideology, and the pressures of desire. If *Kundun* says little about the "real" Tibet or the "real" China, it says a great deal about changing perceptions of both countries—perceptions that are inevitably part of history itself. As suggested earlier, in its fiercely partisan cast, it bears witness both to the negative images of China that came back with a vengeance after 1989 and to the widespread victory of the Tibetan narrative. Pointing to the spread of Buddhism in the West, it also embodies the evolution of the myth of Shangri-La into that of Dharma-La. From a still broader perspective, it suggests a very American tendency to view national differences and strategies as part of a moral battleground in which the political leaders of other countries become trustworthy "friends" or villainous "enemies." And no one, of course, could be more of a friend than the Dalai Lama or more fearsome an enemy than Chairman Mao.

Resonating in these many directions, the mythic cast of *Kundun* also intensifies the tonal dichotomies of earlier films even as it adds a new dimension to twentieth-century screen representations of China. For it suggests the often compelling role played by images in composing layers of perception and memory. Mao is not only a latter-day incarnation of an Oriental despot or even the United States' principal adversary at the time of the cold war: he is also a psychopath who might have stepped out of an American gangster film. Nor is it a coincidence that the role of images—whether drawn from propaganda posters or from earlier films—is felt most intensely when, as in the case of Mao, it comes to the

Chinese. Bathed in cinematic echoes, the Chinese are drawn into the realm of the simulacrum even as they become the latter-day incarnation of the phantasmagorical hordes who descend on Europe in *The Yellow Danger*. In Shiel's era, the heathen nature of the Chinese was perceived as a threat to Western civilization. Giving new life to that threat, *Kundun* denounces China for its embrace of Communism and its "anti-spiritual" nature. Deeming the Chinese "the worst of the worst," one of the Dalai Lama's advisers tells us that "they are worse than ghosts." Impregnated with images, their "ghostly" nature is an indirect reminder of how cinema not only reflects but also shapes history.

Challenges and
Continuities

The Stilling of the Pendulum?

Looking back, Scorsese's refusal to represent traditional Chinese villains in *Kundun*—or even to depict Chinese atrocities in a conventional realistic manner—seems prescient: by the late 1990s figures like the draconian judge of *Red Corner* and the cruel and arrogant generals of *Seven Years in Tibet* had a distinctly anachronistic cast. True, from time to time, one sensed the weight of earlier stereotypes: Kenneth Chan points out that the dominatrix teacher played by Lucy Liu in *Charlie's Angels* (McG, 2000) has a whiff of the Chinese dragon lady about her and that the evil pirate played by Chow Yun-fat in *Pirates of the Caribbean: At World's End* (Gore Verbinski, 2007) hints at more than one earlier Chinese villain.[1] Still, these figures seem pale echoes of the past rather than vibrant creatures of the present. Generally speaking, the new millennium has witnessed both the disappearance of earlier stereotypes and—though this is more debatable—the stilling of the pendulum that governed images of China throughout the twentieth century.

The fading of negative stereotypes does not mean that fears of China have disappeared. On the contrary: China casts the darkest of shadows over contemporary America. But it does mean, as the first part of this chapter attempts to show, that other factors—economic, cultural, and social—have conspired to banish earlier stereotypes and foster radically changed representations of China. Not only have social and demographic changes altered the face of America, but the world of film production and distribution has become increasingly global as well. Does it still make sense to classify films as American or Chinese in the face of a coproduction like Ang Lee's *Crouching Tiger, Hidden Dragon* (2000)? Does it really matter where Jackie Chan triumphs over the bad guys—be it in the Bronx (*Rumble in the Bronx*, 1996), London (*Shanghai Knights*, 2003), or Japan (*Shinjuku Incident*, 2010)? Moreover, these changes were accompanied by still another

far-reaching development: the rise of so-called transnational Chinese cinema—a term that encompasses films from so-called Greater China (Taiwan, Hong Kong, the mainland) as well as from the various far-flung communities of the Chinese diaspora—has meant that Americans can finally see China (or the various Chinas) through Chinese rather than American eyes.[2]

Of course, things are not quite that simple where American perceptions and images of China are concerned. Indeed, I would argue that, while films of the last decade have largely banished the negative impulses of the past, they have not banished something even more fundamental: the impulses—in particular the ethnocentrism that gave rise to a binary view of the world—that engendered such stereotypes. In the second half of this chapter, I would like to explore the persistence of these impulses in two enormously successful animated features set in China: *Mulan* (1998) and *Kung Fu Panda* (2008). In a sense, it may seem strange to conclude this study with films clearly designed for children, or, at least, for a youthful market. But just as fairy tales often testify to attitudes that are repressed or held in check elsewhere, these films bear witness to feelings and impulses that are not always openly acknowledged or expressed. Creating an image of China more unreal and imaginary than ever before, they turn that country into a site of spectacle as well as a repository of American attitudes and beliefs. In so doing, not only do they firmly erase the real China, but they also point to the creation of what might be seen as a new—and distinctly postmodern—form of Orientalism.

The challenge to earlier images and representations of China stemmed, as I have suggested, from a diverse panoply of important social, cultural, and economic changes. To begin with, as we are constantly reminded, the United States is no longer the country it was a generation ago. Not only have huge numbers of immigrants reduced white majorities, but they have also accustomed Americans to seeing erstwhile "others" as people much like themselves. Moreover, as America has grown increasingly diverse, formerly inviolable taboos—especially those surrounding interracial sex and marriage—have receded into the distant past. In a country that is finally allowing same-sex couples to wed and that elected (and reelected) a biracial president, the notion of transgression—at least as it bears on sexual or racial difference—seems an almost incomprehensible relic of an earlier time. True, in wide swaths of the population old attitudes persist—often in virulent form. But to a very great degree, changing demographics, together with a new climate of racial and sexual sensitivity, have dealt mortal blows to the prejudices and stereotypes of the past.

Just as the face of the nation has changed, so, too, has the world of film. Lured by the prospect of huge numbers of potential viewers both at home and abroad, films carefully avoid the stereotypes they might have casually offered

viewers in an earlier era. At the same time, they seek new themes and characters. It is telling, for example, that in the 1990s, Disney—the studio that produced *Mulan*—embraced what Jaap Van Ginneken calls an "exotic offensive." Faced with waning growth in the United States and Europe, the studio was convinced, as Van Ginneken writes, that "a major effort had to be made to break into the emerging markets of Africa, Arabia, Asia and the rest of the Americas."[3] To this end, the studio largely abandoned the very white, distinctly European characters of earlier films such as Snow White for non-European heroes and heroines like those seen in *Aladdin* (John Musker and Ron Clements, 1992), *Pocahontas* (Mike Gabriel and Eric Goldberg, 1995), and, finally, *Mulan*. As if to underscore the importance that Disney placed on success in the Chinese market in particular—and to compensate, perhaps, for Chinese sensibilities ruffled by *Kundun*—the release of *Mulan* in China was greased by a presidential visit by Bill Clinton and a deal brokered by Jack Valenti whereby the Motion Picture Association (of which he was the head) would help distribute some Chinese movies in America.[4]

Changes in film distribution and consumption have been accompanied, moreover, by equally far-reaching changes in production. The rise of coproductions like Ang Lee's *Crouching Tiger, Hidden Dragon* is but the most visible sign that the boundaries separating national cinemas from one another have crumbled. As they do so, the world of film has witnessed an ever-increasing flow of talent between China and America. In the summer of 2012 two of the most famous names in Hollywood announced their involvement in projects in China: James Cameron, director of global hits like *Titanic* and *Avatar,* declared that he was setting up facilities in the Chinese port city of Tianjin to bring cutting-edge 3-D technologies and production services to China; DreamWorks Animation SKG, the studio behind *Kung Fu Panda* and other megahits, announced plans to develop a $3.1 billion cultural and entertainment district in Shanghai with a group of Chinese partners. And for well over a decade Chinese directors and performers have been participating in American films. Indeed, Roger Garcia suggests that Hong Kong cinematic figures, in particular, follow a "career pattern not too different from many Hong Kong businessmen, shuttling between businesses and families on two sides of the Pacific in our increasing global economy."[5] Underscoring this pattern, Kenneth Chan likens Chinese directors like John Woo and Tsui Hark, as well as performers such as Bruce Lee, Jackie Chan, Chow Yun-fat, Jet Li, and Michelle Yeoh to "astronauts who shuttle between Hollywood, Hong Kong, and wherever film production and promotion take them."[6] Often, too, the effects of this shuttling extend beyond America and China. Speaking, in particular, of the impact of Hong Kong action films on Hollywood, Yingjin Zhang makes the point that "as Hollywood became infatuated with the Hong Kong gangster film,

the genre was transported to other sites across the Pacific, and its production and distribution are now truly transnational."[7]

Nor does the resonance of globalization end there. For boundaries are also crossed—and often abolished—within the films themselves. Whatever their country or counties of origin, films often share themes and subject matter as well as techniques. For example, as Julian Stringer points out, a theme dear to Asian American directors—that of Chinese immigrants to America or what he calls "Asian American identities in the process of formation"[8]—has been taken up in films from Hong Kong such as *An Autumn Tale* (Mabel Cheung, 1998) and *Full Moon in New York* (Stanley Kwan, 1990). Action films, in particular, have long testified to the crumbling of national barriers. Even as kung fu masters like Jackie Chan display their skills in the old West (*Shanghai Noon,* 2000), American Westerns, as Daniel Fried puts it, "ride into China."[9] Indeed, the merging of these two immensely popular genres—kung fu films and Westerns—has given rise to a kind of subgenre: the kung fu Western. For example, *Kung Fu* (Jerry Thorpe, 1972) a movie-length pilot for a popular television series with the same title, features David Carradine as a former Shaolin monk, endowed with formidable kung fu skills, who comes to the rescue of oppressed Chinese railway workers in the old West. Describing the play of contemporary cross-cultural filmic influences and borrowings, Kenneth Chan cites a wonderful comment by John Woo, director of such Hollywood films as *Hard Target* (1993), *Broken Arrow* (1994), and *Face/Off* (1997). "Hollywood," said Woo, "began to imitate Hong Kong movies in the late 1980s and 1990s because Hong Kong films (to a certain degree) are imitations of Hollywood films, so Hollywood is imitating Hollywood."[10] (See fig. 6.1.)

The play of imitations that Woo describes here, as well as the flow of talent from one country to another, means that it is often difficult—if not impossible—to classify a given film or director as American or Chinese. "Through attracting mainland Chinese, Hong Kong, and Taiwanese film industry talent," observes Gary G. Xu, "remaking Chinese films, or coproducing films with Chinese companies, Hollywood absorbs the best of Chinese cinema and makes the distinction between American and Chinese films more arbitrary than ever."[11] A striking example of what Xu calls the "arbitrary" nature of such distinctions is provided by the films of Hong Kong superstar Jackie Chan. After popularizing kung fu comedies in Asia with films like *Snake in the Eagle's Shadow* (1978) and *Drunken Master* (1978), Chan broke into the American market with *Rumble in the Bronx* and *Rush Hour* (1998). Noting that *Rumble in the Bronx* was the number one box office attraction in the U.S. market after its opening weekend, Steve Fore makes the point that with this film Jackie Chan and the film's production company "successfully scaled the wall of popular success that previously has been considered all but impregnable to assaults by non-Hollywood renditions of 'entertainment' films."[12]

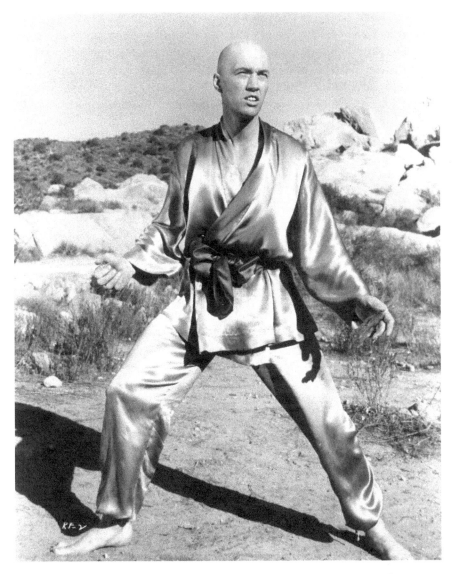

Figure 6.1. Kung Fu: David Carradine as a Shaolin monk in the old West; the kung fu Western as the fusion of genres and cultures

Since that time, Chan has scaled that wall again and again with films that, straddling traditional national boundaries, have clearly been designed to appeal to viewers on both sides of the Pacific. To win these diverse audiences, Chan often plays a Chinese protagonist who finds himself in the West. (In *The Karate Kid* [2010]—a film I will return to a bit later on—the strategy is reversed: the film

features a black American teenager who goes to China.) A good example of this is *Shanghai Noon*—a 2000 film in which Chan plays a former member of the imperial guard in China who comes to the old West in search of an abducted Chinese princess. A kind of postmodernist pastiche filled with scenes that both pay homage to and parody earlier films and cinematic conventions, *Shanghai Noon* is at once a kung fu Western—or what Chan called an "Eastern Western"—and a kind of cross-cultural buddy film in which Chan teams up with a very American outlaw, Roy O'Bannon (Owen Wilson), in the old West. Giving a new twist to the familiar set pieces that punctuate American Westerns—the jailbreak, the encounter with American Indians, and so on—the film evokes iconic figures and films. For example, Chan's name, Chon Wang, evokes that of legendary Western hero John Wayne while the film's title calls to mind a classic 1952 Western: *High Noon* (Fred Zinnemann)[13] (See fig. 6.2.)

But along with all these playful allusions to earlier films and filmic conventions, *Shanghai Noon* also implicitly raises important questions bearing on cultural expectations and stereotypes. For here, as is frequently the case in Chan's films, his presence in the old West—that is, in an environment that is totally strange to him—gives rise to cultural comparisons as well as ethnic jokes. In fact, insofar as Chan plays a kind of innocent abroad, *Shanghai Noon* bears an interesting resemblance to a Harold Lloyd film discussed earlier, *The Cat's-Paw*.

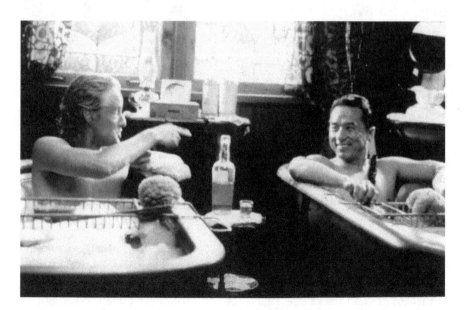

Figure 6.2. Shanghai Noon: Buddies (Owen Wilson, Jackie Chan) in the old West

(A great admirer of Lloyd, Chan paid explicit homage to a famous "thrill" sequence of *Safety Last*—in which Lloyd dangles high above the city streets from the clock tower of a skyscraper—in both *Project A* [1983] and *Shanghai Knights*.). Not only are the protagonists of both *The Cat's-Paw* and *Shanghai Noon* upright innocents from China who find themselves in the rough-and-tumble world of the American frontier, but also, much of the humor of both films stems from the cultural misunderstandings and misadventures they encounter in this most alien of environments. Further, despite his seeming innocence, Chan—like Ezekiel, the character played by Lloyd—manages to emerge triumphant. Chan's eventual triumph may be more traumatic than that of Ezekiel, but it is no less sweeping or total.[14] Transformed into the "Shanghai Kid," he manages to rescue the princess and win her love—all without compromising the moral principles of his Chinese upbringing. Although his American buddy constantly tells him that "this is the West, not the East," the truth is that he—like the film itself—is a creature of both worlds.

The straddling of national boundaries, as well as the challenge to racial stereotypes, seen in a farce like *Shanghai Noon* assumes a very different tone in the work of the director who is probably the most preeminent "astronaut"—as well as the most protean director—in the landscape of contemporary cinema: Ang Lee. After studying filmmaking at New York University, Lee began his career with three films centered on contemporary Chinese and Chinese American families—*Pushing Hands* (1991), *The Wedding Banquet* (1993), and *Eat Drink Man Woman* (1994)—that had much in common with the domestic dramas of his native Taiwan. Since that time, he has worked in both China and America and has revisited genres as deeply American as the Western (*Ride the Devil* [1999], *Brokeback Mountain* [2005]) and as profoundly Chinese as the martial arts epic (*Crouching Tiger, Hidden Dragon*). In 2012, with the *Life of Pi*—an adventure film/philosophical fable featuring a young Indian boy who is stranded in a lifeboat with a wild Bengal tiger—Lee left the terra firma worlds of both China and America behind for a watery realm midway between the real and the unreal. Noting that Lee's cosmopolitan career makes it impossible to qualify the director as either a Chinese or an American filmmaker, Darrell Y. Hamamoto suggests that the director "embodies the transnational nature of Asian American life ways within a globalized system of film production."[15] Looking at this issue from a far more personal, perspective, Lee displayed a melancholy sense of cultural displacement: "I'm a mixture of many things," he said, "and a confusion of many things.... I'm not a native Taiwanese, so we're alien in Taiwan today, with the native Taiwanese pushing for independence. But when we go back to China, we're Taiwanese. Then, I live in the States; I'm sort of a foreigner everywhere. It's hard to find a real identity."[16]

Not surprisingly, the elusive sense of identity that Lee describes here runs throughout his films: if, as he suggests, identity begins with nationality or a sense of home, in his films, it also assumes a far broader cast—one that bears on sexuality, psychology, and ethics. Early in his career, the complicated matrix of impulses related to identity came into sharp focus in one of his best-loved films, *The Wedding Banquet*. A huge commercial success in Asia as well as an art house favorite in the United States, Lee's second film takes as its protagonist a gay Chinese (or Chinese American) man, Wei Tong (Winston Chao) who lives in New York with his lover. Although he is open about his sexuality in New York, he has never been able to come out to his traditional Chinese parents in Taiwan. As a result, they continue to seek possible brides for him in the ardent hope that he will marry and produce a grandchild. Thus, when Wei Tong learns that his parents are about to visit him, he decides to make them happy (and mask the truth) by staging a marriage with a woman friend—a starving Chinese artist from the mainland who rents an apartment from him. Although he proceeds with his plan, things soon spin out of control: he drunkenly impregnates his bride on his wedding night, his jealous and neglected lover threatens to leave him, his father falls ill. But all ends well: his new wife will have the economic support she desperately needs, his parents will have the grandchild they so desire, his lover decides to forgive him. In the most surprising—and perhaps important—twist of all, his father implicitly accepts his son's sexuality by telling him that he suspected all along that his son's lover was more than a friend (see fig. 6.3).

Given the theme of *The Wedding Banquet*, it is hardly surprising that serious discussions of the film have tended to focus on issues related to sexual identity and the construction of gender. But to my mind, what is equally striking about the film is the sureness with which it captures the nuances of the very different cultures—New York/Taiwan/the mainland, straight/gay, Chinese/Chinese American—that affect the life of its protagonist.[17] In terms of New York, for example, the film shows a sensitivity to life in that city equal to that displayed by, say, Woody Allen: the opening scene contains a comic moment—in which the protagonist gives money to a street musician money to *stop* him from singing—that would not be out of place in a film like *Annie Hall* (1977) or *Manhattan* (1979). In many ways, too, the protagonist himself is a quintessential New Yorker: although he has a soft heart, he is often brusque and driven, concerned with success and money. But at the same time he is also deeply Chinese: propelled by the sense of filial duty long central to Chinese culture, he is ready to upend his life and deny his sexuality out of love and duty toward his parents. Speaking of the conflict prompted by this duality—a conflict between two vastly different sets of cultural and social expectations—Lee made an observation with revealing autobiographical overtones. In China, he said, filial piety has been "taught for thou-

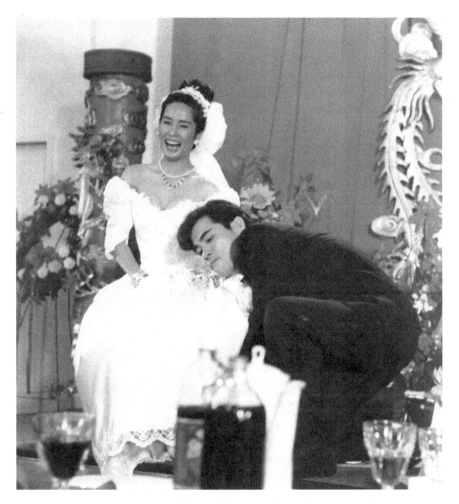

Figure 6.3. The competing claims of love and family in The Wedding Banquet: after staging a marriage for the sake of his parents, Wei Tong gets drunk on his wedding night

sands of years. It's the basic moral code and you cannot follow it. You feel total guilt because you cannot fulfill it. You become a Westerner and you betray your parents. Something you feel unable to deal with: total guilt."[18]

Although focused on a single Chinese family, *The Wedding Banquet* opens upon a broad social landscape: it suggests the cultural dislocations and the existential conflicts, that accompany the advent of an increasingly cosmopolitan world. At the same time—again through the portrait of a single family—it implicitly challenges long-standing stereotypes surrounding China and the Chinese. While,

as we have seen, that challenge usually takes the form of ethnic parodies and jokes in the films of Jackie Chan, in *The Wedding Banquet,* as in other films by Ang Lee, this same challenge assumes a rueful, deeply human tone. Believable and realistic, his characters are often complex men and women faced with the dilemmas of the modern world. None of the characters of *The Wedding Banquet,* for example, can be placed in a given niche. Both deeply Chinese and unabashedly American, the conflicted protagonist is eager to live his own life and yet faithful to his parents; while his father fits the image of a patriarchal figure, he is also deeply human and compassionate. The characters of Lee's other films are equally complex and yet equally universal. The Tai Chi master of *Pushing Hands,* who cannot adjust to the very American life led by his son and his son's family in Queens, is as complicated a figure as the three adult sisters of *Eat Drink Man Woman,* who must deal with the welter of emotions they feel for their widowed father. Even the relatively "unreal" characters of *Crouching Tiger, Hidden Dragon* make us question earlier images: stereotypes of Chinese masculinity and femininity fall away in the face of Lee's melancholy portrait of undying love and the charismatic charms of performers such as Chow Yun-fat, Michelle Yeoh, and Ziyi Zhang.

Jackie Chan and Ang Lee are probably the best known of contemporary Chinese directors. But as suggested earlier, their films are also part of the rise of transnational Chinese cinema. One of the most exciting developments in the cinematic landscape of recent decades, these Chinese films have also had a significant impact on perceptions of China. After all, before that time the vision of China put forth by Hollywood reigned supreme in the United States in large part because few Americans could see competing images. This meant that it was impossible to compare, say, the image of Shanghai seen in the films of von Sternberg with the very different city portrayed in Chinese films of the 1930s. Significantly, it was not until 2005, when the Museum of Modern Art held a retrospective of Chinese cinema, that American viewers could finally see classic works from what is often called the golden age of Chinese cinema. Watching films such as *The Goddess* (*Shennu;* Wu Yonggang, 1934) and *Street Angel* (*Malu tianshi;* Yuan Muzhi, 1937), they saw a Shanghai that was radically different from the decadent city of *Shanghai Express* and *The Shanghai Gesture.* Turning from past to present, the emergence of transnational Chinese films has given Americans the opportunity to compare the China seen in, say, films of the Tibet craze with the country/countries portrayed though a Chinese lens.

What would eventually become a flood of films from transnational China began dramatically, in the early 1970s, with martial arts films from Hong Kong. Sparking a veritable kung fu craze, these films offered Americans what Poshek Fu and David Desser describe as the "glimpse of a cinema at once familiar yet

strangely and wonderfully new."[19] Desser offers an astonishing statistic: in May 1973, *three* Hong Kong kung fu films—*Fists of Fury* (Lo Wei, 1971) *Deep Thrust—The Hand of Death* (Feng Huang, 1972) and *Five Fingers of Death* (Cheng Chang Ho, 1973)—were ranked number one, two, and three on *Variety's* list of the week's top box office draws.[20] While films from Taiwan and from mainland China never rivaled Hong Kong action films in popularity, they, too, have offered American viewers glimpses of a cinema that was "strangely and wonderfully new." From Taiwan came Hou Hsiao-hsien's melancholy meditation on history (*A City of Sadness* [1989], *The Puppetmaster* [1993], and *Good Men, Good Women* [1995]) and Edward Yang's devastating portrait of contemporary alienation (*A Brighter Summer Day* [1991] and *Yi Yi* [2000]). From the mainland came historical epics by the so-called Fifth Generation of directors—Chen Kaige (*Yellow Earth,* 1984), Zhang Yimou (*Red Sorghum,* 1987), and Tian Zhuangzhuang (*The Blue Kite,* 1993)—as well as lush melodramas (Chen Kaige's *Farewell My Concubine* [1993], Zhang Yimou's *Ju Dou* [1989], and *Raise the Red Lantern* [1991]) that astonished viewers by virtue of their stunning landscapes and their exquisite esthetic values informed by an expressive use of color, costumes, and music.

More recently still, Americans have been able to see a host of independent features from China that probe the dark underside—the social dislocations and ever-widening gap between rich and poor—of China's stunning economic boom. In films that for political reasons have usually been easier to see abroad (at art houses or film festivals) than in China itself,[21] directors have documented a wide variety of social ills: the difficult lives of petty thieves and prostitutes (*Xiao Wu;* Jia Zhangke, 1998); workplace abuse and corruption (*Blind Shaft;* Li Yang, 2003); the abduction of young women forced to serve as brides in remote rural areas (*Blind Mountain;* Li Yang, 2007); villages destroyed by the building of the Three Gorges Dam (*Still Life;* Jia Zhangke, 2006). In one of the most complex and interesting of these films, *The World* (2005), director Jia Zhangke—who is probably the best known of this group of directors (usually referred to as the Sixth Generation) explores one of the major problems confronting contemporary China: the plight of rural immigrants to China's principal cities. Set in a huge amusement park on the outskirts of Beijing, the film contrasts the glittering and unreal life of the park—which is dotted with sparkling replicas of iconic cultural monuments from around the world (the Eiffel Tower, the Taj Mahal, the Manhattan skyline)—with the desolate and constrained lives led by the impoverished rural immigrants who work there.

It is true that transnational films are often radically distinct from one another. The divide between, say, a carefully choreographed big-budget historical epic like Zhang Yimou's *Hero* (2002) and a modest, quasi-neorealistic film like Jia Zhangke's *The World* could hardly be starker. But in a sense, the very diversity

of transnational Chinese cinema is a reminder that the image of a monolithic China that persisted so long in the American imagination was a fiction: that modern China is instead, as Sheldon Lu observes, "a collective of [different] communities, peoples, ethnicities, regions, dialects, languages, and temporalities"—a "collective" marked, as he proceeds to point out, by "migration, colonialism, nationalism, political rivalry, military confrontation, and cultural interflow all at the same time."[22] Destroying the image of a monolithic China, transnational Chinese films have also shed light on—and altered perceptions of—what Lu calls its many different "communities." For example, the so-called New Cinema of Taiwan changed the simplistic American perception of Taiwan—as a "bulwark" or island fortress against Communist China—that had been in force since the cold war. Films by Hou Hsiao-hsien and Edward Yang and, later, those of Tsai Ming-liang make it amply clear that Taiwan is a very real place with a complicated history of its own—one shaped by the memory of Japanese colonization and Nationalist rule and by its status as a client state of America.

The challenge all these films posed to earlier images was, of course, neither deliberate nor explicit. Their principal concern was not America—or American perceptions of China—but China, or, more precisely, the various "Chinas." The situation was quite different when it came to still another current of transnational Chinese cinema: films by Chinese American directors. Although such films began to emerge in the 1980s, their roots go back the civil rights struggles of the 1960s. Prompting Chinese Americans to become aware of their identity and their rights as a group, these struggles also sparked important legislation bearing on Chinese Americans and Chinese immigration. In 1964, racial discrimination was declared illegal; the following year Congress passed the Immigration Act of 1965, which abolished the racial exclusion laws (i.e., quotas) that had discriminated against Chinese immigrants for nearly a century. The late 1960s saw important protests on the part of Asian Americans: while students went on strike in places like San Francisco State College and the City College of New York, from 1969 to 1972 Asian Americans organized contingents to participate in the anti–Vietnam War movement. In this rapidly changing political and racial climate, Asian Americans, as Kenneth Chan writes, "began to reexamine their sense of identify, their place in America, their cultural connections to their former homelands, and the political possibilities of asserting their place in a nation that had sought to assimilate them and confine them to the ghettos of America's social margins."[23]

By and large, independent films by Chinese American directors were not concerned with the perceptions and representations of China that—waxing and waning in accord with the swings of the pendulum—had marked American cinema for most of the twentieth century. But they were vitally concerned with a related phenomenon: the stereotypes that had long surrounded Chinese and Chinese Ameri-

cans in the American imagination. Confronting these stereotypes, films explored the racist currents that lay beneath them as well as the crises of identity they provoked in many Chinese Americans. Noting that "explorations of identity have been integral to Asian American film from its inception," Hamamoto argues that "the ceaseless self-interrogation of identity is not merely an idle intellectual exercise. . . . Rather, it is a matter of social survival. Both politically and at the level of individual psychology, the twin questions of identity and nationality have presented an ongoing dilemma to Asian Americans. For Asian American history . . . has been shaped by the group identity imposed and enforced by the 'racial state.' "[24]

It would be difficult to find a film that better illustrates the interrelated impulses described by Hamamoto than the 1982 feature *Chan Is Missing*. Made on a minuscule budget by America's leading Chinese American director, Wayne Wang, *Chan Is Missing* was the first Chinese American film, as it were, to succeed in penetrating the mainstream market. Although it displays the low-key tone and anarchic humor often characteristic of independent films, *Chan Is Missing* nonetheless confronts a range of vital issues bearing on identity and perceptions, on representations and stereotypes, on the social and economic marginalization suffered by the Chinese in America. Its concern with how film images, in particular, contribute to these stereotypes is implicitly announced in its title. That is, *Chan Is Missing* deliberately evokes the memory of the benign detective Charlie Chan—one of the most famous of all cinematic Chinese stereotypes.

The echo of Charlie Chan films heard in the title becomes stronger as soon as *Chan Is Missing* gets under way. Just as the Charlie Chan films featured a pair of detectives—Charlie Chan and his assimilated son—so, too, does *Chan Is Missing*. This time, the pair of detectives consists of Jo (Wood Moy), a middle-aged Chinese cab driver in San Francisco, and his (assimilated) nephew, Steve (Marc Hayashi). No less than Charlie Chan and his son, Jo and Steve are faced with a mystery at the beginning of the film: what happened to Jo's friend, Chan Hung, who disappeared after borrowing four thousand dollars to buy a cab? Did the missing man go back to China with the money? Did something happen to him? As in the Charlie Chan mysteries, enigmatic clue follows enigmatic clue. But this time, in the sharpest of contrasts with Charlie Chan features, clues lead nowhere: everyone who is questioned about the missing man has a different image of him, a different interpretation of what caused his disappearance. It soon becomes clear that we are no longer in a Hollywood universe where everything is resolved at the end but in a distinctly modern world of puzzling ambiguities, shifting identities, and unresolved narratives. The very fact that Chan is never found strikes what is perhaps the most ambiguous note of all: does it simply indicate that not all mysteries can be solved? Or, as Wood Moy, the actor who played Jo, has suggested, does it point to the lack of "identity" that plagues Chinese Americans?

In the end, of course, *Chan Is Missing* is not merely an ironic comment on the certainties and conventions of an earlier film tradition. It is also an exploration of the stereotypes that have marginalized members of the Chinese community and that have rendered Chinese identity problematical. As Jo and his nephew interview inhabitants of San Francisco's Chinatown, virtually every conversation raises the specter of such stereotypes. A Chinese cook complains that although the Chinese have been in the United States for a hundred years, Americans still treat them like foreigners. They want us, says the cook bitterly, to make egg rolls— not to become aeronautical engineers. If the articulate and angry cook explicitly challenges stereotypes, the film itself amplifies this challenge in still another way: the sheer diversity of those interviewed makes clear that, contrary to what most Americans seem to believe, there is no "typical" Chinatown resident. On the contrary, sharp divisions run throughout the community: between FOB (fresh off the boat) and ABC (American-born Chinese) Chinese, between Mandarin and Cantonese speakers, between first- and second-generation Chinese Americans, between those who support the Nationalists on Taiwan and those who favor the Communists on the mainland. Emphasizing the groundbreaking nature of the film's portrait of Chinese diversity, Diane Mark observes that the "very presentation of diversity among Chinese American characters is a concept largely untested in American movies."[25] (See figs. 6.4 and 6.5.)

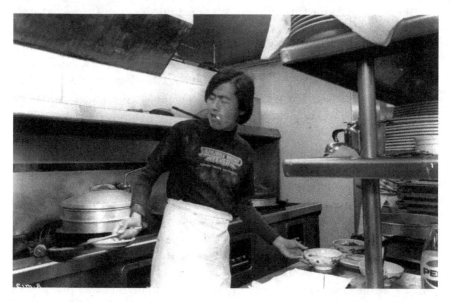

Figure 6.4. Chan Is Missing: An angry cook denounces the Chinese stereotypes that reduce him to "making egg rolls"

Figure 6.5. Chan Is Missing: San Francisco's Chinatown is "seen from the inside" as latter-day detectives Jo and Steve interview possible witnesses concerning a mysterious disappearance

Not surprisingly, just as the inhabitants of Chinatown are presented in a new light, so, too, is Chinatown itself. No longer the exotic place of mystery and sin seen in a long tradition of American films, in *Chan Is Missing* Chinatown is a poor neighborhood of immigrants with its share of hardworking cooks and cab drivers, its senior centers and schools that teach English. To cite Diane Mark again, in *Chan Is Missing,* Chinatown is seen from inside—"inside the Chinese restaurant, inside the kitchen, inside the work. It is inside family apartments, cafes, and even inside Jo's head."[26] (Interestingly, a quarter of a century later, Wayne Wang participated in a collective film, *Chinatown Film Project,* dedicated to exploring New York's Chinatown "from inside.") Indeed, the divide between the Chinatown of fantasy and the real place, as it were, is made very clear in a long montage sequence, which uses sound and image in counterpoint, that occurs toward the end of the film. On the soundtrack, we hear a song, "Grant Avenue," from a Broadway musical, *Flower Drum Song* (later made into a film), that celebrates a mythical Chinatown: voices gaily sing "Grant Avenue, San Francisco, California, U.S.A." On-screen, we see images that are anything but gay or celebratory: the camera shows us tenements, clothes hanging on a line, the careworn features of old women.

Chan Is Missing is probably Wayne Wang's most complex film, but through-
out his oeuvre he returned to the social and cultural issues—to what Hamamoto
calls the "twin questions of identity and nationality"—announced in that work.
For example, *Eat a Bowl of Tea* (1989), which is set in Manhattan's Chinatown in
1949, reveals how the lives of two generations of Chinese men were crushed by
the legacy of the racial discrimination laws forbidding the immigration of Chi-
nese women to America. Turning from the experiences of Chinese men to those
of women, in *Dim Sum: A Little Bit of Heart* (1984), Wang portrays a female pro-
tagonist who, like the protagonist of *The Wedding Banquet,* is torn between the
love and loyalty she feels for her family—in this case, her traditional Chinese
mother—and a desire to strike out on her own.[27] Amplifying this issue still fur-
ther in what was his most successful film, *The Joy Luck Club* (1993), Wang cross-
cuts between the very modern lives led by four young Chinese American women
and the horrors endured by their mothers, who came of age in a China that was
still semifeudal. If the film suggests the radical historical rupture between these
two generations, it also underscores the deep continuities that link them to one
another. Both American and Chinese, the young women are living proof that the
simple binary distinctions and dichotomies of the past have no place in the con-
temporary world.

China as Postmodern Fantasy: Mulan and Kung Fu Panda

The mainstream success of *The Joy Luck Club* suggests how radically the social
and cultural climate of America had changed in the concluding decades of the
last century. But amid a landscape of change, one factor remained constant: fears
of China were as strong as, if not stronger than, they had ever been. This meant
that American filmmakers who wanted to make a work dealing with China faced
an obvious dilemma. Simply put, they were torn between economic imperatives
and political winds. On the one hand, given the fears that surrounded China in
the American imagination, they could hardly make a film that portrayed China
in a favorable light. On the other, an unfavorable portrait of China might well
repel the huge numbers of potential Asian viewers both at home and abroad. It
was easy, or relatively easy, to avoid the stereotypes of the past. But without these
stereotypes, what kind of China could they portray?

The answer—or at least one of the possible answers—to this dilemma came
in the form of animated films such as *Mulan* and *Kung Fu Panda.* On the most
obvious level, the creation of a China far more imaginary than ever before—a
mythical land of bouncing pandas, wise-cracking crickets, and kung fu warriors—
meant that economic and political problems and pressures could be easily

avoided. Further, this imaginary China offered still another important advantage: informed with American values but composed of Chinese motifs and figures, it could attract viewers on both sides of the Pacific. There is no question but that, in the case of *Mulan* and *Kung Fu Panda,* the embrace of this strategy—that is, the mixture of elements drawn from different cultures—resulted in very successful films. At the same time, it gave a vivid demonstration of the so-called process of hybridization that, as suggested earlier, has accompanied the globalization of film. In fact, Kenneth Chan might well have been speaking of films such as these when he remarked that "hybridity, appropriation, and reconfiguration—including cross-cultural borrowings and influences—are part and parcel of global cinematic evolution."[28]

Some critics, like Chan, speak of hybridization in neutral terms. For others, the process of globalization—of "appropriation and reconfiguration"—has a more sinister side. For one thing, such critics charge, a globalized film culture has accelerated the demise of once vibrant national cinemas: for example, while Italian cinema is but a ghost of its former self, French cinema exists by virtue of lifelines provided by the government. For another, even as national cinemas have faded or disappeared, all cinemas, as it were, have taken on a distinctly American cast. As sociologist Todd Gitlin writes, "The American mode is—again, with very rare exceptions—to process promising filmmakers from around the world into banality, Hollywood's premium style."[29] If Gitlin feels that the triumph of the American mode has rendered everything banal, Asian American critics often view this triumph in political terms. For example, Darrell Y. Hamamoto likens the wave of Asiaphilia often visible in the West—a wave marked by a taste for Eastern design, food, martial arts, as well as films—to a latter-day form of imperialism. "Whereas," he writes, " 'Orientalist' discourse in cinema once helped mobilize and sustain support for U.S. and European imperium in the Near East and Asia, Asiaphilia is a deceptively benign ideological construct that naturalizes and justifies the systematic appropriation of culture property and expressive forms created by Yellow people."[30] Moreover, in terms of film, this "appropriation" has given rise to charges of exploitation and even what Evans Chan calls "cannibalization."[31] Along these lines, Michael Curtin suggests that Westernized Chinese films such as *Crouching Tiger, Hidden Dragon; Kung Fu Hustle;* and *Hero* seem "to point to a new phase in Hollywood's ongoing exploitation of talent, labor, and locations around the globe."[32] Gary S. Xu is even more succinct: "The biggest irony," he writes, "is that the more transnational national cinemas become, the more dominant Hollywood is."[33]

However one feels about hybridization or "appropriation," it would be difficult, I think, to find better examples of this process than *Mulan* and *Kung Fu Panda.* To begin, both films drew liberally on talent from Asia. For example,

Taiwan-born artist Chen-Yi Chang helped shape the designs for the characters in *Mulan,* while leading Asian stars lent their voices to the cartoon characters seen on-screen. (To further attract specific markets, the stars chosen to dub voices varied from country to country: for example, Taiwanese viewers of *Mulan* heard the voices of pop stars CoCo Lee and Jackie Chan, while those in Hong Kong and on the mainland heard the voices of Jackie Chan, Chinese actress Xu Qing, and Hong Kong pop singer Kelly Chen.[34]) Above all, though, it is the visual land-scape of both films—full of elements that "signify" China—that testifies to what Hamamoto deems "the systematic appropriation of culture property and expressive forms created by Yellow people." Mining the rich storehouse of Chinese history and legend, life and culture, for inspiration, both films create a fairy-tale world in which kung fu masters and plaintive dragons gambol through mountains like those seen in Chinese scrolls. Moon gates and upturned roofs, as well as iconic Chinese landmarks, are omnipresent: for example, *Mulan* begins with shots of the Great Wall and ends with images of the Forbidden City. Speaking of *Mulan,* Jaap Van Ginneken might well have been describing both films when he observes that the film "included as many 'typical' elements as possible, deriving from restaurant, bazaar, and tourist familiarity with the culture: chopsticks and rice bowls, jade and lacquerwork, calligraphy and watercolors, abacus and incense, rice fields and cherry blossoms, goldfish and cranes, bamboo bushes and misty mountains, red lanterns and butterfly kites, meditation postures and martial arts, circus acts and lion statues—and even the Forbidden City and the Great Wall."[35]

But *Mulan* and *Kung Fu Panda* do more than amass as many "typical" elements as possible. They also—and it is here that the charge of cannibalism seems particularly well-founded—consistently empty these elements of weight and meaning so that no single element is more important, or unimportant, than any other. Stripped of any deeper resonance, the various elements become mere husks, or shells, of their former selves. In this sense, these films take us squarely into what Jean Baudrillard has called the realm of the simulacrum—a depthless realm where nothing is real. Here, China becomes what Gary S. Xu—in a discussion of films set in Hong Kong—calls a site of pure spectacle. Charging that contemporary films set in Hong Kong tend to render the city "insubstantial," Xu charges that they view Hong Kong "not as a place inhabited by modern people who have their shares of everyday struggles and feelings not much different from Westerners' but as a place existing solely as a *cinematic spectacle,* a site where fights between gangsters and policemen break out (*Police Story* and *Rush Hour*), romances between Caucasian men and Asian women unfold (*Chinese Box*), the cold war continues (*Tomorrow Never Dies*), or exotic treasure vanishes (*Tomb Raider II*)."[36]

There is no question but that a similar transformation takes place in both *Mulan* and *Kung Fu Panda*. Only here, of course, it is not Hong Kong but China that is rendered insubstantial. Reduced to a series of visual motifs, the imaginary China seen in these films is anything but a place "inhabited by modern people." Instead, it is even more unreal, more clearly a site of pure spectacle, than the Hong Kong that emerges from films like *Police Story* (Jackie Chan, 1985) and *Rush Hour*. Both *Mulan* and *Kung Fu Panda* transform China into a postmodern fantasy world of pastiche and parody where boundaries—between the real and the imaginary, the mundane and the legendary, history and dream—are as unreal as everything else. In this respect, these films are radically different from earlier works about China. For however "exoticized" or stylized the China of earlier films, it was still perceived as a real country. Even the papier-mâché China of von Sternberg's films was somehow meant to be real. In contrast, the Chinese landscape etched by *Mulan* and *Kung Fu Panda* is simply that—a visual, one-dimensional landscape that has severed all connections with a "real" place or "real" people.

Yet, if on one level the deliberately unreal China of these films marks a sharp break with earlier representations of that country, on another level, it points to a deep continuity. That is, it gives a new dimension to the tonal dichotomies of earlier works. In the past, as we have seen, such dichotomies opposed a mythic China to a realistic America (or, in the case of *Kundun*, a realistic Tibet). It is true, of course, that in the postmodern landscape of *Mulan* and *Kung Fu Panda* there is no distinction between the real and the unreal. And it is also true that these films contain no mention—at least no overt mention—of America. *But the crucial point is this: while China is reduced to a series of visual motifs, at a still deeper level, America—at least American values and sensibilities—is felt at every turn.* Indeed, it is not an exaggeration to say that in terms of behavior and morality, of psychology and pedagogy—for these are, after all, fables for children or young people—the world of *Mulan* and *Kung Fu Panda* is as American as that of *The Good Earth*. And no less than in the case of *The Good Earth*, the American landscape of these films is one in which the other is engulfed, erased, by the self.

This erasure comes into very sharp focus when one compares these films to Chinese works on the same or similar themes. After all, as suggested earlier, the emergence of global cinema has meant that, to a degree unimaginable earlier, such comparisons are relatively easy. Take, for example, the tale of *Mulan*. Probably the best-known Chinese folk heroine in the world, Mulan was a young Chinese woman who, disguised as a man, took the place of her elderly father in the emperor's army and became a legendary warrior before returning home to resume life as a woman. Told and retold from the Middle Ages down to the present, the tale of Mulan has been the subject of countless poems, plays, operas,

narrative works and, in recent times, of films. (In 2009, the legend of Mulan was the subject of a popular Chinese film, *Hua Mulan*.) Not surprisingly, over the years the tale has varied in response to changing political and cultural winds. As Shiamin Kwa and Wilt L. Idema point out, in the twentieth century "the story as modified to represent Mulan as a Han Chinese loyalist battling an encroaching barbarian outsider, became a neat allegory for growing concerns about national identity."[37] If Mulan was seen as a Communist hero after 1949, throughout the twentieth century she has also served as a role model for women in search of strong female characters. More recently still, the character—largely because she disguises herself as a man in order to serve in the army—has attracted critics interested in issues related to gender construction, sexuality, and cross-dressing.[38]

In light of the number and diversity of works about Mulan, it is difficult, if not impossible, to suggest that any single version of the tale is somehow representative of a Chinese viewpoint. Still, in light of Disney's *Mulan*, one version seems particularly interesting to me because it is both superficially akin to Mulan and yet fundamentally different. Entitled *The Saga of Mulan* (1994), it is the filmed version of a Beijing opera performance that was made around the same time as Disney's *Mulan*. The resemblances between the two films are not difficult to discern. That is, not only do both these versions of the tale make extensive use of music but, also, both take us into an imaginary, unreal, world. While Mulan takes place in the animated realm of children's fairy tales where animals sing and dance, *The Saga of Mulan* unfolds in accord with the stylized conventions of Chinese opera. This means that episodes of song and dance, as well as moments of stunning acrobatics, break into the narrative even as they destroy any illusion of realism.

But if both films take us into realms marked by theater and artifice, at a deeper level they offer radically different versions of the age-old tale. To begin with, *The Saga of Mulan* paints a portrait of Mulan herself that is totally different from Disney's version. Watching *The Saga of Mulan*, it is not hard to see why Mulan appealed to Communist revolutionaries in the past or why novelist Maxine Hong Kingston, in a work entitled *The Woman Warrior*, should have used Mulan as a kind of inspiring role model for a Chinese American woman raised in the patriarchal culture of Chinatown. For in *The Saga of Mulan*, the title character displays one virtue after another. A fervent patriot and loyal daughter, she is also a strategic military thinker who eventually becomes a well-loved commander known as General Hua. Deeply respected by her troops, she does not lose their support even when they discover that she is really a woman. At the same time, she is also a deeply thoughtful and compassionate woman who is wise well beyond her years. For example, in one scene in which she and others are discussing the qualities that make a "true man," she makes the compelling

observation that a man is defined not only by strength and bravery but also by his ability to "talk and laugh" and by qualities such as "broad vision" and "elegance." The list of her many virtues includes both delicacy of feeling and a capacity for passion. The latter quality comes to the fore when, after her real identity is discovered, the long and intense friendship she has enjoyed with a fellow soldier, Captain Jin, turns to mutual love. The death of the brave captain in battle prompts her to sing a long and beautiful aria, which constitutes the musical and emotional highlight of the film. Singing mournfully of their many years together, she promises him that, each year, she will faithfully visit his tomb.

Turning from *The Saga of Mulan* to Disney's *Mulan* is rather like leaving one world for another. The difference between the two films is signaled by a dramatic change of mood: in *Mulan*, the tragic cast of *The Saga of Mulan* and its heartfelt emotions give way to pastiche and parody, to jarring and incongruous humor. At the same time, the setting has changed: although the presence of matchmakers and imperial troops might suggest that we are still in the ancient Chinese realm of *The Saga of Mulan*, every time that a character in *Mulan* speaks, we are brutally transported to the world of contemporary America. "She's from your side of the family," insists one of Mulan's ghostly ancestors when he is disappointed with her conduct. Even the songs resonate with American values and beliefs. While *The Saga of Mulan* raises important questions concerning what it means to be a "man," Disney's *Mulan* is content with a song—"I'll Make a Man out of You"— that reduces masculinity to martial values even as it points to a familiar American mind-set. It denotes, as Alan Nadel observes of a song in Disney's *Aladdin*, "an almost American set of accents, images and analogues."[39] By the end of the film, we are hardly surprised when Mulan's ancestors—who finally have reason to be proud of their descendent—celebrate her victory by dancing to rap music.

Amid the welter of American speech and behavior patterns that permeate the film, what is probably the most incongruous note is struck by a small dragon sent to aid Mulan by her ancestors. Known as Mushu—a word that plays on the name of the Chinese dish known as moo shu pork or, in pinyin, *muxurou*—his character suggests what critic Sheng-mei Ma describes as the "fetish of Chinese food [that] has so interpolated the Western consciousness."[40] (As if to further underscore this fetish, the concluding words of the film, uttered by the dragon, are "Call out for egg rolls!") But incongruity does not stop with this fetish, for as dubbed by African American actor Eddie Murphy, the dragon also speaks in a kind of streetwise black dialect: complaining that "this guy messing with my plans," he insists that "I ain't biting no more butt." All this is so bizarre, in fact, that it has given rise to speculations about a hidden—or not so hidden— ideological agenda. Suggesting, for example, that the dragon's inner-city black dialect is marked by the "transparency of race," critic Sheng-mei Ma argues that

it "bespeaks the relative powerlessness of the Asian-American constituency; Disney takes this calculated risk of offending a particular minority for the potential profit it might garner from the majority and other minority groups."[41] If, as Ma suggests, the dragon's speech is shadowed by the issue of race, it seems to me that his size has a problematical political dimension. For given the fact that the dragon is virtually a symbol of China, doesn't Mushu's diminutive appearance— that of a small dog or cat—suggest a desire (conscious or unconscious) to tame the fearsome Chinese dragon? (See fig. 6.6.)

If the dragon is undeniably American, so, too, of course, is Mulan herself. It is here that we come to the most radical difference between *The Saga of Mulan* and Disney's *Mulan*; here, too, that the film transforms the legend so dramatically that, as Sheng-mei Ma observes, Disney's film does nothing less than turn its back "on the very meaning of the tale of Mulan."[42] The fact that in *Mulan*, Mulan's name becomes Ping—a word Americans can easily pronounce—is but the first indication of a broad spectrum of deeper changes. It is not only that Mulan displays almost none of the virtues that ennoble the character of General Hua in *The Saga of Mulan*. It is also that she is the very model of a modern American adolescent. Totally self-concerned, she is at once rebellious—at one point she defiantly storms away from a family dinner—and insecure. If earlier Disney heroines looked into the mirror to see who was the "fairest" of them all, Mulan looks into the mirror to find her "true" self. "Who am I?" she plaintively sings, "when will my reflection show who I am inside?" In fact, her decision to take her

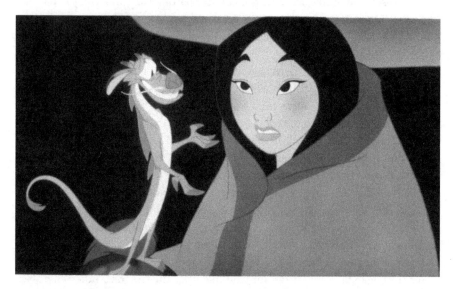

Figure 6.6. Mulan: Mushu, the diminutive dragon, to the rescue!

father's place is motivated not by filial love or patriotic duty but by a desire to find herself after she is rejected as "bride material" by the local matchmaker.

Moreover, as numerous critics have observed, Mulan is not merely an American teenager but also—in some ways, above all—a Disney heroine. "Mulan's hidden last name," writes Sheng-mei Ma, "is Disney. . . . In an effort to re-orient (pun intended) rather than dis-orient, Mulan supplements Orientalist fantasies with contemporary youth culture."[43] Lan Dong takes this one step further. Placing Mulan in the long lineage of Disney heroines, the critic elaborates on the Disney formula embedded in the film. Here, as always, declares Dong, "the company [Disney] uses what has become the Disney fairy or folktale formula to structure the story line: an adolescent protagonist disappointed by his or her present life embarks on a journey or process in search of a true sense of self. After a confrontation with a certain embodiment of evil or challenge as the climax, the heroine or heroine finally achieves individual fulfillment and proves his or her value to the world. He or she is usually rewarded with a marriage or a promising coupling."[44]

Mulan is true to this formula in almost every respect—including the final promise of romantic bliss. What Dong calls the "promised coupling" comes at the end of the film when the brave captain Sheng Lee, who has trained Mulan and fought at her side, follows her to her home. If this romantic conclusion undercuts the film's feminist dimension, as Disney scholars Eleanor Byrne and Martin McQuillan argue,[45] it also adds a final note to the dramatic contrast between the brave General Hua of *The Saga of Mulan* and Disney's heroine. Unlike Hua Mulan, who will never know the joys of home and family, the heroine of *Mulan* not only saves China, discovers her "true" self, and proves herself to her parents, but also is allowed the promise of a happy marriage. Triumphant on every level, she knows nothing of the personal sacrifice and enormous loss endured by the heroine of *The Saga of Mulan*. While the horrors of war touch General Hua in the most profoundly personal way, they barely ruffle the surface of Disney's *Mulan*. In this sense, I think, *Mulan* is far more than a fairy tale for young people—a reassuring tale of a young woman who discovers her "true self." It is also a sunny fable for a country that, desensitized to violence, has conceived of war in terms of targeted killings and mercenary armies.

Significantly, the profoundly American cast of *Mulan* was not lost on Chinese viewers and critics. In this respect it offers an intriguing parallel with *The Good Earth*. For just as it was left to an earlier generation of Chinese critics to decry the "foreignness" of Buck's tale of struggling peasants, it fell to their successors to point out how *Mulan* had transformed the heroine of poem and legend into what one critic called an "American lass." Again and again, they complained about the film's disregard for its Chinese context and its profoundly American lens: while one declared that everything in *Mulan* "is tied to the Hollywood

pattern," another argued that "everywhere in the film one sees the Americans' disfigurement of Chinese history, their lack of understanding of the Chinese environment, their eternal inability to understand Chinese culture, and their skewed comprehension of Chinese people."[46] From a still broader perspective, Zhou Linyu underscored the ideological underpinnings of what is sometimes called the "disneyfication" of Mulan. "In interpreting the Other," wrote the critic, "Disney's animated feature *Mulan* replaces the traditional Chinese culture embedded in the original Chinese ballad 'Ode of Mulan' with individualism, the ideology of American mainstream culture by means of orientalization and Americanization."[47]

Perhaps, though, the most eloquent comment on the film came not from scholars and critics such as these but from the lukewarm reception it received from mainland audiences. In striking contrast to the enthusiastic welcome the film enjoyed in Taiwan and Hong Kong—to say nothing of America—*Mulan* was not really successful on the mainland. Its box office revenue there was the lowest among the thirty-four imported American megafilms since 1994.[48] True, conditions imposed by the Chinese government—which was still upset with Disney's funding of *Kundun*—meant that *Mulan* had an unfavorable release date: it opened shortly after the Chinese New Year, when families were busy with children returning to school. Still, one has to wonder whether, in the end, Chinese audiences simply could not warm to a Disney heroine who had more in common with Snow White and Cinderella than with the woman warrior of Chinese legend.

Unlike *Mulan, Kung Fu Panda* was as successful in mainland China as it was virtually everywhere else it was released. Perhaps this is because this Dreamworks production does not see the world through the lens of Disney characters and situations. Or perhaps its success was simply due to the fact that it is a far better film—more inventive and humorous, less predictable. Yet, viewed from another perspective, the positive reception it received in China *is* intriguing. Not only does it, too, project American realities onto an imaginary Chinese landscape, but also its erasure of China is even more absolute than that effected in *Mulan*. If *Mulan* turned a Chinese icon into a Disney heroine, *Kung Fu Panda* emptied an entire Chinese tradition—that of the martial arts—of its historical, moral, and spiritual weight.

In large measure, certainly, the very decision to make *Kung Fu Panda* reflects the enormous resonance that the Chinese martial arts—as both a practice and a filmic tradition—have enjoyed in the United States. Speaking of martial arts films, Gary G. Xu points out that "in the early twenty-first century, the only foreign-language cinema that consistently appeals to the American audience is the Chinese martial arts film."[49] And this appeal has been particularly marked in

the black community: there, as Nicolas Saada observes "martial arts were blended into American fiction to define the Black super-hero."[50] Still, despite this popularity, it may be difficult for Americans to fully appreciate the enormous hold that the tradition of martial arts exerts on the minds and hearts of many Chinese—or at least many Chinese men. (This is probably especially true of diaspora Chinese, for whom martial arts films offer what David Bordwell has called a form of "mythic remembrance"—that is, a way of identifying with their "Chineseness."[51]) Describing the enormous resonance of this tradition in Chinese culture, Jeff Yang suggests that kung fu "is perhaps the most quintessentially Chinese of disciplines, permeating Chinese art, religion, and history. Its basic skills are the underpinnings of Chinese operatic movement; its mystical foundations are intimately tied to traditional Taoist beliefs; and its practice was the preferred means for rallying revolutions to the patriotic cause."[52]

It is precisely because of the "quintessential" Chinese nature of kung fu that martial arts films raise certain cultural expectations. Both kung fu films and, especially, *wuxia* films—martial arts adventure epics set in the past and characterized by swordplay, colorful costumes, and sweeping landscapes[53]—are expected to retain what Kenneth Chan describes as "a traditionalist, nationalist ideology of Chineseness"—a kind of "cinematic cultural gravitas that efficiently embodies history and tradition."[54] These expectations go far to explain the very different receptions Ang Lee's martial arts epic *Crouching Tiger, Hidden Dragon* received in America and China. In America, the film was enormously successful with both American audiences and critics: nominated in ten categories for an Oscar, it won for best foreign film, cinematography, art direction, and original score. In China, its reception was more mixed: there, many viewers and critics felt that it was too "Westernized." Moreover, many believed that in giving the film a glossy exotic sheen and romantic cast designed to appeal to Westerners, Lee had done far more than bow, as he suggested, to financial considerations.[55] Instead, the film had "betrayed" a beloved tradition that carried with it the weight of national history and memory. Implicitly voicing this sense of betrayal, Sheldon Hsiao-peng Lu charged that the film transformed China into "a shallow fantasy world, a wishful thinking, a stage for global entertainment. The seeming return to history and resort to national culture is a décor, a show, a contemporary spectacle."[56] Nor were critics any kinder to a kind of *wuxia* trilogy—*Hero* (2002), *House of Flying Daggers* (2004), and *The Curse of the Golden Flower* (2006)—made by China's leading director, Zhang Yimou. In their eyes, these big-budget, exquisitely crafted films with stunning images—*Hero* was nominated for the 2003 Academy Award for best foreign film—were too obviously made, as Lu puts it, "for the pleasure and gaze of the Western viewer."[57]

Not surprisingly, if "Westernized" films like *Crouching Tiger, Hidden Dragon* and *Hero* often arouse the ire of Chinese critics, earlier *wuxiapian*—those seen as

embodying a certain tradition of history and memory—burn bright in memory's eye. Again and again, even the most sober critics as well as the most single-minded of directors can barely contain their enthusiasm for *wuxia* films remembered from childhood. Reminiscing about his Singapore boyhood, Kenneth Chan declares that "the *wuxia pian*, or the Chinese sword-fighting movie, occupies a special place in the cultural memory of my childhood . . . the exoticism of one-armed swordsmen, fighting Shaolin monks, and woman warriors careening weightlessly across the screen, informed my sense and (mis)understanding of Chinese culture, values, and notions of 'Chineseness' more radically than any Chinese-language lessons in school could have imparted."[58]

Even Chinese directors who, one might assume, might be relatively impervious to the lure of martial arts films have fallen under their spell. For example, in 2013, Hong Kong director Wong Kar-wai, who is probably best known in the West for the moody and intimate erotic melodrama, *In the Mood for Love* (2000) made *The Grandmaster*. Here, Wong created a deeply nostalgic dreamlike look backward at the life of Ip Man, the legendary kung fu master whose most famous pupil was Bruce Lee. As for Ang Lee, the director has openly acknowledged the nostalgia for a certain filmic tradition that prompted him to make *Crouching Tiger, Hidden Dragon*. He saw the film, he observed, as "a kind of dream of China, a China that probably never existed, except in my boyhood fantasies in Taiwan. Of course, my childhood imagination was fired by the martial arts movies I grew up with and by the novels of romance and derring-do I read instead of doing my homework. That these two kinds of dreaming should come together now, in a film I was able to make in China, is a happy irony for me."[59]

Nowhere, though, is the nostalgia for a bygone tradition of martial arts films expressed more keenly—or with more melancholy—than in one of the most interesting Chinese films of the last decade: *Goodbye, Dragon Inn* (2003). Made by Tsai Ming-liang, a Chinese-Malaysian director based in Taiwan, *Goodbye, Dragon Inn* is both a deeply felt homage to the cinematic tradition of martial arts films—in particular, to King Hu's *Dragon Inn Gate* (1967)—and a melancholy lament for its end.[60] Set in a soon-to-be-demolished movie house filled with a scattering of spectators, *Goodbye, Dragon Inn* intercuts scenes from King Hu's operatic classic—a *wuxia* epic marked by what Jeff Yang calls a "majestic clash of wills and blades"[61]—with scenes devoted to the random comings and goings of those in the movie house. The contrast between these two realms—between an imagined past and a very real present—could hardly be more dramatic. While King Hu's classic film depicts a world of saturated color and desolate mountains, of clashing swords and epic battles, in the dark theater everything speaks of loneliness and alienation: a disabled ticket taker eats her meal in silence, a gay man makes a futile attempt at a pickup, and customers line up silently at the urinals.

The longing for the world of the past that permeates the film is made palpable when, toward the end of the screening, tears begin to roll down the cheeks of a spectator who, in fact, played a lead in King Hu's film and who is watching his younger self on-screen. This intense nostalgia that courses through the film is expressed explicitly in a song that accompanies its final scene: as the ticket taker leaves the theater and painfully limps her way through rainy and deserted streets, we hear an old pop tune from the 1960s, "Liulian" ("Lingering"). "So much of the past," says the song, "lingers in my heart . . . year after year I can't let go . . . I'll remember with longing forever." The song, of course, may refer to a lost love or lost youth, but, in this context, the longing it expresses is, above all, for a cinematic past on the verge of disappearing for ever.

The end of a tradition of memory and history that is implicit in both *The Grandmaster* and *Crouching Tiger, Hidden Dragon*—and explicit in *Goodbye, Dragon Inn*— assumes a radically different guise in the last film explored in these pages: *Kung Fu Panda*. Just as *Mulan* offers a dramatic contrast with *The Saga of Mulan*, *Kung Fu Panda* belongs to a different realm from these Chinese works. Unlike the "dream" of China that comes alive in *Crouching Tiger, Hidden Dragon*, *Kung Fu Panda* is not a celebration of a vanished past, nor is it a melancholy homage directed toward a beloved tradition, as in *Goodbye, Dragon Inn*. Rather, it as an eminently cheerful, consistently superficial, postmodernist pastiche of a familiar genre. Taking us once again into the realm of the simulacrum, it both incorporates and hollows out images and motifs, conventions and tropes, drawn from the world of kung fu and *wuxia*.

A note of subversion and playfulness is struck from the outset: in the magical realm of *Kung Fu Panda*, animals have taken the place of people. The protagonist of the film is, in fact, an overweight and clumsy panda who dreams of exchanging his life as a waiter in his father's noodle shop for that of a kung fu warrior. One day, his dream is set in motion: accidentally shot into the air, he lands in the courtyard of a palace where he is welcomed by one and all as the "dragon warrior" who will save everyone from destruction at the hands of a terrible villain. But before he can truly become this fearsome warrior, the panda—like so many acolytes in kung fu films—must endure a long and punishing regime in order to learn the kung fu skills he so obviously lacks. As he painfully seeks to transform himself into the "dragon warrior," he meets still other archetypal kung fu figures: wise and demanding kung fu masters arrive in the shape of a tortoise and a red panda; his fellow warriors are animals—crane, mantis, tiger, monkey and viper—associated with kung fu postures. Last but not least, he has an epic confrontation with a huge cat-like creature, Tai Lung—a renegade warrior with "darkness" in his heart—whom he vanquishes at the end of the film.

In addition to figures rendered familiar to us by countless martial arts films, the film also embraces what David Bordwell, in *Planet Hong Kong: Popular Cinema and the Art of Entertainment,* has called the "circus esthetic" of kung fu films. Marked, above all, by movement and speed, by harrowing stunts and dazzling physical skills, this esthetic is often punctuated by fantasy elements like, say, the gravity-defying leaps and bounds seen toward the end of *Crouching Tiger, Hidden Dragon.* Underscoring the whirlwind of motion that characterizes this esthetic, Bordwell writes, "Heroes fight by turning cartwheels. A man thwacked by a spear doesn't just go down; he spins forward in a somersault. A perforated gunman flies up and back in a parody of loss of balance."[62] Not only is the animated world of *Kung Fu Panda* particularly suited to this esthetic of somersaults and cartwheels, but also the obvious unreality of the film points to the ways this esthetic has been transformed in recent years by a postmodernist refusal to distinguish between the real and the unreal. Indeed, in describing the "typical swordplay film of the 1990s," Bhaskar Sarkar might almost have been speaking of *Kung Fu Panda.* Such a film, declares Sarkar, "incorporates a whole range of martial art styles and evokes a magical, fantastic realm that can coexist with real, historical characters and situations. This interpenetration of the mythic and the historic, the fantastic and the realistic, is part of a postmodern turn that calls into question the very demarcations between these categories."[63]

Still, if *Kung Fu Panda* embodies the conventions and the esthetic of a long tradition of martial arts films, in one critical respect, it stands apart from this tradition. For one has to remember that kung fu films were not only about arduous apprenticeships and wise kung fu masters, or about flying daggers and death-defying stunts. On the contrary: all these elements were at the service of a deeply moral and ethical vision of the world. It is here that the homage to the world of *wuxiapian* felt in the story and the action of *Kung Fu Panda* turns sharply to subversion, or to what I have called a hollowing out, an erasure, of a deeply rooted national tradition.[64] If the panda wants so desperately to become a kung fu hero, to insert himself into a *wuxiapian,* it is not out of a sense of duty or righteousness but, as befits a postmodernist pastiche, because he loves the *idea,* the *image,* of kung fu. Indeed, as if setting the whole film under the sign of images, *Kung Fu Panda* begins with an archetypal kung fu sequence that is soon revealed as nothing more than the dream of the sleeping panda. Like the film itself, this dream contains no hint of the moral core—or what Verina Glaessner describes as the "codes of knighthood and heroism"—of *wuxiapian.* "In the swordplay films," writes Glaessner, "the scenes of conflict are there to decorate the codes of knighthood and heroism that are the subjects of these elaborate artifices which embrace virtues like reverence to elders, personal honor and unwavering devotion to the cause."[65] Not only was the true kung fu hero inspired

by these codes, but he also only fought when absolutely necessary. "The best fights," says Jackie Chan in *The Karate Kid* (2010) "are the fights we avoid." Still less did the kung fu hero want to kill: as the hero of *Kung Fu* (1972) tells us: "the taking of a life does no one honor."

Based on virtues like reverence to and consideration of others, these moral codes remained in force even when, as in recent years, martial arts films became tinged with comedy or parody. Nowhere is this clearer than in the films of Jackie Chan. Indeed, in a fascinating article on Chan, Steve Fore makes the point that the performer first became successful because he developed a "screen persona" that incorporated many of the behavior traits considered "virtuous" in Hong Kong.[66] That is, it was not only Chan's skill at martial arts that impressed viewers— spectacular as these skills were—but also the emphasis he placed on "a primary consideration for the physical and emotional needs of others" as well as on "interpersonal and intragroup relationships based on principles of loyalty, mutual aid, and selflessness."[67] As we have seen earlier, even in a comedy like *Shanghai Noon*, Chan never loses sight of these moral qualities. Although he finds himself in the most alien of environments, writes Kenneth Chan, the actor "maintains his cultural allegiance through the notions of filial piety, respect for the Emperor, and a healthy sense of cultural pride."[68]

While these moral traits run throughout all of Chan's films, in the context of this study, one film is of particular interest: *The Karate Kid,* a 2010 remake of a 1984 film with the same title. I say that because, as in the case of *The Saga of Mulan* and Disney's Mulan, *The Karate Kid* is both like—and yet totally unlike— *Kung Fu Panda.* In terms of similarities, the films follow virtually the same narrative: that is, both films focus on what might be called the kung fu education of someone who initially seems the most unlikely of acolytes. In fact, the protagonist of *The Karate Kid* is almost as unlikely a kung fu warrior as the fat and clumsy panda of *Kung Fu Panda.* Named Dre Parker (Jaden Smith), he is a very slight, twelve-year-old black American who, as the film opens, has accompanied his widowed mother to Beijing, where she has taken on a job. Once in the Chinese capital, Dre—like the protagonist of *Shanghai Noon* —must adapt to a radically alien environment. At first this seems almost impossible: lost and homesick, Dre is also bullied by Chinese classmates who tower over him and beat him mercilessly with their kung fu skills. The situation seems desperate—that is, until he meets a strange handyman, Mr. Han, who works in the housing complex where he lives. Played by Jackie Chan, Mr. Han is an embittered and lonely man who has never recovered from the loss of his wife and son in a car accident. Not unexpectedly, in true Hollywood fashion, the fatherless boy and the lonely handyman are a perfect match. The handyman teaches the boy kung fu skills that enable him to put an end to the bullying he has endured; by teaching the young

American, Chan discovers that he has a vocation as a kung fu master. Indeed, he eventually wins over the pupils of another kung fu master—a sadistic teacher who resembles a latter-day incarnation of the renegade warrior of countless *wuxiapian.*

Like *Kung Fu Panda,* then, *The Karate Kid* is clearly a heartwarming film designed principally for a youthful audience. As the Mandarin title, *Gongfu Meng* (*Kung fu dream[s]*), suggests, it, too, is a "dream" of kung fu. But if the dreams embodied in the two films follow the same narrative structure, in other respects they offer a striking study in contrasts. The most immediate or obvious difference between them bears on the issue of reality itself. While *Kung Fu Panda* unfolds in a mythic, imaginary China—a one-dimensional place reduced to easily recognized visual motifs—*The Karate Kid* is set in an everyday Beijing neighborhood that could hardly feel more real. Although one scene of *The Karate Kid* features an iconic monument—the Forbidden City—most of the action takes place in neighborhood haunts rarely seen by tourists: in a park where people come to relax, play Ping-Pong, exercise; in the courtyard of the school where the boy meets a friendly Chinese girl; in a busy shopping street where the boy's mother buys ice cream; in front of the handyman's shed where the boy learns kung fu.

Underscored at every turn, the reality of the city merely sets the stage for a still more profound difference between *Kung Fu Panda* and *The Karate Kid:* that is, the nature of the lessons learned by the kung fu acolyte. True, *Kung Fu Panda* contains a few allusions to "deeper" truths, but like everything else in the film, these "truths" are hollow echoes culled from earlier films. In contrast, when Mr. Han (Jackie Chan) instructs the young American in the ancient art of kung fu, the lessons he gives are profoundly moral and heartfelt. Underscoring the cultural gravitas that inheres to kung fu, he repeatedly makes it clear that kung fu is not only a physical skill but an ancient tradition that involves self-control, focus, and patience. Above all, he teaches the young American to show respect not only for those close to him—beginning with his mother—but also for different cultural traditions. "Kung fu," he says at one point, "is everything . . . kung fu is how you treat people." And the transformation in the young American *is* dramatic. While Dre refuses to learn Chinese at the beginning of the film—and expects everyone in Beijing to understand English—by the end, he has learned his lessons so well that he delivers a well-rehearsed apology, *in Mandarin,* to a Chinese girl who has been wounded by his selfish conduct.

A similar scene would be inconceivable in *Kung Fu Panda.* Here, it is abundantly clear that the panda learns nothing from his lessons except the physical skills that will enable him to triumph at the end. Far from showing consideration and respect for others, from first to last, he remains preoccupied with the self. Egotistic and selfish, spoiled and insecure, he is concerned above all with his

comfort and the impression he makes on others. In short, as dubbed by comedian Jack Black, he is, like Disney's Mulan, still another example of a spoiled, insecure—and quintessentially American—teenager. Indeed, as in the case of *Mulan,* much of the humor of the film comes from jarring incongruities between the heroic context in which the panda finds himself and the way he thinks, speaks, and behaves. While the wise kung fu master utters portentous aphorisms—"man meets his destiny on the road he takes to avoid it"—the panda's remarks reflect the vocabulary and preoccupations of teenagers in a suburban mall. "This is really hard," he says while learning kung fu. "Can we find something suited to my level?" Or again, ashamed of his obvious ineptitude, he declares: "I probably sucked more today than anyone else in the history of kung fu." Dubbing his kung fu animal companions the "Fabulous Five," he whines that "they totally hate me." Even his victory elicits nothing but a narcissistic self-affirmation: "I'm not a big fat panda," he announces proudly after his triumph. "I'm *the* big fat panda."

Reminiscent of Mulan's preoccupation with the self, the panda's attitude has still another resonance—one that takes us to the heart of this study. In taking us from a world ruled by righteousness and consideration for others to one ruled by the self, *Kung Fu Panda* erases not only the other but the very idea of otherness. Whereas *The Karate Kid* underscores the presence of cultural differences embodied in language and behavior, *Kung Fu Panda* takes us—once again—into a world ruled by American values, attitudes, and behavior patterns. Erasing the deepest message of *wuxia* films—that of moral codes—*Kung Fu Panda* also erases the profoundly Chinese milieu from which they sprang. In the magical realm of *Kung Fu Panda*—a realm where images reign supreme—the other once again turns into the self before our eyes. Discussing still another film marked by this sleight of hand—Disney's *Aladdin*—Alan Nadel might well have been speaking of both *Mulan* and *Kung Fu Panda*. "The foreign place itself," he writes, "is the medium that allows American cultural narratives—projected out onto the world as foreign policy, clothing styles, and social codes—to return, blessed by an imaginary other, as a form of narcissistic confirmation."[69]

If this "cultural narrative" erases China (as it does virtually every other "foreign place"), it also changes the image of America reflected in the films explored earlier. After all, works such as *The Good Earth* and *The Cat's-Paw* underscored moral and ethical values such as the importance of hard work and perseverance and of righteous behavior. But the postmodern landscape of *Kung Fu Panda* contains no hint of these values. In sharp contrast with the protagonist of *The Karate Kid* who learns to show consideration for others, the panda learns only to believe—"to make something special," muses the panda, "you just have to believe it's special"—and, especially, to *believe in himself.* Not only does this lesson in

narcissism change the cultural narrative of earlier films but, also, it reflects a new and disquieting sense of entitlement and exceptionality. How far is it, after all, from a panda who believes only in himself to a nation convinced that any action it deems important is justified? What role can moral categories play in a world where belief in self is all important?

With the panda's triumph high in the mountains of an imaginary China, this backward look at representations of China in American film comes to an end. The narcissistic panda may be less compelling than earlier characters: he lacks the moral complexity of the noble scholar in *Broken Blossoms* as well as the deep humanity of the peasants in *The Good Earth*. Nor does he radiate the evil intensity of Fu Manchu and other Chinese villains. But, interestingly, he *is* far better known. Graced with his own page on Facebook, by now he is a familiar figure not only to generations of children but to their parents as well. His fame has been fueled by sequels to the original movie as well as the countless commercial tie-ins—books, video games, toys, clothes, party kits—that surround figures of popular culture. As a comic cartoon figure as well as an action hero, he stands at the epicenter of what sociologist Todd Gitlin calls the "genres"—that is, "action movies, road movies, cartoons and physical comedies"[70]—that have done the most to ensure the worldwide dominance of American popular culture.

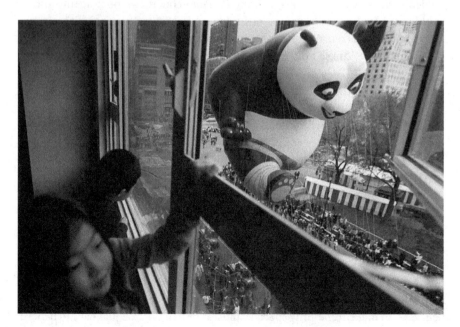

Figure 6.7. Macy's Thanksgiving Day Parade: the apotheosis of the panda

Imbued with the lure of American popular culture, the panda reached his apotheosis, I think, not in the imaginary mountains of *Kung Fu Panda* but in the streets of New York during the 2010 Macy's Thanksgiving Day Parade. It was then that he joined the ranks of the huge balloon figures eagerly watched by the throngs who lined the streets as well as countless television viewers. As the panda sailed—now gracefully—high above the watching faces, few knew or cared that he had once been a cuddly symbol of a friendly China or a noodle maker who nourished dreams of kung fu glory. Instead, totally freed from his origins in China, he joined the ranks of figures like Spider-Man and Shrek, Snoopy and Dora the Explorer. Embodying the transformation of the other into the self, the panda became an American icon (see fig. 6.7).

Afterword

The Darkening Mirror

The triumph of the American cultural narrative seen in films like *Mulan* and *Kung Fu Panda* is, of course, a global or quasi-global phenomenon. China's culture is by no means the only one in the landscape of contemporary film that has been hollowed out, reduced to "banality" (to use Todd Gitlin's term). Yet its virtual erasure in these works inevitably has a political resonance. For in the end, of course, China *is* different. Long granted a special place in the American imagination, it is now shrouded in fear and perceived as America's most formidable rival. What better way, after all, to rid America of this rival than to turn it into a site of pure spectacle? And what better way to tame the awakening dragon than to replace it with a cuddly panda or a diminutive creature like the pint-size Mushu of *Mulan*?

In this sense, I think, it is not difficult to discern the contemporary political relevance of films like *Kung Fu Panda* and *Mulan*. But the case is somewhat different when it comes to earlier works. There, practices and stereotypes that so clearly belong to the past—the use of yellowface, the force of sexual taboos, the presence of dragon ladies and brutal warlords—risk obscuring more fundamental impulses. Yet, as I argue throughout these pages, if figures like Fu Manchu and Charlie Chan have been banished from America's screens, the schizophrenic images of China they embody are still alive and well. Again and again, one feels the continuing weight of the attitudes and beliefs that underlie even the earliest films about China. Contemporary battles over abortion and the teaching of evolution suggest the persistence of the desire for a Christian America reflected in works like *Broken Blossoms* and *Shadows*. So, too, do current suspicions of Muslims take us back to the fear of heathens displayed by the young American missionary in *The Bitter Tea of General Yen*. The suspicion and fear of otherness that run throughout these films—and that fuel a desire to transform the other into the self or to banish the other from America's midst—have prompted harsh immigration laws and eruptions of populist nativism. Foreigners and immigrants are blamed for the fact that, as Ronald Dworkin suggests in an essay on

the success of the Tea Party, America is no longer the "most envied and wonderful country in the world."[1]

Suspicion of others—be they Hispanic, black, Muslim, or Chinese—both feeds into and is fueled by the outburst of the paranoid style that took shape in the wake of the attack of 9/11. Even before that watershed event, as historian Tony Judt once observed, Washington tended to view the world as "a series of discrete challenges or threats, calibrated according to their implications for America."[2] But the tragedy that took place on that fatal day prompted an outburst of paranoia as ferocious and intense as that which swept over the nation in the early 1950s. Dissent was stifled, privacy concerns swept aside, civil liberties suspended, torture condoned. To read Hofstadter's essay about the paranoid style, declared *New York Times* columnist Paul Krugman five years after 9/11, "is to be struck by the extent to which he seems to be describing the state of mind not of the lunatic fringe, but of key figures in our political and media establishment."[3] Striking a still bleaker note, Mark Danner suggests that the decades-long cold war that began in the 1950s has morphed, before our eyes, into today's War on Terror. "The politics of fear," he writes, "have been embodied in the country's permanent policies, without comment or objection by its citizenry. The politics of fear have won."[4]

In the climate of fear Krugman and Danner describe, the impulses at the heart of cold war films—the confusions that mark the films of Samuel Fuller, the paranoid cast of *The Manchurian Candidate*, the insistence on American benevolence seen in *55 Days at Peking*, the ambivalences toward empire that run throughout *The Sand Pebbles*—have assumed a new resonance. Once again, paranoia seems to have engendered surreal confusions: attacked from one country, the United States invades still another. Once again—reflecting the apocalyptic worldview seen in a film like *Kundun*—the world seems to have split in two: in the words of the first President Bush, other nations are either "with us" or "against us." Even as fears grow, what Reinhold Niebuhr calls the United States' "messianic consciousness"—Americans' conviction that the United States has been elected to bring "freedom" and "democracy" to the other countries of the world—assumes new fervor.[5] Convinced of their nation's mission, Americans continue to cling to the moral high ground, to maintain the illusion that the United States has no imperial designs, even while engaged in one of the greatest imperial ventures in history. The wars the United States wages are seen not as imperial ventures but as wars of liberation. In short, Americans want to arrive as conquerors and be welcomed as benefactors.

In the ranks of the nations who are "against" the United States, China seems—as at the time of the cold war—to have been assigned a leading role. The Middle Kingdom may no longer be seen as the land of Genghis Khan or Fu

Manchu, but the fears sparked by its growing economic might—fears that be-
came particularly intense in the wake of the economic meltdown of 2008—mean
that the specter of these earlier villains is still alive and well. A report published
in July 2013 concerned a poll that indicated that American attitudes toward
China—as well as Chinese attitudes toward America—had soured even more
in the last two years. Americans seem to resent China's growing self-confidence
on the world stage, Chinese companies' acquisition of American brands, and
even the wealth often displayed by Chinese visitors to America's shores. "In the
United States," writes reporter Jane Perlez, "Chinese personal wealth has been on
conspicuous display, generating bitterness."[6] In some cases, this bitterness leads
to incendiary rhetoric. For example, a 2012 film by Peter Navarro, which argues
that the admission of China to the World Trade Organization has harmed Amer-
ican interests, bears the inflammatory title *Death by China*.

Negative feelings about China inevitably shadow the American political land-
scape. Americans have become accustomed to politicians who campaign on the
strength of their toughness toward China. "With many Americans seized by
anxiety about the country's economic decline," observed David W. Chen in Octo-
ber 2010, "candidates from both political parties have suddenly found a new vil-
lain to run against: China. . . . The ads are striking not only in their volume but
also in their pointed language."[7] Most telling of all, perhaps, is a political ad di-
rected against President Barack Obama that has run in two presidential elections.
It depicts a large auditorium where people are listening to a lecture delivered in
Mandarin. Translated for the viewer by subtitles, the speaker's words carry a
chilling message for America. Insisting that "empires destroy themselves through
spending," the speaker tells his audience that China owns America's debt. This
means, he concludes, that "now we own them [i.e., the Americans]." If the origins
of the ad remain murky, its meaning is crystal clear: "bought" by Chinese wiles,
profligate America will have to recognize its new master.

The distance between the Chinese lecturer in the ad and Fu Manchu is both
great—and not great at all. On the surface, of course, the speaker hardly resem-
bles the sinister doctor. He has neither Fu Manchu's mustache nor his clawlike
fingers; nor does he share Fu Manchu's knowledge of mysterious brews or his
talent for torture. But the point is this: he and his fellow technocrats and bureau-
crats do not need these qualities to succeed in their quest. By buying American
debt, and manipulating currencies and markets, they can manage to "own" Amer-
ica. In this sense, if, in the words of Sax Rohmer, Fu Manchu embodies the
"Yellow Peril incarnate in one man," these anonymous-seeming bureaucrats are
the latter-day incarnation, the new face, of the yellow peril specter.

Infused with this specter, this ad also bears witness to what Harold Isaacs, in
remarks made well over half a century ago, called the "apocalyptic" view of China

that often prevailed in the West. "Lack of contact," he wrote, "plus images of un-differentiated vastness plus Fear equal An apocalyptic view."[8] As the films explored here make clear, it is precisely this view that held sway for much of the last century. From the torture chambers of Fu Manchu to the diabolical brainwasher of *The Manchurian Candidate* and the terrifying ghosts of *Kundun*, China evoked fears of an overwhelming clash of civilizations. But films also remind us of moments, however brief, when the pendulum shifted—a time when the China was seen as the land of noble Confucian scholars, of virtuous peasants, and even of fighting men who were just like "our boys." It is probably safe to say that these particular positive images—infused with stereotypes of their own—will not reappear. Nor would we want them to. But is it too much to hope that one day China will be seen without the distortions imposed both by the weight of ancient images and by America's own fears and apprehensions? Or that some day, as Richard Madsen urges, China's leaders and America's will "develop new 'master narratives for a new world, new visions allowing a new politics to show its postmodern face"?[9] In short, that one day China will be seen as a country like any other?

Notes

Chapter 1: The Pendulum Swings . . . and Swings Again

1. Marc Ferro, *Cinéma et histoire* (Paris: Denoel/Gonthier, 1977), 12.
2. Jerome Ch'en, *China and the West: Society and Culture, 1815–1937* (London: Hutchison, 1979), 34.
3. David Halberstam, *The Coldest Winter: America and the Korea War* (New York: Hyperion, 2007), 188.
4. Henry Steele Commager, foreword to *Americans and Chinese: Passage to Differences,* by Francis L. K. Hsu (Honolulu: University of Hawai'i Press, 1981), xii.
5. See Keith Bradsher, "China Drawing High-Tech Research from U.S.," *New York Times,* March 18, 2010, sec. A; Keith Bradsher, "As China Builds a Vast Network of Fast Trains, the U.S. Falls Further Behind," *New York Times,* February 13, 2010, sec. A; Jane Perlez, "China Races to Replace U.S. as Economic Power in Asia," *New York Times,* June 28, 2002, sec. A.
6. William Grimes, "Car Clones and Other Tales of the Mighty Economic Engine Known as China," *New York Times,* February 15, 2005, sec. B.
7. Tony Judt, "Its Own Worst Enemy," *New York Review of Books,* August 15, 2002, 12.
8. John K. Fairbank, *China Perceived: Images and Policies in Chinese-American Relations* (New York: Knopf, 1974), xvi.
9. Harold Robert Isaacs, *Scratches on Our Minds: American Images of China and India* (New York: John Day, 1958), 66.
10. Ibid., 104–106.
11. Ibid., 63.
12. David B. Chan, "The China Syndrome: Some Thoughts and Impressions after a 1979 Trip," in *America Views China: American Images of China Then and Now,* ed. J. Goldstein, J. Israel, and H. Conroy (Bethlehem, PA: Lehigh University Press, 1991), 184.
13. Jasper Becker, *The Chinese* (New York: Free Press, 2000), 3–4.
14. Harry Harding, "From China, with Disdain: New Trends in the Study of China," in Goldstein, Israel, and Conroy, *America Views China,* 244.

15. Richard Madsen, *China and the American Dream: A Moral Inquiry* (Berkeley: University of California Press, 1995), 28.

16. Warren I. Cohen, *America's Response to China: A History of Sino-American Relations,* 4th ed. (New York: Columbia University Press, 2000), i.

17. On the close relationship between American foreign policy and the *New York Times'* reporting about China, see Wenjie Yan, "A Structural Analysis of the Changing Image of China in the *New York Times* from 1949 through 1988," *Quality and Quantity* 32 (1998): 47–62. On the broader issue of biased reporting, see Edward Herman and Noam Chomsky, *Manufacturing Consent: The Political Economy of the Mass Media* (New York: Pantheon, 1988).

18. Craig S. Smith, "Doctor Says He Took Transplant Organs from Executed Chinese Prisoners," *New York Times,* June 29, 2001, sec. A.

19. Elizabeth Rosenthal, "Herbs? Bull Thymus? Beijing Leaps at Anti-SARS Potions," *New York Times,* May 10, 2003, sec. A.

20. Jim Yardley, "Chinese Diners Shrug Off SARS: Bring on the Civet Cat," *New York Times,* December 29, 2003, sec. A; Jim Yardley, "The SARS Scare in China: Slaughter of the Animals," *New York Times,* January 7, 2004, sec. A.

21. See, for example, Jake Hooker, "Before Guests, Beijing Hides Some Messes," *New York Times,* July 29, 2008, sec. A; Andrew Jacobs, "Specter of Arrest Deters Demonstrators in China," *New York Times,* August 14, 2008, sec. A; Andrew Jacobs, "A Would-Be Demonstrator Is Detained in China After Seeking a Protest Permit," *New York Times,* August 19, 2008, sec. A; Andrew Jacobs, "No Voice Is Too Small for a China Still Nervous About Dissent," *New York Times,* August 30, 2008, sec. A.

22. Jim Yardley, "In Beijing's Grand Olympic Show, Politburo Initiated Sleight of Voice," *New York Times,* August 13, 2008, sec. A.

23. On the difference between America and China in regard to two key areas of experience—the law and the relationship between the individual and the social whole—see John K. Fairbank, *The United States and China,* 4th ed. (Cambridge, MA: Harvard University Press, 1983), 123.

24. From the coverage of the *New York Times,* we would be hard put to learn, as Nicholas D. Kristof points out in an article in the *New York Review of Books,* that in crucial respects China has been far more successful than India. See Nicholas D. Kristof, "A Little Leap Forward," *New York Review of Books,* June 24, 2004, 56.

25. Gore Vidal, *Screening History* (Cambridge, MA: Harvard University Press, 1992), 42.

26. Robert McClellan, *The Heathen Chinee: A Study of American Attitudes Toward China, 1890–1905* (Columbus: Ohio State University Press, 1971), 105–106.

27. Commager, foreword to Hsu, *Americans and Chinese,* xvii.

28. Paul A. Varg, *The Closing of the Door: Sino-American Relations, 1936–1946* (Ann Arbor: Michigan State University Press, 1973), 3. For a discussion of the influence of the missionary sensibility on American foreign policy, see James Reed, *The Missionary Mind and American East Asian Policy, 1911–1915* (New York: John Day, 1958).

29. Isaacs, *Scratches on Our Minds,* 67–68.

30. Stuart Creighton Miller, "Ends and Means: Missionary Justification of Force in Nineteenth-Century China," in *The Missionary Enterprise in China and America,* ed. John K. Fairbank (Cambridge, MA: Harvard University Press, 1974), 273.

31. Raymond Dawson, *The Chinese Chameleon* (London: Oxford University Press, 1967), 134. Jane Hunter makes the point that women missionaries, in particular, saw China as a land "mired in the timeless dirt, death, and degradation of the ages." See Jane Hunter, *The Gospel of Gentility: American Women Missionaries in Turn-of-the-Century China* (New Haven, CT: Yale University Press, 1984), 1.

32. Bret Harte, *The Complete Poetical Works of Bret Harte* (London: Chatto and Windus, 1886), 131.

33. Cited in Paul Varg, *Missionaries, Chinese, and Diplomats: The American Missionary Movement in China, 1890–1952* (Princeton, NJ: Princeton University Press, 1958), 2.

34. Lian Xi, *The Conversion of Missionaries: Liberalism in American Protestant Missions in China, 1907–1932* (University Park: Pennsylvania State University Press, 1997), 3.

35. William Hutchison, *Errand to the World* (Chicago: University of Chicago Press, 1987), 7. For a discussion of how the notion of manifest destiny was used to legitimize the "myth" of empire, see Thomas Hietala, *Manifest Design: American Exceptionalism and Empire* (Ithaca, NY: Cornell University Press, 1985), 225.

36. Cited by Arthur Schlesinger Jr. in "The Missionary Enterprise and Theories of Imperialism," in Fairbank, *Missionary Enterprise,* 356.

37. Cited in Hunter, *Gospel of Gentility,* 8–9.

38. James Thomson, *While China Faced West: American Reformers in Nationalist China, 1928–1937* (Cambridge, MA: Harvard University Press, 1969), xii.

39. Isaacs, *Scratches on Our Minds,* 127, 125.

40. Fairbank, *United States and China,* 309.

41. Lian, *Conversion of Missionaries,* 7.

42. "Insofar as the missionary conversion had expressed our conviction that we led the march of human progress," writes Fairbank, "our self-confidence was dealt a grievous blow.... If the Chinese people willingly chose communism, it could be concluded that a majority of mankind was not going our way." Fairbank, *United States and China,* 455.

43. Shirley Stone Garrett, "Why They Stayed," in Fairbank, *Missionary Enterprise,* 309–310.

44. Gary Y. Okihiro, *Common Ground: Reimagining American History* (Princeton, NJ: Princeton University Press, 2001), xii, xvi, 120.

45. Edward W. Said, *Orientalism* (New York: Vintage, 1979), 1–2.

46. Isaacs, *Scratches on Our Minds,* 68.

47. Lynn Pan, *Sons of the Yellow Emperor: A History of the Chinese Diaspora* (New York: Kodansha International, 1990), 220.

48. In light of what appeared to be the anti-China bias of the *New York Times,* it is interesting that that paper led the charge against Lee. In an article devoted to the

"case" against Lee, Lars-Erik Nelson writes that, in terms of these unproven accusations, "no newspaper has been more credulous than *The New York Times*." Lars-Erik Nelson, "Washington: The Yellow Peril," *New York Review of Books*, July 15, 1999, 6.

49. Richard Bernstein, "A Very Superior 'Chinaman,'" *New York Review of Books*, October 28, 2010, 16.

50. Pan, *Sons of the Yellow Emperor*, 292.

51. Jill Lepore, "Chan, the Man," *New Yorker*, August 9, 2010, 70. For a discussion of the continuing controversies surrounding Charlie Chan, see Pradnya Joshi, "A Charlie Chan Film Stirs an Old Controversy," *New York Times*, August 3, 2010, sec. B.

52. Charles McGrath, "Charlie Chan: A Stereotype and a Hero," *New York Times*, August 11, 2010, C6.

53. In terms of the connection between Fu Manchu and Charlie Chan, it is noteworthy that the same actor, Warner Oland, played both roles.

54. Such works include Jachinson Chan's *Chinese American Masculinities: From Fu Manchu to Bruce Lee* (2001); Robert G. Lee's *Orientals: Asian Americans in Popular Culture* (1999); Eugene Wong Franklin's "On Visual Media Racism: Asians in the American Motion Pictures" (1978); Jun Xing's *Asian America Through the Lens: History, Representation, and Identity* (1998); Darrell Y. Hamamoto and Sandra Liu, eds., *Countervisions: Asian American Film Criticism* (2000); and Peter Feng, ed., *Screening Asian Americans* (2002).

55. Fairbank, *China Perceived*, xvi.

Chapter 2: East Meets West

1. "The motion picture industry," writes Kevin Brownlow, "as a rule followed the popular line. The Chinese tended to be portrayed as friendly but idiotic laundrymen, the subtitles leplesenting their lemarks thus, or sinister opium fiends, mastermind operations of unspeakable evil. The very word 'wily' seemed to have been coined for these characters." Kevin Brownlow, *Behind the Mask of Innocence: Sex, Violence, Prejudice, Crime: Films of Social Conscience in the Silent Era* (Berkeley: University of California Press, 1992), 320.

2. Paul A. Varg, *Missionaries, Chinese, and Diplomats: The American Missionary Movement in China, 1890–1952* (Princeton, NJ: Princeton University Press, 1958), 79. No one expressed these hopes better than philosopher John Dewey. After witnessing one of the massive strikes that sparked the so-called May Fourth Movement, which put China on the path to becoming a modern nation, Dewey declared: "We are witnessing the birth of a nation, and birth always comes hard. . . . To think of kids in our country from fourteen on, taking the lead in starting a big cleanup reform politics movement and shaming merchants and professional men into joining them. This is some country." Cited in Lynn Pan, *In Search of Old Shanghai* (Hong Kong: Joint Publishing Company, 1982), 104.

3. Lian Xi, *The Conversion of Missionaries: Liberalism in American Protestant Missions in China, 1907–1932* (University Park: Pennsylvania State University Press, 1997), 5–6.

4. Cited in Karen Janis Leong, "The China Mystique" (PhD diss., University of California at Berkeley, 1999), 130.

5. Brownlow, *Behind the Mask of Innocence,* 325.

6. Cited by Verina Glaessner in *Kung Fu: Cinema of Vengeance* (London: Lorrimer, 1974), 91.

7. Alfred Kazin, introduction to *Limehouse Nights,* by Thomas Burke (New York: Horizon Press, 1973), 15–16.

8. Thomas Burke, "The Chink and the Child," in *Limehouse Nights* (New York: Horizon Press, 1973), 26.

9. Richard Schickel, *D. W. Griffith: An American Life* (New York: Simon and Schuster, 1984), 390.

10. Cited by Dorothy B. Jones, *The Portrayal of China and India on the American Screen, 1896–1955* (Cambridge, MA: MIT Press, 1955), 15.

11. Schickel, *D. W. Griffith,* 389.

12. See Gary Y. Okihiro, *Common Ground: Reimagining American History* (Princeton, NJ: Princeton University Press, 2001), 122–124.

13. Schickel, *D. W. Griffith,* 390.

14. Julia Lesage, "Artful Racism, Artful Rape," *Jump Cut,* no. 26 (December 1981), 54.

15. Robert G. Lee, *Orientals: Asian Americans in Popular Culture* (Philadelphia: Temple University Press, 1999), 129.

16. Sander L. Gilman, *Difference and Pathology: Stereotypes of Sexuality, Race, and Madness* (Ithaca, NY: Cornell University Press, 1985), 120.

17. Gaylyn Studlar, *In the Realm of Pleasure: Von Sternberg, Dietrich, and the Masochistic Aesthetic* (Urbana: University of Illinois Press, 1988), 18.

18. Gilles Deleuze, "Coldness and Cruelty," in *Masochism* (New York: Zone Books, 1991), 32.

19. Ibid., 34.

20. Studlar, *In the Realm of Pleasure,* 20.

21. Deleuze, "Coldness and Cruelty," 33.

22. Alice Maurice, "What the Shadow Knows: Race, Image and Meaning in *Shadows,*" *Cinema Journal* 47, no. 3 (2008), 76. In an interesting interpretation of the film, Maurice begins by arguing that *Shadows* "links the Chinese subject to shadow puppetry, theatricality, and magic in order to produce the mystical, mysterious 'Oriental.'"

23. Michael F. Blake, *Lon Chaney: The Man Behind the Thousand Faces* (Vestal, NY: Vestal Press, 1993), 88.

24. Wilbur Daniel Steele, "Ching, Ching, Chinaman," in *Full Cargo* (Garden City, NY: Doubleday, 1951), 107.

25. Ibid., 109.

26. Anthony Lane, "Lady Be Good," *New Yorker*, April 30, 2007, 46.

27. "I would urge," writes Ray Carney, "that the dichotomy is a false one and that the films of the second type can only be understood properly when the imaginative extravagance or inordinacy that profoundly links them with the 'exotic' films is appreciated." Ray Carney, *American Vision: The Films of Frank Capra* (Hanover, NH: University Press of New England/Wesleyan University Press, 1986), 225–226.

28. Joseph McBride, *Frank Capra: The Catastrophe of Success* (New York: Simon and Schuster, 1992), 280.

29. Gina Marchetti, *Romance and the "Yellow Peril": Race, Sex, and Discursive Strategies in Hollywood Fiction* (Berkeley: University of California Press, 1993), 54.

30. Cited in McBride, *Frank Capra*, 280.

31. Gina Marchetti, "The Threat of Captivity: Hollywood and the Sexualization of Race Relations in *The Girls of the White Orchid* and *The Bitter Tea of General Yen*," *Journal of Communications Inquiry* 11, no. 2 (Winter 1987), 32.

32. Linking the figure of the warlord to that of the gangster, Dorothy Jones makes the point that Chinese "warlords—military personalities outside the official Chinese government who were seeking control and domination over certain areas of the country—came to be pictured on the American screen as the Chinese equivalent of the American gangster." Jones, *Portrayal of China and India*, 19.

33. "As in the most traditional captivity stories," observes Marchetti of *The Bitter Tea of General Yen*, "Megan here is severely punished for straying from male authority. In fact, her odyssey takes her to a point at which she comes to understand her true 'place' as a woman—kneeling, subservient, passive, and broken by her own passion." Marchetti, *Romance and the "Yellow Peril,"* 54.

34. McBride, *Frank Capra*, 280.

35. Elliott Stein, "Frank Capra," in *Cinema: A Critical Dictionary*, vol. 1, ed. Richard Roud (New York: Viking, 1980), 186.

36. Cited by Eric Smodin in his *Regarding Frank Capra: Audiences, Celebrity, and American Film Studies, 1930–1960* (Durham, NC: Duke University Press, 2004), 250.

37. Cited in McBride, *Frank Capra*, 281.

38. Jeffrey Vance and Suzanne Lloyd, *Harold Lloyd: Master Comedian* (New York: Harry Abrams, 2002), 180; Adam Reilly, *Harold Lloyd: The King of Daredevil Comedy* (New York: Macmillan, 1977), 127.

39. John Belton, "Harold Lloyd: The Man and His Times," in Reilly, *Harold Lloyd*, 198.

40. Richard Schickel, *Harold Lloyd: The Shape of Laughter* (Boston: New York Graphic Society, 1974), 5.

41. William K. Everson, "Harold Lloyd: The Climb to Success," in Reilly, *Harold Lloyd*, 170.

42. Interestingly, Clarence Budington Kelland, who wrote the story upon which *The Cat's-Paw* is based, also wrote Capra's *Mr. Deeds Goes to Town* (1936).

43. Roland Lacourbe, *Harold Lloyd* (Paris: Seghers, 1970), 45.

44. Everson, "Harold Lloyd: The Climb to Success," in Reilly, *Harold Lloyd,* 171–172.

45. Schickel, *Harold Lloyd,* 4.

Chapter 3: Questions of Otherness

1. Interestingly, both the play and the novel explicitly denounce the racist stereotypes embraced by the English family. Suggesting that even the most sympathetic of Westerners are marked by racial prejudice, in the novel, Mr. Wu delivers an eloquent speech—filled with allusions to Shakespeare's *Merchant of Venice*—in which he compares the British mistreatment of the Chinese to the way Venetian merchants shunned and exploited the Jews. See Louise Jordan Miln, *Mr. Wu* (New York: Frederick A. Stokes Company, 1918), esp. 117.

2. Harold Robert Isaacs, *Scratches on Our Minds: American Images of China and India* (New York: John Day, 1958), 164.

3. Dorothy B. Jones, *The Portrayal of China and India on the American Screen, 1896–1955* (Cambridge, MA: MIT Press, 1955), 20.

4. Sax Rohmer, *The Insidious Dr. Fu-Manchu* (New York: Dover, 1997), 13.

5. Lynn Pan, *Sons of the Yellow Emperor: A History of the Chinese Diaspora* (New York: Kodansha International, 1990), 89.

6. For a concise overview of the various incarnations of Fu Manchu, see Eugene Franklin Wong, *On Visual Media Racism: Asians in the American Motion Pictures* (PhD diss., University of Denver, 1978), 97–102.

7. Sheridan Prasso points out that even when Fu Manchu himself was not present, his presence often made itself felt. Prasso discerns the shadow of the evil doctor in "such evil Chinese triad Leader roles as John Lone in *Year of the Dragon* (1985), and Jet Li, yet again, in *Lethal Weapon 4* (1998), among many others." See Sheridan Prasso, *The Asian Mystique* (New York: Public Affairs, 2005), 106.

8. Robert G. Lee, *Orientals: Asian Americans in Popular Culture* (Philadelphia: Temple University Press, 1999), 117.

9. Jones, *Portrayal of China and India,* 41.

10. Kevin Brownlow, *The Parade's Gone By* (New York: Ballantine, 1968), 231.

11. Josef von Sternberg, *Fun in a Chinese Laundry* (New York: Macmillan, 1965), 263.

12. Ibid., 262.

13. Herbert G. Weinberg, *Josef von Sternberg: A Critical Study of the Great Film Director* (New York: Dutton, 1967), 218.

14. Claude Ollier, "Josef Von Sternberg," in *Cinema: A Critical Dictionary,* vol. 2, ed. Richard Roud (New York: Viking, 1980), 953.

15. Homay King, *Lost in Translation: Orientalism, Cinema, and the Enigmatic Signifier* (Durham, NC: Duke University Press, 2010), 2.

16. John Baxter, *The Cinema of Josef von Sternberg* (New York: Barnes, 1971), 91.

17. Von Sternberg, *Fun in a Chinese Laundry*, 81.

18. Baxter, *Cinema of Josef von Sternberg*, 154–155.

19. Andrew Sarris, *The Films of Josef von Sternberg* (New York: Museum of Modern Art, 1966), 8.

20. Lynn Pan, *In Search of Old Shanghai* (Hong Kong: Joint Publishing Company, 1982), 3.

21. Stella Dong, *Shanghai: The Rise and Fall of a Decadent City* (New York: HarperCollins, 2000), 1.

22. Harriet Sergeant, *Shanghai: Collision Point of Cultures, 1918/1939* (New York: Crown, 1990), 3.

23. Cited in Weinberg, *Josef von Sternberg*, 215. Underscoring the resonance of Dietrich in this role, a musical made shortly afterward—*Footlight Parade* (Lloyd Bacon, 1933)—contains a dreamlike sequence choreographed by Busby Berkeley that pays explicit homage to Shanghai Lily. In this sequence, an American sailor (James Cagney) searches for his sweetheart, named Shanghai Lil, in all the dives of a port city. "I've been searching high," he sings, "and I've been searching low, looking for my Shanghai Lil." Finally, he finds her: she is none other than dancer Ruby Keeler made up to look a bit like a latter day Madama Butterfly.

24. Baxter, *Cinema of Josef von Sternberg*, 94.

25. An observation by Andrew Sarris suggests some of the possible terms of such a debate. At the end of the film, writes Sarris, as Doc Harvey searches his lover's countenance for some sign of explanation or expiation, "her face merely taunts him in a myriad of mirrors until he surrenders to the illusion she represents, but on her terms rather than his." See Sarris, *Films of Josef von Sternberg*, 35.

26. Prasso, *Asian Mystique*, 29.

27. Lee, *Orientals*, 116.

28. Gary Hoppenstand, "Yellow Devil Doctors and Opium Dens: A Survey of the Yellow Peril Stereotypes in Mass Media Entertainment," in *The Popular Culture Reader*, ed. Jack Nachbar and Christopher D. Geist (Bowling Green, OH: Bowling Green University Popular Press, 1983), 174.

29. Weinberg, *Josef von Sternberg*, 71.

30. See von Sternberg, *Fun in a Chinese Laundry*, 80–81.

31. Cited by Weinberg, *Josef von Sternberg*, 217.

32. Ado Kyrou, *Le surréalisme au cinéma* (Paris: Terrain Vague, 1963), 121.

33. Cited in Weinberg, *Josef von Sternberg*, 217.

34. See John Colton, *The Shanghai Gesture: A Play* (New York: Horace Liveright, 1926), 166.

35. Cited in Jones, *Portrayal of China and India*, 46.

36. Jones, *Portrayal of China and India*, 46.

37. James C. Thomson, "Pearl S. Buck and the American Quest for China," in *The Several Worlds of Pearl S. Buck*, ed. Elizabeth J. Lipscomb, Frances E. Webb, and Peter Conn (Westport, CT: Greenwood Press, 1994), 14.

38. Isaacs, *Scratches on Our Minds*, 63.

39. Ibid., 155–156.

40. Thomson, "Pearl S. Buck and the American Quest for China," 13.

41. Reader's supplement to *The Good Earth,* by Pearl S. Buck (New York: Pocket Books/Washington Square Press, 1973), 40.

42. Ibid., 37.

43. Ibid., 43.

44. Carl Van Doren, *The American Novel, 1789–1939* (New York: Macmillan, 1940), 353.

45. Michael H. Hunt, "Pearl Buck: Popular Expert on China, 1931–1939," *Modern China* 3, no. 1 (January 1977), 47.

46. Sophia Chen Zen, "*The Good Earth,*" *Pacific Affairs* 4 (October 1931), 915–916.

47. Younghill Kang, "China Is Different," *New Republic* 67 (July 1, 1931), 186.

48. Cited by Kang Liao in his *Pearl S. Buck: A Cultural Bridge across the Pacific* (Westport, CT: Greenwood Press, 1997), 43.

49. Almost forty years after the publication of *The Good Earth,* Paul Doyle, a scholar of Buck's work, deemed "reprehensible" the way several Chinese scholars and intellectuals behaved in this matter. See Paul Doyle, *Pearl S. Buck* (New York: Twayne, 1965), 52–54.

50. Isaacs, *Scratches on Our Minds,* 157.

51. Zhang Longxi, "The Myth of the Other: China in the Eyes of the West," *Critical Inquiry* 15 (Autumn 1988), 127.

52. Hunt, "Pearl Buck: Popular Expert," 57.

53. Pearl Buck, *Is There a Case for Foreign Missions?* (New York: John Day, 1932), 30.

54. In an incendiary speech that precipitated her break with the missionary establishment, Buck left no doubt about her dismay at the cultural blindness and arrogance that in her view too often characterized American missionaries in China. "I have seen missionaries," she declared, "so lacking in sympathy for the people they were supposed to be saving, so scornful of any civilization except their own, so harsh in their judgments upon one another, so coarse and insensitive among a sensitive cultivated people that my heart has fairly bled with shame. I can never have done with my apologies to the Chinese people that in the name of a gentle Christ we have sent such people to them." See Buck, *Is There a Case for Foreign Missions?,* 8.

55. Lian Xi, *The Conversion of Missionaries: Liberalism in American Protestant Missions in China, 1907–1932* (University Park: Pennsylvania State University Press, 1997), 116.

56. In her biography of her father, Absalom Sydenstricker, Buck describes him as the "manifestation of a certain spirit in his country and his time. For he was a spirit, and a spirit made by the blind certainty, that pure intolerance, that zeal for mission, that contempt of man and earth, that high confidence in heaven, which our forefathers bequeathed to us." Pearl S. Buck, *Fighting Angel: Portrait of a Soul* (New York: Reynal and Hitchcock, 1936), 11.

57. On this issue, see Doyle, *Pearl S. Buck,* 40.

58. Discussing this issue, Mari Yoshihara suggests Buck's "annihilation of specificity" functioned as a "technique to evade positioning the novel in relation to the political and ideological debate over China's modernization." Mari Yoshihara, *Embracing the East: White Women and American Orientalism* (New York: Oxford University Press, 2003), 155.

59. Zhang, "The Myth of the Other," 116.

60. Michel Foucault, *The Order of Things: An Archeology of the Human Sciences* (New York: Vintage, 1973), xix. For a discussion of Chinese otherness seen in the light of Foucault, see Zhang, "The Myth of the Other."

61. On the social and political dimension of these films, often deemed part of the golden age of Chinese cinema, see Lai Kwan Pang, *Building a New Cinema in China: The Chinese Left-Wing Cinema Movement, 1932–1937* (Lanham, MD: Rowman and Littlefield, 2002).

62. Cited by Bob Thomas in his *Thalberg, Life and Legend* (Garden City, NY: Doubleday, 1969), 302–303.

63. The original director of the film, George Hill, died before production began. His role was taken over by Victor Fleming; when Fleming became ill, it fell to director Sidney Franklin to complete the film.

64. See Samuel Marx, *Mayer and Thalberg: The Make-Believe Saints* (New York: Random House, 1975), 247.

65. Jones, *Portrayal of China and India,* 45.

66. On this letter, see James Hoban Jr., "Scripting *The Good Earth:* Versions of the Novel for the Screen," in Lipscomb, Webb, and Conn, *The Several Worlds of Pearl S. Buck,* 127.

67. Cited in Peter Conn, *Pearl Buck: A Cultural Biography* (New York: Cambridge University Press, 1996), 159. On that same page, Conn points out that it initially seemed as if the notoriously strong-willed novelist would have her way: the crew did indeed take shots of peasants and their farms, of mud huts and beasts of burden. But, he writes, Buck's triumph was short-lived. "When the crew brought the footage out of China, the Kuomintang arranged to have all the containers X-rayed. A few weeks later, several thousand feet of blank film arrived in Hollywood."

68. Pearl Buck, *My Several Worlds: A Personal Record* (New York: John Day, 1954), 393.

69. Roland Flamini, *Thalberg: The Last Tycoon and the World of MGM* (New York: Crown, 1994), 255.

70. See Jones, *Portrayal of China and India,* 43.

71. See ibid., 46.

72. Buck, *My Several Worlds,* 393.

73. Cited in Conn, *Buck: A Cultural Biography,* 196.

74. Robert Gottlieb, "Orientally Yours," *New York Review of Books,* January 13, 2005, 42.

75. Frank Nugent, "*The Good Earth,*" *New York Times,* February 3, 1937.

76. Van Doren, *American Novel*, 353.

77. Conn, *Buck: A Cultural Biography*, 131.

78. Karen Janis Leong, "The China Mystique" (PhD diss., University of California at Berkeley, 1999).

79. Hunt, "Pearl Buck: Popular Expert," 51.

80. Cited in Jones, *Portrayal of China and India*, 46.

81. Cited in Hoban, "Scripting *The Good Earth*," 138.

82. Cited in ibid., 139.

83. Buck, *Good Earth*, 181–182.

84. Ibid., 186.

85. Conn, *Buck: A Cultural Biography*, 192.

86. Hoban, "Scripting *The Good Earth*," 139.

87. Conn, *Buck: A Cultural Biography*, 193.

88. Hunt, "Pearl Buck: Popular Expert," 58.

89. Even a later critic like Dorothy Jones makes the point that "every effort was made to make the film not only faithful to the Pearl Buck novel, but also as accurate as possible a picture of China and the Chinese people." Jones, *Portrayal of China and India*, 45.

90. Cited by Hoban, "Scripting *The Good Earth*," 141.

91. Hunt, "Pearl Buck: Popular Expert," 47.

Chapter 4: The Cold War in Three Acts

1. Nora Sayre, *Running Time: Films of the Cold War* (New York: Dial, 1978), 25.

2. A. T. Steele, *The American People and China* (New York: McGraw-Hill, 1966), 37.

3. Ronald Steel, *Pax America* (New York: Viking, 1967), 131.

4. Iris Chang, *The Chinese in America* (New York: Viking, 2002), 149. A 2000 documentary, *The Chinatown Files*, contains firsthand accounts of the experiences of seven Chinese Americans who found their loyalties questioned at the beginning of the cold war.

5. Cited by Martin Walker in *The Cold War* (New York: Holt, 1993), 67.

6. Warren Cohen makes the point that, at first, Chinese Communism seemed quite different from the Soviet variety: rallying peasants rather than urban workers, it seemed inspired less by Marxism than by nationalism. See Warren Cohen, *America's Response to China: A History of Sino-American Relations*, 4th ed. (New York: Columbia University Press, 2000), 135.

7. David Halberstam, *The Coldest Winter: America and the Korea War* (New York: Hyperion, 2007), 187.

8. Walker, *Cold War*, 66.

9. "Throughout the twentieth century," writes Jane Hunter, "Americans regarded Chinese missionaries as emblems of the purity of American motives. This

was particularly apparent following the Communist victory of 1949." Jane Hunter, *The Gospel of Gentility: American Women Missionaries in Turn-of-the-Century China* (New Haven, CT: Yale University Press, 1984), 7.

10.　Theodore H. White, *In Search of History* (New York: Harper and Row, 1978), 127.

11.　Halberstam, *Coldest Winter,* 242.

12.　"Madame Chiang Kai-shek, a Power in Husband's China and Abroad, Dies at 105," *New York Times,* October 25, 2003, sec. A.

13.　Cited by Patricia Neils in *China Images in the Life and Times of Henry Luce* (Savage, MD: Rowman and Littlefield, 1990), 94.

14.　Halberstam, *Coldest Winter,* 223.

15.　Ibid.

16.　Cited by Michael Schaller in *The United States and China: Into the Twenty-First Century* (New York: Oxford University Press, 2002), 123. In large measure, McCarthy's animus against this division of the State Department stemmed from the fact that its China experts had never endorsed the vision of an anti-Communist, pro-American China dear to McCarthy's (and to Luce's) heart. On the contrary, they had warned against the "bankruptcy" of the Nationalist regime and cautioned that China was falling apart.

17.　Cited in Steel, *Pax America,* 129.

18.　Cited in Schaller, *United States and China,* 1, 122.

19.　Cited in Walker, *Cold War,* 66.

20.　Cited in Harold Robert Isaacs, *Scratches on Our Minds: American Images of China and India* (New York: John Day, 1958), 196.

21.　Cited in James C. Thompson, Peter W. Stanley, and John Curtis Perry, *Sentimental Imperialists: The American Experience in East Asia* (New York: Harper and Row, 1987), 245.

22.　Cited by Hugh Deane in *The Korean War, 1945–1953* (San Francisco: China Books, 1999), 103.

23.　Historians have often speculated on the reasons behind the decision to ignore Chinese warnings and to drive American troops deep into North Korea. Some lay the blame on an overconfident General Douglas MacArthur, who wanted to provoke the Chinese to intervene so that he could deliver a crushing defeat against Communism. Others, like Ronald Steel, remind us that the administration, having lost Eastern Europe, was under tremendous pressure to show that it could "liberate" a Soviet satellite. See Ronald Steel, "Harry of Sunnybrook Farm," *New Republic,* August 10, 1992, 38.

24.　Cited in Schaller, *United States and China,* 131.

25.　Colin Mackerras, *Western Images of China* (New York: Oxford University Press, 1989), 94.

26.　Lewis McCarroll Purifoy, *Harry Truman's China Policy: McCarthyism and the Diplomacy of Hysteria, 1947–1951* (New York: New Viewpoints, 1976), xiv.

27.　Cohen, *America's Response to China,* 180.

28. Richard Hofstadter, "The Paranoid Style in American Politics," in *The Fear of Conspiracy: Images of Un-American Subversion from the Revolution to the Present,* ed. David Brion Davis (New York: Cornell University Press, 1971), 6.

29. David Brion Davis, introduction to Davis, *Fear of Conspiracy,* xxi.

30. Phil Hardy, *Samuel Fuller* (New York: Praeger, 1970), 13.

31. Walker, *Cold War,* 78.

32. Samuel Fuller, *A Third Face: My Tale of Writing, Fighting, and Filmmaking,* with Christa Lang Fuller and Jerome Henry Rudes (New York: Knopf, 2002), 353. Despite this remark, the prologue did not "stand"—at least in some versions of the film. One version I saw recently begins by saying that the film is dedicated to France, whose battle in Indonesia is vital to stopping the advance of Communism in Asia.

33. Ibid., 353.

34. An even more bizarre rescue is featured in still another strange film of the era. In *Blood Alley,* John Wayne portrays a rugged Westerner living in China who comes to the rescue of an entire Chinese village oppressed by the new Communist regime. Assuming the role of a modern-day Noah, Wayne commandeers a ferry and carries the inhabitants of the village downriver until they reach safety in the non-Communist haven of Hong Kong. If the film raises unanswered questions— what, after all, is the film's protagonist doing in Communist China?—its ideological message (like that of *China Doll*) is crystal clear. Underscoring American benevolence, it suggests that China's new Communist regime oppressed the Chinese people.

35. Cited by Schaller, *United States and China,* 3.

36. Greil Marcus, *The Manchurian Candidate* (London: BFI, 2002), 45. See also Greil Marcus, "A Dream of the Cold War," in *The Dustbin of History* (Cambridge, MA: Harvard University Press, 1995).

37. Susan L. Carruthers, "*The Manchurian Candidate* and the Cold War Brainwashing Scare," *Historical Journal of Film, Radio and Television* 18, no. 1 (March 1998), 83–84.

38. Bruce Crowther, *Hollywood Faction: Reality and Myth in the Movies* (London: Columbus Books, 1984), 157.

39. See Sean Wilentz, "Confounding Fathers: The Tea Party's Cold War Roots," *New Yorker,* October 18, 2010.

40. In a book that traces the history of these weird experiments, John D. Marks (who worked for the CIA at one point) makes the point that if a "brainwashing" machine "were even remotely feasible, one had to assume the communists might discover it. And in that case, national security required that the United States invent the machine first." John D. Marks, *The Search for the "Manchurian Candidate": The CIA and Mind Control* (New York: Norton, 1991), 139.

41. Thomas Powers, introduction to Marks, *Search for the "Manchurian Candidate,"* viii.

42. Ibid., ix. In recent years we have witnessed still another bizarre consequence of American fears of Chinese torture in Korea. A front-page article published

in the *New York Times* on April 22, 2009, recounts that the American use of torture techniques in Iraq was apparently based on methods used on American soldiers during their military training in the 1950s to prepare them lest they fall into Chinese hands.

43. Richard Rovere, *Senator Joe McCarthy* (New York: Harcourt Brace, 1959), 72.

44. Cited by Carruthers, "*Manchurian Candidate* and the Cold War Brainwashing Scare," 75.

45. See, for example, Stephen Badsey, *The Manchurian Candidate* (Trowbridge, UK: Flicks Books, 1998), 41.

46. See J. Hoberman, "When Dr. No Met Dr. Strangelove," *Sight and Sound* 3, no. 12 (December 1993), 19.

47. Purifoy, *Harry Truman's China Policy*, 170.

48. Tom Engelhardt, *The End of Victory Culture: Cold War America and the Disillusioning of a Generation* (New York: Basic Books, 1995), 184.

49. Marks, *Search for the "Manchurian Candidate,"* 134.

50. Charles S. Young, "Missing Action: POW Films, Brainwashing and the Korean War," *Historical Journal of Film, Radio and Television* 18, no. 1 (1998), 53.

51. Ibid., 53.

52. "We consulted every book written about brainwashing," said Frankenheimer, "and I remember reading one called *In Every War but One,* about American prisoners of war in Korea, and not one prisoner ever attempted to escape." Cited in Gerald Pratley, *The Films of Frankenheimer: John Frankenheimer Talks about His Life in the Cinema* (Bethlehem, PA: Lehigh University Press, 1998), 40.

53. Eugene Kinkead, *In Every War but One* (New York: Norton, 1959), 15.

54. Badsey, *Manchurian Candidate,* 9–10.

55. Callum MacDonald, *Korea: The War before Vietnam* (New York: Free Press, 1986), 255–256.

56. Marks, *Search for the "Manchurian Candidate,"* 194.

57. Kinkead, *In Every War but One,* 125.

58. Robert Jay Lifton, *Thought Reform and the Psychology of Totalism: A Study of "Brainwashing" in China* (New York: Norton, 1961), 4.

59. Richard Condon, *The Manchurian Candidate* (New York: Mysterious Book Club, 1988), 38.

60. Isaacs, *Scratches on Our Minds,* 191.

61. John King Fairbank, *Chinabound: A Fifty-Year Memoir* (New York: Harper and Row, 1982), 332.

62. Rovere, *Senator Joe McCarthy,* 8.

63. For a discussion of the references to Lincoln and other American symbols, see Badsey, *Manchurian Candidate,* 43.

64. Pauline Kael, *5001 Nights at the Movies* (New York: Henry Holt, 1991), 462.

65. Ray collapsed midway through the shooting and the task of director fell to second unit director Andrew Marton. For Marton's contributions to the film, see Bernard Eisenschnitz, *Nicholas Ray: An American Journey,* trans. Tom Milne (London: Faber and Faber, 1993), 387.

66. Jerome Ch'en, *China and the West: Society and Culture, 1815–1937* (London: Hutchison, 1979), 144.

67. Since the title of the film is *55 Days at Peking,* I use "Peking" throughout this chapter to refer to the Chinese capital rather than its modern pinyin romanization, Beijing.

68. John King Fairbank, *The Great Chinese Revolution, 1800–1985* (New York: Harper and Row, 1987), 138.

69. Diana Preston, *The Boxer Rebellion: The Dramatic Story of China's War on Foreigners That Shook the World in the Summer of 1900* (New York: Walker and Company, 2008), 24.

70. Immanuel C. Y. Hsü, *The Rise of Modern China* (New York: Oxford University Press, 1995), 389–390.

71. Paul A. Cohen, *China and Christianity: The Missionary Movement and the Growth of Chinese Antiforeignism, 1860–1870* (Cambridge, MA: Harvard University Press, 1963), 269.

72. See Preston, *Boxer Rebellion,* 26.

73. Cited in Fairbank, *Great Chinese Revolution,* 137.

74. Cited in Preston, *Boxer Rebellion,* 26.

75. Jonathan D. Spence, *The Search for Modern China* (New York: Norton, 1990), 234.

76. Paul A. Cohen, *History in Three Keys: The Boxers as Event, Experience, and Myth* (New York: Columbia University Press, 1997), 15.

77. Pearl S. Buck, *My Several Worlds: A Personal Record* (New York: John Day, 1954), 34.

78. Cited in Preston, *Boxer Rebellion,* xx.

79. James L. Hevia, *English Lessons: The Pedagogy of Imperialism in Nineteenth-Century China* (Durham, NC: Duke University Press, 2003), 284.

80. On the changing Chinese versions of the Boxer Rebellion, see Cohen, *History in Three Keys.*

81. See Sterling Seagrave, *Dragon Lady: The Life and Legend of the Last Empress of China* (New York: Random House/Vintage, 1992), 288; Hsü, *Rise of Modern China,* 397.

82. Seagrave, *Dragon Lady,* 288.

83. Hevia, *English Lessons,* 222.

84. Seagrave, *Dragon Lady,* 287.

85. Sheridan Prasso, *The Asian Mystique* (New York: Public Affairs, 2005), 29.

86. Buck, *My Several Worlds,* 30.

87. Seagrave, *Dragon Lady,* 11.

88. Isaacs, *Scratches on Our Minds,* 99.

89. On this issue, see John K. Fairbank, *China Perceived: Images and Policies in Chinese-American Relations* (New York: Knopf, 1974), 90.

90. Ibid., 94.

91. Preston, *Boxer Rebellion,* 34.

92. "The perceived superiority of the westerner," writes Preston, "and in particular of the English-speaking white male, dominates American and British accounts of the Boxer uprising. They speak disparagingly of 'Continentals' lounging about, smoking and drinking and generally keeping out of harm's way, while the Anglo-Saxons got on with the hard work." Preston, *The Boxer Rebellion,* xvi. The reverse apparently also held true: Lanxin Xiang observes that that French and German accounts of the events offer a far-from-flattering view of Anglo-American diplomats. See Lanxin Xiang, *The Origins of the Boxer War* (London: RoutledgeCurzon, 2002), viii.

93. Buck, *My Several Worlds,* 49.

94. Peter Wollen, "Never at Home," *Sight and Sound* 4, no. 5 (1984), 13.

95. Isaacs, *Scratches on Our Minds,* 99.

96. Cited in Bernard Cole, *Gunboats and Marines: The United States Navy in China, 1925–1928* (London: Associated University Presses, 1983), 21.

97. Cited by Dorothy Borg in *American Policy and the Chinese Revolution, 1925–1928* (New York: Macmillan, 1947), 17.

98. Paul A. Varg, *Missionaries, Chinese, and Diplomats: The American Missionary Movement in China, 1890–1952* (Princeton, NJ: Princeton University Press, 1958), 186.

99. Borg, *American Policy and the Chinese Revolution,* 288.

100. "The mission cause is in sight of defeat at this moment," warned an editorial in a leading religious journal, the *Christian Century,* "because, in the eyes of the Chinese, it is inextricably bound up with the economic imperialism of western nations.... It is time for the missionary organizations to make it clear to the world that the Christian cause as a whole is done with gunboats." Cited in Borg, *American Policy and the Chinese Revolution,* 73–74.

101. Lian Xi, *The Conversion of Missionaries: Liberalism in American Protestant Missions in China, 1907–1932* (University Park: Pennsylvania State University Press, 1997), 12.

102. Buck, *My Several Worlds,* 216.

103. Cole, *Gunboats and Marines,* 172.

104. Ibid., 173.

105. See Casey St. Charnez, *The Films of Steve McQueen* (Secaucus, NJ: Citadel Press, 1984), 125.

106. Cited by Danièle Grivel and Roland Lacourbe in *Robert Wise* (Paris: Edilig, 1985), 122.

107. Richard McKenna, *The Sand Pebbles* (New York: Harper and Row, 1962), 158–159.

108. Ibid., 260.

109. Ibid., 558–559.

Chapter 5: The World Splits in Two

1. Arthur Miller and Inge Morath, *Chinese Encounters* (New York: Farrar, Strauss, and Giroux, 1979), 40.

2. Warren I. Cohen, *America's Response to China: A History of Sino-American Relations,* 4th ed. (New York: Columbia University Press, 2000), i.

3. Kenneth Chan, *Remade in Hollywood: The Global Chinese Presence in Transnational Cinemas* (Hong Kong: Hong Kong University Press, 2009), 57.

4. On these events, see "Sympathy on the Streets, But Not for the Tibetans," *New York Times,* April 18, 2008; "Chinese Student in U.S. Caught in Ugly Confrontation," *New York Times,* April 17, 2008.

5. Nicholas D. Kristof, "A Not-So-Fine Romance," *New York Times,* April 3, 2008, sec. A.

6. Nicholas D. Kristof, "An Olive Branch from the Dalai Lama," *New York Times,* August 7, 2008, sec. A.

7. Donald Lopez, foreword to *Authenticating Tibet: Answers to China's 100 Questions,* ed. Anne-Marie Blondeau, Katia Buffetrille, and Wei Jing (Berkeley: University of California Press, 2008), xvii.

8. Orville Schell coins the term in his *Virtual Tibet: Searching for Shangri-la from the Himalayas to Hollywood* (New York: Metropolitan Books, 2000).

9. Jim Sangster, *Scorsese* (London: Virgin Books, 2002), 257.

10. Years earlier, the Chinese had made what I think is a far more powerful propaganda film, *Nongnu,* which advances the view of Tibet as a feudal society liberated by the Chinese.

11. Clearly designed to appeal to Western viewers, the feminist hue of the film implicit in the monk's reincarnation in a woman disturbed certain scholars and students of Buddhism. Calling the film's implicit appeal to feminist values "dishonest and mystifying," Martin Brauen declared that while nothing stands in the way of a female incarnation, throughout "the long Tibetan tradition, not a single reincarnation combination is known that matches the one shown in the film." Martin Brauen, with the help of Renate Koller and Markus Vock, *Dreamworld Tibet: Western Illusions,* trans. Martin Wilson (Trumbull, CT: Weatherhill, 2004), 87.

12. Chan, *Remade in Hollywood,* 63.

13. Ian Buruma, "Found Horizon," *New York Review of Books,* June 29, 2000, 14.

14. Brauen, *Dreamworld Tibet,* 168.

15. On the distortion of history in *Seven Years in Tibet,* see Marc Abramson, "*Kundun* and *Seven Years in Tibet,*" *Cinéaste* 23, no. 3 (April 1998).

16. Buruma, "Found Horizon," 14.

17. Ibid.

18. Abramson, "*Kundun* and *Seven Years in Tibet,*" 3.

19. Cited by Sandra Marti, "*Kundun:* Scorsese et la non-violence," in *Martin Scorsese, Études Cinématographiques,* vol. 68, ed. Michel Estève (Paris: Lettres Modernes-Minard, 2003), 230.

20. Beginning in 1956, America did offer clandestine—that is, CIA—aid to Tibetan guerrillas. But as Tibet historian Melvyn C. Goldstein puts it, this help was "too little too late." See Melvyn C. Goldstein, *The Snow Lion and the Dragon: China, Tibet, and the Dalai Lama* (Berkeley/Los Angeles: University of California Press, 1997), 55. On the issue of CIA involvement in Tibet, see John Kenneth Knaus, *Orphans of the Cold War: America and the Tibetan Struggle for Survival* (New York: Public Affairs, 1999); Kenneth Conboy and James Morrison, *The CIA's Secret War in Tibet* (Lawrence: University of Kansas Press, 2002).

21. Blondeau, Buffetrille, and Wei Jing, *Authenticating Tibet*, 69.

22. Dalai Lama XIV, *Freedom in Exile: The Autobiography of His Holiness the Dalai Lama of Tibet* (New York: HarperCollins, 1990), 89.

23. Goldstein, *Snow Lion and the Dragon*, ix–x.

24. On these competing narratives, see John Powers, *History as Propaganda: Tibetan Exiles versus the People's Republic of China* (New York: Oxford University Press, 2004).

25. An interesting discussion of the way the Chinese view the Tibet question is found in Peter Hessler's "Tibet through Chinese Eyes," *Atlantic Monthly*, February 1999, 56–66.

26. Summarizing these competing claims, Powers writes that "the Tibetan version of Tibetan history is one in which Tibet, prior to the Chinese takeover in the 1950s, is presented as an independent and closed society based on Buddhist principles and ruled by Buddhist monks. The people were both happy and devout. . . . According to the Chinese version, China is a multiethnic society in which the Han make up over 93 percent of the population, but fifty-six minorities [including Tibet] are also an integral part of the 'motherland,' coexisting peacefully since time immemorial." Powers, *History as Propaganda*, 4.

27. Ibid., 158.

28. On this issue, see Jeffrey Paine, *Re-enchantment: Tibetan Buddhism Comes to the West* (New York: Norton, 2004), 13.

29. On the issue of homosexuality, reports Patrick French, the Dalai Lama's stand is "close to that of Pope John Paul II, something his Western followers find embarrassing and prefer to ignore." See French, "Dalai Lama Lite," *New York Times*, September 19, 2003, sec. A.

30. Paine, *Re-enchantment*, 15.

31. Indeed, a number of important Tibetan activists and scholars lament the fact that contemporary Tibet continues to be seen less as a real country (that might awaken the political will of the West) than as a mythic repository of spiritual and sacred values. On this issue, see, for example, the essays by Jamyang Norbu, Robert Barnett, and Toni Huber in *Imagining Tibet: Perceptions, Projections and Fantasies*, ed. Thierry Dodin and Heinz Räther (Boston: Wisdom Publications, 2001).

32. Peter Bishop, *The Myth of Shangri-La: Tibet, Travel Writing and the Western Creation of Sacred Landscape* (London: Athlone Press, 1989), 7.

33. Antonin Artaud, "Adresse au Dalaï Lama," in *Oeuvres completes*, vol. 1 (Paris: Gallimard, 1956), 262.

34. Although, of course, it was Hilton who first imagined the community of Shangri-La, it was arguably the film that gave it its enormous resonance in the popular imagination. Capra's beloved classic, declares John R. Hammond, "has done more to popularize the idea of Shangri-La than any other film or book and seems destined to have a permanent place in the history of motion pictures." John R. Hammond, *Lost Horizon Companion* (Jefferson, NC: McFarland, 2008), 144–145.

35. Bishop, *Myth of Shangri-La*, 212.

36. Lowell Thomas Jr., *Out of This World: Across the Himalayas to Forbidden Tibet* (New York: Greystone Press, 1950), 30–31, 17. Pointing to the continuing resonance of Shangri-La, in the decades since Hilton published his famous novel—which has never gone out of print—novelists have written sequels to *Lost Horizon*, while explorers have sought the "real" Shangri-La. In a contemporary ironic twist, the Chinese are now building tourist facilities in a remote mountainous region that, they have determined, is the site of Shangri-La.

37. "One cannot appreciate the Tibetan landscape that was forming in the imagination of eighteenth-century Britain," declares Bishop, "without simultaneously understanding the era's fantasy of China." Bishop, *Myth of Shangri-La*, 34.

38. James Hilton, *Lost Horizon* (New York: William Morrow & Co., 1934), 114.

39. Ibid., 214.

40. Thomas, *Out of This World*, 30–31.

41. Bishop, *Myth of Shangri-La*, 206.

42. Hilton, *Lost Horizon*, 237.

43. Bishop, *Myth of Shangri-La*, 206.

44. Amaury de Riencourt, *Roof of the World: Tibet, Key to Asia* (New York: Rinehart and Co., 1950), 306.

45. Bishop, *Myth of Shangri-La*, 209.

46. Riencourt, *Roof of the World*, 306.

47. Colin Thubron, *To a Mountain in Tibet* (New York: HarperCollins, 2011), 30.

48. Bishop, *Myth of Shangri-La*, 244.

49. Brauen, *Dreamworld Tibet*, 1.

50. Bishop, *Myth of Shangri-La*, 243.

51. Schell, *Virtual Tibet*, 206.

52. Thubron, *To a Mountain in Tibet*, 32.

53. Donald Lopez Jr., *Prisoners of Shangri-La* (Chicago: University of Chicago Press, 1998), 7.

54. Ian Christie, "Martin Scorsese's Testament," in *Martin Scorsese Interviews*, ed. Peter Brunette (Jackson: University Press of Mississippi, 1997), 235.

55. "Scorsese: la tentation bouddhiste," *Le nouvel observateur*, May 21–27 (1991), 55. Scorsese's memory may have played him false here: *Storm over Tibet* and *The Mask of the Himalayas* seem to be different titles for the same film.

56. Scorsese, "La tentation bouddhiste," 55.

57. Brauen, *Dreamworld Tibet,* 87.

58. Schell, *Virtual Tibet,* 246.

59. Thelma Schoonmaker, "Il voulait évoquer le Tibet, pas l'expliquer," *Positif* 447 (May 1998), 30. Interestingly, the Criterion release of *The Tales of Hoffman* is accompanied by a commentary by Scorsese.

60. Marti, "*Kundun:* Scorsese et la non-violence," 239.

61. Cited by Gavin Smith, "The Art of Vision: Martin Scorsese's *Kundun,*" in Brunette, *Martin Scorsese: Interviews,* 239.

62. For example, Marc Abramson argues that neither *Seven Years in Tibet* nor *Kundun* shows "the exploitive, regressive, and ultimately self-defeating nature of the dual religious and secular hierarchies which governed Tibet." Abramson, "*Kundun* and *Seven Years in Tibet,*" 9. Pankaj Mishra reminds us of the use of torture in twentieth-century Tibet. See Mishra, "Holy Man," *New Yorker,* March 31, 2008, 121.

63. Discussing these maneuvers, former Tibetan activist Patrick French tells us that the Dalai Lama's great-uncle and elder brother "were important reincarnate lamas in Amdo, his uncle was financial controller of nearby Kumbum monastery, and the region's notoriously brutal Muslim warlord, Ma Bufang—who was personally instrumental in choosing the Dalai Lama—turned out to be a friend of his mother's family." Patrick French, *Tibet, Tibet: A Personal History of a Lost Land* (New York: Vintage, 2003), 18.

64. Thubron, *To a Mountain in Tibet,* 87, 32.

65. Michael Henry, "*Kundun* vu par Martin Scorsese: Quel est le pouvoir de la compassion?" *Positif* 447 (May 1998), 26.

66. Michael Pye and Linda Myles, *The Movie Brats: How the Film Generation Took over Hollywood* (New York: Holt, Rinehart and Winston, 1979), 202.

67. On this issue, see Martin Brauen, *Dreamworld Tibet,* 260.

68. Henry, "*Kundun* vu par Martin Scorsese," 27.

69. Hubert Niogret, "*Kundun:* Une conscience en development," *Positif* 447 (May 1998), 20.

70. Cited by Sandra Marti, "*Kundun:* Scorsese et la non-violence," 236.

71. Niogret, "*Kundun:* Une conscience en développement," 20.

72. Dalai Lama XIV, *My Land and My People, by His Holiness, the Dalai Lama of Tibet* (New York: McGraw Hill, 1962), 56.

73. Cited in Amy Taubin, "Everything Is Form," in Brunette, *Martin Scorsese: Interviews,* 258.

74. Henry, "*Kundun* vu par Martin Scorsese," 27.

75. Dalai Lama, *Freedom in Exile,* 92, 90.

76. Ibid., 89.

77. Ibid., 98–99, 100.

78. French, *Tibet, Tibet,* 284.

79. Marti, "*Kundun:* Scorsese et la non-violence," 236.

80. Serafino Murri, *Martin Scorsese* (Milan: Editrice il Castoro, 2000), 134.

81. Henry, "*Kundun* vu par Martin Scorsese," 26.

82. Taubin, "Everything Is Form," 260.

83. French, *Tibet, Tibet,* 264.

84. Pankaj Mishra, "Staying Power: Mao and the Maoists," *New Yorker,* December 20 and 27, 2010, 126.

85. "What Mao accomplished between 1949 and 1956," writes a leading historian of the Mao years, Roderick MacFarquhar, "was in fact the fastest, most extensive, and least damaging socialist revolution carried out in any communist state." Cited by Mishra in "Staying Power," 128.

86. Murri, *Scorsese,* 134.

87. Abramson, *"Kundun* and *Seven Years in Tibet,"* 12.

Chapter 6: Challenges and Continuities

1. Kenneth Chan, *Remade in Hollywood: The Global Chinese Presence in Transnational Cinemas* (Hong Kong: Hong Kong University Press, 2009), 4, 25.

2. The term was apparently first used in an anthology of writings edited by Sheldon H. Lu, *Transnational Chinese Cinemas: Identity, Nationhood, Gender* (Honolulu: University of Hawai'i Press, 1997). Arguing that Chinese national cinema "can only be understood in its properly transnational context," in his introduction to this volume, Lu observes that "transnationalism in the Chinese case can be observed at the following levels: first, the split of China into several geopolitical entities ... second, the globalization of the production, marketing, and consumption of Chinese film in the age of transnational capitalism in the 1990s; third, the representation and question of 'China' and 'Chineseness' in filmic discourse itself ... fourth, a reviewing and revisiting of the history of Chinese 'national cinemas,' as if to read the 'prehistory' of transnational filmic discourse backwards." Sheldon H. Lu, "Historical Introduction: Chinese Cinemas (1896–1996) and Transnational Film Studies," in Lu, *Transnational Chinese Cinemas,* 3. On transnational Chinese cinema, also see Gina Marchetti, *From Tian'anmen to Times Square: Transnational China and the Chinese Diaspora on Global Screens, 1989–1997* (Philadelphia: Temple University Press, 2006).

3. Jaap Van Ginneken, *Screening Difference* (Lanham, MD: Rowman and Littlefield, 2007), 31, 21.

4. Ibid., 39.

5. Roger Garcia, "Outside Looking In: Notes on Asian America," in *Out of the Shadows: Asians in American Cinema,* ed. Roger Garcia (Milan: Olivares, 2001), 78.

6. Chan, *Remade in Hollywood,* 8.

7. Yingjin Zhang, *Screening China: Critical Interventions, Cinematic Reconfigurations, and the Transnational Imaginary in Contemporary Chinese Cinema* (Ann Arbor, MI: Center for Chinese Studies, 2002), 40.

8. Julian Stringer, "Cultural Identity and Diaspora in Contemporary Hong Kong Cinema," in *Countervisions: Asian American Film Criticism,* ed. Darrell Y. Hamamoto and Sandra Liu (Philadelphia: Temple University Press, 2000), 302.

9. Daniel Fried, "Riding off into the Sunrise: Genre Contingency and the Origin of the Chinese Western," *PMLA* 122, no. 5 (October 2007).

10. Cited in Chan, *Remade in Hollywood*, 10.

11. Gary G. Xu, *Sinascape: Contemporary Chinese Cinema* (Lanham, MD: Rowman and Littlefield, 2007), 4.

12. Steve Fore, "Jackie Chan and the Cultural Dynamics of Global Entertainment," in Lu, *Transnational Chinese Cinemas*, 255.

13. Chan seemed to confuse two iconic Western figures when he remarked that John Wayne (rather than Gary Cooper) played the lead in *High Noon*. He saw *Shanghai Noon*, he said, as a "very smart pun on the John Wayne film *High Noon*." See Chan, *Remade in Hollywood*, 138.

14. Kenneth Chan, for one, views Chan's transformation in a particularly dark light. In his view, the difficulties that Chon Wang faces and overcomes "expose the cultural violence involved in the processes of immigrant assimilation, in this case pitched against the racial impossibility of measuring up to the mythic standards of a John Wayne. The ultimate violation, of course, comes when Lo Fong cuts off Chon Wang's queue, a moment of symbolic 'racial castration.'" See Chan, *Remade in Hollywood*, 141.

15. Darrell Y. Hamamoto, "Introduction: On Asian American Film and Criticism," in Hamamoto and Liu, *Countervisions*, 17.

16. Cited by Gina Marchetti in "*The Wedding Banquet*: Global Chinese Cinema and the Asian American Experience," in Hamamoto and Liu, *Countervisions*, 277.

17. Significantly, the film, as Sheldon H. Lu reminds us, "has been advertised under different rubrics for different audiences: a gay and lesbian film, a Chinese American film, a Taiwanese film, and so forth." See Lu, "Historical Introduction," in Lu, *Transnational Chinese Cinemas*, 18.

18. Cited by Chan, *Remade in China*, 81.

19. Poshek Fu and David Desser, introduction to *The Cinema of Hong Kong: History, Arts, Identity*, ed. Poshek Fu and David Desser (New York: Cambridge University Press, 2000), 2.

20. David Desser, "The Kung Fu Craze: Hong Kong Cinema's First American Reception," in Fu and Desser, *Cinema of Hong Kong*, 20.

21. Gary G. Xu points out that although films such as "Wang Xiaoshuai's *So Close to Paradise* (1999), Lou Ye's *Suzhou River* (2000), and Jia Zhangke's Hometown Trilogy series (*Xiao Wu*, 1998; *Platform*, 2000; *Unknown Pleasures*, 2002) all achieved tremendous success in overseas house markets and at international film festivals . . . none made it to Chinese movie theaters due to their violations of state regulations governing the film industry." Xu, *Sinascape*, 47–48.

22. Lu, "Historical Introduction," 12.

23. Chan, *Remade in Hollywood*, 27.

24. Hamamoto, introduction to *Countervisions*, 10.

25. Diane Mark, introduction to Wayne Wang, *Chan Is Missing* (Honolulu, HI: Bamboo Ridge Press, 1984), 2.

26. Ibid., 6.

27. A similar dilemma confronts the female protagonist of Canadian director Mina Shum's film *Double Happiness* (1994). She, too, is torn between a desire to live her own life—in this case to pursue her dreams of becoming an actress—and familial demands and ties. Interestingly, whenever she auditions for a film, she is confronted by stereotypes: in the midst of an audition for a Canadian production she is asked to assume a Chinese accent; when she attempts to join a Hong Kong theatrical troupe she is rejected because she cannot read Chinese. Constantly forced to assume one role or another, she questions her very identity.

28. Chan, *Remade in Hollywood,* 76. On this issue, see also Joseph M. Chan, "Disneyfying and Globalizing the Chinese Legend Mulan: A Study of Transculturation," in *In Search of Boundaries: Communication, National-States and Cultural Identities,* ed. Joseph M. Chan and Bryce T. McIntyre (Westport, CT: Ablex Publishing, 2002), 225–248.

29. Todd Gitlin, "The Unification of the World under the Signs of Mickey Mouse and Bruce Willis: The Supply and Demand Sides of American Popular Culture," in Chan and McIntyre, *In Search of Boundaries,* 31.

30. Hamamoto, introduction to *Countervisions,* 12.

31. See Evans Chan, "Postmodernism and Hong Kong Cinema," in *Postmodernism and China,* ed. Arif Dirlik and Xudong Zhang (Durham, NC: Duke University Press, 2000).

32. Michael Curtin, *Playing to the World's Biggest Audience: The Globalization of Chinese Film and TV* (Berkeley: University of California Press, 2007), 1. Curtin nonetheless goes on to express the hope that Hollywood—like the Detroit of forty years ago—might well collapse because of its inability to envision "transformations now on the horizon." "What if," he asks, "the future were to take an expected detour on the road to Disneyland, heading instead toward a more complicated global terrain characterized by overlapping and at times intersecting cultural spheres served by diverse media enterprises based in media capitals around the world?"

33. Xu, *Sinascape,* 151.

34. On this issue, see Lan Dong, *Mulan's Legend and Legacy in China and the United States* (Philadelphia: Temple University Press, 2011), 216.

35. Van Ginneken, *Screening Difference,* 38.

36. Xu, *Sinascape,* 135.

37. Shiamin Kwa and Wilt L. Idema, eds., *Mulan: Five Versions of a Classic Chinese Legend* (Indianapolis, IN: Hackett Publishing Co., 2010).

38. For example, the issue of female "transgression" runs throughout Dong, *Mulan's Legend and Legacy.*

39. Alan Nadel, "A Whole New (Disney) World Order: *Aladdin,* Atomic Power, and the Muslim Middle East," in *Visions of the East: Orientalism in Film,* ed. Matthew

Bernstein and Gaylyn Studlar (New Brunswick, NJ: Rutgers University Press, 1997), 192.

40. Sheng-mei Ma, *The Deathly Embrace: Orientalism and Asian American Identity* (Minneapolis: University of Minnesota Press, 2000), 127.

41. Ibid., 129.

42. Ibid., 138.

43. Ibid., 127.

44. Dong, *Mulan's Legend and Legacy,* 166.

45. "As ever," they write, "the reimposition of the patriarchal order at the end of the Disney film serves to undo the liberating potential of its central female character. A woman might be allowed to save China but she voluntarily gives up her place as a member of the Emperor's council to return home to look after her father and take a husband." Eleanor Byrne and Martin McQuillan, *Deconstructing Disney* (London: Pluto Press, 1999), 165.

46. Cited by Dong in *Mulan's Legend and Legacy,* 172.

47. Ibid., 219.

48. See Dong, *Mulan's Legend and Legacy,* 170.

49. Xu, *Sinascape,* 49.

50. Nicholas Saada, "The Shadow of Whom? Asian Films and Hollywood Action Cinema," in *Out of the Shadows: Asians in American Cinema*, ed. Roger Garcia (Locarno Film Festival, August, 2001), 68.

51. David Bordwell, *Planet Hong Kong: Popular Cinema and the Art of Entertainment* (Cambridge, MA: Harvard University Press, 2000), 194.

52. Jeff Yang, *Once upon a Time in China: A Guide to Hong Kong, Taiwanese, and Mainland Chinese Cinema* (New York: Atria, 2003), 52.

53. Although the term *wuxia* is often translated as "chivalry" or "knight errantry," I prefer the definition given by my Chinese dictionary: here *wuxia* is defined as "a person adept in martial arts and given to chivalrous conduct (in olden times)."

54. Chan, *Remade in Hollywood,* 76.

55. Speaking of these considerations, Lee raised a crucial question confronting Chinese directors: given the economic dominance of Hollywood—and the need to appeal to Western audiences—how can they make a martial arts film without "exoticizing" China for the Western gaze? "Hollywood," said Lee of *Crouching Tiger, Hidden Dragon*, "was responsible for the esthetics. I use a lot of language that's not spoken in the Ching dynasty. Is that good or bad? Is it Westernization or modernization? . . . In some ways modernization *is* Westernization—that's the fact we hate to admit. Chinese people don't watch Chinese films anymore. They watch Western movies." Cited in Chan, *Remade in Hollywood,* 79.

56. Sheldon H. Lu, "*Crouching Tiger, Hidden Dragon,* Bouncing Angels: Hollywood, Taiwan, Hong Kong, and Transnational Cinema," in *Chinese-Language Film,* ed. Sheldon H. Lu and Emilie Yueh-yu Yeh (Honolulu: University of Hawai'i Press, 2005), 231.

57. Sheldon H. Lu, "National Cinema, Cultural Critique, Transnational Capital: The Films of Zhang Yimou," in Lu, *Transnational Chinese Cinemas*, 127.

58. Chan, *Remade in Hollywood*, 75.

59. Cited by Chan in *Remade in Hollywood*, 80.

60. Speaking of the impact that Hu's film had on him, Tsai Ming-liang waxed as rhapsodic as Ang Lee when he spoke of his "dream" of China. "The sound of the vertical flute in [Hu's] film," recalled the director, "made me feel for the first time the vastness and loneliness of the world of knights-errant. In other martial arts films, the characters fly around and tread freely on roofs and walls. Only King Hu's knights-errant walk the lonely path in desolate mountains. Some say King Hu chose a lonely and difficult road of filmmaking, but this is precisely what makes his films unforgettable." Cited in Xu, *Sinascape*, 89. See Chapter 4 of Xu's work for a very interesting discussion of *Goodbye, Dragon Inn*. Tsai Ming-liang was not alone in his admiration for King Hu's film. *Dragon Gate Inn* has been remade at least twice in recent decades: by Raymond Lee in his 1992 *Dragon Inn* and in 2012 in a 3-D version by Tsui Hark, *Flying Swords of Dragon Gate*.

61. Yang, *Once upon a Time in China*, 142.

62. Bordwell, *Planet Hong Kong*, 217.

63. Bhaskar Sarkar, "Hong Kong Hysteria: Martial Arts Tales from a Mutating World," in *At Full Speed: Hong Kong Cinema in a Borderless World*, ed. Esther C. Yau (Minneapolis: University of Minnesota Press, 2001), 154.

64. In this respect, *Kung Fu Panda* belongs to what Kenneth Chan describes as "a growing line of Hollywood films that exaggerate and make fun of martial arts films and kung fu comedies from Hong Kong: *Big Trouble in Little China* (1986), *Beverly Hills Ninja* (1997), *Kung Pow: Enter the Fist* (2002), and the bizarre sports-kung fu *Balls of Fury* (2007) . . . these films thrive on and are protected by their (sometimes questionably) ironic play on ethnic stereotypes." Chan, *Remade in Hollywood*, 129.

65. Verina Glaessner, *Kung Fu: Cinema of Vengeance* (London: Lorrimer, 1974), 51.

66. Fore, "Jackie Chan," 253.

67. Ibid.

68. Chan, *Remade in Hollywood*, 139. In terms of this "cultural allegiance," it is telling that when, as in *Shinjuku Incident* (Derek Lee, 2009) Chan loses—or is forced to lose—his moral compass, comedy gives way to tragedy.

69. Nadel, "A Whole New (Disney) World Order," 200.

70. Gitlin, "The Unification of the World," 29.

Afterword: The Darkening Mirror

1. Ronald Dworkin, "The Historic Election: Four Views," *New York Review of Books*, December 9, 2010, 56.

2. Tony Judt, "Its Own Worst Enemy," *New York Review of Books*, August 15, 2002, 16.

3. Paul Krugman, "The Paranoid Style," *New York Times*, October 9, 2006.

4. Mark Danner, "The Politics of Fear," *New York Review of Books*, November 22, 2012, 54.

5. "Bush's Freedom Agenda," writes Brian Urquhart, "was the latest restatement of the venerable idea that Providence had chosen Americans to ensure the blessings of liberty for all." Urquhart, "What You Can Learn from Reinhold Niebuhr," *New York Review of Books*, March 26, 2009, 24.

6. Jane Perlez, "In China and U.S., Mutual Distrust Grows, Study Finds," *New York Times*, July 18, 2013, sec. A.

7. David W. Chen, "China Emerges as a Scapegoat in Campaign Ads," *New York Times,* October 10, 2010.

8. Harold Robert Isaacs, *Scratches on Our Minds: American Images of China and India* (New York: John Day, 1958), 59.

9. Richard Madsen, *China and the American Dream: A Moral Inquiry* (Berkeley: University of California Press, 1995), 228.

Bibliography

Abramson, Marc. "*Kundun* and *Seven Years in Tibet.*" *Cinéaste* 23, no. 3 (April 1998): 8–11.

Artaud, Antonin. "Adresse au Dalaï Lama." In *Oeuvres completes,* vol. 1. Paris: Gallimard, 1956.

Badsey, Stephen. *The Manchurian Candidate.* Trowbridge, England: Flicks Books, 1998.

Baxter, John. *The Cinema of Josef von Sternberg.* New York: Barnes, 1971.

Becker, Jasper. *The Chinese.* New York: Free Press, 2000.

Belton, John. "Harold Lloyd: The Man and His Times." In *Harold Lloyd: The King of Daredevil Comedy,* by Adam Reilly, 191–199. New York: Macmillan, 1977.

Bernstein, Richard. "A Very Superior 'Chinaman.'" *New York Review of Books,* October 28, 2010, 16–17.

Bishop, Peter. *The Myth of Shangri-La: Tibet, Travel Writing and the Western Creation of Sacred Landscape.* London: Athlone Press, 1989.

Blake, Michael F. *Lon Chaney: The Man Behind the Thousand Faces.* Vestal, NY: Vestal Press, 1993.

Blondeau, Anne-Marie, Katia Buffetrille, and Wei Jing, eds. *Authenticating Tibet: Answers to China's 100 Questions.* Berkeley: University of California Press, 2008.

Bordwell, David. *Planet Hong Kong: Popular Cinema and the Art of Entertainment.* Cambridge, MA: Harvard University Press, 2000.

Borg, Dorothy. *American Policy and the Chinese Revolution, 1925–1928.* New York: Macmillan, 1947.

Bradsher, Keith. "As China Builds a Vast Network of Fast Trains, the U.S. Falls Further Behind." *New York Times,* February 13, 2010, sec. A.

———. "China Drawing High-Tech Research from U.S." *New York Times,* March 18, 2010, sec. A.

Brauen, Martin. *Dreamworld Tibet: Western Illusions.* With the help of Renate Koller and Markus Vock. Trans. Martin Wilson. Trumbull, CT: Weatherhill, 2004.

Brownlow, Kevin. *Behind the Mask of Innocence: Sex, Violence, Prejudice, Crime: Films of Social Conscience in the Silent Era.* Berkeley: University of California Press, 1992.

———. *The Parade's Gone By.* New York: Ballantine, 1968.

Buck, Pearl S. *Fighting Angel: Portrait of a Soul*. New York: Reynal and Hitchcock, 1936.

———. *Is There a Case for Foreign Missions?* New York: John Day, 1932.

———. *My Several Worlds: A Personal Record*. New York: John Day, 1954.

Burke, Thomas. "The Chink and the Child." In *Limehouse Nights*, 18–30. New York: Horizon Press, 1973.

Buruma, Ian. "Found Horizon." *New York Review of Books,* June 29, 2000, 12–17.

Byrne, Eleanor, and Martin McQuillan. *Deconstructing Disney*. London: Pluto Press, 1999.

Carney, Ray. *American Vision: The Films of Frank Capra*. Hanover, NH: University Press of New England/Wesleyan University Press, 1986.

Carruthers, Susan L. "*The Manchurian Candidate* and the Cold War Brainwashing Scare." *Historical Journal of Film, Radio and Television* 18, no. 1 (March 1998): 75–93.

Chan, David B. "The China Syndrome: Some Thoughts and Impressions after a 1979 Trip." In *America Views China: American Images of China Then and Now,* ed. J. Goldstein, J. Israel, and H. Conroy, 183–192. Bethlehem, PA: Lehigh University Press, 1991.

Chan, Evans. "Postmodernism and Hong Kong Cinema." In *Postmodernism and China,* ed. Arif Dirlik and Xudong Zhang, 294–311. Durham, NC: Duke University Press, 2000.

Chan, Jachinson. *Chinese American Masculinities: From Fu Manchu to Bruce Lee*. New York: Routledge, 2001.

Chan, Joseph M. "Disneyfying and Globalizing the Chinese Legend Mulan: A Study of Transculturation." In *In Search of Boundaries: Communication, National-States and Cultural Identities,* ed. Joseph M. Chan and Bryce T. McIntyre, 225–248. Westport, CT: Ablex Publishing, 2002.

Chan, Kenneth. *Remade in Hollywood: The Global Chinese Presence in Transnational Cinemas*. Hong Kong: Hong Kong University Press, 2009.

Chang, Iris. *The Chinese in America*. New York: Viking, 2002.

Chen, David W. "China Emerges as a Scapegoat in Campaign Ads." *New York Times,* October 10, 2010.

Ch'en, Jerome. *China and the West: Society and Culture, 1815–1937.* London: Hutchison, 1979.

Christie, Ian. "Martin Scorsese's Testament." In *Martin Scorsese Interviews,* ed. Peter Brunette, 220–235. Jackson: University Press of Mississippi, 1997.

Cohen, Paul A. *China and Christianity: The Missionary Movement and the Growth of Chinese Antiforeignism, 1860–1870.* Cambridge, MA: Harvard University Press, 1963.

———. *History in Three Keys: The Boxers as Event, Experience, and Myth*. New York: Columbia University Press, 1997.

Cohen, Warren I. *America's Response to China: A History of Sino-American Relations,* 4th ed. New York: Columbia University Press, 2000.

Cole, Bernard. *Gunboats and Marines: The United States Navy in China, 1925–1928.* London: Associated University Presses, 1983.

Colton, John. *The Shanghai Gesture: A Play*. New York: Horace Liveright, 1926.

Commager, Henry Steele. Foreword to *Americans and Chinese: Passage to Differences,* by Francis L. K. Hsu, xi–xviii. Honolulu: University of Hawai'i Press, 1981.

Conboy, Kenneth, and James Morrison. *The CIA's Secret War in Tibet.* Lawrence: University of Kansas Press, 2002.

Condon, Richard. *The Manchurian Candidate.* New York: Mysterious Book Club, 1988.

Conn, Peter. *Pearl Buck: A Cultural Biography.* New York: Cambridge University Press, 1996.

Crowther, Bruce. *Hollywood Faction: Reality and Myth in the Movies.* London: Columbus Books, 1984.

Curtin, Michael. *Playing to the World's Biggest Audience: The Globalization of Chinese Film and TV.* Berkeley: University of California Press, 2007.

Dalai Lama XIV. *Freedom in Exile: The Autobiography of His Holiness the Dalai Lama of Tibet.* New York: HarperCollins, 1990.

———. *My Land and My People, by His Holiness, the Dalai Lama of Tibet.* New York: McGraw Hill, 1962.

Danner, Mark. "The Politics of Fear." *New York Review of Books,* November 22, 2012, 50–54.

Davis, David Brion. Introduction to *The Fear of Conspiracy: Images of Un-American Subversion from the Revolution to the Present,* ed. David Brion Davis, xiii–xxiv. New York: Cornell University Press, 1971.

Dawson, Raymond. *The Chinese Chameleon.* London: Oxford University Press, 1967.

Deane, Hugh. *The Korean War, 1945–1953.* San Francisco: China Books, 1999.

Deleuze, Gilles. "Coldness and Cruelty." In *Masochism,* 9–138. New York: Zone Books, 1991.

Desser, David. "The Kung Fu Craze: Hong Kong Cinema's First American Reception." In *The Cinema of Hong Kong: History, Arts, Identity,* ed. Poshek Fu and David Desser, 19–43. New York: Cambridge University Press, 2000.

Dodin, Thierry, and Heinz Räther, eds. *Imagining Tibet: Perceptions, Projections and Fantasies.* Boston: Wisdom Publications, 2001.

Dong, Lan. *Mulan's Legend and Legacy in China and the United States.* Philadelphia: Temple University Press, 2011.

Dong, Stella. *Shanghai: The Rise and Fall of a Decadent City.* New York: HarperCollins, 2000.

Doyle, Paul. *Pearl S. Buck.* New York: Twayne, 1965.

Dworkin, Ronald. "The Historic Election: Four Views." *New York Review of Books,* December 9, 2010, 56–57.

Eisenschnitz, Bernard. *Nicholas Ray: An American Journey.* Trans. Tom Milne. London: Faber and Faber, 1993.

Engelhardt, Tom. *The End of Victory Culture: Cold War America and the Disillusioning of a Generation.* New York: Basic Books, 1995.

Everson, William K. "Harold Lloyd: The Climb to Success." In *Harold Lloyd: The King of Daredevil Comedy,* by Adam Reilly, 168–175. New York: Macmillan, 1977.

Fairbank, John K. *Chinabound: A Fifty-Year Memoir.* New York: Harper and Row, 1982.

———. *China Perceived: Images and Policies in Chinese-American Relations.* New York: Knopf, 1974.

———. *The Great Chinese Revolution, 1800–1985.* New York: Harper and Row, 1987.

———. *The United States and China.* 4th ed. Cambridge, MA: Harvard University Press, 1983.

Feng, Peter, ed. *Screening Asian Americans.* New Brunswick, NJ: Rutgers University Press, 2002.

Ferro, Marc. *Cinéma et histoire.* Paris: Denoel/Gonthier, 1977.

Flamini, Roland. *Thalberg: The Last Tycoon and the World of MGM.* New York: Crown, 1994.

Fore, Steve. "Jackie Chan and the Cultural Dynamics of Global Entertainment." In *Transnational Chinese Cinemas: Identity, Nationhood, Gender,* ed. Sheldon Hsiao-peng Lu, 239–262. Honolulu: University of Hawai'i Press, 1997.

Foucault, Michel. *The Order of Things: An Archeology of the Human Sciences.* New York: Vintage, 1973.

Franklin, Eugene Wong. "On Visual Media Racism: Asians in the American Motion Pictures." PhD diss., University of Denver, 1978.

French, Patrick. "Dalai Lama Lite." *New York Times,* September 19, 2003, sec. A.

———. *Tibet, Tibet: A Personal History of a Lost Land.* New York: Vintage, 2003.

Fried, Daniel. "Riding off into the Sunrise: Genre Contingency and the Origin of the Chinese Western" *PMLA* 122, no. 5 (October 2007): 1482–1496.

Fu, Poshek, and David Desser. Introduction to *The Cinema of Hong Kong: History, Arts, Identity,* ed. Poshek Fu and David Desser, 1–11. New York: Cambridge University Press, 2000.

Fuller, Samuel. *A Third Face: My Tale of Writing, Fighting, and Filmmaking.* With Christa Lang Fuller and Jerome Henry Rudes. New York: Knopf, 2002.

Garcia, Roger. "Outside Looking In: Notes on Asian America." In *Out of the Shadows: Asians in American Cinema,* ed. Roger Garcia, 74–82. Milan: Olivares, 2001.

Garrett, Shirley Stone. "Why They Stayed." In *The Missionary Enterprise in China and America,* ed. John K. Fairbank, 283–310. Cambridge, MA: Harvard University Press, 1974.

Gilman, Sander L. *Difference and Pathology: Stereotypes of Sexuality, Race, and Madness.* Ithaca, NY: Cornell University Press, 1985.

Gitlin, Todd. "The Unification of the World under the Signs of Mickey Mouse and Bruce Willis: The Supply and Demand Sides of American Popular Culture." In *In Search of Boundaries: Communication, Nation-States, and Cultural Identities,* ed. Joseph M. Chan and Bryce T. McIntyre, 21–33. Westport, CT: Ablex Publishing, 2002.

Glaessner, Verina. *Kung Fu: Cinema of Vengeance.* London: Lorrimer, 1974.

Goldstein, Melvyn C. *The Snow Lion and the Dragon: China, Tibet, and the Dalai Lama.* Berkeley/Los Angeles: University of California Press, 1997.

Gottlieb, Robert. "Orientally Yours." *New York Review of Books,* January 13, 2005: 40–42.

Grimes, William. "Car Clones and Other Tales of the Mighty Economic Engine Known as China." *New York Times,* February 15, 2005, Sec. B.

Grivel, Danièle, and Roland Lacourbe. *Robert Wise.* Paris: Edilig, 1985.

Halberstam, David. *The Coldest Winter: America and the Korea War.* New York: Hyperion, 2007.

Hamamoto, Darrell Y. "Introduction: On Asian American Film and Criticism." In *Countervisions: Asian American Film Criticism,* ed. Darrell Y. Hamamoto and Sandra Liu, 1–22. Philadelphia: Temple University Press, 2000.

Hamamoto, Darrell Y. and Sandra Liu, eds. *Countervisions: Asian American Film Criticism.* Philadelphia: Temple University Press, 2000.

Hammond, John R. *Lost Horizon Companion.* Jefferson, NC: McFarland, 2008.

Harding, Harry. "From China, with Disdain: New Trends in the Study of China." In *America Views China: American Images of China Then and Now,* ed. J. Goldstein, J. Israel, and H. Conroy, 244–268. Bethlehem, PA: Lehigh University Press, 1991.

Hardy, Phil. *Samuel Fuller.* New York: Praeger, 1970.

Harte, Bret. *The Complete Poetical Works of Bret Harte.* London: Chatto and Windus, 1886.

Henry, Michael. "*Kundun* vu par Martin Scorsese: Quel est le pouvoir de la compassion?" *Positif* 447 (May 1998): 21–29.

Herman, Edward, and Noam Chomsky. *Manufacturing Consent: The Political Economy of the Mass Media.* New York: Pantheon, 1988.

Hessler, Peter. "Tibet through Chinese Eyes." *Atlantic Monthly,* February 1999, 56–66.

Hevia, James L. *English Lessons: The Pedagogy of Imperialism in Nineteenth-Century China.* Durham, NC: Duke University Press, 2003.

Hietala, Thomas. *Manifest Design: American Exceptionalism and Empire.* Ithaca, NY: Cornell University Press, 1985.

Hilton, James. *Lost Horizon.* New York: William Morrow & Co., 1934.

Hoban, James Jr. "Scripting *The Good Earth*: Versions of the Novel for the Screen." In *The Several Worlds of Pearl S. Buck.* eds. Elizabeth Lipscomb, Frances E. Webb and Peter Conn, 127–144. Westport, CT, Greenwood Press, 1994.

Hoberman, J. "When Dr. No Met Dr. Strangelove." *Sight and Sound* 3, no. 12 (December 1993): 16–21.

Hofstadter, Richard. "The Paranoid Style in American Politics." In *The Fear of Conspiracy: Images of Un-American Subversion from the Revolution to the Present,* ed. David Brion Davis, 2–22. New York: Cornell University Press, 1971.

Hooker, Jake. "Before Guests, Beijing Hides Some Messes." *New York Times,* July 29, 2008, sec. A.

Hoppenstand, Gary. "Yellow Devil Doctors and Opium Dens: A Survey of the Yellow Peril Stereotypes in Mass Media Entertainment." In *The Popular Culture Reader,* ed. Jack Nachbar and Christopher D. Geist. Bowling Green, OH: Bowling Green University Popular Press, 1983.

Hsü, Immanuel C. Y. *The Rise of Modern China.* New York: Oxford University Press, 1995.

Hunt, Michael H. "Pearl Buck: Popular Expert on China, 1931–1939." *Modern China,* 3, no. 1 (January 1977): 33–64.

Hunter, Jane. *The Gospel of Gentility: American Women Missionaries in Turn-of-the-Century China.* New Haven, CT: Yale University Press, 1984.

Hutchison, William. *Errand to the World.* Chicago: University of Chicago Press, 1987.

Isaacs, Harold Robert. *Scratches on Our Minds: American Images of China and India.* New York: John Day, 1958.

Jacobs, Andrew. "No Voice Is Too Small for a China Still Nervous About Dissent." *New York Times,* August 30, 2008, sec. A.

———. "Specter of Arrest Deters Demonstrators in China." *New York Times,* August 14, 2008, sec. A.

———. "A Would-Be Demonstrator Is Detained in China After Seeking a Protest Permit." *New York Times,* August 19, 2008, sec. A.

Jones, Dorothy B. *The Portrayal of China and India on the American Screen, 1896–1955.* Cambridge, MA: MIT Press, 1955.

Joshi, Pradnya. "A Charlie Chan Film Stirs an Old Controversy." *New York Times,* August 3, 2010, sec. B.

Judt, Tony. "Its Own Worst Enemy." *New York Review of Books,* August 15, 2002, 12–16.

Kael, Pauline. *5001 Nights at the Movies.* New York: Henry Holt, 1991.

Kang, Younghill. "China Is Different." *New Republic* 67 (July 1, 1931): 185–186.

Kazin, Alfred. Introduction to *Limehouse Nights,* by Thomas Burke, 1–16. New York: Horizon Press, 1973.

King, Homay. *Lost in Translation: Orientalism, Cinema, and the Enigmatic Signifier.* Durham, NC: Duke University Press, 2010.

Kinkead, Eugene. *In Every War but One.* New York: Norton, 1959.

Knaus, John Kenneth. *Orphans of the Cold War: America and the Tibetan Struggle for Survival.* New York: Public Affairs, 1999.

Kristof, Nicholas D. "A Little Leap Forward." *New York Review of Books,* June 24, 2004, 56–59.

———. "A Not-So-Fine Romance," *New York Times,* April 3, 2008, sec. A.

———. "An Olive Branch from the Dalai Lama." *New York Times,* August 7, 2008, sec. A.

Krugman, Paul. "The Paranoid Style." *New York Times,* October 9, 2006.

Kwa, Shiamin, and Wilt L. Idema, eds. *Mulan: Five Versions of a Classic Chinese Legend.* Indianapolis, IN: Hackett Publishing Co., 2010.

Kyrou, Ado. *Le surréalisme au cinéma.* Paris: Terrain Vague, 1963.

Lacourbe, Roland. *Harold Lloyd.* Paris: Seghers, 1970.

Landler, Mark. "Dollar Shift: Chinese Pockets Filled as Americans Emptied Theirs." *New York Times,* December 26, 2008.

Lane, Anthony. "Lady Be Good." *New Yorker,* April 30, 2007, 40–49.

Lee, Robert G. *Orientals: Asian Americans in Popular Culture.* Philadelphia: Temple University Press, 1999.

Leong, Karen Janis. "The China Mystique." PhD diss., University of California at Berkeley, 1999.

Lepore, Jill. "Chan, the Man." *New Yorker,* August 9, 2010, 70–74.

Lesage, Julia. "Artful Racism, Artful Rape." *Jump Cut,* no. 26 (December 1981): 51–55.

Lian Xi. *The Conversion of Missionaries: Liberalism in American Protestant Missions in China, 1907–1932.* University Park: Pennsylvania State University Press, 1997.

Liao, Kang. *Pearl S. Buck: A Cultural Bridge across the Pacific.* Westport, CT: Greenwood Press, 1997.

Lifton, Robert Jay. *Thought Reform and the Psychology of Totalism: A Study of "Brainwashing" in China.* New York: Norton, 1961.

Lopez, Donald. Foreword to *Authenticating Tibet: Answers to China's 100 Questions,* ed. Anne-Marie Blondeau, Katia Buffetrille, and Wei Jing, xvi–xxi. Berkeley: University of California Press, 2008.

———. *Prisoners of Shangri-La.* Chicago: University of Chicago Press, 1998.

Lu, Sheldon Hsiao-peng "*Crouching Tiger, Hidden Dragon,* Bouncing Angels: Hollywood, Taiwan, Hong Kong, and Transnational Cinema." In *Chinese-Language Film,* ed. Sheldon H. Lu and Emilie Yueh-yu Yeh, 220–233. Honolulu: University of Hawai'i Press, 2005.

———. "Historical Introduction: Chinese Cinemas (1896–1996) and Transnational Film Studies." In *Transnational Chinese Cinemas: Identity, Nationhood, Gender,* ed. Sheldon Hsiao-peng Lu, 1–31. Honolulu: University of Hawai'i Press, 1997.

———. "National Cinema, Cultural Critique, Transnational Capital: The Films of Zhang Yimou." In *Transnational Chinese Cinemas: Identity, Nationhood, Gender,* ed. Sheldon Hsiao-peng Lu, 105–138. Honolulu: University of Hawai'i Press, 1997.

———, ed. *Transnational Chinese Cinemas: Identity, Nationhood, Gender.* Honolulu: University of Hawai'i Press, 1997.

Ma, Sheng-mei. *The Deathly Embrace: Orientalism and Asian American Identity.* Minneapolis: University of Minnesota Press, 2000.

MacDonald, Callum. *Korea: The War before Vietnam.* New York: Free Press, 1986.

Mackerras, Colin. *Western Images of China.* New York: Oxford University Press, 1989.

"Madame Chiang Kai-shek, a Power in Husband's China and Abroad, Dies at 105." *New York Times,* October 25, 2003, sec. A.

Madsen, Richard. *China and the American Dream: A Moral Inquiry.* Berkeley: University of California Press, 1995.

Marchetti, Gina. *From Tian'anmen to Times Square: Transnational China and the Chinese Diaspora on Global Screens, 1989–1997.* Philadelphia: Temple University Press, 2006.

———. *Romance and the "Yellow Peril": Race, Sex, and Discursive Strategies in Hollywood Fiction.* Berkeley: University of California Press, 1993.

———. "The Threat of Captivity: Hollywood and the Sexualization of Race Relations in *The Girls of the White Orchid* and *The Bitter Tea of General Yen.*" *Journal of Communications Inquiry* 11, no. 2 (Winter 1987): 29–41.

———. "*The Wedding Banquet:* Global Chinese Cinema and the Asian American Experience." In *Countervisions: Asian American Film Criticism,* ed. Darrell Y. Hamamoto and Sandra Liu, 275–297. Philadelphia: Temple University Press, 2000.

Marcus, Greil. "A Dream of the Cold War." In *The Dustbin of History,* 192–208. Cambridge, MA: Harvard University Press, 1995.

———. *The Manchurian Candidate.* London: BFI, 2002.

Mark, Diane. Introduction to Wayne Chang, *Chan Is Missing,* 1–9. Honolulu, HI: Bamboo Ridge Press, 1984.

Marks, John D. *The Search for the "Manchurian Candidate": The CIA and Mind Control*. New York: Norton, 1991.

Marti, Sandra. "*Kundun:* Scorsese et la non-violence." In *Martin Scorsese, Études Cinématographiques*, vol. 68, ed. Michel Estève, 229–241. Paris: Lettres Modernes-Minard, 2003.

Marx, Samuel. *Mayer and Thalberg: The Make-Believe Saints*. New York: Random House, 1975.

Maurice, Alice. "What the Shadow Knows: Race, Image and Meaning in *Shadows*." *Cinema Journal* 47, no. 3 (2008): 66–89.

McBride, Joseph. *Frank Capra: The Catastrophe of Success*. New York: Simon and Schuster, 1992.

McClellan, Robert. *The Heathen Chinee: A Study of American Attitudes Toward China, 1890–1905*. Columbus: Ohio State University Press, 1971.

McGrath, Charles. "Charlie Chan: A Stereotype and a Hero." *New York Times*, August 11, 2010, sec. C.

McKenna, Richard. *The Sand Pebbles*. New York: Harper and Row, 1962.

Miller, Arthur, and Inge Morath. *Chinese Encounters*. New York: Farrar, Strauss, and Giroux, 1979.

Miller, Stuart Creighton. "Ends and Means: Missionary Justification of Force in Nineteenth-Century China." In *The Missionary Enterprise in China and America*, ed. John K. Fairbank, 249–281. Cambridge, MA: Harvard University Press, 1974.

Miln, Louise Jordan. *Mr. Wu*. New York: Frederick A. Stokes Company, 1918.

Mishra, Pankaj. "Holy Man." *New Yorker*, March 31, 2008, 120–123.

———. "Staying Power." *New Yorker*, December 20 and 27, 2010, 124–130.

Murri, Serafino. *Martin Scorsese*. Milan: Editrice il Castoro, 2000.

Nadel, Alan. "A Whole New (Disney) World Order: *Aladdin*, Atomic Power, and the Muslim Middle East." In *Visions of the East: Orientalism in Film*, ed. Matthew Bernstein and Gaylyn Studlar, 184–203. New Brunswick, NJ: Rutgers University Press, 1997.

Neils, Patricia. *China Images in the Life and Times of Henry Luce*. Savage, MD: Rowman and Littlefield, 1990.

Nelson, Lars-Erik. "Washington: The Yellow Peril." *New York Review of Books*, July 15, 1999, 6–10.

Niogret, Hubert. "*Kundun:* Une conscience en development." *Positif* 447 (May 1998): 19–20.

Nugent, Frank. "*The Good Earth*." *New York Times*, February 3, 1937.

Okihiro, Gary Y. *Common Ground: Reimagining American History*. Princeton, NJ: Princeton University Press, 2001.

Ollier, Claude. "Josef Von Sternberg." In *Cinema: A Critical Dictionary*, vol. 2, ed. Richard Roud, 949–960. New York: Viking, 1980.

Paine, Jeffrey. *Re-enchantment: Tibetan Buddhism Comes to the West*. New York: Norton, 2004.

Pan, Lynn. *In Search of Old Shanghai*. Hong Kong: Joint Publishing Company, 1982.

———. *Sons of the Yellow Emperor: A History of the Chinese Diaspora*. New York: Kodansha International, 1990.

Pang, Lai Kwan. *Building a New Cinema in China: The Chinese Left-Wing Cinema Movement, 1932–1937*. Lanham, MD: Rowman and Littlefield, 2002.

Perlez, Jane. "China Races to Replace U.S. as Economic Power in Asia." *New York Times,* June 28, 2002.

———. "In China and U.S., Mutual Distrust Grows, Study Finds." *New York Times,* July 18, 2013. Sec. A.

Powers, John. *History as Propaganda: Tibetan Exiles versus the People's Republic of China.* New York: Oxford University Press, 2004.

Powers, Thomas. Introduction to *The Search for the "Manchurian Candidate": The CIA and Mind Control* by John D. Marks, vii–xviii. New York: Norton, 1991.

Prasso, Sheridan. *The Asian Mystique.* New York: Public Affairs, 2005.

Pratley, Gerald. *The Films of Frankenheimer: John Frankenheimer Talks about His Life in the Cinema.* Bethlehem, PA: Lehigh University Press, 1998.

Preston, Diana. *The Boxer Rebellion: The Dramatic Story of China's War on Foreigners That Shook the World in the Summer of 1900.* New York: Walker and Company, 2008.

Purifoy, Lewis McCarroll. *Harry Truman's China Policy: MyCarthyism and the Diplomacy of Hysteria, 1947–1951.* New York: New Viewpoints, 1976.

Pye, Michael, and Linda Myles. *The Movie Brats: How the Film Generation Took over Hollywood.* New York: Holt, Rinehart and Winston, 1979.

Reader's supplement. In *The Good Earth* by Pearl S. Buck, 1–48. New York: Pocket Books/Washington Square Press, 1973.

Reed, James. *The Missionary Mind and American East Asian Policy, 1911–1915.* New York: John Day, 1958.

Reilly, Adam. *Harold Lloyd: The King of Daredevil Comedy.* New York: Macmillan, 1977.

Riencourt, Amaury de. *Roof of the World: Tibet, Key to Asia.* New York: Rinehart and Co., 1950.

Rohmer, Sax. *The Insidious Dr. Fu-Manchu.* New York: Dover, 1997.

Rosenthal, Elizabeth. "Herbs? Bull Thymus? Beijing Leaps at Anti-SARS Potions." *New York Times,* May 10, 2003.

Rovere, Richard. *Senator Joe McCarthy.* New York: Harcourt Brace, 1959.

Saada, Nicholas. "The Shadow of Whom? Asian Films and Hollywood Action Cinema." In *Out of the Shadows: Asians in American Cinema,* ed. Roger Garcia. Locarno Film Festival, August 2001, 65–70.

Said, Edward W. *Orientalism.* New York: Vintage, 1979.

Sangster, Jim. *Scorsese.* London: Virgin Books, 2002.

Sarkar, Bhaskar. "Hong Kong Hysteria: Martial Arts Tales from a Mutating World." In *At Full Speed: Hong Kong Cinema in a Borderless World,* ed. Esther C. Yau, 159–176. Minneapolis: University of Minnesota Press, 2001.

Sarris, Andrew. *The Films of Josef von Sternberg.* New York: Museum of Modern Art, 1966.

Sayre, Nora. *Running Time: Films of the Cold War.* New York: Dial, 1978.

Schaller, Michael. *The United States and China: Into the Twenty-First Century.* New York: Oxford University Press, 2002.

Schell, Orville. *Virtual Tibet: Searching for Shangri-la from the Himalayas to Hollywood.* New York: Metropolitan Books, 2000.

Schickel, Richard. *D. W. Griffith: An American Life.* New York: Simon and Schuster, 1984.

——. *Harold Lloyd: The Shape of Laughter.* Boston: New York Graphic Society, 1974.

Schlesinger, Arthur, Jr. "The Missionary Enterprise and Theories of Imperialism." In *The Missionary Enterprise in China and America,* ed. John K. Fairbank, 336–373. Cambridge, MA: Harvard University Press, 1974.

Schoonmaker, Thelma. "Il voulait évoquer le Tibet, pas l'expliquer." *Positif* 447 (May 1998): 30–33.

"Scorsese: la tentation bouddhiste." *Le nouvel observateur,* May 21–27 (1991): 55–56.

Seagrave, Sterling. *Dragon Lady: The Life and Legend of the Last Empress of China.* New York: Random House/Vintage, 1992.

Sergeant, Harriet. *Shanghai: Collision Point of Cultures, 1918/1939.* New York: Crown, 1990.

Smith, Craig S. "Doctor Says He Took Transplant Organs from Executed Chinese Prisoners." *New York Times,* June 29, 2001.

Smith, Gavin. "The Art of Vision: Martin Scorsese's *Kundun.*" In *Martin Scorsese: Interviews,* ed. Peter Brunette, 236–256. Jackson: University Press of Mississippi, 1997.

Smodin, Eric. *Regarding Frank Capra: Audiences, Celebrity, and American Film Studies, 1930–1960.* Durham, NC: Duke University Press, 2004.

Spence, Jonathan D. *The Search for Modern China.* New York: Norton, 1990.

St. Charnez, Casey. *The Films of Steve McQueen.* Secaucus, NJ: Citadel Press, 1984.

Steel, Ronald. "Harry of Sunnybrook Farm." *New Republic,* August 10, 1992, 34–39.

——. *Pax America.* New York: Viking, 1967.

Steele, A. T. *The American People and China.* New York: McGraw-Hill, 1966.

Steele, Wilbur Daniel. "Ching, Ching, Chinaman." In *Full Cargo,* 18–30. Garden City, NY: Doubleday, 1951.

Stein, Elliott. "Frank Capra." In *Cinema: A Critical Dictionary,* vol. 1, ed. Richard Roud, 181–188. New York: Viking, 1980.

Sternberg, Josef von. *Fun in a Chinese Laundry.* New York: Macmillan, 1965.

Stringer, Julian. "Cultural Identity and Diaspora in Contemporary Hong Kong Cinema." In *Countervisions: Asian American Film Criticism,* ed. Darrell Y. Hamamoto and Sandra Liu, 298–312. Philadelphia: Temple University Press, 2000.

Studlar, Gaylyn. *In the Realm of Pleasure: Von Sternberg, Dietrich, and the Masochistic Aesthetic.* Urbana: University of Illinois Press, 1988.

Taubin, Amy. "Everything Is Form." In *Martin Scorsese: Interviews,* ed. Peter Brunette, 257–266. Jackson: University Press of Mississippi, 1999.

Thomas, Bob. *Thalberg, Life and Legend.* Garden City, NY: Doubleday, 1969.

Thomas, Lowell, Jr. *Out of This World: Across the Himalayas to Forbidden Tibet.* New York: Greystone Press, 1950.

Thomson, James C. "Pearl S. Buck and the American Quest for China." In *The Several Worlds of Pearl S. Buck,* ed. Elizabeth J. Lipscomb, Frances E. Webb, and Peter Conn, 7–15. Westport, CT: Greenwood Press, 1994.

——. *While China Faced West: American Reformers in Nationalist China, 1928–1937.* Cambridge, MA: Harvard University Press, 1969.

Thomson, James C., Peter W. Stanley, and John Curtis Perry. *Sentimental Imperialists: The American Experience in East Asia.* New York: Harper and Row, 1987.

Thubron, Colin. *To a Mountain in Tibet.* New York: HarperCollins, 2011.

Urquhart, Brian. "What You Can Learn from Reinhold Niebuhr." *New York Review of Books,* March 26, 2009, 22–24.

Vance, Jeffrey, and Suzanne Lloyd. *Harold Lloyd: Master Comedian.* New York: Harry Abrams, 2002.

Van Doren, Carl. *The American Novel, 1789–1939.* New York: Macmillan, 1940.

Van Ginneken, Jaap. *Screening Difference.* Lanham, MD: Rowman and Littlefield, 2007.

Varg, Paul. *The Closing of the Door: Sino-American Relations, 1936–1946.* Ann Arbor: Michigan State University Press, 1973.

———. *Missionaries, Chinese, and Diplomats: The American Missionary Movement in China, 1890–1952.* Princeton, NJ: Princeton University Press, 1958.

Vidal, Gore. *Screening History.* Cambridge, MA: Harvard University Press, 1992.

Walker, Martin. *The Cold War.* New York: Holt, 1993.

Weinberg, Herbert G. *Josef von Sternberg: A Critical Study of the Great Film Director.* New York: Dutton, 1967.

White, Theodore H. *In Search of History.* New York: Harper and Row, 1978.

Wilentz, Sean. "Confounding Fathers: The Tea Party's Cold War Roots." *New Yorker,* October 18, 2010, 32–39.

Wollen, Peter. "Never at Home." *Sight and Sound* 4, no. 5 (1984): 12–15.

Xiang, Lanxin. *The Origins of the Boxer War.* London: RoutledgeCurzon, 2002.

Xing, Jun. *Asian America Through the Lens: History, Representation, and Identity.* Walnut Creek, CA: AltaMira Press, 1998.

Xu, Gary G. *Sinascape: Contemporary Chinese Cinema.* Lanham, MD: Rowman and Littlefield, 2007.

Yan, Wenjie. "A Structural Analysis of the Changing Image of China in the *New York Times* from 1949 through 1988." *Quality and Quantity* 32 (1998): 47–62.

Yang, Jeff. *Once upon a Time in China: A Guide to Hong Kong, Taiwanese, and Mainland Chinese Cinema.* New York: Atria, 2003.

Yardley, Jim. "Chinese Diners Shrug off SARS: Bring on the Civet Cat." *New York Times,* December 29, 2003, sec. A.

———. "In Beijing's Grand Olympic Show, Politburo Initiated Sleight of Voice." *New York Times,* August 13, 2008, sec. A.

———. "The SARS Scare in China: Slaughter of the Animals." *New York Times,* January 7, 2004, sec A.

Yoshihara, Mari. *Embracing the East: White Women and American Orientalism.* New York: Oxford University Press, 2003.

Young, Charles S. "Missing Action: POW Films, Brainwashing and the Korean War." *Historical Journal of Film, Radio and Television* 18, no. 1 (1998): 49–74.

Zen, Sophia Chen. "*The Good Earth.*" *Pacific Affairs* 4 (October 1931): 915–916.

Zhang Longxi. "The Myth of the Other: China in the Eyes of the West." *Critical Inquiry* 15 (Autumn 1988): 109–131.

Zhang, Yingjin. *Screening China: Critical Interventions, Cinematic Reconfigurations, and the Transnational Imaginary in Contemporary Chinese Cinema.* Ann Arbor, MI: Center for Chinese Studies, 2002.

Index

Page numbers for illustrations are in boldface.

About the Author

Naomi Greene is professor emeritus of French and film studies at the University of California at Santa Barbara. She has devoted most of her career to exploring the intersecting points between film and history—how cinema is influenced by, and influences, the broader social, political, and cultural context. Her earlier works on cinema—*Pier Paolo Pasolini: Cinema as Heresy* (1990), *Landscapes of Loss: The National Past in Postwar French Cinema* (1999), and *The French New Wave: A New Look* (2007)—explored this issue largely in terms of European film and history. In the wake of a trip to China more than a decade ago, however, she developed an interest in China and in American perceptions of China, which has resulted in this book.

Production Notes for Greene | *From Fu Manchu to Kung Fu Panda*

Cover design by Julie Matsuo-Chun

Text design by University of Hawai'i Press Production Staff
with display type in Seria Sans LF and text type in Minion pro

Composition by Westchester Publishing Services

Printing and binding by Sheridan Books, Inc.

Printed on 60 lb. House White, 444 ppi.